MAGNUM

Fifty years at the Front Line of History

MAGNUM

Fifty Years at the Front Line of History

Russell Miller

GROVE PRESS
New York

Originally published in Great Britain by Secker & Warburg
Published simultaneously in Canada
Printed in the United States of America

FIRST AMERICAN EDITION

Library of Congress Cataloging-in-Publication Data

Miller, Russell.
Magnum : fifty years at the front line of history / Russell
Miller.
p. cm.
Includes bibliographical references and index.
ISBN 0-8021-1631-0
1. Commercial photography—History. 2. Magnum Photos, Inc.—
History. I. Title.
TR690.M55 1998
070.4'9—dc21 97-49040

Grove Press
841 Broadway
New York, NY 10003

98 99 00 01 10 9 8 7 6 5 4 3 2 1

Contents

Preface

This is the unauthorised biography of a large, unruly and highly talented family which, by some miracle, has stayed together for fifty years. Since it would be impossible to write a book about Magnum that would please everyone in Magnum, I am resigned to the probability that many members of the Magnum family will be displeased with this effort, if for no other reason than that some photographers are inevitably given more prominence in the narrative than others. As in all families, favouritism, real or imagined, is a potent source of dissension. From the outset my aim was simply to tell a cracking good story as impartially, truthfully and entertainingly as was within my capabilities, and to disregard the notoriously fragile sensibilities of the participants.

Having worked as a journalist with a number of Magnum photographers, I imagined that securing Magnum's co-operation for this book would be a formality. I was wrong. It took close on a year for the family to decide to allow me through the front door and the freedom to rummage through its files. Even then, there were many reservations. The French members made no secret of the fact that they would have much preferred a French writer. Some members felt the manuscript should be approved by Magnum − an absurd proposition from people who build their careers on the principle of editorial freedom.

In the end, all the present members of Magnum agreed to be interviewed, with the regrettable exceptions of Bruce Davidson and Gilles Peress. Davidson explained he did not want to be interviewed because Magnum had of late been treating him 'like shit'. Peress said he did not want to talk about his years at Magnum for reasons he was keeping to himself, but furthermore he did not want anyone else at Magnum to talk about *him*, which naturally prompted me to ask everyone about him. I made three separate attempts to interview

Cornell Capa, prickly keeper of his brother, Robert's, flame, but on each occasion it seemed he considered my questions to be either insulting or boring; I gave up. In stark contrast, the formidable Henri Cartier-Bresson, the only founding member of Magnum still alive, was entirely happy to answer all my questions, once he had assured me how much he was bored by photography and how much he hated talking about it.

To all those photographers, past and present, who gave so generously of their time and loaned both letters and memoranda, I hereby place on record my sincere thanks. Their contributions will be found throughout the book. Similarly, the staff of the Magnum offices in London, Paris, New York and Tokyo were unfailingly helpful. The idea for this book originated from my good friend Graeme Salaman, the sociologist. I would also like to thank the librarians of the Museum of Modern Art and the International Center of Photography in New York, the High Wycombe branch of the Buckinghamshire County Library, Jinx Rodger, John Morris, Peter Hamilton, Neil Burgess, Tom Keller, Chris Boot, Liz Grogan, Stephen Gill, François Hebel, Agnes Sire, Amélie Darras, Fred Ritchin, Lee Jones and Simon Kelner, the editor of *Night & Day*, who provided me with sufficient space between foreign assignments to complete the manuscript.

Finally, but most importantly, I want to pay tribute to my wife, Renate, who not only conducted all the French-speaking interviews, but worked tirelessly as my researcher and transcribed many, many hours of audio tape, not all recorded in perfect conditions. This book would not exist without her loving support.

Introduction

In the last fifty years, Magnum photographers have been present at the defining moments of the second half of the twentieth century, bearing witness on the front line of world history, documenting the tragedies, triumphs and follies of mankind, creating some of the century's most memorable still images and proving that photography remains one of the most pervasive and powerful art forms of our time.

In the hands of a Magnum photographer, the camera is not just an objective eye, but an instrument to enlighten and inform, a stimulating force to influence opinion and sometimes to speak for those with no voice. No other group demonstrates such intense empathy and involvement with the way we live and the world in which we live. Before television brought images of conflict and famine and environmental disaster and political upheaval into every living room almost as it happened, Magnum photographers were the eyes of the world, often the first to show what was happening in far-flung places and feeding the public's post-war hunger for information.

Today Magnum photographers can no longer be first with the news, but their pictures continue to provoke, continue to prick consciences, continue to amuse, continue to stun an increasingly cynical world and continue to bridge the divide between journalism and art. Magnum can justifiably claim to have raised the standards of photo-journalism and invested it with moral purpose, self-respect and gravitas. Membership of Magnum is still one of the highest accolades to which a photographer can aspire.

Notwithstanding all this, it is nothing short of a miracle that the world's greatest photo agency has survived to celebrate its fiftieth anniversary. From its inception over a convivial lunch at the Museum of Modern Art in New York in the spring of 1947, it has

reeled from crisis to crisis, usually financial, sometimes emotional, occasionally personal and often potentially terminal. Paradoxically, that it has survived five decades is a tribute to the very people who most endanger its existence – its own photographers.

Magnum is a true co-operative, non-profit making, owned in equal parts by its shareholders. To join Magnum you must first submit an extensive portfolio of your work to the critical scrutiny of all the existing members. Financial potential is considered secondary to quality, but personality and dedication are important. If half the members approve, you are invited on to the bottommost rung of the ladder as a nominee, a novitiate, entitled to represent yourself as a Magnum photographer, but with no voting rights. After a minimum of two years, you must submit an even more extensive portfolio to even more critical scrutiny by your peers. If a majority again approves, you become an associate, still with no rights. A further portfolio must be submitted and approved before you are invited to take the final vows to become a member and shareholder and thus a part owner of the agency.

This is Magnum's great strength and its fatal flaw. Brilliant photographers are not necessarily brilliant businessmen; indeed, one could reasonably argue that someone engrossed by photography, by art, design and composition, is unlikely to be well equipped to run a multimillion-pound international business, which is what Magnum is. This recipe for chaos is further soured by the fact that these ill-equipped members are supposed to run the business together, despite all having different, strongly held, views about how to do it. The hapless staff thus find themselves working for forty-odd difficult and demanding bosses. 'It's like the inmates taking over the asylum,' a former bureau chief gripes. 'It's mob rule. Although they are an incredibly talented group of people, they have never run the organisation well. Magnum isn't a democracy, it's anarchy in the truest sense because the guiding principle is not the greatest good for the greatest number, but the rights of the individual to do whatever they like.'

Freedom is fundamental to the Magnum culture – freedom for the photographers to work on their own projects in their own time without deadlines or influence from editors, freedom from the pressure of crass commercialism, freedom to behave badly, freedom to dismiss outsiders. There is a story of a famous fashion photographer who proudly showed his documentary work in some foreign part to a member of Magnum. 'You know how long I was there,' the fashion photographer enthused, 'two weeks!' The Magnum man looked up from the pictures. 'Really?' he said, 'That long?'[1]

It is sometimes claimed, not entirely facetiously, that at any one moment in time there are 500 photographers around the world yearning to get into Magnum and fifty (in other words, the entire membership) yearning to get out. This may not accurately reflect the whole truth, but it certainly reflects the starkly differing perceptions of Magnum from within and without. It is hardly surprising that every young, ambitious photographer dreams of joining Magnum because it remains, despite its problems, the world's pre-eminent photographic agency. To be able to add 'Magnum' after your name on a picture credit signifies not only that that you have been accepted into an exclusive club, but that the existing members of that club have approved your entry. It means, as a photographer, that you have submitted your work to the critical scrutiny of the finest photographers in the world and they have found it of sufficient quality to admit you to their illustrious ranks, albeit in a lowly position. It means you are no longer just another photographer, you are a *Magnum* photographer.

But what do you find once you have been so honoured? You find you have become a member of a dysfunctional family, surely a family like no other, comprised of fractious and temperamental mavericks with huge egos and short fuses, riddled with jealousy and intrigue and fragmented by byzantine plotting. They are a pot-pourri of nationalities from widely differing backgrounds, people who would probably have never met, let alone become enmeshed in the love-hate relationship that characterises membership of Magnum, but for their shared interest in photography. Magnum's annual general meeting is notorious for its bad behaviour, heated passions, vituperation and hurled insults. Rare is the meeting not marked by tantrums, slamming doors, someone flouncing out or taking offence at a slight, real or imagined. It is particularly odd behaviour when you consider that many of those present are uniquely experienced in the ways of the world, courageous, enterprising and usually undaunted by adversity.

So it is that while from the outside the agency is exemplified by its prestige, its absolute commitment to excellence, its espousal of individual freedom and its high ideals, from the inside it is scarred by dissension and battered by the inescapable frictions of talented, opinionated, independent people trying to work together. 'The only thing they agree on,' former bureau chief Tom Keller observes, 'is that they are all brilliant. And in a way, they are.'

Even that which unites them, their common interest in photography, also serves to divide them, for the conflicting demands of aesthetics and journalism have never been reconciled. Those who

consider themselves to be serious photo-journalists, engaged in the important task of documenting history and trying to help people understand an increasingly confusing world, have little time for their fellow members involved in the struggle to produce art. The 'art photographers', in turn, can barely disguise their contempt for the grubby business of servicing popular magazines.

And yet and yet . . . the influence of Magnum on the history of photography is out of all proportion to the number of members. The Magnum archive is the antithesis of the bland notion that equates photographic objectivity with dispassionate neutrality. It preserves not only a multitude of important historical documents, but some of the century's most memorable still images, among them Robert Capa's death of a soldier in the Spanish Civil War, Henri Cartier-Bresson's picnic on the banks of the Marne, Dennis Stock's picture of James Dean in Times Square, René Burri's iconic portrait of a cigar-chewing Che Guevara and Sebastião Salgado's unforgettable essay on the gold miners in Brazil. Philip Jones Griffiths's courageous coverage of Vietnam, more than almost any other factor, opened America's eyes to what the war was doing to the benighted Vietnamese people.

Setting aside the bickering, membership of Magnum provides photographers with a rare opportunity to give and receive frank criticism of their work and sharpen each other's eyes by the constant interchange of superlative images. The result is an incomparable standard of photography which captures life's beauty and tranquillity as well as laying bare the face of inhumanity and suffering.

Thus does Magnum represent photo-journalism at its zenith – fearless, committed, intensely involved, passionate, demonstrating a sense of moral purpose. Magnum photographers at their best transform bearing witness into an artistic *tour de force* that transcends journalism and occupies a revered place in the photographic canon. The price has been costly – three lives lost – yet still Magnum photographers may be found risking their lives at trouble spots around the world, following the advice of one of the agency's revered founders, Robert Capa, who died in Indo-China in 1954: 'If your pictures aren't good enough, you're not close enough.'

I

The Meeting

PHOTOGRAPHERS LIKE to joke that becoming a member of Magnum is tantamount, in the rigour of the initiation, to joining a religious order. Not for nothing do critics deride the agency as a closed community of self-righteous monks scorning heathen outsiders. Acolytes accepted on probation may claim membership of the order, but have no privileges and must prove their worth while undergoing rigorous assessment and instruction from older members. After two years they are required to submit a portfolio of work to move on to the next stage and become a novitiate in preparation for taking their final vows as a penitent and fully fledged member entitled to vote at the annual convocation. Fortunately, none of the usual monastery rules regarding chastity and obedience apply.

The annual convocation of Magnum photographers takes place towards the end of June each year, rotating between the major Magnum offices in New York, Paris and London. Part business meeting, part social gathering, part therapy session, part family reunion, part tedious debating chamber, it is axiomatic that it is held against a background of crisis, since Magnum is always embroiled in a crisis of some kind, and it is almost a tradition that at one point or another the meeting will deteriorate into a furious shouting match, if not worse.

Many and colourful are the stories about Magnum's incendiary meetings. One year the shouting got so bad that Erich Lessing, who is a professor of photography in Vienna and was then in his sixties, was obliged to clamber on to a table, stamp his feet and bellow at the top of his voice to try and restore order. Another year Bruce Davidson and Burt Glinn, both long-standing Magnum colleagues based in New York, could be found on their feet, leaning over from opposite sides of a table, noses inches apart, veins bulging, screaming at each other. Observers vividly remember Davidson, who was in his

fifties, accusing Glinn, who was in his sixties, of being a 'prostitute', an apparent reference to Glinn's willingness to take on corporate work. A different disagreement, the details of which few can now remember, left Erich Hartmann looking as if he might be the sole surviving member after everyone else had threatened to resign *en masse* and in high dudgeon. On yet another occasion, when Philip Jones Griffiths refused to attend the meeting in New York, a delegation went round to his apartment intent on kidnapping him. Unfortunately Jones Griffiths is a burly Welshman built like a rugby forward and all attempts to bundle him into the elevator on the eleventh floor of his building failed. Jones Griffiths's grievance was that he disapproved of a decision to move the New York office into new premises in Spring Street, SoHo, and consequently vowed never to set foot inside the place. Since the meeting was being held in the new office, he naturally felt honour bound to absent himself.

Eugene Richards was so appalled by the experience of his first meeting that he could have left the agency that very day. 'There were tirades that went on for hours and there was a sort of pleasure in the abuse. This kind of behaviour among such a sophisticated and talented group of people was quite shocking. And it went on and on. It was an eye-opener and I didn't understand it: such malevolence, such negativity seeping into the institution and the quality of the relationships. It was very sad that such bitterness would persist for so long that it developed into paranoia and fear.'

'It takes several years of meetings to begin to have a clue as to what is going on,' explains Alex Webb, a Harvard graduate who joined Magnum in 1974. 'You can be listening to someone speaking and you begin to realise he is referring to something that could have happened fifteen years ago, some great grievance that is still sitting there and you can't understand why. Why all the anger, what's it about?'

'I often thought Magnum would self-destruct,' says Lee Jones, who was New York bureau chief in the 1960s. 'There were always lots of fights, people walking out, doors slamming. Rumours ran rife that so-and-so was resigning, or had already resigned, and then they would turn up next day in the middle of dinner. Sometimes the photographers would literally throw tantrums, lie on the floor and drum their heels or bang spoons on the table.

'The history of Magnum is full of murders. They always kill their kings; they killed anybody who tried to run them. It's probably why they're still around. The things that most organisations offer are money or power or glory. In Magnum money has always been problematical, power is something that was never allowed to rest in

one person's hands for very long and glory most certainly had to be shared. A great many people have come in, rolled up their sleeves and tried to get the place straightened out, but it always fell apart when they tried to do it.'[1]

The annual general meeting in 1996 was held in Paris, at the Magnum offices in Passage Piver, in the distinctly unfashionable 11th arrondissement. Before the meeting a black-bearded Iranian member who goes by the single name of Abbas circulated a memorandum warning of problems ahead: 'As we are about to celebrate – with some complacency – our 50th [anniversary], the main danger we are facing is not money, shrinking markets, shifting organisation and a tough outside world. The danger is within ourselves: *it is mediocrity.* Wa salaam.'

With these portentous words to chew on and chew over, members gathered in the courtyard at Passage Piver on a warm and sunny Thursday morning for the first session, which was due to start at 10.30 but was promptly postponed because a number of the French photographers were due to attend a ceremony at which Robert Delpire, director of the Centre National de la Photographie in Paris, was being invested with a medal. Chris Steele-Perkins, the president of Magnum, announced that the meeting would now start at one o'clock sharp.

With his white T-shirt, baggy cotton trousers and sandals without socks, Steele-Perkins set the informal tone for the occasion. Multi-pocketed waistcoats and variations on a safari theme were favoured by other members. But no one could mistake the fact that this was a conclave of photographers, for many of them had Leicas hanging round their necks and amused themselves by taking pictures of each other. Larry Towell, who farms in rural Ontario when he is not working as a photographer, turned up in a straw hat, striped shirt, braces and jeans, while Micha Bar-Am, who has covered every war in the Middle East since the foundation of Israel, would have looked like an Old Testament prophet, with his luxuriant beard, had it not been for his combat jacket and tinted spectacles. Jean Gaumy, the French vice-president, bears a striking resemblance to a mischievous pixie and darted about with a video camera to produce a filmed record.

Usually only those members who are sulking or are on unavoidable assignments miss the annual meeting, even though it often means travelling halfway round the world. But travel is nothing to these people; it is an integral part of their lives as professional photographers and getting to Paris is a lot easier than reaching many of the places in which they find themselves. Indeed, not long after

chairing the meeting, Chris Steele-Perkins was in Afghanistan with the government forces just outside Kabul when a rocket-propelled grenade failed to explode right in front of him.

The meeting did not, of course, start at one o'clock prompt because by then a buffet lunch had materialised in the courtyard with cold chicken, salads, some fine cheese, an excellent red wine and, curiously, two bottles of Pernod which remained primly unopened. But at two, after much cajoling, the members were assembled in a darkened ground floor studio for the traditional opening event, an opportunity for members to show what they have been working on during the previous twelve months. 'Please make it very tight', the agenda pleaded, 'as there are a lot of people, around 30 slides per presentation.'

Chris Steele-Perkins kicked off with a selection of bleak pictures of the homeless he had taken as part of a project he was working on with a London charity. As the carousel clicked, the wretched faces of the urban dispossessed stared out from the white wall on to which the pictures were being projected. They were followed by scenes of crime and violence in South Africa, competitors at the Paralympics and British football supporters. Steele-Perkins's presentation was received with a polite ripple of applause.

For the next hour or so those present were whisked around the world, mostly with images in black and white, which is the preferred medium for those who consider themselves to be serious about photography. (It is also an enigma for ordinary folk: why would anyone want to photograph an indisputably colourful world in monochrome? If colour film had been invented first, would anybody even *contemplate* photographing in black and white?)

Thomas Hoepker showed the destruction of the rainforest in Borneo and Sarawak; Patrick Zachmann showed the elections in Taiwan, the Mafia in Russia and the funeral of François Mitterand; Nicos Economopoulos showed the Greek Orthodox religion struggling in Israel, Serbia, Albania and Monrovia; Abbas brought along pictures from Israel and the Philippines, part of a major project on Christianity around the world; John Vink had been working in the mountains of Guatemala with Médicins sans Frontières – 'I kept the project cheap,' he explained. 'I only spent $300 in six weeks'; Larry Towell showed a portfolio on a Mennonite community in Mexico; Elliott Erwitt presented a typically wry selection from a new book called *Museum Watching*; David Hurn showed Welsh landscapes, portraits and lifestyle; Martine Franck had photographed children in Nepal and India considered to be reincarnations of deceased lamas; David Harvey gave his presentation on Spanish

culture in Cuba; and Ferdinando Scianna showed a moving set of
pictures of invalids clinging to faith and hope on a pilgrimage to
Lourdes.

As a demonstration of a truly international organisation it was
impressive in every way, not least in the backgrounds of the
presenters, who were: an Englishman born in Burma; a German
living in America; a Frenchman; a Greek; a Belgian; an Iranian living
in France; a Canadian; an American born in Paris to Russian
immigrants; a Welshman born in England; a Belgian raised in
America and married to a Frenchman; an American and an Italian.

At four o'clock it was time for the first business meeting in a
borrowed room on the opposite side of the courtyard. Eve Arnold,
diminutive, silver-haired and slightly stooped, arrived just before it
was due to begin and was warmly welcomed by everyone with kisses
on both cheeks, rather like a much loved Jewish mother turning up
for a big family reunion, which in a way is what she was. She took
her place at the long table in the centre of the room and those unable
to find chairs sat around the floor and leaned up against the wall or
squatted on a flight of stairs leading to an office above. This proved
to be something of a nuisance since the office above was a
production company auditioning for a television commercial and
throughout the meeting a procession of astonishingly beautiful
young women picked their way up and down the stairs, causing
considerable distraction and much nudging and eye-rolling.

The first business was to hand out a green report containing the
previous year's figures. This was initially studied with enormous
concentration, not because everyone present was suddenly taking an
interest in the balance sheet, but because the report listed what each
photographer had earned. 'Of all the paper that is going to be pushed
around this weekend', one member whispered, 'this makes the most
interesting reading.'

The news that Chris Steele-Perkins had to impart to his colleagues
was uniformly bad. Magnum, he said, was facing the worst crisis in
its history. It was different from the crises that are always raised at
every annual meeting: this one was life-threatening. Unless urgent
action was taken, Magnum would collapse. The figures continued to
go down relentlessly. Assignments, both editorial and commercial,
were decreasing every year. The archive, the so-called 'gold mine'
that everyone said Magnum was sitting on, was not being sufficiently
exploited, particularly in America, which was the biggest market in
the world. The debts incurred by the New York office were now no
longer sustainable, but none of the offices was working properly. A
new, radical business strategy had to be devised, and additional

funding identified, if Magnum was to stand any chance of surviving . . .

The members received all this with remarkable equanimity. It was immediately clear that Magnum meetings were unlike any corporate meeting anywhere in the world. While Steele-Perkins was talking, people wandered in and out, whispered among themselves, read newspapers, took photographs and occasionally nodded off to sleep. Philip Jones Griffiths remained engrossed in *Private Eye* more or less throughout.

'When I look at the consolidated figures,' Steele-Perkins continued, 'I find it very depressing that a lot of the new members are only earning peanuts, making $9,000 or even less. With the offices not working properly, we have not much to offer them. What we are saying to them is, give us your money and get screwed and they should be thanking us. Is that what we are offering new photographers?'

Jones Griffiths looked up from his magazine for a moment to offer the following: 'Everything that has happened in the world of photography we did first and here we are bankrupt and divided and on our knees and our competitors are millionaires. Why? Everyone think on that before they go to sleep tonight.'

'How can we be efficient and make concrete decisions in the next days?' asked Gilles Peress. 'We must have a business plan.'

'Every year we make plans and rules,' complained Thomas Hoepker, 'and every year they are forgotten as soon as we walk out of the door.'

Patrick Zachmann said the structure of the agency had to be made lighter to make them all more free. If you ask younger members if they are satisfied with the structure, they are not.

'We've never been businessmen,' Leonard Freed put in. 'If it's a business, let's hire businessmen to run it. We are out photographing, that's what we do. Why ask us to make business decisions?' Freed was wearing a T-shirt which resonated curiously with the despairing nature of the debate. Written across his chest was 'What does it all mean? What is the purpose of it all?'

A young Belgian member, Carl De Keyzer, complained that he had been in Magnum for six years and had only had five or six assignments.

'We don't just fail in one area,' Jones Griffiths put in, this time not bothering to look up from his magazine; 'we fail in all areas.'

'People keep blaming each other,' Martin Parr, one of the most successful of the London members, pointed out. 'But if you are not selling pictures, maybe your pictures are not good enough. If you

want to do a project, you have to set it up yourself. You can't blame everyone else.'

Burt Glinn swore that running the New York office for the last year had been the hardest year of his life.

'When I came to my first meeting,' said Patrick Zachmann, 'I thought we were going to talk about photography and photographic issues, but all we talked about was business, even though we are not businessmen.'

At this point Chris Steele-Perkins asked for views from those members who had so far not spoken and Georgui Pinkhassov, a quiet Russian attached to the Paris office, volunteered the information that thus far he had *rien compris*. He was ashamed because he did not speak English and he did not want to talk in banalities.

'That won't disqualify you here,' Glinn quipped.

When Gilles Peress offered to translate, Pinkhassov embarked on a long and emotional speech about what it meant to him to be a member of Magnum, how much he was stimulated by membership and how much more cultured he had found his Magnum colleagues than those unfortunates who worked for other photo agencies. 'I am looking for someone in Magnum,' he finally concluded, somewhat mysteriously, 'who will be on my side against the world.'

Chris Boot, the bureau chief in London warned the members that they had to decide collectively which way they wanted to go. 'You could decide to celebrate the fiftieth anniversary by closing Magnum down. The first question is whether there is the collective will in the organisation to work together and reach the market potential.'

'Options,' said Chris Steele-Perkins, summing up, 'will be put on the table and you will have to decide. It's your company.'

With these words, the meeting adjourned for the day, leaving everyone just about enough time to prepare for the party which is always held on the first evening. No stranger attending the crowded party on the roof of the Paris office that night would ever have guessed that Magnum had a care in the world. It was a wonderfully warm evening with the last rays of the sun bathing the surrounding rooftops in a pink glow. Taittinger champagne flowed, appropriately by the magnum, the buffet was magnificent and spirits were high, to judge by the animated conversation and the laughter. Only later did Paris bureau chief François Hebel admit that Taittinger had donated the champagne in return for a Magnum member photographing the bottle.

Friday was the big day for the presentation and assessment of portfolios from photographers aspiring to join Magnum and from those wishing to move up a level from nominee to associate and

from associate to full member. All young photographers are welcome, and indeed encouraged, to show their work to Magnum at any time, but to join the agency the work has to be seen and approved by a majority of members at the annual meeting. A leaflet advising aspirants how to present a portfolio to Magnum is hardly encouraging: it points out that successful applicants will only be invited to become a nominee member – 'a category of membership which presents an opportunity for Magnum and the individual to get to know each other but where there are no binding commitments on either side' – and that in each of the last five years no more than two applicants have ever been successful. Some years none made it.

The meeting was due to start at 10.30 on Friday morning and so it started promptly at 11.30, with Steele-Perkins muttering dark threats about what he intended to do if people couldn't keep to the schedule. The morning was occupied by presentations from Donovan Wylie, a Belfast-born associate applying for full membership, and from Luc Delahaye, a young Frenchman hoping to move up from nominee to associate. Both, by coincidence, showed photographs from the bitter fighting in Chechnya earlier that year. Wylie bolstered his portfolio with an offbeat photo essay of Russians going to the polls, while Delahaye included more war pictures from Bosnia and Rwanda, among them some terrible shots of bodies being tipped into a mass grave by bulldozers, and a quirky set of pictures taken with a hidden camera of people travelling on the Métro in Paris.

Thirty-three-year-old Delahaye was a popular figure in the Paris office and was talked about as a worthy successor to Robert Capa. By the time he had joined Magnum in 1994, he was already a veteran of Beirut, the fall of Ceausescu in Romania, Bosnia, Afghanistan and Rwanda. Only a few months after being elected as a nominee he was arrested by the Serbs in Bosnia and held blindfolded for three days, during which he was tortured and frequently told he was going to be taken outside to be executed. He was only released after Magnum put pressure on the French foreign ministry to take action.

The discussion over the relative merits of the pictures submitted by Wylie and Delahaye was animated and occasionally heated. If there were any reservations about Delahaye's work it was only that it conformed too closely to Magnum's bulging archive of war pictures. 'I've seen so many pictures in war situations,' sighed the voluble Italian, Ferdinando Scianna, 'that I'm starting to think I have seen them all before.'

London member Peter Marlow tended to agree. 'How many

people have to die,' he asked, 'for someone to become a member of Magnum?'

James Nachtwey, Magnum's best-known and most experienced war photographer, argued persuasively that while the world suffered from war it had to be covered. He was supported by Stuart Franklin, the British photographer who took the famous picture of the student standing in front of a tank in Tiananmen Square: 'I think Luc is documenting history in an eloquent and forceful way, not just for us but for the world.'

The argument then moved on to the struggle between art and journalism, Magnum's tendency to reincarnate itself and its doubtful willingness to consider truly innovative work seriously. 'What kind of photographers do we want?' Patrick Zachmann demanded. 'Those who reassure us by taking the same kind of pictures we are taking, or those doing really new work?'

It was finally left to Ferdinando Scianna to put his finger on what was going on. 'While we are talking about them,' he announced, 'what we are actually doing is talking about ourselves.'

In the end, Delahaye was accepted as an associate. Wylie's application for full membership was rejected, but it was agreed he should be asked to stay on as an associate and apply again later. Both men were sitting outside in the courtyard waiting for the decision. David Hurn, a long-standing and respected member who was a friend of Wylie's, was designated to break the bad news to him, while everyone else fell on the alfresco lunch buffet laid out on trestle tables.

Wylie seemed philosophical about it. Indeed, it is no disgrace to be passed over for membership since it is far from an infrequent occurrence. Sebastião Salgado, one of the most illustrious names to be working in Magnum in the 1980s, failed on his first attempt to become a full member, although he admitted it hurt at the time. Peter Marlow recalls walking round New York in a fury muttering 'Bastards, bastards' under his breath after being told he was 'not ready' for full membership.

In the afternoon it was time to consider the portfolios submitted by would-be nominees. They were spread around on tables in the studio and were mercilessly scrutinised. None provoked much enthusiasm and most were dismissed as not worthy of serious consideration, even though they represented the best of the work tendered to the individual offices. Only one submission generated any heat – a portfolio by a woman photographer of intriguing colour pictures of ordinary Russian families at home, staring directly into the camera. They were in some ways strangely compelling, the kind

of pictures that instantly make you want to know more about the subjects, but they had nothing to do with photo-journalism and thus immediately aroused the animosity of the photo-journalists, while the 'art photographers' waxed enthusiastic.

The debate quickly returned to the topic of the morning, Magnum's unwillingness to accept genuinely original work, and soon everyone was talking at once, their voices rising to try and make themselves heard. When Philip Jones Griffiths boomed 'WE ARE *NOT* ARTISTS' there was complete uproar, with many members on their feet shouting, some quivering with rage. Sadly, the argument turned personal when someone said that the photographer concerned was a 'bit pushy'; Eve Arnold ventured the view that if she was admitted she would be divisive. So then they began to quarrel about why it was that the personality and character of women applicants was always taken into greater consideration than when men were being considered.

In the end it was academic, since only three names got through to a final short list and only one, a young Italian, was deemed acceptable to the majority.

The final meeting of the day was to discuss the photographers' contracts. By then Magnum's lawyer, Howard Squadron, had shown up at Passage Piver. Squadron is a highly regarded corporate lawyer in New York who numbers Rupert Murdoch among his clients. He has been the legal adviser to Magnum since the 1950s, more out of affection than out of any hope that the agency will ever be able to pay his fees. He is an unashamed fan, a close friend of many of the photographers and describes the annual meeting as his 'marvellous annual lost weekend'. He enjoys the adventures of the photographers vicariously. He still talks about the meeting when Burt Glinn arrived straight from Cuba after accompanying Castro on his triumphant entry into Havana, while other photographers arrived from covering the revolution in Hungary and war in the Middle East: 'I remember looking round the room and thinking what a very remarkable group of people they were.' Squadron has handled most of Magnum's numerous divorces and he and and his family have, he says, been photographed 'up, down and sideways' by members.

The lawyer sees his role in the agency as somewhere between a rabbi and a business adviser, helping the photographers to figure out a way of doing whatever it is they want to do. 'Essentially the same issues are discussed at every meeting,' he explains. 'The first is how to run an agency when the bosses are constantly travelling all over the world, the second is money; the third is competition between the offices and the fourth is philosophy, the direction Magnum

should be taking. Because photographers are concerned with the creative aspects of their work, they are neither interested nor involved in the nuts and bolts of corporate management and are not very business oriented.'

Squadron candidly admits that he is 'stunned' that Magnum has endured so long. 'It is extremely difficult to run what is essentially a profit-making business on a non-profit basis. I think it is held together by a rather special glue – the commitment of the photographers and their conviction that the only way they can protect their rights is by staying together.'

Saturday was devoted to the thorny question of how Magnum is to survive. Chris Steele-Perkins greeted his colleagues like this: 'Today is the day. We are in a lot of trouble. Today we have the chance to put it right, or we can just hope for a miracle.' The New York office had lost $300,000 in the last twelve months and accumulated losses now stood at around $1 million. The loyalty of the photographers was in doubt because they could never be sure when they would get their money. The previous October the New York office literally ran out of money and could not even pay its telephone bill, let alone the fees owed to photographers. Both the Paris and Tokyo offices had also lost money, although not to the same extent as New York.

'The reason New York is such a disaster,' someone would confide later, 'is that the photographers there won't work together because they all hate each other.'

François Hebel and Chris Boot, the bureau chiefs in Paris and London, began explaining a radical rescue package they had devised which would involve setting up a separate company within Magnum – Boot called it M2 – to co-ordinate the global marketing of the archive, including a catalogue. It would require raising new investment but could dramatically improve profit. A key part of the plan, they emphasised, was that the members should be willing to loosen their control of the agency and allow the staff to get on with it.

Howard Squadron, the voice of reason, was sceptical. 'What is being suggested here is an entrepreneurial exercise and in general entrepreneurial exercises are run by entrepreneurs and not by committees. This proposal will essentially eliminate photographer control and I would suggest that that is a matter for discussion. Many photographers over the years have been concerned about how their images are presented and marketed. If you embark on this path many of those concerns will have to be put aside if you are going to have commercial success. Every business venture starts with the question: what is the market? If you do not know the market very clearly, you

are not going to be able to proceed. Furthermore I think it will be very difficult to borrow the money; I don't think a bank will lend without a demonstrable track record of commercial success, which you do not have. That brings me to investment. It would be best for the photographers themselves to invest the money needed rather than give away part of the store and give up some control. Quite frankly, and do not take this wrongly, this is not an amateur exercise.'

Uniquely among those present, Squadron could command complete silence and total attention, even from those French photographers who could not understand a word of English. After he had finished, a babble broke out with a dozen different points of view being expressed at once. When Steele-Perkins had restored a semblance of order, everyone was given the opportunity to put their point of view, but Patrick Zachmann, who was sitting on the floor on one side of the room, clearly felt he was not getting a fair hearing: suddenly he got to his feet, shaking his head and muttering something in French, threw his bag over his shoulder and stalked out, his dark eyes flashing furiously.

For a moment there was silence while everyone looked at each other, possibly wondering what had brought on this fit of pique or whether an attempt should be made to persuade him to come back. Eventually Gilles Peress went out after Zachmann, followed by François Hebel, followed by Steele-Perkins, followed by Jean Gaumy, followed by Bruno Barbey. They all huddled in the courtyard while those remaining in the room read the newspapers or gossiped. 'There was no reason for him to walk out like that, slamming the door,' someone said. 'He didn't slam the door,' Burt Glinn pointed out; 'there isn't a door.'

Zachmann, who joined Magnum in 1985, is one of the cadre of Paris-based photographers who see themselves as artists rather than journalists. He takes pictures, he explains, to express himself and to try to understand the world and himself better. This has not, however, prevented him from being shot. He happened to be in South Africa, working on a personal project, when Nelson Mandela was released from prison. Because he was a Magnum photographer and because he thought he might be able to make a little money, he decided he ought to try and record the occasion and so he made his way to the city hall in Cape Town, where Mandela was due to meet the people. Waiting with two other photographers for the great man to arrive, they heard shooting and ran to where the noise was coming from, straight into a confrontation between nervous white policemen and a crowd apparently looting shops. As Zachmann

turned the corner the police fired and he took a full blast of buckshot in the chest, legs and arms. He clearly remembers falling and thinking he was going to die and being angry at the injustice of being shot when he wasn't even a journalist. He was also rather irritated that one of his companions, who clearly *was* a journalist, took a picture of him before dragging him into shelter and calling an ambulance.

It took about half an hour to persuade Zachmann to return to the meeting, but he would only stand at the back, glowering. He was in time to hear an impassioned speech from Ferdinando Scianna which was hard for an outsider to follow, partly because he spoke from his scribbled notes in a mixture of English, French and Italian and partly because his theme was centred on the need to 'free ourselves from our mothers and the kibbutz'. When he finally resumed his seat he received a round of applause, perhaps more for *élan* than for content.

A suggestion that every photographer should ante up $10,000 to help the New York office out of its financial crisis was rejected on the incontestable grounds that many members did not have anything like that kind of money available to put into the pot, even if they felt so inclined. There was also an unpleasant spat between Gilles Peress and Chris Boot, when Peress complained about the accounting in New York and asserted that he could spot mistakes in 'the blink of an eye'. 'If we tried to answer all the questions you raise,' Boot retorted, 'it would take up all the time of the staff.' Peress fixed Boot with a sullen stare as Boot explained that Peress had once asked him to provide all his figures for the previous fifteen years. Peress has since insisted he could not have asked Boot for the figures for the last fifteen years but only those for the last fifteen months in which the photographers did not receive their monthly statements and, that when accounting figures were finally received, they contained substantial inaccuracies.

It was clearly a surprise to all those present that when it was time to take a vote on the rescue package, everyone agreed that it should go ahead. Boot was jubilant. 'Do you realise,' he whispered, 'this is a real breakthrough?' Howard Squadron, a slight smile playing on his lips, said nothing.

By Sunday it was evident that the members were getting demob happy and looking forward to the meeting drawing to an end. There were no fireworks and the debate was flaccid, covering a whole range of issues, from the legal implications of people injured by a bomb in Algeria successfully petitioning that photographs of them at the scene had invaded their privacy, to whether or not Magnum should have its own Web site and design its own screensaver. Jones

Griffiths was dismissive. 'Will a screensaver make Magnum look like a serious organisation with its finger on the pulse. What next? A T-shirt? The asset strippers will be marketing our toenail clippings in plastic bags next.'

One desultory exchange prompted a rare contribution from the taciturn Elliott Erwitt, who, as one of the very early photographers to be recruited, says he only intervenes in the debate to 'protect some of the things that the younger ones are too stupid to understand'. Someone complained that a proposal was unfair. 'Well life *is* unfair,' said Burt Glinn, 'no question about it.' 'Since when?' said Erwitt.

A journalist who was once commissioned to write a 12,000-word article about Erwitt was warned that it would be impossible because Erwitt had 'never spoken 12,000 words in his whole life'. He certainly had only one word – 'tiresome' – to describe the tenor of most annual meetings. 'Magnum is a combination of a lot of diverse people who are prima donnas. There are a lot of egos and so there is a lot of in-fighting. I have been a witness to this stuff for the last forty-three years and it gets a little tiresome because a lot of it is the same, but I guess it's a part of running your own business. If you analyse it, I guess it's better than working for Time Inc. or Murdoch.'

'The meetings used to be great fun in the old days,' said Ian Berry. 'I used to look forward to them. You know, this crazy gang, with not a damn thing in common except photography, would get together and try to sort out why we'd lost so much money during the year. There were some great characters around and it would always deteriorate into the most marvellous rows.'

During the lunch break Jones Griffiths told a wonderfully malicious and probably apocryphal story about how the New York photographers had once organised a joint project on Paris, much to the fury of the Paris office, which could not abide the idea of American photographers working in their beloved city. When the project was selected for inclusion in an exhibition in Paris it was the final straw. On the night before the exhibition, said Jones Griffiths, Cartier-Bresson organised a van loaded with pictures taken by the Paris photographers, drove round to the gallery, removed all the pictures by American photographers and replaced them with the French pictures. ('Totally untrue', Cartier-Bresson said later, 'Absolute rubbish.')

Coincidentally, a letter from Henri Cartier-Bresson was read out that afternoon expressing his regret that he could not be present – he was in hospital for a minor operation – but wishing everyone well.

Cartier-Bresson, the sole surviving founding member, retains considerable affection for Magnum. Although he has not been working actively as a photographer for more than twenty years he says there is an umbilical cord which keeps him attached to the agency. He points out, with delight, that in the year he was chairman of the board the minutes of the annual meeting note that the chairman was 'kindly requested to avoid doing water colours during the meeting'.

'Magnum,' he says, 'is a community of thought, a shared human quality, a curiosity about what is going on in the world, a respect for what is going on and a desire to transcribe it visually. That is why the group has survived. That's what holds it together.'

'Sure we're like a family,' says Elliott Erwitt; 'that's why we tear each other's throats out.'

'Oh yes, we're a family,' says Ferdinando Scianna. 'I hate my family.'

PATRICK ZACHMANN, a member since 1985, talking in the Magnum office in Paris: 'I always have a problem with the meeting, a problem of identification with the group. During the year, there is no problem, you do your own work, you have some personal relationships with some good friends who are photographers in Magnum. In Paris we are also a good team, you deal a lot with the staff more than with other photographers – the staff is young and a bit more open-minded, I think, than some of the photographers. But during the meeting, it is as if the image of your group, your family, suddenly appears to you and you don't always accept your family and you have some problems of identification. This is a sensitive time for me – either I make the effort and I integrate with the group and all the arrangements and maybe lose something from myself, or I won't integrate truly.

'When I joined in 1985, I was one of the youngest photographers and I felt very isolated, especially in Paris. The greatest difficulty to enter and to join Magnum is just to find your place. That is the greatest difficulty. You have a lot of great personalities there, old people, strong personalities. The trap would be to be a copy; you have to remain yourself and that is the most difficult thing. You have some photographers who try to get you into their camp.

'I thought that amongst the members they would be talking a lot about photography, showing each other their work, criticising their work and so on. I was expecting that. In fact, it didn't happen at all. It happens with maybe one or two photographers but I can have that outside of Magnum. I was disappointed by that. I tried to push in that sense among the other young photographers: we wanted confrontation, discussion. That was the greatest disappointment in a way.

'There are always conflicts about "art" in Magnum. If you just pronounce the word "artist" in Magnum you get killed. They think you don't belong to the same group any more. This dispute should be discussed quietly and reasonably and anyway, it is something they should get out of the way, it is not important any more. I think Magnum is divided into four camps – artists, photo-journalists, old and young. I have no problem with art v. journalism. Artist is something you define for yourself, although I feel it is not possible to be an artist and a photo-journalist. It is a contradiction because as a journalist you have to be objective, have a point of view towards the reality; artists are different. I find journalism interesting only if it helps the world to change. Now my deep reasons for being a photographer are not journalistic, slightly artistic maybe, but mostly

for reasons of survival – I have to express myself and understand things for myself.

'In 1990 when I was in South Africa I was photographing the Chinese community living and working in Johannesburg. It was about the time Mandela was to be released and I thought it was a good opportunity to be there, to cover a great moment in history, but it was also a good moment for me as a human being to be there just to see it. I also thought – though this was a mistake – that financially it would help me with my Chinese project. Unfortunately, I got shot the first or second day and I didn't even see Mandela, or photograph him. I just learned that he would be released only a day before. I made the choice not to go to the prison because I didn't want to have the same pictures as everyone else. There were about 500 journalists and TV men waiting there and anyway I didn't have the lenses that I would have needed. I thought I would go to the place where he would have the first meeting with the population, in Cape Town, just in front of the *mairie*. I saw more and more people arriving and it was getting really crowded. There was a delay and it was very hot. Black people were becoming nervous and I was just hanging around with two other photographers and then suddenly heard firing. I thought it was a demonstration, firing of tear gas, so I rushed to where the noise was coming from with two others, one a photographer from Gamma, the other from Reuters. I was in front of the other two. We ran into a street where there were only black people and at the end were some white policemen protecting some stores which had been looted, or were starting to be looted. This day the police also were very nervous and upset, they didn't want Mandela to be released, they didn't want black power, so I think they were revenging themselves. They shot with buckshot, but it happened I was close to them and they shot me. As you know, when you are close to buckshot, you take the full blast, fifty shots in one. So I got the first shot and was quickly down. It was just like in a Western – wham! argh! and I was down. At that moment I thought I was dying, because I didn't know that it was buckshot. It was painful and it was strong – I was hit partially in the chest. Fortunately I was partly protected by my cameras and I took the rest in my legs and arms. Then they shot me again before I was on the ground. First you think you are dying and then you think "Oh wow, this is too bad!" In a way, I was regretting it because it was not justified for me to be shot here, even to be there as a journalist. I had no assignment, I was not being paid.

'When you are down, you reverse your relationship with people you photograph. There were two photographers, one from Gamma, who

left, and the Reuters photographer. He helped me, but first he shot a picture of me. That is very, very weird. At that moment I thought I was really not a journalist because I thought if the position were reversed, I would not have taken the picture and I would therefore have been a bad professional, because he was right to take it.

'But he did help me and so did some black guy, to put me out of range and get medical help. But after such a thing happening, I have to say I am now afraid for the first time in my life. As soon as I hear shooting, I am afraid. I think: it has happened once, it can happen again. Something has really changed. I see now that I am not a journalist. I was not a journalist then. I was just doing it mechanically, out of habit, because I am with Magnum.'

2

The Founders

THE FOUNDERS of Magnum were the unlikeliest band of brothers imaginable: four men of different nationalities and from widely differing backgrounds whose paths would never have crossed had they not shared a precocious passion for photography. The inspiration and driving force was Robert Capa, a swarthy Hungarian adventurer, notorious womaniser and incorrigible gambler who became known as the world's greatest war photographer. He was joined by a French intellectual, Henri Cartier-Bresson, a radical left-winger who liked to insist, a mite tetchily, that his main interest was painting but who nevertheless went on to inspire generations of photo-journalists and dominate the photographic pantheon. David Seymour, known to everyone as Chim, was a plump, owl-like Polish Jew, a shy, gentle polyglot and epicurean who, unusually for a photographer, invariably wore a suit and collar and tie. Finally there was the quiet Englishman, George Rodger, a former public schoolboy who described himself as a dreamer and only drifted into photography as a means of seeing the world.

As their paths crossed and re-crossed, these four developed trust and respect, almost love, for one another. All they had in common was the fact that they were photographers; otherwise they might easily have come from different planets. Yet their relationship would ultimately become essential for the survival of their finest creation – the world's most prestigious photo agency, Magnum. As Rodger was to remark, years later: 'To this day I do not understand how four personalities of such differing types as we were could get along so well together and for so long. Our backgrounds, our lifestyles and our way of working could not have been more different.'[1]

While in later years the credit would be diligently shared, it was Capa who had the idea and Capa who made it happen. In fact his name was not Capa at all, but André Friedmann. He was born in

Budapest on 22 October 1913, the son of a tailor. This is how he is remembered by his younger brother, Cornell: 'Bob, whom we called Bandi in those days, was an engaging child and everyone – family, friends and strangers alike – adored him. He was the middle child. László, the eldest, was born in 1911 and I arrived on the scene in 1918. Our parents were kept very busy by the demands of their dressmaking salon, but our mother, Julia, always found time to be loving, possessive and proud of us. She tried to be fair and impartial to all three of us, but she was especially attentive to Bob. He was a warm and outgoing child; his personality was irresistible, as it would remain throughout his life. Furthermore, the adventurousness that he began to manifest very early on meant that he needed and desired extra attention. Bob was only seventeen when he got into serious trouble with the Hungarian government, which was then a dictatorship under the proto-Fascist and anti-Semitic Admiral Horthy. As a politically precocious (and not very religious) Jewish student, Bob did what rebellious and idealistic students were beginning to do all over Europe: he contacted a Communist Party recruiter. During a long walk at night, the man told him that the party was not interested in young bourgeois intellectuals. Conversely, Bob decided he was not interested in the party. But the damage had been done, for the walk had been observed by the secret police. Not long after Bob returned home, two agents pounded on our apartment door and demanded that he get dressed and go with them to police headquarters. Our mother's passionate pleas and reassurances fell on deaf ears and Bob was taken away. Fortunately, the wife of the head of the secret police was a good customer of our parents' salon. Through that connection our father was able to secure Bob's release on the condition that he leave Hungary at once. He became a political exile at seventeen and never, thereafter, had a real home.'[2]

The young André went first to Berlin and enrolled at the respected Hochschule für Politik to study journalism, but his parents ran into financial difficulties and were no longer able to support him, so he found a job working as a darkroom assistant and errand boy for the Degephot photo agency. Simon Guttman, the owner of the agency, recognised that the boy had an eye for a good picture, lent him a Leica and began sending him out on simple assignments. In November 1932 he was entrusted to handle an assignment for *Der Welt Spiegel* photographing Trotsky, who was due to address a rally in Copenhagen on the meaning of the Russian Revolution. Later in life, Capa would tell a colourful, and somewhat improbable, story about how Trostky did not want to be photographed and none of

the other photographers could get into the rally because they were all carrying big box cameras, but he was able to slip in unobserved with his little Leica ('when some workers came to carry long steel pipes into the chamber I joined them') and get up close to the stage. To his great satisfaction, *Der Welt Spiegel* devoted an entire page to his pictures, crediting them 'Friedmann-Degephot'.

André would have been happy to stay in Berlin and capitalise on his early success, but the Nazis were on the march and in January 1933, soon after Hitler was appointed chancellor, he decided, as a Jew, that it was prudent to leave. He first went home, then made his way to Paris, at that time a veritable haven for refugees, artists and intellectuals fleeing from Fascism. He was determined to try and earn a living as a freelance photographer even though his French was at best rudimentary and at worst non-existent, but he quickly found that almost every other *émigré* in Paris seemed to have the same idea and work was hard to find: sometimes things got so bad he was forced to pawn his precious camera. Living hand to mouth, often hungry, sometimes discouraged, he spent much of his time hanging around with *émigré* friends at the café du Dôme in Montparnasse and it was there he met a young Polish photographer by the name of David Szymin, who had managed to find a job working for the Communist weekly, *Regards*. Szymin's name was pronounced 'Shimmin', which was why everyone called him 'Chim'.

Although they were both Jews from Eastern Europe, both interested in photography, in truth no two people could have been more different than Friedmann and Szymin. One was a flamboyant extrovert, the other a sensitive, scholarly introvert, but they nevertheless became inseparable, perhaps drawn together by what they were able to offer each other. André respected Chim's obvious intellect and talent as a photographer and felt he could learn much from him; Chim, in turn, learned from André how to enjoy life. André teased his new friend mercilessly, particularly when he discovered that Chim was very conscious of his appearance, usually wearing three-piece suits and hand-knitted ties, which Capa would slyly suggested were made for him by his girlfriends.

Chim was born in Warsaw on 20 November 1911, the only son of a well-known Yiddish publisher. Growing up in a wealthy and cultured family, he attended a local Jewish *Gymnasium* (secondary school) where his main interest was music. He first hoped to pursue a career as a concert pianist, but gave it up when he realised he did not have perfect pitch and was encouraged by his father to go to Leipzig to study printing and graphic arts. It was his father's earnest hope that Chim would follow him into the family business, but

Chim was restless and sought permission to continue his studies at the Sorbonne in Paris, this time on a course in advanced chemistry and physics. He had not been in Paris long when he received word from home that his father's business was suffering from the wave of anti-Semitism sweeping the country and that the family could no longer afford to send him a monthly allowance. Determined to remain in Paris, he cast about for a way of earning some money and decided to try his hand at photography. A family friend, David Rappaport, owned a small photo agency called Photo-Rap and offered to lend him a 35mm camera. With no experience at all, he began experimenting, taking pictures on the streets of anything that caught his eye. His first contact sheets impressed Rappaport, who was soon selling his pictures to newspapers and magazines. In 1933 he was able to write, with obvious pride, to a girlfriend back in Warsaw: 'I am sitting at my big desk, with a globe of the world on it, in my new apartment. I am a reporter, or more exactly, a photo-reporter. Lately I have been shooting a very interesting reportage – people working at night.'[3]

Chim was interested in using his camera to examine the social and political problems of the day and spent much of his time photographing workers, documenting the appalling conditions in which they laboured and lived. In March 1934 he was given his first byline on a picture in *Regards*, which published frequent features about social inequality and the plight of the working class. Thereafter he was a regular contributor and through his work in *Regards* he was invited to join a group of left-wing writers and photographers organised by Louis Aragon, editor-in-chief of the Communist newspaper, *Ce Soir*. It was at one of the meetings of this group that he met Henri Cartier-Bresson. They were both carrying Leicas round their necks and naturally got talking. 'I said to him "What have you got there?"' Cartier-Bresson recalled. 'And he said it was a Vidom, which was a viewfinder of that time, and we started a conversation. We soon became good friends, but he was so cautious that about four months passed before he introduced me to Capa, who was living in a room in the Hôtel de Blois with, I think, laundry hanging from the ceiling.'

Cartier-Bresson hardly came from the kind of background that would encourage him to knock around with two penniless *émigrés*, but he had always viewed himself as something of a rebel. Born in 1908 into a wealthy Norman family with major interests in the textile business, his mother was descended from Charlotte Corday, the woman who was executed for the murder of the revolutionary Jean-Paul Marat, and his father was a businessman with artistic

inclinations. So successful was the family business that it was said that there was not a sewing basket in the whole of France that did not contain a roll of Cartier-Bresson thread. Cartier-Bresson grew up in Chanteloup, not far from Paris, was educated at a school that numbered Marcel Proust and André Malraux among its alumni, painted at Cambridge for a year, studied with the Cubist André Lhote and travelled extensively through Europe, North America and Africa before turning from Surrealist painting to photography. 'Before I met Capa and Chim I didn't really know photographers,' he would explain. 'I was living with writers and painters more than photographers. When I took my camera and went out into the streets I didn't care about other photography: for me it was the curiosity of looking with a camera, sniffing, sniffing, with a Surrealist attitude. Capa was not primarily a vision man, he was an adventurer with a tremendous sense of life. But the photography was not the main thing, it was what he had to say, his whole personality. Chim was a philosopher, a chess player, a man who though not religious at all carried the burden of being Jewish within him as a kind of sadness. I was closer to Chim intellectually than I was to Capa.'

Cartier-Bresson read widely – Engels, Freud, Joyce, Rimbaud and Schopenhauer, among others – and at the age of twenty-two went to Africa, where he hunted by the light of an acetylene lamp strapped to his head. 'On the Ivory Coast I bought a miniature camera of a kind I have never seen before or since, made by the French firm Krauss. It used film of a size that 35mm would be, without the sprocket holes. On my return to France I had my pictures developed – it was not possible before, for I lived in the bush, isolated, during most of that year – and I discovered that the damp had got into the camera and that all my photographs were embellished with the superimposed patterns of giant ferns. I had had blackwater fever in Africa, and was now obliged to convalesce. I went to Marseille. A small allowance enabled me to get along and I worked with enjoyment. I had just discovered the Leica. It became the extension of my eye, and I have never been separated from it since I found it. I prowled the streets all day, feeling very strung-up and ready to pounce, determined to 'trap' life – to preserve life in the act of living. Above all, I craved to seize the whole essence, in the confines of one single photograph, of some situation that was in the process of unrolling itself before my eyes.'[4]

By the time he met Capa and Chim in Paris he had already held exhibitions of his work in Mexico and Madrid. The three of them shared a fifth-floor walk-up studio and employed André's younger brother, Cornell, to make their prints. Cornell had followed his

brother to Paris hoping to study medicine at university. 'At night in my hotel bathroom that I converted into an improvised darkroom, I developed and printed Bob's, Chim's and Henri's work. Every morning I carried the wet prints, wrapped in a newspaper like a package of fish, to my job in the lab of a commercial photographic studio, where my pay consisted of the right to use the electric print dryer during my lunch hour. I was eventually fired for using too much electricity.'[5]

Chim, Henri and André met regularly at the Café du Dôme but preferred to talk about politics rather than photography. The emergence of the Popular Front, a fiery coalition of liberals, socialists and Communists, had turned Left Bank pavement cafés into arenas for passionate debate on the merits of clashing political doctrines – Communism, Fascism, Nazism and socialism. 'We never, never talked about photography,' says Cartier-Bresson. 'Never! It would have been monstrous, presumptuous.' Left-wing, communitarian and anti-capitalist, the Popular Front was given powerful impetus by the spread of Fascism in France, the growing threat of Nazism and Mussolini's aggression in Ethiopia. There were almost daily demonstrations, marches, mass meetings and strikes. Chim and André, who was at last beginning to pick up work, were out every day photographing the turmoil on the streets, the militant masses marching with unfurled banners, waving clenched fists and inviting violent confrontation. They covered the First International Congress in Defence of Culture, attended by André Gide, André Malraux, Henri Barbusse, Boris Pasternak, Alexei Tolstoy and Aldous Huxley, and the spectacular demonstration on Bastille Day when a crowd of 250,000 gathered to listen to speeches in the Bois de Vincennes.

Although few were aware of it at the time, least of all Friedmann, Chim and Cartier-Bresson, the rise of the Popular Front effectively marked the birth of modern photo-journalism and the recognition of the power of the camera as a political instrument. The photo-story, illustrated by a series of linked images and captions, became the staple of big-circulation magazines like the *Berliner Illustrierte Zeitung*, thought to be the model for *Life*, and the *Münchner Illustrierte Presse* and as similar magazines began to make their presence felt, 'photo-journalists', using small portable cameras and the streets as their studio, emerged to fill the demand for pictures showing what was happening and how people lived.

Like the Bakelite radios crackling in homes around the world, picture magazines were a new medium of immense political and social influence and there was a fierce intellectual debate not just on the responsibility and purpose of photo-journalism, but on whether

artistic merit was either desirable or attainable. The influential painter, photographer and Bauhaus lecturer László Moholy-Nagy argued that what mattered was not that photography should become art, but that it should be 'the undistorted document of contemporary reality'. The radical Worker Photographers' Movement went even further: 'The aim must be to express the motif in its most succinct and convincing form. If this requires a distorted perspective, then it is because the end has justified the means. But the end is not in the material things themselves, nor in the work of art.' The end, as far as the Worker Photographers' Movement was concerned, was to use photo-journalism to serve its own preferences and promote its own interests.[6]

André by this time had fallen in love with an attractive German refugee called Gerda Taro, who first found a job selling pictures for the Alliance photo agency and then started working for the agency as a photographer, along with both Chim and Cartier-Bresson. Alliance was founded by a vivacious young woman by the name of Maria Eisner, who had also fled from Nazi Germany four years earlier. She ran Alliance from her own apartment, moving frequently and finally ending up at 125 rue du Faubourg St Honoré.

Maria is probably 'the German girl' Chim mentions meeting in one of his letters home. 'Socially, I am moving in new circles, away from the Polish gang. I am more among photographers, thinking people, interested in the same problems as myself. However, I feel a stranger and I am missing the "togetherness" of our Polish bunch. I met a German girl, who became quite prominent in the French press and she feels as I do. We are trying to organise some kind of association of revolutionary-minded photographers . . .'[7]

It was Gerda who introduced André to Alliance, where Maria looked at his work and offered him a monthly advance of 1,100 francs in return for covering three assignments a week. It was slightly less than Gerda was receiving, but André was in no position to haggle; he was more than pleased to have enough money to eat regularly, for a change.

There are any number of stories about how André Friedmann became Robert Capa and even the accepted version is treated with a fair amount of scepticism by Capa's biographer, Richard Whelan, but it has been so often repeated that it has become an integral part of the Capa legend. It is claimed that Gerda and André came up with the idea that his pictures would command bigger fees if editors thought they were taken by a successful American photographer rather than a struggling young *émigré*, so they simply invented such a photographer and called him Robert Capa. Gerda agreed to peddle

André's pictures as Capa's and explain to editors that Mr Capa would be deeply insulted by fees less than three times the going rate. Maria Eisner is believed to have seen through the ruse, but played along, probably because she was happy to sell 'Robert Capa's' photographs at higher fees. In fact, the legend goes, 'Capa' was only exposed when Lucien Vogel, editor of *Vu* magazine, saw Friedmann taking photographs of police roughing up a journalist while Emperor Haile Selassie was addressing the League of Nations in Geneva and was later offered the same pictures accredited to Capa. When he was told the pictures would cost 300 francs, he is said to have snorted: 'This is all very interesting about Robert Capa, but please advise the ridiculous boy Friedmann, who goes around shooting pictures in a dirty leather jacket, to report to my office at nine o'clock tomorrow morning.' So it was that André Friedmann became Robert Capa, and it was as Robert Capa that he was soon to make his name when, on 17 July 1936, General Franco led an army insurrection against Spain's newly elected left-wing Popular Front government.

The Spanish Civil War was uniquely well timed for the propagation of photo-journalism as an influential, pervasive and exciting medium. First it coincided with the greater use of small, highly portable cameras and more light-sensitive film, enabling war photographers to get up close among the troops, to bear witness at the front line and to show what it was really like to be in battle. Second, the war broke out in the year when *Life* magazine was launched – the first issue, 466,000 copies, sold out – and in the decade in which Europe was beginning to be well served by fine picture magazines – *Berliner Illustrierte Zeitung* and the *Münchner Illustrierte Presse* in Germany, *Vu* and *Regards* in France and, of course, the marvellous *Picture Post* in Britain. Third, it was a conflict that spread far beyond the borders of Spain. With Mussolini ranting from the balcony of the Palazzo Venezia in Rome and Hitler taking back control of the Rhineland, people began to sense a darkness closing in on Europe, and the Spanish Civil War quickly began to be seen as a secular crusade against the increasing excesses of Fascism. Franco's army was perhaps only intent on preventing Spain from slipping into the embrace of socialists, Communists, anarchists and church burners, but from outside Spain it became a war of democracy against Fascism, of working man against vested interests, of the secular and modern pitted against the ancient domination of the Church, against centuries of repression and religious fanaticism. Some 42,000 volunteers, mainly from Britain, France and Germany, made their way to Spain to fight for the Republican cause and Paris

became a centre for rallying support and a focus for moral and political outrage.

As photo-journalists, liberals and anti-Fascists, it was inevitable that Capa, Chim and Cartier-Bresson would want to cover the Spanish Civil War and help further the Republican cause and none of them wasted any time. Capa got an assignment from *Vu* and left almost immediately, with the indomitable Gerda, on a plane chartered by the magazine. Chim waited only long enough to photograph solidarity demonstrations in Paris, then left for Barcelona to cover the formation of the International Brigade. Cartier-Bresson, who had been working as an assistant director with the film-maker Jean Renoir, made a documentary film about the military hospitals.

One of the first photographers to arrive at the front, Capa began sending back pictures showing war as it had never been seen before, so close to the action you could see the fear in the eyes of the troops and almost feel the boom of artillery, the blast of exploding shells and the rattle of rifles. His pictures were also imbued with extraordinary compassion, never shrinking from the horror, despair and desolation of war, the dying and the wounded, the refugees, the children and the rare glimpses of humour and humanity. He recalled marching with refugees on the dusty roads fleeing from Franco's advancing troops: 'The refugees on the road are in the hands of fate, with their lives at stake. Sometimes the planes fly low and aim their machine guns at the stream of people below, killing men and animals. At such times the stream stops for a few minutes . . . but soon the terror of the moment is forgotten and is absorbed in the determined silence with which almost all these people bear their fate.'[8]

On 5 September, probably near Cerro Muriano, a village on the front line, Capa clicked the shutter to create what was to become the most famous picture of his career – a Republican militiaman, arms outflung, falling backwards at the moment of being shot. It first appeared in *Vu* later that month, a couple of weeks before Capa's twenty-third birthday, and when it was picked up by *Life*, captioned 'A Spanish soldier the instant he is dropped by a bullet through the head', Capa found himself becoming a celebrity. The dramatic picture, a potent symbol of Republican sacrifice, is viewed by many as the greatest war photograph ever taken and subsequently became the most reprinted photograph of the Spanish Civil War, but it would ultimately cause the Capa family considerable anguish when, years later, doubts were raised about its authenticity.

Perhaps as much out of jealousy and spite as out of genuine journalistic curiosity, years after Capa's death people began to ask questions: why was Capa *in front* of the soldier who had been killed,

why was there no sign of a wound, why was his camera focused on that particular man at that particular moment? The implication was clear: the world's most famous war photograph might have been faked. Capa failed to clear up the mystery in his lifetime and makes no mention of the picture in any of his own writings. John Hershey, a fellow war correspondent and a friend, claimed that Capa once told him that the picture was nothing more than a stroke of luck, that he'd poked his camera above the parapet as the Republicans charged a machine-gun nest and had no idea that he'd captured a man being shot until the film was processed back in Paris. But in an interview with the New York *World Telegram* in 1937, Capa said that he and the soldier were stranded in a trench on the Córdoba front and that the soldier was impatient to get back to the Republican lines; every time he peered over the sandbags he drew machine-gun fire, but eventually he muttered something about taking a chance and clambered out of the trench. Capa followed, shot the picture instinctively as the machine-guns opened up, then fell back into the trench alongside the body of his companion. He made it to safety later that night, crawling back under the cover of darkness.

The problem with the 'moment of death' picture is that no contact sheets, which would surely have told the whole story, have survived and other pictures shot at around the same time appear to show soldiers in training rather than in action. In 1975, to the fury of the Capa family, the author and journalist Phillip Knightley included in his book, *The First Casualty*, an interview with a *Daily Express* correspondent who had been in Spain with Capa and who claimed that the famous picture had been taken during manoeuvres staged specifically so that Capa could shoot some photographs during a quiet spell. Although Cornell Capa never wavered in his belief that his brother's famous picture was genuine, several other Magnum members harboured secret reservations about it.

One theory was that the editors at *Vu*, the first people to see the print, assumed that the picture showed a dying soldier and that once it had been published as a 'moment of death' shot, Capa was too embarrassed to tell the truth. Capa supporters dismissed the idea, pointing to Capa's undoubted integrity as a photographer and his irrefutable bravery; he was only reluctant to talk about the picture, they said, because he did not want to appear to capitalise on a man's death. But real evidence capable of settling the dispute remained elusive until recently, when it was revealed that an amateur historian had finally tracked down the identity of the soldier as Federico García, a twenty-four-year-old mill worker from Alcoy, near Alicante. In 1996 García's sister-in-law still lived in Alcoy and

recognised him in the picture; she remembered her husband coming home alone from the war and saying that Federico had been killed; he'd been seen throwing up his arms as he was shot. Military archives in Madrid confirm that Federico García was the only soldier to die at Cerro Muriano on 5 September 1936 – the day Capa took the famous picture.

Capa shuttled backwards and forwards to the front throughout the Spanish Civil War and he was temporarily back in Paris when, in July 1937, he received terrible news from Spain. His lover, Gerda Taro, who had also made a considerable name for herself as a war photographer, had been killed. She was covering the Republican offensive west of Madrid and had spent an afternoon in a dugout photographing wave after wave of Franco's aircraft strafing the Republican lines; one plane caught a glint from her cameras and swooped down towards her, but she coolly continued shooting. When the action was over, she hitched a lift on a staff car carrying wounded men back to base, flinging her cameras on to the front seat and clinging to the running board. Not far down the road, the car was sideswiped by a tank careering out of control. Gerda was thrown into the path of the tank and crushed under the tracks. She died the following morning.

Capa was grief-stricken. At Gerda's funeral he wept bitterly and hid his face on a friend's shoulder when the cortège passed. He was clearly distraught: for months afterwards he carried pictures of Gerda with him, handing them out to everyone he met, claiming she was his wife and that he had been with her when she died. None of the multitude of women who followed Gerda into Capa's affections would have the same effect on him. That year his mother, Julia moved to New York, where two of her sisters had settled after the First World War. She took Cornell with her and pleaded with Robert to join them, but he steadfastly refused, believing his future to be in Europe. (László, the eldest brother had died of rheumatic fever; their father died in 1938.)

While Capa had more or less concentrated on taking pictures at the front in Spain – in 1938 *Picture Post* declared him to be 'The Greatest War Photographer In The World' – Chim turned his camera on the luckless victims of the war – the refugees, women and children suffering ever more savage bombardments from German and Italian pilots fighting on Franco's side. His moving photo-essay depicting the people of Barcelona under aerial bombardment documented their anguish and their courage and won Chim worldwide recognition as a photo-journalist. Pictures of civilians under fire would become routine in a few years' time after the

outbreak of the Second World War, but then they were a shocking journalistic novelty and attracted considerable attention.

Chim and Capa would often get together when they were back in Paris taking a break from the war and Maria Eisner liked to tell a story about being in a noisy group with them in a café while Capa held forth, recounting ever more more lurid stories about his adventures during the battle around the university in Madrid. At one point, when he paused for breath, Chim grinned, shook his head and muttered 'Typical Hungarian!', making everyone, including Capa, laugh.

In May 1939 Chim covered almost the last act of the Spanish Civil War, the voyage to Mexico, on the SS *Sinai*, of 1,000 Republican refugees going into exile after Franco's victory. From Mexico he made his way into the United States, to New York, where he opened a darkroom on 42nd Street, opposite the New York Public Library, in partnership with a German immigrant photographer called Leo Cohn. They numbered among their clients luminaries like Philippe Halsman and André Kertesz. In 1942, after Pearl Harbor, Chim first tried to enlist in OSS, thinking his six languages would be useful, but was turned down. The US Air Force was similarly uninterested in his services and he was finally drafted into the US Army as a private, despite his poor eyesight, and assigned to photo-interpretation. As a member of the military, he was able to become a US citizen with a minimum of fuss and he finished the war with a new name, David Robert Seymour, and the rank of lieutenant.

After the end of the Spanish Civil War, Capa got a contract with *Life*, even though Ed Thompson, the magazine's cigar-chewing managing editor, claimed he could barely understand a word Capa said because of his thick accent; indeed, Capa himself used to joke that he had won his English in a crap game in Shanghai. Thompson tried to find assignments for Capa that would suit his talents and temperament, but he could be difficult – reporter Don Burke returned to the *Life* office in New York to tell astonished colleagues that Capa had kicked up a scene in a railroad dining car because there was no vintage French wine on offer with dinner.

The writer Irwin Shaw recalled meeting Capa in a bar in Greenwich Village. He was with a pretty girl. It was not, Shaw drily noted, the last time they were to meet in a bar or the last time Capa was seen with a pretty girl. 'Just returned from the war in Spain, which he had photographed with such brilliance, he was already famous, and I recognised him immediately: the thick-lashed dark eyes, poetic and streetwise, like the eyes of a Neapolitan urchin, the

curled, sardonic mouth with the eternal cigarette plastered to the lower lip. Although he was famous, he was impoverished, a condition that, because of the hazards of his trade and his lust for gambling, was almost chronic with him. He was also in danger of being deported to his native Hungary, a country that he memorialised in his accent, a musical deformation of speech in all languages, which was dubbed "Capanese" by his friends.

'Undaunted by his various problems, economic and governmental, and keeping hidden whatever psychic wounds his experiences in Spain had inflicted upon him, he was gently and perceptively witty, with a gaiety that enchanted men and women alike. It was these qualities, along with a shrewd understanding of what people were like and a fearless ability to prove himself equal to all situations, that made him welcome at the headquarters of generals, in foxholes, at the best tables at "21" and the gaudiest of Hollywood parties, at the lowest bars in Paris and George's back room at the Ritz, at brawling poker games and fashion shows at the salons of the most modish Paris designers. He knew how to use his talents and his insights and if, as sometimes happened, you were exasperated with something he did and called it the old Hungarian charm, you did so knowing that if it pleased him he could turn it with good effect on you and you would fall for it, lend him the two hundred dollars he needed to replace the two hundred dollars you had lent him the night before and which he had promptly lost at the casino in Cannes. You would also forgive him for monopolising your phone all day and bringing back girls from the beach who had not bothered to go home for a change of clothing and had to be properly covered in the morning with a wrap that you stole from your wife's wardrobe. He was not a proper guest or a proper friend or a proper anything – he was Capa and splendid and doomed and that was the end of it.'⁹

Capa had not been working for *Life* long when the US immigration authorities caught up with him and threatened him with imminent deportation. At that time he was operating with a grimy, taped-together document called a 'Nansen passport', named after Fridtjof Nansen of the League of Nations and issued to stateless people, and while he had managed to wangle a number of monthly extensions to his US visa, the immigration department warned him that no further extensions would be issued and he would have to leave the country. Capa solved the problem, typically, at a raucous party. When he announced that he was shortly to be thrown out, one of the guests, a svelte New York model and dancer named Toni Sorel, immediately offered to marry him, thereby providing him with an opportunity to stay, as the husband of a US citizen. They

'eloped' the following day to Maryland, the closest state without a waiting period for a marriage licence, but Toni might have regretted her impetuosity, for when Capa tried to kiss her in the back seat of a car on the way back to New York she slapped his face and the marriage was never consummated.

When war broke out in Europe, Capa chafed at the bit while *Life* kept him busy on trivial domestic assignments. He had to threaten to resign so he could return to Europe and cover the war, and it was the spring of 1941 before he finally arrived in Liverpool on board a transport loaded with lend-lease planes and boats, which had crossed the Atlantic in a convoy of forty-four merchant ships. To his great frustration, he arrived too late to cover the Battle of Britain, and the other big story of the war at that time – the Blitz – was also nearly over. He first moved into the Dorchester, but was soon asked to leave because the hotel wearied of the succession of flashy young women, actually Mayfair tarts, making their way up to his room. He found a small service apartment not far away in Hill Street, directly above another *Life* photographer, Bill Vandivert.

Capa, always irritated by the restrictions and demands placed on him by commissioning editors, had often discussed starting a co-operative agency with photographer friends before the war. (Cartier-Bresson remembers him talking about creating a 'brotherhood' of photo-journalists at the time of the Spanish Civil War.) Capa's idea was for a small agency owned and run by the photographers themselves, an organisation that would provide them with the freedom to choose their own assignments and essentially run their own lives free from the whims and vagaries of editors. He already had in mind enrolling Cartier-Bresson and Chim and when he raised the subject with Vandivert, the American seemed enthusiastic, to judge by a letter Capa wrote to Cornell, then working in the *Life* darkroom in New York: 'Bill Vandivert and I are looking for one more guy. We would like to put up a small agency having one fellow in England, one in Russia, one maybe in South America and something in New York.'[10]

When Germany attacked Russia in June 1941, Capa immediately applied for a Soviet visa but heard nothing. He waited months, killing time covering routine assignments, before he finally realised that a visa was not going to materialise. He persuaded *Collier's* magazine to assign him to cover the Allied invasion of France in the spring of 1942, but the invasion never happened; then he found he could not get full accreditation as a correspondent from the US Army because he was still registered as an enemy alien. Thus it was March 1943 before 'the world's most famous war photographer'

finally arrived at the front, in North Africa, to cover the Allies' final thrust against Rommel's Afrika Korps and the invasion of Sicily.

In September, Capa landed at Salerno in Italy and accompanied the 82nd Airborne and a division of British tanks into the devastated city of Naples, where thousands of homeless families were camping amid the ruins. Booby traps left behind by the Germans destroyed what was left of the public buildings and killed many more people while Capa was there. In a high school in the Vomero district he found twenty coffins containing the bodies of boys who had stolen guns and ammunition to fight the Germans during the last days of the occupation; the coffins were made for younger children and the ends had to be left open for the protruding feet. Capa remembered the moment well:

'The narrow street leading to my hotel was blocked by a queue of silent people in front of a schoolhouse. Inside were twenty primitive coffins not well enough covered with flowers and too small to hide the feet of children – children old enough to fight the Germans and be killed, but just a little too old to fit in children's coffins. These children of Naples had stolen rifles and bullets and had fought the Germans for fourteen days while we had been pinned down in the Chiunzi pass. These children's feet were my real welcome to Europe. I who had been born there. More real by far than the welcome of the hysterically cheering crowds I had met along the road, many of them the same that had yelled "Duce!" in an earlier year.'[11]

Capa, typically, found comfortable accommodation in a villa on a hillside overlooking the Bay of Naples and while he was resident there a jeep drew up with another *Life* photographer wearing a stylish cravat. He was an Englishman, as became clear when he politely introduced himself as George Rodger.

Rodger had had, without question, a 'better war' than Capa. The son of a Scottish Presbyterian father involved in shipping and the Lancashire cotton trade, he was born in Hale, Cheshire in 1908 and was educated at St Bees College in Cumbria, where he distinguished himself as a brilliant shot and a keen horseman. At the age of eighteen, determined to see the world, he enlisted in the Merchant Navy as an apprentice deck officer on a tramp steamer and by the time he was nineteen he had circled the globe twice. His primary ambition was to be a writer and in 1928 he managed to sell a story

about the gardens in Assam to the Baltimore *Sun*, but he was so appalled by the drawn illustration – 'I was pictured encircled by snakes, cutting my way through the jungle. Perfectly absurd!' – that he determined to illustrate future pieces with his own photographs and acquired a folding Kodak camera.

During the Depression years he bummed around America working as a machinist, wool sorter, steel rigger and farmhand, taking pictures during his travels and developing films in the bath:

> When I came back I wondered what the hell I could do and I saw an advertisement for a photographer for the BBC. I did up six or eight of my pictures as a portfolio and to my absolute amazement they took me on – and to my embarrassment, of course, because I knew nothing about it. I was provided with a studio with a lot of lights I was unable to operate and an awesome plate camera I had no idea how to load. Fortunately there was a little girl they gave me as an assistant and she'd been to the Bloomsbury School of Photography, which was *the* school of the day and she knew something about it, thank the Lord. We used to stay late after the BBC had closed down experimenting by taking each other's pictures in the studio so I could get everything standardised – lights, exposure, time, temperature and so on – for taking portraits of the BBC's guest speakers for *The Listener*. That's how I started in photography.[12]

Rodger also photographed the BBC's early television broadcasts and when he discovered that the shutter of his cumbersome American Speed Graphic was too noisy, he turned to using a 35mm Leica, completely unaware that its lightness, quietness and manoeuvrability would make it the basic tool for generations of photo–journalists to come.

When war broke out, the BBC's photography department closed down and Rodger found himself out of work. He considered volunteering for the RAF – he had starry visions of being a rear gunner – but discovered that as a photographer he was in a 'restricted occupation', so he joined Black Star, a photo agency set up in direct response to the rapidly expanding market for illustrated magazines. He recalled spending some considerable time with a posse of other photographers and reporters, sitting in the sunshine on Shakespeare Cliff, near Dover, waiting to record the German invasion which never came, but he found plenty to photograph when the Blitz began and he was out every night capturing the heroism and fortitude of Londoners whose homes were reduced to

rubble. He never forgot seeing a man sitting in his bath on the third floor, waving to firemen to be rescued, after the wall had been blown away.

Rodger's career as a photographer really took off when *Picture Post* devoted eight pages to his photographs of the Blitz, after which he came to the attention of the editors at *Life*, who offered him a job as a staff photographer at the almost unheard-of salary of $100 (£75) a week. He had no hesitation in accepting. 'I felt I really could contribute to the war effort by bringing to the millions of *Life* readers an understanding of Britain under the threat of Nazi invasion. Desperately we needed American aid – war materials, fuel, food and money – and in my pictures, published almost weekly, I could show not only how much we needed it, but also what we did with it when we got it. Anyway, I felt I could do much more that way than by being conscripted.'[13]

Towards the end of 1940 Rodger sailed for Africa, on a blacked-out tramp steamer loaded with aeroplanes, guns and munitions, on his first assignment as a war photographer, attached to De Gaulle's Free French forces harassing the Italians in Chad and Libya. He thought he would only be away for a matter of weeks, but did not return home for two years. Landing at Douala in French Cameroon, he embarked on the first of the many epic cross-country journeys that would mark his career. In the company of a choleric Frenchman who claimed to be a baron and the owner of a goldmine, but whom Rodger remembered chiefly for his formidable ability to swear, he travelled 4,000 miles: they drove in two Chevrolet pick-ups across Chad to the Kufra Oasis in Libya, only to arrive on the day after the occupying Italians had surrendered. Undaunted, they decided to continue on to Eritrea, a further 3,000 miles to the east, where the Foreign Legion was in action. Ignoring warnings that the direct route across the desert was passable only by camels, they soon ran into trouble. Two days out, one of the pick-ups broke an axle. The baron took the remaining vehicle back to Kufra to collect a replacement, leaving Rodger and the rest of the party temporarily stranded. Within a short time their water ran out. 'The sky was like burnished brass and without water the heat was intolerable,' Rodger later recalled. 'By the end of the fourth day my tongue was blue and swollen and I was already writing out a farewell message to put in a bottle for some wandering camel rider to find, when the Baron arrived in a swirl of dust and a torrent of vitriolic French obscenities.'[14]

It transpired he had been hospitalised for sunstroke in Kufra and had had to sneak out of the hospital in order to return and rescue his

friends. Somehow they reached Khartoum, where Rodger parted company with the colourful baron, not without some regrets, and began taking pictures. He covered Free French operations in Eritrea, the Sudan and Syria, survived being dive-bombed and machine-gunned, and eventually landed up in Cairo, where he was delighted to discover that *Life* maintained a permanent suite at the famous Shepheard's Hotel.

In Cairo Rodger met Randolph Churchill, the British prime minister's son, who was then an officer in military intelligence, serving with the 4th Queen's Own Hussars. Churchill was keen to persuade Rodger to cover a naval operation aimed at relieving Tobruk, but Rodger felt he was distinctly too keen and discovered that Churchill was trying to divert media attention from a potentially much more interesting story to the north, where the British and the Russians were planning a simultaneous invasion of Iran from different fronts. With a *Life* correspondent, he hitched a ride on a plane to Baghdad, where, incredibly, they found a taxi driver willing to drive them, at breakneck speed, to the rendezvous of the Russian and British forces. The official press party was furious to discover on arrival that Rodger had already been there for some days and had been present at the historic moment when the two armies linked. Back in North Africa he photographed the big Allied tank offensive against Rommel's Afrika Korps and was waiting in Cairo for further instructions when a cable arrived from *Life* asking him to make his way to Burma.

Rodger arrived in Rangoon by flying boat during a Japanese attack on the harbour. It was a baptism of fire which barely prepared him for what was to follow. His first story was about the Flying Tigers, a squadron of American volunteer pilots flying Tomahawks with sharks' teeth painted on their noses, who had been fighting in China against the Japanese before Pearl Harbor. The Flying Tigers boasted that they were worth ten Japanese pilots each, but they were not invulnerable. Rodger photographed them scrambling to repel a Japanese raid and then waited to record their return. All of them got back except one – ironically the most popular member of the squadron, a young flyer whose portrait Rodger had taken the previous day. From Rangoon he travelled north to photograph the building of the Yunnah-Burma railway, but he was captivated by the country and often 'deserted' his duties to take pictures of the local people and the landscape. 'Not quite the correct thing to do for a war photographer,' he confessed.

Shortly before Rangoon fell to the Japanese, Rodger managed to get out of the city with a Movietone News cameraman and the two

of them made their way to Shwegyin, which had recently been recaptured by the Indian Army. 'After weeks of retreating before the little yellow men who filtrate unseen and unheard through the jungle,' he wrote, 'our forces in Burma were considerably heartened by the recapture of Shwegyin, which had been in enemy hands for the past three weeks. Greatest effect of this local success has been on our troops' morale: playing catch-as-catch-can with an unseen enemy in steaming tropical jungle; finding the heads of their officers and comrades jabbed on bamboo stakes in jungle clearings; having unseen hands light firecrackers round their camps at night; having their patrols and sentries spirited mysteriously away and continual retreats westward; all went to undermine morale, and the kick in the pants we gave the Japs at Shwegyin has had the same effect as a great strategic victory. Now the troops are all raring to go . . .'[15]

Rodger subsequently went on to photograph the Burma Road – the only supply route into China – and was invited to meet Chiang Kai-shek and the formidable Madame Chiang; afterwards he had his picture taken with American general 'Vinegar Joe' Stilwell. None of these impressive credentials prevented him from spending three days in a local jail when he tried to get into China. By then Burma was cut in two and both the British and the Americans were in retreat. Rodger joined other correspondents attempting to escape through Naga head-hunter territory. Building rafts to ford rivers and crossing makeshift bridges they eventually reached territory where the jeeps could go no further. There was no alternative but to continue their escape on foot, sustained by peanut butter and cocktail cherries which for some curious reason were the only supplies available. With hired coolies to act as guides, they marched 300 miles through dense, leech-infested jungle to the India border, where they were able to catch a train to Calcutta.

Rodger was still resting in Calcutta when he received another cable from *Life* asking him to return to New York as soon as possible. He got a Sunderland flying boat to take him as far as Liberia, where he found a seat on an American clipper bound for Brazil, then took separate flights to Trinidad, Miami and New York. He arrived to discover he was something of a hero – *Life* had just published seventy-six of his pictures in an eight-page profile which boasted that he had 'gone to more sweat and pain to get a few pictures' than any other *Life* photographer. Always shy and retiring, Rodger was dismayed to learn that the *Life* editors expected him to make speeches to important advertisers. Even worse, the magazine had published a picture of him and he found he was 'sort of famous. People would recognise me in subways and hotels and things. I

found it very embarrassing; I didn't enjoy the glamour of it at all. Some old lady would come up to me and say "Aren't you George Rodger?" and I'd reply "No, I'm little Lord Fauntleroy" or something like that because it annoyed me. I had shellshock anyway and a terrible pain in my ears and I couldn't take all these things. Then they pushed me out on a lecture tour and I couldn't stand it.'[16]

He eventually persuaded *Life* to let him return home to Britain to marry his long-standing girl friend, Cicely. He stayed home until August 1943 when, sporting a new uniform he had had made in Savile Row and a cravat of camouflage parachute silk, he returned to the war, covered the landings at Salerno and devised an ingenious technique for crossing stone bridges in a jeep – ducking low in the vehicle and driving blind so that the stone parapets of the bridge provided cover from German sniper fire. He joined Montgomery's Eighth Army advancing up the Adriatic coast then crossed to Naples when it fell to the Americans and, typically, made a point of photographing a spectacular eruption of Vesuvius which coincided with the Germans' departure.

Capa had been resident for a few days in the villa outside Naples when George Rodger drove up in his jeep. Although they were aware of each other's work, the two men had never met, but instantly took a liking to each other. Indeed, Capa was so impressed by Rodger's dashing cravat that he took to wearing one himself for a time and he invited the Englishman to join him in Capri to celebrate his thirtieth birthday. They spent six days on the island together and it was inevitable that during this time Capa would raise the subject he always broached with photographers he liked and respected – the prospect of running a co-operative agency after the war. As Rodger recalled:

That was when we first started talking about a future brotherhood, because he was *Life* and I was *Life* and we were not very happy. The object of this brotherhood was that we would be free of all sort of editorial bias and that we would work on the stories we wanted to work on and have somebody do all the dogsbody work. He always called me 'Old Goat', I think because on our first meeting I had been campaigning for three weeks without a wash and maybe I didn't smell too good, but that stuck. So he said 'Listen old goat, today doesn't matter and tomorrow doesn't matter. It is the end game that counts and what counts is how many chips you've got in your pocket, that is if you're still playing.' I remember that remark very vividly, very Capa.[17]

Before they went their separate ways – Rodger returned to his old stamping ground in North Africa and Capa stayed in Italy to cover the action around Montecassino – they made a pact to meet in Paris on the day of liberation. Capa suggested they should stay at the Hôtel Lancaster, of course, and they agreed that the first one to arrive would book two rooms in the certain assumption that the other would shortly follow. It is unlikely that either of them took it too seriously since the chances of them both getting to Paris on the day when the city was liberated must have seemed remote.

In the spring of 1944 Capa took a break from the front and returned to London to ensure that he was accredited to cover D Day, which was expected soon. He moved into a suite at the Dorchester Hotel in the company of an RAF pilot's ravishingly beautiful wife, with whom he had started an affair the year previously. Her name was Elaine Justin, but Capa called her 'Pinky' because of her strawberry blonde hair. He remained irresistibly attractive to women. Sheila Hardy, wife of the photographer Bert Hardy, worked at *Picture Post* during the war and remembered Capa going into the London office. 'All the girls were saying "Capa's coming, Capa's coming" and they all got themselves made up and stood in the corridor because they had heard of this glamorous war photographer and there was Capa with his wonderful big eyes and long lashes, slicked-back hair and cigarette dangling from his lips walking down the corridor. All the girls fell for him.'

Capa and Pinky moved from the Dorchester into a large luxury apartment nearby, which became the scene for innumerable parties and late-night poker sessions. Ed Thompson, *Life*'s managing editor, who was in London as a major in the US Army, recalled running into a *Life* colleague, Frank Scherschel, and being carted off to a party Capa was hosting with Pinky. It was raucous, lively and very crowded. Capa introduced Thompson to someone with a beard, who was called 'Ernest', but as it seemed to Thompson that most of the guests had beards and would happily have answered to the name of Ernest he did not pay much attention. Leaving the party in the early hours of the morning, Thompson and Scherschel discovered 'Ernest' furiously trying to wrench open the door of Scherschel's Morris Minor. When Scherschel politely suggested he might be trying to get into the wrong car and pointed to an identical model a little further along the road, Ernest shambled off without a word. Thompson only realised who he was the following day when he read in the newspaper that Ernest Hemingway had fractured his skull after driving into a lamp-post during the blackout on his way home from a party.

'London before D Day was a time of revelry for Capa,' Irwin Shaw wrote, 'an occupation for which he had a highly developed taste. When he was not touring the pubs, he was the host at his girl-friend's apartment for intense poker games, during which, in the middle of the almost nightly bombings by the Luftwaffe, it was considered very bad form indeed to hesitate before placing a bet or to move away from the table, no matter how close the hits or how loud the anti-aircraft fire. If Capa was making money out of the war, the poker games made it certain that when peace came he would not be a rich man. He did not take losing to heart, though. When he came up with a pair against three of a kind or was caught with a four flush, the most he would say would be "*Je ne suis pas heureux*", a favourite line from the opera *Pelléas et Mélisande* that he used on other, more dangerous occasions.'[18]

Both Capa and Rodger covered D Day but whereas Rodger stepped ashore on a relatively quiet beach at Arromanches in what he later described as a 'blaze of anti-climax', Capa chose to land with the first wave into a firestorm on Omaha, the bloodiest of the Normandy beaches, where there were more than 2,000 casualties. This was Capa laconically explaining his decision to land with the first wave:

I would say that the war correspondent gets more drinks, more girls, better pay and greater freedom than the soldier, but that at this stage of the game having the freedom to choose his spot and being allowed to be a coward and not be executed for it, is his torture. The war correspondent has his stake – his life – in his hands, and he can put it on this horse or that horse, or he can put it back in his pocket at the very last minute. I am a gambler. I decided to go with Company E in the first wave.[19]

Using two Contaxes, he took 106 pictures of the bloody battle on the beach before rushing back through the surf to clamber on to a landing craft returning to the invasion fleet offshore. A week later he learned that most of his pictures had been destroyed by a darkroom assistant in London who became so excited that he tried to hasten the drying process by turning up the heat, and melted the images off the negatives. Only eight frames could be salvaged. (In later years there were persistent rumours that the darkroom assistant was Larry Burrows, subsequently a famous *Life* photographer who was killed in Vietnam, but Ed Thompson says this is nonsense.) *Life* first told Capa that the pictures were spoiled because sea water had leaked into his cameras so when he discovered what had really happened he was

doubly furious, but at same time he told *Life* editors he would never work for them again if they fired the assistant who was responsible. When the magazine finally ran the redeemable photographs it attempted to explain their quality by claiming that Capa had not focused properly in the heat of battle, further enraging him. (When he wrote a colourful, not to say fanciful, autobiography after the war he called it '*Slightly Out Of Focus*' as a bitter jibe at the *Life* editors.)

When Capa met up with Irwin Shaw later in the Normandy campaign he confessed that the experience had completely disillusioned him and that he was no longer interested in photographing war. He continued, nevertheless, to be in the forefront of the action, recorded De Gaulle's triumphant entry into Paris and the subsequent panic when snipers suddenly opened fire on the crowds in the place de l'Hôtel de Ville. When he arrived at the Hôtel Lancaster he discovered that a room had already been reserved for him by George Rodger, who had got there just an hour earlier.

A few days later Chim, by then a lieutenant in the US Army, made it to Paris and went straight to his old apartment on the boulevard Brune. 'I went up two flights and found the door sealed with a notice of the Gestapo,' he wrote to his sister, Eileen. 'I broke the seal, turned the key, and entered. Here was my old room with everything intact after five years – scraps of old letters and old photographs and old books and old junk . . .'[20]

Much of Chim's family had disappeared in the Holocaust – he would learn later that both his parents had been killed in the Warsaw ghetto in 1942 – and at that time he had no idea if his old photographer friends had survived the war. One day he was driving down the boulevard Montparnasse in a command car when he saw John Morris, a former picture editor at *Life*, sitting in a pavement café. He stopped the car and jumped out, still an awkward figure in uniform, to say hello. 'I was sitting there on the terrace having a beer,' John Morris recalled, 'when I looked up and who should I see getting out of a command car but Chim!' Morris immediately invited him to a party being given that night by the Paris editor of *Vogue*, where, to his undisguised delight, he found both Capa and Henri.

Cartier-Bresson was by then married to a Javanese dancer by the name of Ratna Mohini and had spent most of the war as a prisoner of the Nazis. Drafted in 1939, he was a corporal in the French Army's Film and Photo Unit when it was captured by the Germans in June 1940, at St Dié, in the Vosges. Initially sent to a prisoner of war camp in the Black Forest, he was put to work in the fields, planting potatoes, and soon made his first escape attempt, with a

fellow prisoner. Walking at night and sleeping by day in the forest, they set off for the Swiss border but it started to snow heavily, holding up their progress so much that they were swiftly caught and sentenced to twenty-one days solitary confinement and two months hard labour. Later, working in a factory in Karlsruhe making bomb crates, he tried again but was found within twenty-four hours. He succeeded on his third attempt, in 1943, disguised as a foreign labourer, and made his way back to Paris, where he immediately joined the Resistance and organised a subversive photographic unit to document the German occupation. Not long after he escaped, Braque gave him a copy of *Zen and the Art of Archery*, sparking a lifelong fascination with Buddhism, and to avoid the attentions of the Gestapo he often posed as an absent-minded painter, blithely uninvolved in the tribulations of the war.

After the liberation he photographed De Gaulle's great victory parade – in one shot George Rodger can be clearly seen – and made *Le Retour*, a documentary film about the liberation of the concentration camps and the home-coming of those who survived. The film provided him with the opportunity to take one of his best-known photographs – the triumphant unmasking of a collaborator. Later he would disclose that he had wanted to return to painting after the war, but had felt compelled to 'bear witness to the wounds and upheavals of the world with some instrument more rapid than a brush'.

Capa, too, worked in and around Paris for a while recording the painful aftermath of the liberation, producing his famous picture of a shaven-headed young woman collaborator carrying her baby through the streets of Chartres followed by jeering crowds. He noted on his caption sheet that a woman standing nearby who had fought in the Resistance had muttered 'This is unnecessary, so hypocritical', and indeed the only figure in the picture to emerge with any dignity was the wretched young mother.

In March 1945 Capa took part in the last major operation of the war – a mass parachute drop with the 17th Airborne Division across the Rhine:

I flew in the lead plane with the regimental commander and I was to be number two man in the jump, right behind him. Before boarding the plane, the G-2 major had taken me aside. If anything happened to the Old Man when we got the signal to jump, I was instructed to boot him through the door. It was a very important and comforting feeling. I put on an act and began to read a mystery story. At 10:15 I was only up to page 67 and the red light

came on to get ready. For a moment I had the foolish idea of saying 'Sorry, I cannot jump. I have to finish my book.' I stood up, made sure that my cameras were well strapped to my legs and that my flask was in my breast pocket over my heart. The green light flashed and I did not have to kick the colonel. When I hit the ground I kept clicking my shutter. We lay flat, nobody wanted to get up. The first fear was over, and we were reluctant to begin the second. Ten yards away were tall trees and some of the men who had jumped after me had landed in them and now were hanging helplessly 50 feet from the good earth. We were firmly established on the other side of the Rhine. We lost many of our men, but this was easier than Salerno or Anzio or Normandy.[21]

After the war his friend Pierre Gassmann would tell a story about how he asked Capa if parachuting out of a plane was very dramatic and Capa had replied 'It's not particularly scary to jump, not particularly hard to go down. But when you hit the ground in a hail of bullets and discover your pants are full and you have to take them off – *that's* dramatic.'[22]

Rodger also followed the Allied advance across Germany to what would be his most dreadful experience – entering Belsen: 'I was with four Tommies in a jeep and amongst the first to get in and the horror of it affected me tremendously. I was talking to a very cultured gentleman and he was absolutely emaciated and in the middle of the conversation he fell down dead. I took a picture of him dead. The dead were lying around, 4,000 of them, and I found I was getting bodies into photographic compositions. And I said my God what has happened to me? It is too much, something has affected me. It had to be photographed because people had to know and so I just couldn't leave it. And so I just did what I would have done with some landscape or something else, got people into nice compositions and sent the pictures in. But at the same time I swore I would never, never take another war picture and I didn't. That was the end.'[23]

Anxious that the story in all its horror should get out, Rodger wrote a moving report for *Time* magazine:

The magnitude of suffering and horror at Belsen cannot be expressed in words and even I, as an actual witness, found it impossible to comprehend fully – there was too much of it; it was too contrary to all principles of humanity – and I was coldly stunned. Under the pine trees the scattered dead were lying not in twos or threes or dozens, but in thousands. The living tore ragged clothing from the corpses to build fires over which they boiled

pine needles and roots for soup. Little children rested their heads against the stinking corpses of their mothers, too nearly dead themselves to cry. A man hobbled up to me and spoke to me in German. I couldn't understand what he said and I shall never know, for he fell dead at my feet in the middle of his sentence. The living lay side by side with the dead, their shrivelled limbs and shrunken features making them almost indistinguishable. Women tore away their clothing and scratched the hordes of lice which feed on their emaciated bodies; rotten with dysentery, they relieved themselves where they lay and the stench was appalling. Naked bodies with gaping wounds in their backs and chests showed where those who still had the strength to use a knife had cut out the kidneys, livers and hearts of their fellow men and eaten them that they themselves might live . . .[24]

(Rodger never spoke about Belsen after the war, until many years later, when he read that young people were beginning to doubt the existence of the concentration camps.)

Not long afterwards Rodger was one of only two stills photographers present in the famous tent on Lüneburg Heath where Montgomery, hands in pockets, accepted the surrender of Germany. He then set out to record the celebrations in Denmark, driving with a Union Jack in the windscreen of his jeep past columns of demoralised German soldiers struggling home. At the end of the war he returned to Paris with Cicely, stayed for a while at the Hôtel Lancaster, and made plans to return to Africa to escape the horrors of the war in Europe and nightmarish memories of Belsen.

Chim returned to New York, reopened his darkroom business and tried to get work as a photographer. Better known in Europe than he was in the United States, he found few openings until his friend Henri arrived in town to attend his 'posthumous' exhibition at the Museum of Modern Art. The curators of MoMA, somehow believing that Cartier-Bresson had been killed during the war, had decided to mount a retrospective exhibition of his work along with a book. Cartier-Bresson was tickled pink by the idea of turning up at his exhibition and while he was in New York he took the opportunity of introducing his friend Chim to picture editors. Chim was soon heading back to a devastated Europe on assignment for *This Week* to photograph the appalling aftermath of the war.

Cartier-Bresson also got an assignment, to collaborate on a book about America with the journalist John Malcolm Brinnin. They travelled thousands of miles together not entirely in harmony, to judge by Brinnin's whimsical account of their journey, *Just Like Java*

published some time later. Brinnin came to the conclusion that the compassion evident in Cartier-Bresson's pictures was curiously at odds with the man himself. He described an incident in a diner when one of the customers suffered an epileptic fit and Cartier-Bresson managed to get in the way in his determination to get pictures of the frothing victim. Brinnin claimed the Frenchman was quick to blame others for missed opportunities and furious when anyone got in his own way – at one point he apparently pushed Brinnin to the ground in his anxiety not to miss a picture. He shot hundreds of pictures every day, Brinnin observed, despite his oft-repeated claim that 'taking pictures constantly is the sign of an amateur'. The American was irritated by the fact that his travelling companion, despite being the heir to a textile fortune, spent much of their time together on the road roundly denouncing the American capitalist system. The final straw came when Cartier-Bresson finally presented his pictures to a publisher in New York and it was decided that no words were needed; Brinnin had been wasting his time. Cartier-Bresson was unconcerned and suggested that the American should do a book on his own.

Capa, too, was in America. At the end of the war he had returned to Paris, where he embarked on a passionate affair with Ingrid Bergman, whom he had encountered in the lobby at the Ritz hotel. He and Irwin Shaw sent her a note inviting her out to dinner that evening and, somewhat to their surprise, she accepted. Within a few weeks they were lovers. When she had to return to the United States, and to her husband, Capa promised to seek her out in Hollywood where she was due to start filming Alfred Hitchcock's *Notorious* at the beginning of 1946. He claimed to be working on assignment for *Life* to get access to the set and stayed in Hollywood for several months writing up his war memoirs as a film script – it was never made – and learning about the movie business, but he did not like Los Angeles and returned to New York, where he at last became an American citizen. Not long afterwards his romance with Bergman was over, but they parted amicably. Years later she spoke of him fondly in her memoirs, although she was worried what her children would think. One evening as her daughter, Isabella Rossellini was about to go to bed, she gave her the manuscript and said 'Here you are. Read it, but don't think too badly of me.' Isabella apparently sat up all night reading about her mother's adventures and next day put her mind at rest by saying 'It's incredible you had such a lover!'[25]

HENRI CARTIER-BRESSON, talking in his Paris apartment on the rue de Rivoli, overlooking the Tuileries: 'We all met in Montparnasse before the war, I don't know dates. I met Chim first at an association where Man Ray belonged, Brassai and so on, called "Artistes et Ecrivains Revolutionaires". It was under the control, naturally, of Aragon and the Communist party, but in those days it was just a meeting place and so on. None of us were party members but we were all left-wing. There were hardly any right-wing people in those days. I was an adventurer; so were we all.

'I just met Chim there one day among heaps of people and he had a Leica and so had I and he asked me "What have you got there?" I said it was a Vidom, which was a viewfinder of that time, of a Leica, which is of course, no longer in use, and started up this conversation. And we saw each other and he told me "I know somebody very, very curious, a very strange person. You'll meet." It took him about four months to introduce me to Capa, who was living in the Hôtel de Blois with his mother, little Cornell and two Japanese and I think on the ceiling was hanging the laundry.

'None of us was well known. What does it mean, well known? Maybe they were known to the police, who knows? Photography as a profession didn't really exist; it was rather despised. It has no relation to now, none. But you see, we never, never, never talked about photography, never! It would have been monstrous, presumptuous, no never. We used to take photographs and try to peddle them, Chim, Capa and I, to Maria Eisner. She was very beautiful and we were very shy. Imagine Capa being shy!

'Chim, Capa and I were working for Aragon at *Ce Soir*, an evening paper, very popular and controlled by the Communist Party. Aragon left us in complete peace to just take pictures; there were no political aspects. There would be a meeting of the *comité de redaction* in the morning, maybe at 8.30 I don't know, and we had to be back to put our stuff in the soup, we said, to develop by such a time. And that is all. We could take any photographs at all, practically . . . I was escaping, taking pictures, enjoying myself, watching, looking, sniffing and that is all.

'Sometimes we had to use the big 9 by 12 plates and they sent me to photograph Cardinal Pacelli in Montmartre and I had a plate camera and I took a picture over my head, because I was squeezed by people shouting "Vive Dieu! Vive Dieu! Vive Dieu!" and I couldn't move, I could not see, and I was too close, that was my picture of a future Pope.

'I didn't look at my pictures, I was just shooting, shooting, shooting all the time, just like making daily sketches. Those who go

into the darkroom to develop our photos, that is a marvellous craft. Anyone can be a photographer, even a monkey can be taught to do that, but a developer, no. It is the work of real craftsmen, exactly like an engraver, a real profession. He knows his value and level, he doesn't have the pretence of an artist, whereas the photographers take themselves for artists. I have always had a very strong feeling for the people in the lab. We each have somebody working for us in the lab, in the dark, while we are going outside being glorious and I think it is a community. Pierre Gassman, a friend from before the war who was doing it for us, printed in his bathroom and washed our prints in his bidet. Now he has created a huge enterprise, but then he had a little lab in an ex-stable of Henri IV, the King, not far from the Invalides and I remember the yard had the pavements from those days and the models were coming with their high heels being photographed there, and there was a fruit woman with a pushcart and another one cleaning mattresses in that yard.

'I photographed Simone de Beauvoir after the liberation. I photographed her some years later and she said "Oh, you took a very pretty photo of me the last time and I thought, *Zut*! am I getting old or what is he going to do with me?" I was a bit embarrassed. I looked at her legs: she had stockings with a fern pattern – that was the beginning of such things – and she was embarrassed and kept pulling her skirt down and I felt like a blackguard. She wanted me to take the photo and she said to me "I am rather in a hurry, how long will you be?" And I said just what came into my head: "A bit longer than a dentist, but not as long as a psychoanalyst". She didn't even laugh and that was it. It was all over. I had no photograph. So I said goodbye and thank-you, I suppose I said it politely but . . . that's why we are at the mercy of everything. It is so fragile, a conversation.

'On the whole, when I take a portrait I want just to be alone with a person and I don't speak because you can't speak and look and concentrate. Photography is concentrating, being ready, available. If you have somebody putting questions, it is finished. To take a portrait, to get the silence of a person, the inward person, it is just like putting your camera between the shirt and the skin. Not very pleasant, eh? So, it needs a lone concentration.

'I am a very bad journalist, very, very bad. I'll give you an example. I was with Beriosova, taking photographs of her for *Queen*, and one evening someone said "Somebody just came out from Russia and we'll see him tonight." It was Nureyev and I spent the whole night with them and I never had the idea of taking a snapshot. It never came into my head. Sometimes it is more important to talk and

listen, you see. Photography is not that important for me. It was the same for Capa and Chim.

'Capa was a flamboyant person and Chim, on the contrary, was very quiet. Chim carried all the weight of being a Jew on his shoulders. Chim and I read the same books and had the same preoccupation and so on. There was an intimacy, fundamental. With Capa it was different, because he didn't read the same books, but as far as enjoying ourselves together there was complete unity. Capa would say about Chim: "Look at his sinister black ties woven by his girlfriends, ah, so sad. And look where he lives! He lives in a studio, next door there must be kept girls who live there, instead of living at the Lancaster" and so on. And to me, when he was coming to visit after the war, he used to bring little things from the PX. He used to say: "All I get at your family are grey, cold noodles, Henri! Stingy, stingy!"

'Magnum is a group of men which is very difficult to define. Quite often when I talk with my friends – writers, architects, painters, who ask me how it works, how it functions – I describe it and they say they don't understand. You could not have an association of architects like that anywhere in the world. That would have broken up fifty times. But you see we may say bad things about it, but we love Magnum and it doesn't break up. Why? In my opinion it is the mechanism of being co-opted by a kind of invitation. It is surely as stupid as any form of initiation, but at the same time it verifies the wish of people to participate in an enterprise, a myth, a community of men, a place where one does things. It is a very special thing.'

3

The Founding

IN THE spring of 1947 Capa at last got round to doing something about setting up the photographers' co-operative he had talked about for so long: he organised a lunch. In a way it was an entirely appropriate launch pad for an organisation founded by a notable bon vivant, but it also set a standard for the organisation's casual attitude towards its own history. It is known that the lunch was held in the elegant restaurant on the second floor of the Museum of Modern Art on West 53rd Street in New York, but no one thought to make a note of the date. It was almost certainly in March or April, but the actual day is anyone's guess.

Similarly, no one had the presence of mind to record precisely who came up with the name Magnum or why, although it seems safe to speculate that the discussions were accompanied by at least a magnum of something or other, probably not sarsparilla. It was, however, presumably agreed by those present that Magnum was a fine name for such a bold new venture, indicative as it was of greatness in its literal Latin translation, toughness in its gun connotation and celebration in its champagne mode.

That the nominal host of the lunch was Robert Capa is certain, but whether or not he lifted the tab is less sure, since he was often out of funds. If he had had a good day at the racetrack or at the poker table the previous evening, he would willingly have called for the bill, but if Lady Luck had temporarily deserted him he would have had no difficulty, with his famous charm, in persuading another of those present that the honour of paying for the occasion was theirs.

Sitting at the table with him, that day in March or April 1947, was the *Life* photographer Bill Vandivert and his wife, Rita, and the beautiful Maria Eisner, who had run Alliance Photos in Paris before the war. In 1940 she had been interned in a refugee camp in the

Pyrenees but had talked her way out and escaped to the United States, where she stayed for the duration of the war. Conspicuous by their absence were the three friends of Capa who would later become known as co-founders of Magnum: Henri Cartier-Bresson, who was still travelling the United States on the book assignment with John Malcolm Brinnin; Chim, who was in Europe documenting the aftermath of war, particularly as it affected the thousands of homeless children roaming the devastated cities; and George Rodger, who had recently settled with his wife in Cyprus and who was preparing to leave for North Africa on an assignment for *Illustrated*, tracing the progress of Montgomery's Eighth Army at the wheel of a bullet-riddled straight-eight Packard he had liberated from the German Army in Brussels.

Perhaps it is just as well that they were not all present at the lunch at the Museum of Modern Art that day, for their absence enabled Capa to dominate the proceedings. Since before the war he had nurtured the idea of setting up a photographic agency with a few congenial and like-minded individuals which would function as a co-operative and provide its members with the freedom to choose their own assignments. In the post-war reconstruction period, many communitarian groups – anti-capitalist, liberal, driven by left-wing idealism and demanding to be in charge of their own lives – were looking to co-operative projects to offer a workable realisation of their utopian aims. Humanism, and a philosophy which elevated the individual, was the dominant big idea in a world that had so recently experienced the horrors of totalitarianism.

In 1945 Capa had joined the recently formed American Society of Magazine Photographers and become an active participant at meetings, arguing for photographers' rights. He already had the Magnum concept in his mind at that time. Primarily he wanted to cover the stories that interested him, not necessarily those that interested the editors of magazines. Most importantly, he wanted to keep his negatives and retain the copyright of his pictures. It was a revolutionary concept; up until then magazine editors assumed that the fees they paid to photographers also bought negatives and copyright in perpetuity. Capa recognised that he had already effectively given away some of his most famous pictures – pictures that, in his own archive, would have provided him with an income for the rest of his life – and he did not want to give away any more.

In the words of one editor at the time, the concept that a photo-journalist was nothing unless he owned the rights to his negatives, and that the best way to safeguard those rights was through a co-operative, proved to be the most sensible idea in the history of

photography: 'Capa and his friends invented the copyright for photography. Even if they had done nothing else, they gave their *métier* freedom and turned photographers in servitude into free artists.'[1]

Whether or not Capa knew that he was embarked on such a grand mission is debatable, for the details thrashed out that lunchtime hardly constituted history in the making. It was agreed that the seven founding shareholders would be those present at the lunch, plus the three absentees, all of whom, Capa airily claimed, had indicated their willingness to be counted in. (This would soon prove to be not quite true.) Each of them would contribute $400 to cover initial expenses and the new agency would extract 40 per cent of the fees from assignments it set up for its photographer-members, 30 per cent of the fees from assignments the photographers arranged for themselves and 50 per cent of reprint fees. Rita Vandivert, who knew the business well from running her husband's affairs, was to be president and head of the New York 'office' at a salary of $8,000 a year; Maria Eisner was appointed secretary and treasurer and head of the Paris 'office' on $4,000 a year. The New York operation was to be run from the Vandiverts' small office and darkroom in a brownstone on Eighth Street in Greenwich Village, while the Paris office was to be Eisner's apartment at 125 rue du Faubourg St Honoré, from where she had run Alliance before the war.

Each of the photographers was allocated a territory, what George Rodger would describe as their 'personal hunting ground': Vandivert would cover the United States; Chim would take Europe; Cartier-Bresson had Asia and the Far East, where he had extensive experience; Rodger's preferred beat was to be the Middle East and Africa, leaving Capa free to take on roving assignments anywhere in the world. John Morris, at that time picture editor of the *Ladies' Home Journal* and soon to be a major Magnum client, described the motivation of Capa and his chums like this: 'Their hope, based on previously shared experience in the hungry days of pre-war Paris journalism, was to eat and drink more regularly in the post-war world. Their objective, mutually experienced in a world just gone amok, was to bring back alive, from the jungle of world events, photographic images bearing credible witness to the incredible daily life of mankind.'[2]

Capa anticipated that Magnum would gross $50,000 in its first year, with maximum expenses in New York of $5,000 and half that sum in Paris. It was not an unreasonable expectation. Illustrated magazines like *Life* and *Picture Post* were enjoying a bonanza feeding the post-war hunger for information about what was going on in the

rest of the world. New titles proliferated at an astonishing rate and were selling in huge numbers. If the post-war years taught editors anything it was that readers wanted to try to understand an increasingly confusing and complex world, so the market for the kind of photo-journalism practised by Magnum's founder members seemed insatiable.

Perhaps preoccupied by legal niceties, it took several weeks for Rita Vandivert to get round to writing to Cartier-Bresson, Chim and Rodger to inform them that they were now vice-presidents of an agency called Magnum and to welcome them to what she described as the 'Time Inc. Stink Club', probably a reference to Time-Life's churlish reaction to the news that the infant agency intended to retain the copyright of all the pictures it supplied. Vandivert told them they each had a contract for one year, at the end of which time they would all sit down and split the profits. 'I think we should all try to meet in Paris, London or New York when that great day comes,' she enthused. 'How about it? And, of course, celebrate in nothing but champagne!'

She also laid out Capa's canny vision for his brainchild: 'The way Capa sees it working out for himself and some of the others is this: he makes a deal with a publication to send him somewhere, gets expenses money, etcetera, and does the agreed number of stories or pages for them. Then he shoots as much material as he can on the side, keeping closely in touch with both Paris and New York offices so that we know what he can get, just where he will be and how long he thinks it worthwhile to stay. Only by this close co-operation can we hope to save waste of time, energy and material – the photographer must know what the magazines are interested in, what they are hoping to get, and the agency girls must know at all times what the photographers are up to (except on their evenings off). Do you think it sounds as though we could work it out this way for you too?'

The certificate of incorporation for Magnum Photos Inc. filed on 22 May 1947, in New York County, listed its aims and aspirations in sober legal jargon:

(a) To engage in a photographic, portrait, picture and painting business; to make, formulate, originate, design, create and produce likenesses, composites and representations of persons, places, landscapes, scenes . . . to do commercial, industrial, artistic and arterial photography of whatsoever kind, nature or description . . . to deal in and with photographers', painters' and artists' supplies, material and equipment, and in pictures and works of art of all

kinds . . . and to carry on the business of photography in all its branches, in any part of the world.

The lawyers saw to it that all the fledgling agency's options were covered: paragraph (b) suggested that Magnum might want to 'design, acquire patents for, manufacture, buy, sell, import and export and generally deal in cameras of all kinds and for all uses', while paragraph (d) covered manufacturing, producing and trading in 'colored and plain motion picture films of all widths, gauges and dimensions'; other paragraphs dealt with owning and operating a motion picture laboratory and with the 'buying, selling, importing, exporting and exhibiting of paintings, drawings, etchings and photographs'.

Irwin Shaw recalls a wild party to celebrate the founding of Magnum, a bash he picturesquely described as 'a combination of a union meeting which had just unanimously voted to strike, a winning football team's locker room and a Roman Saturnalia.'³ John Morris has no such recollection – he says there was a gathering at the Vandiverts' on the evening of the day the papers were filed and they all drank champagne, but that there were no more than a dozen people there.

Rita's letter to George Rodger took two weeks to get to his home in Cyprus and he had barely finished reading it before a cable arrived from New York asking for his reactions and acceptance. While Capa had indicated at the inaugural meeting that Rodger was keen to be included, the truth was that Rodger had barely given it a thought, as he explained in his reply:

Magnum Photos Inc. certainly seems a very sound idea and, if handled properly, can develop into a pretty big organisation. I'm pleased to be in on the ground floor. It's just the suddenness of its birth which knocked the props from under me. True, Capa did mention something about organising an agency in Paris with New York representation but I'm afraid he was a little too vague and mysterious. It all sounded too halcyon to be true and, as he mentioned an initial investment per person of £500 I'm afraid I rather dismissed the whole thing from my mind . . . I had no idea that I was going to be considered part of the organisation and hence my surprise on receiving your letters and cables.

(Very much later, writing a memoir on Magnum's thirtieth anniversary for *Photo Technique*, Rodger remembered it slightly differently: 'Bob spoke of the future after the North African landings.

He spoke of it in Tunis and Palermo and, after we had been through Salerno and Anzio and Montecassino, he spoke of it again . . . He spoke then of a co-operative of photographers – a brotherhood – beyond the pale of editorial sanction and censorship, who could interpret the world as it was and who worshipped only things as they were.'[4]

The thoughtful and pragmatic Englishman went on to offer his thoughts on the suggested organisation and immediately raised a spectre that would haunt Magnum through the years and still haunts the agency today – the doubtful ability of working photographers being able to run their own agency. 'Does it make sense,' he asked, 'to have a board of directors, five sevenths of which is bound to be spread over the four corners of the world? Even one annual board meeting would be very difficult to arrange when, be it held in either New York, London or Paris, it would mean calling the entire productive force of the company away from their fields of operation in distant countries. Production would have to stand still while the board met. With journeys from China to Paris or Cairo to New York involved, a lot of time would be wasted and we would be lucky if, at the end of a year, the company could afford to call the board together.' Rodger suggested recruiting two non-photographer directors – probably a lawyer and a top publishing executive – to run the company. Sadly, his advice was ignored.

Chim, meanwhile, had also blithely failed to respond to Rita's letter and instead sent a note saying he was planning to return to the United States, even though he had been allocated Europe as his 'personal hunting ground'. Capa was furious and dispatched a night letter to Chim's hotel in Berlin: 'MARIA WROTE YOU DETAILS AGENCY SETUP STOP YOU ARE VICE-PRESIDENT MAGNUM PHOTOS INCORPORATED STOP ARRANGEMENTS ALREADY MADE . . . WILL CABLE YOU DETAILS TWO DEFINITE ASSIGNMENTS NEXT WEEK STOP IF YOU RETURN NOW WHOLE AGENCY DEFINITELY COMPROMISED STOP ABSOLUTELY ESSENTIAL YOU STAY EUROPE STOP MARIA AND EYE DUE PARIS WITHIN FEW WEEKS PLEASE CABLE SOONEST STOP CAPA.'

Chim agreed to stay, but began to fret when work failed to materialise. A gentle complaint dispatched to New York produced the following tart response from Rita Vandivert: 'First rule of correspondence with me is that it is not necessary to remind me to do things . . . When I talk to editors here in New York and tell them that Chim is in France and going to Poland and Germany, they do not get excited. I have not a single story to show them what you have done, I have no portfolio of your work, and they frankly do

not know your work either. If you are feeling so unhappy, go out and shoot a good picture story and send it to me.'

Chim's first assignment was photographing the French underground nuclear energy programme being developed by Nobel Prize winners Irène and Frédéric Joliot-Curie. Getting access to the Curies was quite a scoop, but Chim had a bad scare, as he explained in a letter to Magnum's New York office: 'After photographing the graphic pile, the liaison officer announced very seriously that he believed I went too close to the pile and that all my films will turn black because of radiation. I had all my previous rolls in my pockets and I said goodbye to the story. Naturally, nothing happened.' Chim added a postscript revealing that he had beaten Madame Joliot-Curie at ping-pong, 27–17. His pictures were widely published in Europe, but failed to excite much interest in America, probably because the Curies were known to be Communists who had criticised US policy preventing the disclosure of scientific developments in the nuclear field.

Capa, meanwhile, was waiting for a visa to visit Russia with his friend the writer John Steinbeck, whose powerful novels published before the war, most notably *The Grapes of Wrath* and *Of Mice and Men*, had summed up the bitterness of the Depression era and aroused widespread sympathy for the plight of migrant farm workers. Capa and Steinbeck had been friends for some time, but they had not talked since early in 1947, when they ran into each other by chance in the bar of the Hôtel Bedford. Over a drink Steinbeck mentioned that he was planning to make a trip to Russia, which he had last visited in 1936, to look at the changes that had taken place in that vast and still mysterious country. Capa immediately saw the potential for a story.

Americans at that time were just becoming familiar with a sinister term that was somehow to encapsulate their innate fears about Communism – the Cold War. The financier and presidential adviser Bernard Baruch had first coined the phrase during a congressional debate in 1947 and it was instantly assimilated into the language to represent the bitter rivalry and deteriorating relations between the two greatest powers on earth – the United States and the Soviet Union. This was after President Truman had asserted, in what became known as the Truman Doctrine, the determination of the United States to help 'free peoples' resist 'attempted subjugation by armed minorities or by outside pressures' and after Winston Churchill, in a speech in Fulton, Missouri, had spoken memorably about 'an iron curtain' dropping down over Europe and separating east from west.

To Capa the outbreak of the Cold War made Russia a hot story and he suggested to Steinbeck that they should go together and then collaborate on a book which would focus on the everyday lives of ordinary Russians. Steinbeck agreed. In truth, Capa had an ulterior motive for wanting to travel with the writer. He had tried several times to get a visa to visit Russia but had always been refused; he imagined that Steinbeck, whose books were extraordinarily popular in the Soviet Union, would provide him with an entrée. He was wrong. When they applied for visas, Steinbeck's was granted without delay while Capa's was again rejected. Steinbeck, by now determined to make the trip with Capa, contacted the Russian consul in New York and informed him that he would not go at all unless he could go with Capa. The consul promised to get Capa's visa application reconsidered. By this time Capa had already sold the syndication rights to the New York *Herald Tribune*, which had promised a small advance to help finance the trip.

While waiting for his visa to be 'reconsidered' Capa entered into negotiations with the *Ladies' Home Journal*, then the world's leading women's magazine, for Magnum's first major international assignment. John Morris, the *Journal*'s dynamic picture editor, had recently read a series in the *New York Times* in which the newspaper's correspondents around the world reported on the everyday lives of locomotive drivers and their families in eighteen different countries. Morris was fascinated by the series, but was convinced it would work even better with photographs and he discussed the concept with Capa, who was enthusiastic. They decided to substitute railwaymen with farmers, on the basis that farming was a truly international activity, and proposed putting together photo-essays comparing the daily lives of farming families in twelve countries as different from each other as possible. The noble intention was to highlight similarities between the families and thus they called the project 'People Are People the World Over', a title that seems unbelievably trite today, but which was modish and compelling in the 1940s.

Magnum, with its five photographers spread around the world, was ideally placed to take on such an assignment, but before the *Journal* editors would agree to finance such an ambitious and expensive proposal, Capa was asked to produce a sample set of pictures. John Morris offered to help him find a suitable American farming family and they decided to begin the search in the Midwest, in Iowa. Capa turned up at La Guardia airport with a thundering hangover and on the flight to Des Moines astonished both Morris and the flight attendants by asking for an oxygen mask and taking

frequent whiffs; he assured the bemused Morris there was no better cure for a hangover. At Des Moines they rented a car and drove to the home of a woman friend of Capa's, a divorcee, who had invited them to dinner; later Capa could not have been happier to discover a pinball machine in the lobby of their hotel. Next day, a Sunday, they set out across Iowa's flat and featureless cornfields in search of a typical Midwest farming family living in a typical Midwest farmhouse. After driving for four hours alongside green fields rippling in the hot wind, they came upon exactly what they were looking for, just outside the little town of Glidden – a classic white-painted farmhouse with a traditional red barn just to the rear. Pulling up outside, they introduced themselves to the bewildered farmer's wife, who immediately fetched her husband while the children stared wide-eyed at the visitors as if they had arrived from outer space. When the project was explained to the family they willingly agreed to co-operate and Capa spent three days with them, photographing every aspect of their lives.

Back in New York, the *Journal* editors loved Capa's pictures and agreed a budget of $15,000 for the 'People Are People' series. Capa wanted Magnum photographers to take all the pictures, but Morris gently pointed out that it was his idea and he intended to keep control. In particular he was not prepared to assign Cartier-Bresson to the project. 'Bob wanted Henri to do families in China and Japan, but I refused because I didn't think Henri would do it the way we wanted it done. In those days picture editors gave photographers rigid shooting scripts and I knew Henri was a man who liked to explore his own vision. He wasn't a God in those days and was virtually unknown in America, except in avant-garde circles.' In the end it was agreed that Chim, who was by then working in Europe for UNESCO on a project to document the plight of children impoverished or orphaned by the war, would photograph two families, one in France and one in Germany, Rodger would cover three, in Africa, Egypt and Pakistan, and Capa would find a family in Russia – a visa for his trip with Steinbeck had finally materialised. Non-Magnum photographers were assigned to the remainder of the project, but Morris asked Capa to find time in Russia to produce a photo-essay for the *Journal* on how women and children lived in the Soviet Union.

Capa and Steinbeck left for Russia in July, but the trip went wrong from the start. They had expected to be met by the *Herald-Tribune*'s Moscow correspondent, but he had not received their cable and was out of town on assignment. So there was no one to meet them at the airport, it was pouring with rain, there were no taxis and

in any case they had no Russian money. Eventually a French diplomatic courier took pity on them and gave them a ride into the city, where they discovered that they had no reservation at the Metropol Hotel and it had no rooms available. The Savoy, the only other hotel where foreigners were allowed to stay, was similarly full. They ended up in the apartment of the absent *Herald Tribune* correspondent.

VOKS, the Russian cultural-relations agency which was sponsoring their visit, finally sorted out the muddle, got them a hotel room and assigned them an interpreter, but it was still nearly a week before Capa was given a permit to take photographs and even then he was constantly stopped by Russian police, who insisted on checking and re-checking his papers. They were able to visit the Ukraine and the still-devastated city of Stalingrad, but Capa, to his great disappointment, was refused permission to photograph the famous tractor factory which had been converted to tank production during the war and heroically defended by its workers. After a ten-day trip to Georgia they returned to Moscow, where Capa wanted to photograph the celebrations for the city's 800th anniversary. Shortly before they were due to leave he was informed that all his negatives would have to be examined before he would be allowed to take them out of the country. Steinbeck was amused by his agitation after a messenger had arrived to collect his film. 'He paced about clucking like a mother hen who has lost her babies. He made plans, he would not leave the country without his films . . . Half the time [he] plotted counter-revolution if anything happened to his films and half the time he considered simple suicide.'[5] In fact, no films were confiscated, but Capa was very unhappy with the quality of the processing.

Capa arrived back in New York in October to discover that he was one of twenty correspondents awarded the Medal of Freedom for 'exceptionally meritorious achievement which aided the United States in the prosecution of the war against the enemy in Continental Europe'. He was flattered, but much more interested in getting his Russian pictures published. Over lunch with John Morris at the Algonquin he confessed that the trip had not gone well, that they had been 'pushed around' and he was unhappy with the pictures. Next day Morris looked through the prints in Capa's room at the Bedford and realised immediately that they offered an insight into ordinary Soviet life that few Americans had ever seen. He took a selection back to show Beatrice and Bruce Gould, the husband and wife team who edited the *Journal*. 'Bruce said "How much is this going to cost us?" I knew that Capa would have been surprised to

get $5,000 but I also knew the Goulds were used to paying $25,000 for a big cover story, so I said "$25,000." He said 'See if you can get it for $20,000.' I called Capa and asked him to meet me in the bar at Toots Shor in half an hour. When I told him he could hardly believe it.' Neither could Steinbeck, when he heard about it later, particularly as the *Journal* had only offered him $3,000 to write the text.

The *Ladies' Home Journal*'s introduction to its cover story on 'Women and Children in the USSR' was touching, if not entirely accurate:

> Here for the first time in an American magazine, is a full report on day-to-day life in the Soviet Union. The editors of the *Journal* commissioned John Steinbeck and Robert Capa to go to Russia, not to picture Communism, but in the hope that they might bring back exactly what is offered here – proof in words and pictures that . . . Russians are people too. The editors believe that it is good for the 25 million Americans who read the *Journal* to have these near straight glimpses into the homes and lives of Russian women and children and they wish with all their hearts it might be possible to put before 25 million Russians just such a picture story about Americans.

Despite the fears of the magazine's advertising department that advertisers would object to the Russians being portrayed in anything like a sympathetic light – America would soon be in the grip of a 'Red Scare', thanks to the machinations of the senator from Wisconsin, Joe McCarthy – the issue sold out. Steinbeck and Capa's *Russian Journal*, published as a book and syndicated by the *Herald Tribune*, fared rather less well, even though Steinbeck was critical of Soviet bureaucracy and emphasised how much the Soviet Union lagged behind in terms of technological progress. Speaking at a forum in New York organised by the *Herald Tribune*, Capa explained that whenever they were asked, in Russia, about political persecution in the United States, he and Steinbeck always replied that to the best of their knowledge there were no political prisoners in America 'as yet'. The FBI, then under the direction of the paranoid J. Edgar Hoover, was distinctly unamused, not to say suspicious, and a report on Capa's trip to the Soviet Union duly found its way into the file that had been opened on him before the war, when an anonymous informer told the FBI that Capa had joined the Communist Party during the Spanish Civil War.

The accountant's report for Magnum Photos Inc. 'from inception May 27, 1947, to October 31, 1947', showed total assets of $14,632.05 and liabilities of $11,068.01. The *Ladies' Home Journal* was Magnum's most important client, accounting for nearly two-thirds of the $15,294 the photographers earned in fees during Magnum's first five months. The agency owed nearly $9,000 to its photographers. George Rodger seemed to be the biggest earner by far, with $3,687.78 owing, compared to $2,323.43 owed to Capa, $1,677.29 to Chim and $55.20 to Cartier-Bresson, who had only recently arrived in India with his Javanese wife, Ratna Mohini, known to all her friends as Eli.

It had not been easy for Capa to persuade Cartier-Bresson to join Magnum. Although they were friends, they were very different photographers. Cartier-Bresson looked for visual coherence within fragmentary instants, what he called 'the organic co-ordination of elements seen by the eye', while Capa's resonant creed was 'the truth is the best picture, the best propaganda'. The two would eventually come to represent opposing camps in Magnum – the battle between art and journalism that continues to this day. Capa won his friend over by unashamedly appealing to his sense of adventure and offering him India and the Orient as his turf, but Cartier-Bresson still did not care to think of himself as a photo-journalist so Capa had to convince him that his Surrealist soul would not be corrupted by the magazine marketplace. 'Watch out for labels,' Capa warned him. 'They're reassuring but somebody's going to stick one on you that you'll never get rid of – "the little surrealist photographer". You'll be lost, you'll get precious and mannered. Take instead the label of "photojournalist" and keep the other thing for yourself, in your heart of hearts.'

Having been promised by Capa that Magnum would make every effort to ensure magazines did not crop his pictures, Cartier-Bresson sailed for Bombay in the summer of 1947, intending to cover the partition of India. Capa had hoped to get his friend an assignment with *Life*, but the magazine already had Margaret Bourke-White in the country and did not consider that the story rated two photographers. It was just as well: Cartier-Bresson's ship was delayed in the Sudan with engine trouble and did not arrive in India until September, a month after the ceremonies marking the end of the British Raj. There was, however, much still to photograph. Partitioned into two states, the country was in turmoil, plagued by street riots and communal violence which had already claimed half a million lives.

Eli was a close friend of one of Jawaharlal Nehru's sisters, and

through her Cartier-Bresson was invited to meet Mahatma Gandhi, the revered leader of the nationalist movement. Gandhi, still weak from a recent fast for Hindu-Muslim unity, received Cartier-Bresson in the gardens of Birla House in Delhi, where he had taken up residence, on the afternoon of 30 January 1948. The Frenchman had brought along a copy of a book published to coincide with his 'posthumous' exhibition at the Museum of Modern Art. The Mahatma seemed intrigued by the pictures in the book and slowly turned the pages without speaking for a long time. Then he stopped at a photograph of a hearse and asked: 'What is the significance of this picture?' Cartier-Bresson confessed that he did not know, that he never analysed what he was doing and never wanted to. The Mahatma shook his head, muttered 'Death, death, death', then put the book down. The two men chatted for half an hour before Gandhi indicated the interview was over. Cartier-Bresson collected the bicycle he used to get around the city and pedalled back to his hotel.

Twenty-five minutes after the Frenchman had left Birla House Gandhi was being helped across the gardens by his two grand-nieces on his way to evening prayers when a young Hindu fanatic stepped out of the crowd and shot him. Cartier-Bresson heard the news almost the moment he arrived at his hotel. He immediately rushed back to Birla House and fought his way through the hysterical crowds to the room where the Mahatma lay dying. Out of respect, he felt he ought not to enter the room, so he shot his pictures discreetly through the curtains. The formidable Margaret Bourke-White apparently felt no such reservations and forced her way in, so offending those present that after she had taken her pictures they followed her outside and tore the film out of her cameras.

When *Life* editors in New York heard what had happened, that their star photographer had been upstaged by a Magnum representative, one of them immediately got on the telephone to Magnum's office in Paris to buy up the rights to Cartier-Bresson's pictures. Maria Eisner had received no clear instructions from Henri about what he wanted done with his pictures, so she prevaricated, suggesting that the agency had already made other arrangements. The enraged editor in New York could hardly believe some pipsqueak agency would dare to refuse to supply pictures to the world's most powerful magazine. 'All right,' he snarled, 'go ahead with your different arrangements. But I'm telling you we will never buy a picture from any Magnum photographer *ever again*!' Maria, terrified of getting Magnum banned from *Life*, immediately burst into tears and relented.

Cartier-Bresson's pictures of the death of Gandhi were the first of thousands of Magnum photographs to grace the pages of *Life*. Not long afterwards the first instalment of 'People Are People The World Over' appeared in the *Ladies' Home Journal* and the series continued every month for the remainder of the year. It was a product of its time, answering the American magazine readers' growing curiosity about the world and established a formula for global photo-essays that Magnum would use repeatedly in the coming years. Capa was not around to savour the agency's success – he was on his way to the Middle East to cover the birth of the state of Israel on assignment for *Illustrated*.

Capa flew into Tel Aviv on 8 May, six days before the British mandate in Palestine was due to end. Braced for war and bustling with activity, the city was, to Capa, reminiscent of Madrid during the Spanish Civil War or London during the Blitz and he instantly felt at home. Correspondents from all over the world, many of them his friends, were packed into the big hotels, furious poker games were played every night and Capa always seemed to know where to acquire black-market food and liquor, despite serious shortages of both. After covering the official ceremony marking the founding of the state of Israel at the Tel Aviv Museum on 14 May, Capa and two other correspondents – Frank Scherschel of *Life* and a Hungarian-born photographer called Paul Goldman – hitched a ride to the northern Negev desert to cover what Capa would later describe as 'the bitterest and most romantic fight of the whole war'.

This was Goldman's account of their arrival at the kibbutz of Negba, which was holding out against an Egyptian advance from the south:

Negba was then almost completely surrounded by the Egyptians. Because of the continuous shelling, you literally had to crawl into the settlement. We had to lie flat for about two hours and during that period we counted about three hundred shells. Suddenly, and characteristically, Capa said 'Who the hell can lie still while a fight is going on?' Jumping up, he ran for the settlement. Scherschel, frightened to death, shouted after him 'Bob, keep low! You'll get hit!' So Capa shouted back 'My address isn't on those **** shells' and he kept on running. We reached the settlement safely and were shown to the shelters where the settlers took cover. Capa jumped down and greeted everyone with his spicy Hungarian-accented Shalom . . . He cheered them up and kept them in high spirits all afternoon. Naturally, there was soon a circle of girls and women around him . . .[6]

Naturally, too, Capa spent quite a bit of time photographing the prettiest of the women soldiers who joined the men in buses and trucks to be driven out each day from Tel Aviv to the front. Being Capa, his interest was not entirely confined to pictures; one night when fighting suddenly erupted unexpectedly and flares soared up into the sky, he could be seen on a hillside energetically making love to a young woman whose uniform was in considerable disarray.

As Capa had learned how to find his way round a war long ago, he knew the importance of ignoring all official instructions issued to war correspondents. David Michael Marcus, a West Point graduate who had been appointed commander of the forces between Tel Aviv and Jerusalem, tried to keep Capa out of his hair but signally failed, as David Eldans, who worked in the government press office, explained:

Whenever Marcus told Capa not to go to a certain area, you could take it for granted that he would go. So then began a game, with Marcus claiming that one place was dangerous in order to keep Capa away . . . but in the end Capa always found him out, so Marcus had to turn to other methods. There were very strict security regulations, and the commandos and patrols had orders to turn the photographers back from places that were too hot. But Marcus failed to take Capa's cleverness and personal charm into account. He simply made friends with all the soldiers – with fascinating stories and with the brandy flask he always carried in his hip pocket – and so he went everywhere.[7]

Actually Marcus and Capa got to like and respect each other and when Capa got into Jerusalem he promised Marcus a 'delirious experience' – a hot bath at the Eden Hotel. Sadly, Marcus was never to enjoy it – returning from a late night walk outside his camp he failed to give the correct password and was shot by one of his own sentries. Capa was deeply affected by such an unnecessary death and insisted on accompanying the convoy that carried Marcus's body back to Tel Aviv.

A few days later Capa's own luck very nearly ran out, not, by any means, for the first time. On the morning of 22 June, after a cease-fire had been negotiated, a group of 500 extreme right-wing Irgunists anchored in a ship off the main beach of Tel Aviv and announced its intention to begin unloading arms. It was a deliberately provocative act, since shipping arms into the country would violate the terms of the cease-fire and provide the Arabs with an excuse to resume the war. The Irgunists assumed the Israeli

government would be unwilling to order its troops to fire on fellow Jews, but after the first wave had landed and set up machine-gun posts, orders were issued to oppose the landing and a full-scale battle was soon raging on the beach.

Capa was quickly on the scene, ignoring the gunfire and edging his way across the beach to get into the best position to take pictures. Kenneth Bilby of the *Herald Tribune* saw a man killed not five feet from the photographer, but Capa continued to work until he suddenly felt a sharp pain between his legs and thought, for one dread moment, that his genitals had been blown off. As he told it later to friends back in Paris, despite the battle going on all around him, he undid his belt and dropped his pants on the spot to check on the damage. Fortunately, a bullet had merely grazed his inner thigh, but it was enough of a close call to persuade him to get out. He pulled up his pants and, doubled up with pain, scuttled off the beach, packed his bags in his hotel room and caught the first plane out. Back in Paris, he swore he was through with war photography. 'They got too close this time,' he said. 'I am not going to continue to photograph for posterity the men who play this little game.'

Tragically, it was a promise that he was not to keep.

While Capa was engrossed with the struggle for a Jewish homeland, Chim was touring Europe photographing children spiritually and physically maimed by the war. Chim fervently believed that wars were crimes against children and his pictures from that period are astonishing in their affection and compassion – one particularly memorable photograph was of a little girl with a bow in her hair who had been asked to draw a picture of her home and had simply scribbled furiously across a blackboard. She stared hopelessly into Chim's camera, the very essence of war's misery. 'Chim picked up a camera,' said Cartier-Bresson, 'the way a doctor takes his stethoscope out of his bag, applying his diagnosis to the condition of the heart.'

Cartier-Bresson, meanwhile, was making plans to move from India to cover the civil war in China, and gentle George Rodger was planning an epic overland trek across Africa with his wife, Cicely, in search of what he would describe as 'healing innocence' after the savagery he had witnessed during the war. He wanted to look for stories at his own pace and document Africa's extraordinary tribal societies, people with whom he felt a strong bond. They began their journey in Johannesburg, where they fitted out a reliable Willys station wagon with reinforced crates, for cameras and film, and extra petrol and water tanks. Additional stores were to be carried on a trailer on which Rodger had constructed a curious kind of conning

tower from which he could shoot pictures while remaining concealed. While this work was being undertaken the segregationist Nationalist Party swept to power in South Africa, heralding the introduction of apartheid, and George and Cicely were glad when at last they could get on the road. They first headed for Uganda, where they were invited to attend the wedding of the Kabaka of Buganda, then moved on to Tanzania, where Rodger took a damning set of pictures of the groundnut fiasco for *Illustrated* magazine and was furious to discover, months later, that the magazine had decided not to publish them after threats of legal action from John Strachey, the Minister for Food. They covered 13,000 miles even before reaching the equator, sleeping under the stars and photographing every form of human and animal life on the way – the lions of the Serengeti plains, the great herds of game in the Ngorongoro volcanic crater, the Baris in Uganda and the Lotuko rainmaking ceremony in the Sudan. With his unassuming manner and quiet charm Rodger usually found it easy to be accepted in aboriginal tribes, although the Masai in Kenya did threaten him with spears when he attempted to take their picture. But his instinctive respect and sympathy for the people, his obvious delight in observing and absorbing their courtesies and customs, helped ensure their safety. He did not photograph exhaustively and never intruded with his cameras, but simply took pictures when, as he later drily observed, 'something happened'.

Both George and Cicely endured the travails of their journey with remarkable fortitude. Rodger described the conditions in a letter to a friend, written from the Williamson diamond mine in Tanzania:

At the moment I am writing by the light of a hurricane lantern. It attracts the bugs and beetles from miles around. Crawling around me are long ones, short ones, thin ones and fat ones, some with clogs on and some which stamp around on big flat feet, some that jump and some that fly. The mosquitoes are dreadful. They zoom down, do a three-point landing on the table then sit back on their heels and roar at me. If it hadn't been for Williamson finding that diamond under the baobab tree and then setting to and digging them out of the thick black soil at the rate of 50 million dollars a year, I wouldn't have come here at all.[8]

In Dar es Salaam Rodger received a cable from the Magnum office in Paris suggesting he venture up into the mountains in the Kordofan province in southern Sudan, virtually unknown territory, to look for the Nuba tribe. It was an assignment that would result in

some of Rodger's most memorable photographs. 'The Nubas had never even seen a white in those days,' he recalled. 'I lived with them for a couple of months and really got to know them. For me it was an ideal assignment.'⁹ Nuba men proved their manhood wrestling while wearing heavy metal bracelets and Rodger's photograph of a magnificent Nuba wrestler being carried in triumph on the shoulders of a compatriot has probably been published in every country in the world with a publishing industry.

'When we came to leave the Nuba Jebels,' Rodger wrote later, 'we took with us only memories of a people, primitive it is true, but so much more hospitable, chivalrous and gracious than many of us who live in the "Dark Continents" outside Africa.'¹⁰ Sadly, Rodgers's pictures were ultimately to bring tragedy to the Nubas. Leni Riefenstahl, the famous film director and close friend of Hitler, saw Rodgers's pictures in *National Geographic* magazine and wrote to ask him where the tribe was located, offering him \$1,000 if he would introduce her to the wrestler. He refused, but she persisted and eventually tracked down the tribe, taking a series of colour pictures that were published around the world. Rodger was furious: not that she had taken similar pictures to his own, but because she had put the Nubas at risk. As he was to explain later:

> It was the time of the Islamic genocide in the south of Sudan: not exactly a religious war but an ethnic cleansing of the Nuba. They had had their share of bad treatment. They were peace-loving, without arrogance and tried to live simply. At that moment when the Sudan government decided that people should cover themselves up, women should wear brassières and the men shorts, Riefenstahl arrived to spend several weeks with them, presumably with a large advance from *Stern*. She gave them a lot of money and several Landrovers and she had the cheek to make the Nuba undress. In order to take pictures like mine, she paid these people to take their clothes off and to make them fight in contests, which at that time was equally forbidden.¹¹

It was not long before photographic safaris were being organised into Nuba territory and the fragile nature of the 'primitivism' he had so valued was threatened. The reaction of the fundamentalist Islamic government of Sudan was to encourage Arab encroachment on to Nuba territory to such an extent that their culture and habitat were virtually destroyed. It was the outcome that Rodger had most feared.

In July 1948 the Vandiverts quietly resigned from Magnum and more or less sacrificed their place in photographic history as founders

of the agency (their names rarely appear in any reference to the birth of Magnum). There was no row, no real disagreement – it was simply that Bill Vandivert decided after a year with Magnum that he could probably do better operating independently, as he had before. He had a lucrative contract with *Life* and had had reservations from the beginning; he had only been persuaded to become involved out of loyalty and friendship to Capa. The acerbic Rita had also rather blotted her copybook by suggesting that Magnum could not afford Cartier-Bresson. He was not really a photo-journalist, she argued, and occupied too much of the staff's time. It was not, understandably, an idea viewed with any favour by the other founders, particularly in light of the astonishing pictures Cartier-Bresson was sending back from the East.

In December 1948, *Life* magazine cabled Cartier-Bresson in Rangoon asking him to make his way to China, where the Nationalist forces under Marshal Chiang Kai-shek were steadily losing ground to the massive Communist army commanded by a former schoolteacher, Mao Tse-tung. Cartier-Bresson and his wife first flew to Shanghai, where he checked in at the *Life* bureau, before continuing alone to Peking, which was about to fall to the Communists. He found it very difficult to work, not so much because of the war, but because his white skin cost him his prized anonymity. He liked to pop up, as if out of nowhere, take a picture, and then innocently walk on as if nothing had happened, but in China it was impossible because he was hampered, he complained to Magnum, by 'fifty kids stuck to my legs'. China was 'the most difficult country to photograph I have been to. A photographer should, to work well, have the same space as a referee has around boxers.' To make matters worse, the Chinese considered all impromptu photography to be a breach of etiquette. Taking pictures unasked in a Chinese home, he said, 'showed about as much tact as patting the fanny of the daughter of the house'.[12] It was deeply frustrating: one morning he came across a group of men doing exercises in the T'ai Miao Gardens, by the Imperial Palace. When they broke up a few were 'still sketching some movements unconsciously, as one going out of an opera hums an air . . .' Cartier-Bresson was charmed by the idea that one could act as an individual without being thought eccentric, but added sadly: 'I did not take this picture of dancing in the street as I have too much respect for them and it might have seemed that I was making fun of them.'[13]

Even as the battle for the city loomed ever closer, Cartier-Bresson was impressed by the uninterrupted tenor of life and recorded an

extraordinarily evocative description, in words, of a visit to a teahouse:

> Around nine a.m. gentlemen come and have a cup of tea, bringing with them their birds and crickets. They hang the cage at the ceiling, or put it next to their cup on the table. With the faint rays of the winter sun floats into the room the fumes of gone centuries. An old man rubs in his fist two nuts against each other, they get dark red and shiny, he is the fourth generation who is rubbing these same two nuts, while his neighbour holds a stick with a string, at the end of it flies a bird as a kite or a toy – it is a *companion* not a captive. Another one reads the paper – is it about the government troops progressing southwards or just the local ads? The old waiter passes ritually from table to table, pouring hot water on the tea; a man stood up and took out of his sleeve a little piece of wood with a horsehair at the end, introduced it through the holes in a little box where he keeps his cricket, and this makes the cricket sing; behind him some refugee students are sitting in leather battle jackets; an old man comes in with his cage with a cover around so the bird does not catch cold or get frightened in the streets; all is very quiet, everyone thinks more than he talks, the birds sing and the crickets too when their master tickles them with the little hair. On the walls some posters: 'Track down unstable elements' (Communists) . . . The room is full of lip noises of sipping the tea, birds, crickets and kind smiles.[14]

It was typical of Cartier-Bresson that he would still be prowling the streets while a key battle was being fought on the plains to the north of the city. He found a pedicab driver, known obscurely as Buddha 34, to run him around town and act as interpreter. One day Cartier-Bresson took a picture of what looked like an old lady with a fox fur around her neck, surrounded by a crowd of army recruits. Buddha 34 ran across to look her over and returned with information that 'she has no hole in her ear, so she is a eunuch'. Cartier-Bresson was delighted: he had long wanted an introduction and a few days later he could be found photographing a community of forty elderly eunuchs, the last survivors of 3,000 castrated servants of the late Emperor, who were working a small patch of land within earshot of the bombardment of the city. One of them told him it had been his duty to wrap the Emperor's favourite concubine, naked, in a length of red silk and carry her to the Emperor's bed. 'They said that times were hard for them, so if I would be so kind as to give them a little money, they would be glad to pose. I shot them while

clever and faithful Buddha 34 did them a striptease act, with some
dollars, to make the pleasure last.'

On another occasion, like a curious small boy, he simply tagged
along at the end of a wedding procession coming out of a temple. A
silk-draped palanquin holding the bride was preceded by her family
in their best robes and a group of trumpeters and drummers beating
golden drums. As they reached the open expanse beyond the city
walls, they encountered a straggling line of exhausted and demoral-
ised soldiers withdrawing from the battle.

The retreating soldiers were not in order, they seemed to have
been marching from the infinity of the Chinese plains to some
gigantic adventure. Their origin seemed as untraceable as the
origin of these streams of ants one comes across in the jungle. Our
procession and the army finally met, passed each other, neither
paying any notice of each other, as separate worlds never meet in a
cosmic universe. Our procession had reached the house of the
parents of the groom, and the carriers were pushing the palanquin
with its precious load through the narrow gate, while the army
was still passing by, on their way to meet their fate somewhere.[15]

Shortly before Peking fell Cartier-Bresson returned to Shanghai,
where he and Eli took an apartment in Broadway Mansions,
overlooking the bustling Suchow Canal, where sampans unloaded
bales of cotton. One morning on his way to the *Life* office he found
a large crowd gathered outside one of four government banks. He
discovered they were all wanting to withdraw gold. Realising that
the Kuomintang currency was collapsing, he ran upstairs and began
photographing the scene from a window. Detachments of mounted
police were brought in to hold back the growing crowd, while
policemen on foot patrol tried to maintain order by lashing out with
the thin steel rods used for cleaning rifles. The angle of his view from
the window was not quite right, so he decided he would see what
pictures he could get on the street. Trying to force his way through
the crowds, he soon became completely jammed and was marooned
in the seething mass of bodies for some time while his pockets were
picked and those closest to him eyed his camera covetously.
Fortunately no one tried to take his camera. Only a few days earlier,
riding in a crowded streetcar, Cartier-Bresson discovered one of his
cameras had been stolen, cut off from its strap with a razor. At the
next stop he jumped down and frisked the passengers as they got off.
Observing what was going on, the thief surreptitiously dropped the

camera on the steps of the streetcar, where Cartier-Bresson found it after checking the pockets of the last bemused passenger.

Cartier-Bresson and his wife left Shanghai in April 1949 on the last British steamer out of the city and with a million-strong Communist army camped on the far shore of the Yangtze river. The ship was packed with refugees trying to escape the city before the Communists arrived. Cartier-Bresson remembers that on the evening they sailed there was a 'whisky party' on board, with entertainment provided by a fiddler and an accordionist from the Silk Cat night club.

After the departure of the Vandiverts, Maria Eisner, who had made a great success of the Paris office, was asked to take over as president. As she was at that time engaged to a doctor living in the United States she was delighted to accept. Magnum Photos Inc. moved out of the Vandiverts' place in Greenwich Village into a dingy office building on West 4th Street, between Fifth and Sixth Avenues, not particularly commodious but at least convenient for the Algonquin, where Capa liked to lunch. Toots Shor's, the celebrity gin mill where you could find anyone from Joe DiMaggio and Frank Sinatra to Harry Truman and Ernest Hemingway, was only a few blocks to the north.

Without Bill Vandivert, Magnum was even less well equipped to undertake the global projects that Capa kept dreaming up, so it became imperative for the agency to recruit new members, both to keep up the cash flow and to provide sufficient talent to cover major international assignments. A number of photographers – among them Gisèle Freund, Fenno Jacobs, Herbert List and Homer Page – were using the agency to distribute their pictures, but they were not 'family'; Magnum simply represented them in return for a percentage. The problem with recruiting new members was that it had been agreed from the outset that no one would be accepted unless they fitted in personally, politically and professionally, with the first two factors being quite as important as the last. At the time of the Vandiverts' departure, the founding members had identified only one photographer who fulfilled their exacting criteria – a thirty-two-year-old Swiss national by the name of Werner Bischof – and he was not at all sure he wanted to join.

INGE BONDI, who joined Magnum as a secretary/researcher in 1950 after answering an advertisement in the *New York Times*, talking at the Leica Gallery in New York: 'Magnum was in a dingy little building in one of those dingy little streets between Fifth and Sixth Avenues, although the Algonquin and the offices of *Life* magazine were only a couple of blocks away. You went up in one of those elevators with a metal grille and as you got out there was a rough wooden shelf arrangement lining one wall, a couple of shabby desks and three or four filing cabinets. It was really just one room with a partition making a little office for Maria. There were typewriters and telephones, but it was really depressing. I remember saying to Maria "Do you think this is going to last?"

'Maria was the sales person and she was absolutely wonderful. She was devoted to all the original lot – I never knew quite what was going on with her and Capa – and she was very professional and a wonderful editor. I think she got on very well with the people at *Life*, who were very difficult. Capa wasn't just interested in making money out of pictures, he was interested in developing talent and he was terribly good at it. He also worked very hard, editing other photographers' pictures when they were in the field.

'I remember the first photographer I met was Capa. He told me to buy a lot of film, a whole suitcase full of film, because there wasn't any to be had in Europe at that time. He was small, squat and glamorous and I remember he said to me "You'll do." That was high praise. Not long afterwards Capa started running the office from Paris and when he came over, usually at Christmas time, there was always a lot of socialising. Very often we'd have a bottle of champagne or a bottle of whisky, sometimes some caviare, at the end of the day. It was a tradition at Christmas to hold a party, a good time to wine and dine editors and present new ideas. Capa was great at selling ideas. He'd take people to lunch upstairs at the 21 and then invite people for drinks at the Algonquin, where he was staying, in the evenings. On the invitation it said "Bob Capa invites you to cocktails" and I remember some of the other people got very annoyed because it didn't say Magnum. Then there was a famous party at the Algonquin with double drinks being served to everyone and when the bill came in all the other photographers were upset. They didn't understand that Capa would get people lots of jobs from occasions like that. They were upset by the size of the bill because Magnum was always having financial problems. It was like a bank: people would leave their money in there and when you needed money for some other photographer who didn't have any, you used somebody's else's money. You had to do it with great discretion and

be very careful not to go bust. If a photographer cabled for money from somewhere you had to try and find it. There was a very good photographer called Homer Page who went off to South Africa with a writer and they both drank too much and we were sending him money all the time and all of a sudden there was a huge hole in our cash flow. Capa took the blame because I was very young and inexperienced. Usually we used to try and do everything on a shoestring. Werner used to say he slept under bridges in the Far East and when Ernst [Haas] went out to do his famous New Mexico pictures he went hitchhiking with his suitcase; he didn't even know how to drive a car. Their expenses were all terribly modest. There were telexes flying backwards and forward between New York and Paris all the time. Relations were always absolutely friendly; it was like being part of one big family.

'The guys were so great, they weren't jealous of each other, they didn't copy each other's ideas, they were all secure in themselves. It was a real co-operative. It started from a long friendship and they had all been through a lot. They were all gentlemen, all generous, all loyal and, to a certain degree, they were prepared to share with the people who were working with them.'

4

The Recruits

WERNER BISCHOF was an abstract still-life photographer who had originally made his living from fashion and advertising and had only recently turned his hand to photo-journalism, moved by a desire to document the ravages visited on Europe by the Second World War. In May 1946 the respected Swiss magazine *Du* devoted almost an entire issue to his harrowing pictures of refugees, many of them children, adrift amid the devastation of a liberated Europe. At that time he was being represented by the Black Star agency, although not entirely happily, as he had made clear in a letter:

'I will not do this type of work that you keep going on about, i.e. political documentaries; it is not in my nature. The social aspects of life – hardship, development, yes. Do not forget that I seek beautiful things. For instance, I am interested in how the different nations are educating their post-war youth, what will arise out of the destruction, and how much marvellous humanity is present even in extreme hardship. There is absolutely no sense in burdening me with political documentaries that a clever American reporter can do far better.'[1]

Despite his difficulties with Black Star, Bischof was in no hurry to make up his mind when he was approached by Magnum; he was in Helsinki, on his way to photograph the nomad tribes in Lapland, when he received a formal contract in September 1948. 'I have yet to make a big decision,' he wrote to Rosellina Mandel, the young woman who would soon become his wife. 'I have the Magnum contract in my hand. This is an agency (organised on a cooperative basis) of photographers – the best in the world – Capa, Cartier-Bresson, Chim and Rodger. What is important to me is that they are all sound people and socialist-inspired. Two of them were in the

Spanish Civil War. They are free people, too independent to tie themselves to one magazine.'[2]

While Bischof was dithering, it was decided that a similar offer should be extended to another promising young photographer called Ernst Haas, who had sprung to prominence with a moving set of pictures taken outside Vienna's main railway station of women meeting the trains bringing prisoners of war home. Born in Vienna in 1921, Haas was working on a fashion assignment when he learned that the first transport bringing Austrian prisoners of war home from Russia in 1947 was due to arrive at the main railway station within an hour. He dropped everything, hurried across the city with his cameras and found a huge crowd of women waiting outside the station holding up family pictures of their missing husbands and sons in the hope that one of the returning prisoners might have news. 'Nobody knew who was due to arrive,' he recalled later. 'Tension and quiet lay over the place until the first prisoners stepped forward, as if out of a backdrop on a stage. What happened next could only be described with a camera. I worked intoxicated . . . Scenes of happiness quickly gave way to scenes of disappointment. It was barely possible to take it all in. Women holding out faded photographs fell upon new arrivals. "Do you know him? Have you seen my son?" They called out the names of their men. Children with photographs of fathers they had never seen compared their pictures with the faces of returning men. It was almost too much. I went home numb.'[3]

The pictures Haas took that afternoon were published around the world and led to an invitation to join the staff of *Life*, unquestionably the world's most powerful picture magazine. No doubt to the astonishment of the editors in New York, Haas politely refused, explaining his reasons in an eloquent letter:

There are two kinds of photographers, the ones who take pictures for a magazine, and the ones who gain something by taking pictures they are interested in. I am the second kind. I don't believe in this in-between success of becoming famous as quickly as possible. I believe in the end success of a man's work, to become a real human being, who obtains the idea of life and its connection with earth and cosmos and who is able to understand the mistakes and to admire the achievements of other people . . . I have always felt better taking a risk rather than an easier route, for what I believe in. I am young enough to do that and I am full of energy and hope to reach my goal. I prefer to be noticed, some day, first for my ideas and second for my good eye . . . I don't

consider myself so important that I say I don't need the discipline of working for a magazine, that means to photograph co-operatively what they need and what I need. But not only a magazine has a plan, I have one too. And isn't it also a discipline to resign a good chance just to keep the aim you have in your mind? For me it is always a better feeling to risk something for what I believe in, than to go the more pleasant way. I am young enough to do it and I am filled with energy to see it through. Maybe you think I am not quite on the earth with both legs . . . What I want is to stay free, so that I can carry out my ideas . . . I don't think there are many editors who could give me the assignments I give myself.[4]

Haas's letter could have been a manifesto for the photographers of Magnum and perhaps it was, since at the time he wrote it he had already agreed to join Capa and company. Like everyone else, Capa had been impressed by Haas's pictures and had invited him to visit Magnum in Paris. Haas travelled from Vienna by rail, on hard wooden benches in a third-class coach, with his beautiful young researcher, Inge Morath, who would herself eventually become a distinguished member of Magnum. The year was 1949, she was wearing a new hat and they had a pile of sandwiches which Haas's mother had brought to the railway station before they departed. This is how Inge recalled their arrival in Paris:

Haasi and I got out at the Gare de l'Est. We can't have had much luggage, because in order to protect our small French funds we walked to the Magnum office at 125 Rue du Faubourg Saint-Honoré, which is quite a distance. The office was on the fourth floor. 'The elevator' said a stern notice on the iron-grille door, 'can be taken up but not down' – a piece of information we were already familiar with from Vienna, which must be the only other city that had such a restriction. We rang the bell, expecting all the big shots to come out to greet us. For a long time there was no response, but we went on ringing because we had had the arrival date confirmed in a letter. Finally, a tall thin man appeared with an icebag on his head. He was Carl Perutz, who photographed chic things brilliantly, and he had a hangover. 'Today,' he said, 'is the Quatorze Juillet, Bastille Day, and I don't know if anyone will be coming to the office. But sit down anyway.' He disappeared again.

The office was installed in an apartment . . . The place still looked like an apartment too, with a kitchen, bathroom, and bedroom. Only the big front room had a vaguely official air. Here

were a long high table for editing, a phone on a long line that could be carried around, a few filing cabinets, and a couch on which I often slept when I had no money – a great convenience except for the absence of bed linen and the very early arrival each morning of the concierge to clean up . . .

Capa finally appeared in the company of his friend Len Spooner, editor of *Illustrated* magazine of London. Capa was handsome and full of life, and he made us feel right away that everything was under control, although so far nothing had happened. It did, soon enough: while continuing to plan Magnum projects with Spooner, Capa had picked up the phone, found us cheap hotel rooms, and firmed up a job for us with Unesco in Italy. This done, we proceeded to Saint-Germain-de-Prés, where we had a glorious dinner. There were fireworks, the narrow streets were jammed with dancing couples, and Ernst and I showed everyone how to do the waltz-to-the-left. David Seymour, 'Chim' to us all, turned up, too. He was gentle and more inclined than Capa to answer our myriad questions in detail. Cartier-Bresson, we heard, was at the time driving with his first wife, Eli, from the Orient to Egypt and we would meet him later. George Rodger would soon arrive from Cyprus en route to Africa.[5]

During the dinner that night Capa congratulated Haas on becoming a member of the agency. 'But what does that mean?' Haas inquired nervously. 'It means,' Capa replied breezily, 'that your money is in Magnum, that Magnum is a non-profit company, and that you will never see your money again.'

Haas was not fooled: 'Capa considered himself anti-art, religion, poetry, sentiment; but it was his hands which really gave away his character. They were tender and feminine and the opposite of his whole appearance, voice and so on. In many ways he was looking for – if one can say something like that – the poetry of war. The phenomenon of war – this is tragic poetry . . . There was a poetic element in Magnum in the beginning . . . one wanted to go beyond the purpose, to work purely for a magazine and what they needed. It really was Capa who said 'You don't only satisfy the market, you create the market . . . you create values, which will be asked for afterwards.'[6]

When he was in Paris Capa stayed just round the corner from the Magnum office at the Hôtel Lancaster, where the concièrge gave him tips for the races at Longchamps. Although he remained the inspiration and driving force of Magnum, he hated to spend time in

the office. He would sweep in to make telephone calls or write a few captions or flirt with the pretty girls the agency invariably employed, but most of the business was discussed, and jobs assigned, in the café on the ground floor, where he would spend hours wrestling with the pinball machine, a Chesterfield cigarette dangling from the corner of his mouth, his eyes squinting from the smoke.

John Morris, the picture editor of *Ladies' Home Journal* always found visiting Magnum's Paris office a memorable experience: 'If one came early, one might be greeted by a sleepy photographer emerging from the back bedroom, and perhaps his girlfriend. The kitchen had been stripped down to a refrigerator – full of film. The large living room was lined floor to ceiling with cardboard boxes of prints and albums of contact sheets. Laundry, luggage and camera cases filled odd corners. A vague tone of conspiracy prevailed at the long editing table, except when Robert Capa came roaring in. How he loved to disrupt the calm!'[7]

Anyone from the New York office, or anyone who knew anyone in the New York office, was always welcome at the Magnum office in Paris. Morris's assistant, Lois Witherspoon, known to everyone by her family nickname of Jinx, took a four-month leave of absence from the *Ladies' Home Journal* in the spring of 1949 to travel in Europe and made Magnum in Paris her first port of call. 'There was a rickety elevator up to the first floor where Maria's old apartment was. It was very crowded, very French – completely different from the New York office. There were hysterical discussions going on in one corner and arguments in another. People were falling out with each other all the time, friends one day and bitter enemies the next. I was accepted as one of the gang because I knew everybody from New York. In a way they were probably chatting me up a bit because I had the *LHJ* behind me. The staff were typically French and there were conversations going on in English, French and German simultaneously and ideas and plans sparking off the walls. It was terribly exciting, just incredible.

'Chim and Capa were in and out of the office. Chim was like a little owl, short and stubby with hair swept back, big eyes and sad face. He would slink into the elevator with all these cameras hung all over him. We would say "Poor Chim" but it wasn't a case of poor Chim: he loved it. He lived very well and had friends everywhere. He would say "I think it is time to go to lunch" and he always knew where to go and always seemed to have enough money to pay for it. I don't know how. Everybody chipped in what they could, it depended on who had money at the time.

'Poor Ernst Haas was as broke as anything and I remember going

to lunch with him and saying I would pay because I had some dollars and he said "No, you are my guest." Not only did he pay for my lunch he also bought me a beautiful book, by the Seine, as a little gift.'

Money was always short at Magnum, partly because Capa was in the habit of treating the office like a private bank from which he could borrow for any reason, whether it was to fund an assignment for a photographer or to enjoy a day at the races or to entertain a girlfriend to a fancy lunch or finance his evening's poker. The petty cash was kept in a small tin box and the key was kept by Suzi, a pretty cousin of Capa's who worked in the office. Unfortunately anyone, including Capa, could open the box with a nail file, and he invariably helped himself before he went to the racecourse. If he won, he would put it back; if he lost . . . well, who was going to complain? On the rare occasions money was flush, Capa was quite capable of pushing a $100 bill into the hand of one of the girls in the office and telling her to go off and 'enjoy yourself'.

'Capa was an incredible person,' says Inge Morath, who joined in the early 1950's, 'totally unforgettable even if you only met him for five minutes, a real *force de la nature*. He didn't put on any airs and was quite vulgar occasionally, but he had a generosity I have seldom seen in human beings. He would give you the shirt off his back, but in return demanded a lot from you and if you didn't respond, then forget it. Maybe he would take all your money, but he would always explain just why he needed it and would give it back later. Nobody minded.'

Maria Eisner claimed she lived in constant fear that someone like Cartier-Bresson, away in the Far East and sending back pictures regularly, would suddenly demand to be paid when there was no money in the kitty. She imagined having to tell him that Capa had 'borrowed' all the fees he (Cartier-Bresson) had been earning for the past six months and quaked at the possible consequences. Capa suffered no sleepless nights over such an eventuality. When Pierre Gassmann, who did all the printing for the Paris office, told Capa that he needed the $400 he was owed by Magnum in order to pay his staff, Capa blithely suggested he could make at least $400 by putting his money on a horse racing at Longchamps that afternoon. Gassmann demurred, but Capa made the bet anyway and won enough to pay the printer. It would not be the first, or the last, time that Capa rescued Magnum with his winnings at the track or at a poker table.

In fact Maria Eisner's worst nightmare did come true. Cartier-Bresson did ask for some money: 'When I came back from India

after three years there, I had some money due to me from books and I said to Capa I need it. He said "Why? Your wife has got a fur coat, she doesn't need a second one. You don't like cars, what are you going to do with the money?" You see, that was the sort of relationship we had. I had the idea to buy a house, for a very cheap price, which needed a lot of work and I told Capa that was why I needed the money. He said "I've taken your money because we were practically bankrupt." I said "Oh you could have warned me." He said "Don't jiggle like a frog. Come on, Preminger is making a film, you go and shoot pictures of that film." How could I get angry? Money was not the problem between us. We had to live and he was gambling, providing work. It was always like this.'

In October, 1949, a shadow was cast across Magnum when a cable arrived from George Rodger in Cyprus. It said, simply: 'My darling wife Cicely died today and the baby too.' Cicely Rodger and the baby had succumbed to complications during the birth. Rodger was, of course, devastated and was unable to work for several months. His friends in Magnum were loving and supportive, but there was little they could do apart from wait for his grief to dissipate. When he was finally ready to work again he showed up in the New York office wearing a Basque beret and a long cape that looked as if it had been liberated from the Foreign Legion and accepted an assignment for a story in Haiti. It was the beginning of a long healing process which would end with his falling in love with the young woman who accompanied him as a researcher – Jinx Witherspoon. 'I had corresponded with him for two years on the "People Are People" assignments in Africa, India and Egypt and so I was writing to him all the time. His letters back were absolutely fascinating, because he wouldn't just discuss the job but what the country looked like and the people and the problems he had getting to places – quite riveting. So when he came over to New York to join the Magnum people for the first time he walked into the 21 Club wearing a Basque beret and a great French Foreign Legion cape. He was very much the glamour boy and I was hooked.'

Capa, meanwhile, was trying to capitalise on the success of the 'People Are People' project with another global assignment he called 'Generation X', which was designed to compare and contrast the post-war generation around the world. He explained it like this: 'It suddenly struck me that something called the half century was impending. At Magnum, most of us were close to our forties, which is just about the half way mark in the life's span of a human being. So we congratulated each other on our exceptional luck in being able to spend our lives in two so different halves of this great century. We

talked about expectations we had when we were 20, and we found out that although the members of Magnum came from different countries, our hopes as 20-year-olds were very similar – but very different from what has happened since then. From there it was only one step to think of the ones who were reaching their 20th birthdays at the half-mark of the century, and who have reasonable hope of living through the second half of it, and of celebrating the year 2000. We named this unknown generation the Generation X and even in our first enthusiasm we realised that we had something far bigger than our talents and our pockets could cope with. Still, we were deciding to spread around the world and choose a young man and a young girl in each of 12 different countries, on five different continents, and try to find out their present way of life, their past history, and their hopes for the future.'[8]

He sold the idea to *McCalls*, who agreed to provide a substantial advance. This time Capa was determined that the entire project would be handled exclusively by Magnum photographers and it thus became imperative to recruit more new members to join Haas and Bischof, who had finally decided to throw in his lot with Magnum. So it was that when a young woman called Eve Arnold nervously showed up at the New York office with a portfolio containing just two stories – a fashion show in Harlem and an opening night at the Met – she was immediately invited to become a 'stringer' – a freelance contributor – for Magnum. She was followed by Dennis Stock, who had won a *Life* competition for young photographers with a startling set of pictures of East German refugees arriving in New York. 'They were being subjected to all sorts of interrogation: were they Communists and this and that,' he explained. 'It was a very strange kind of setting; McCarthy was in the air. Old ladies were being asked if they were committed Communists! So the photographs expressed that, I guess, and the *Life* editors chose me as first prize winner. After that Bob Capa invited me to Magnum.'

After Stock came Erich Hartmann. While delivering pictures to another company in the same building, he got out of the elevator on the wrong floor and found himself facing a door marked MAGNUM PHOTOS INC. He recalled that the previous Sunday the *New York Times* magazine had published four or five pages of pictures of the St Patrick's Day parade credited to 'Henri Cartier-Bresson, Magnum', and so on an impulse he walked in.

'Smiling at me was this nice lady who turned out to be Maria Eisner and who spoke to me in this lovely Berlin accent, so I knew I was speaking to a fellow German and fellow refugee and we began chatting. I told her I was a photographer and was interested in

Magnum and then I met Capa who said to Maria "Well he doesn't know much, but I think we can do something with him.' I was allowed to hang around the office to see the way photographers worked and what they thought of the world and I realised that what they were doing was not just descriptive pictures of wherever they were. They were making a comment on what it was they were looking at. They were saying: I've been here and I've looked at that and that's what I think about it."[9]

Erich Lessing, an Austrian photographer working for Associated Press, was recruited in Paris by Chim, bringing the total number of Magnum photographers to ten. Arnold, Stock, Lessing and Hartmann would all still be with the agency fifty years later. Lessing was born in Vienna in 1923, son of a dentist and a concert pianist, and learned photography as child. When Hitler occupied Austria most of the family fled to Palestine, but Lessing's mother opted to stay behind. She died in Auschwitz. Lessing worked as a camel breeder, taxi driver and beach photographer before joining Associated Press. He needed no convincing of the need for Magnum. 'Around 1950, during the first session of the Council of Europe in Strasbourg, I did some photography and returned full of excitement about what I had seen and heard there – from Schuman, Adenauer and Jean Monnet. I was inspired by the vision of a New Europe in a new peaceful world. When I saw the picture ready for printing in *Quick* the caption was absolutely anti-European. I shouted out so loudly on the first floor of the picture department that the editor-in-chief came down from the third floor to see what the trouble was. In the discussion that ensued my standpoint was accepted and the caption was re-worded objectively in keeping with the occasion. These and similar experiences were the reason for the founding of the Magnum agency: we knew we were good enough not to have anything forced on us.'[10]

At first Capa did not seem in the least daunted by the prospect of organising assignments for nine other photographers, coaxing the best work out of them, chastising them when stories were not up to standard, fighting for their rights when editors misbehaved. 'Bob was the ideas man, the promoter and the salesman,' George Rodger explained. 'Project after project poured from Bob's fertile mind and our tiny office in the Faubourg St Honoré was where his ideas were sifted by the rest of us ... All the time he concentrated on promoting and encouraging the individual likes and leanings of each member; such as my ventures into Africa and my love of the wild, Ernst's fascination with movement and colour; Henri's ability to turn the most mundane subject into a work of art, and never would Bob

or any other member take an assignment for himself if he thought another more fitted to carry it out. That was our true brotherhood.'[11]

While he was usually affectionately characterised as warm and flamboyant he also had a ruthless streak inasmuch as he would move heaven and earth to get what he wanted and always considered that the end justified the means. 'Ask ten people what they thought about Capa,' said someone who worked with him at that time, 'and you'd get ten different answers. He could be a wonderful friend but he could also be a complete bastard.'[12]

'Whenever he wanted to give you hell about lousy pictures or a story not well done, he took you down to the pinball machine,' said Erich Lessing.

I was in Turkey doing photographs for the Marshall Plan when I got a cable from Capa saying 'LOCUST INVASION PERSIA. YOU HAVE LIFE ASSIGNMENT. GO.' I finally got a visa and went. I only found out afterwards that we didn't have a *Life* assignment at all, that Capa had said if Erich comes back with some pictures, I'll get him into *Life*. Then I had an idea for a story on Germany. He said okay, do it, but you need some backing. You have a *Look* assignment. I said how come I have a *Look* assignment? He said, if I tell you you have a *Look* assignment, you have a *Look* assignment. I had a *Look* assignment.[13]

Even the cautious and pragmatic Werner Bischof had fallen under Capa's spell. In April 1950 he wrote an enthusiastic letter to his wife, Rosellina, after a meeting with Capa in London: 'It is Thursday night, and Capa has returned to Paris after a lengthy and satisfying conversation. Sometimes he is like a father when one is alone with him. [Actually, there was only two years' age difference between them.] Spooner, he and I had lunch together and talked a lot. Afterwards I drove with Len Spooner to the office. Tomorrow I start working on my first story for *Illustrated*, which wants a whole series from me in the coming weeks. The first story will be on a hospital in the East End of London, which stays open 24 hours a day and where you meet all types of people and all sorts of diseases and accidents. I shall work mostly in the Accidents Dept, and try to present a gripping contrast between the dark, sleeping city and the bright, helping atmosphere in the hospital.'[14]

Eve Arnold liked to describe Capa as her 'photographic university' and she would spend hours studying his contact sheets, image by image. 'At first I was puzzled: the pictures were not consistently well designed, he wasn't persistent in pursuing an image the way Ernst

Haas did – beginning before the action, following through to the peak of the action, then tapering off – nor of making the single, formal, definitive photograph like Cartier-Bresson. He got to the core of the situation, but in his own idosyncratic way.

I didn't understand his work until I met the *New Yorker* writer Janet Flanner later in 1950. She put things in perspective for me. Since I was a Magnum photographer did I know her friend Robert Capa? Yes. She talked glowingly about his courage, his intelligence, his understanding of world affairs. She talked and I listened. Noticing my silence, she started to probe. I blurted out that I thought his pictures didn't design well. She looked at me pityingly. 'My dear,' she said, 'history doesn't design well either.'

I began to understand that the strength of his work was that just by being there, where the action was, he was opening new areas of vision. All good journalism tries to project the message with immediacy and impact and he was aware that it is the essence of a picture, not necessarily its form, which is important.[15]

As a photographer Arnold was dauntless and made no concessions to the fact that she was a woman, and a rather small woman at that. As a white photographer, she would have cigarettes stubbed out on her at a Black Muslim rally and as a Jew she was told that she would be turned into a bar of soap at a Fascist rally. She remained unperturbed. It was typical of Arnold that one of the first assignments she chose to carry out for Magnum was to photograph Senator Joseph McCarthy, who was sending shivers across America by whipping up anti-Communist hysteria during the hearings of the House Un-American Activities Committee. When she mentioned it to Capa, she was very surprised by his reaction. 'I can't tell you why I am going to ask you not to do this,' he said, 'but please don't do it now. I'm going to Paris and I'll let you know from there if I think you should proceed.' Only later did she discover that Capa was worried he would lose his passport if he was accused of being a 'Commie', although he later telephoned her from Paris and told her to go ahead.

Arnold arrived in Washington on the day Dorothy Parker was due to testify. 'She didn't show up and her lawyer sent a cable saying that she had amnesia and she wouldn't make a good witness. But I remember seeing an old couple there who were absolutely terrified of being interrogated. The sense of fear was palpable and when the hearing broke for lunch McCarthy had a press conference. I was there, photographing the press conference, and afterwards, because I

was the only woman in the group he came over and put his hand on my shoulder and said "Are you getting everything you want?" My instinct was to brush his hand away but I realised I had to play his game, so I stood there for a split second and then said "Excuse me, Senator, but I really have to go to work." Some newsmen were watching me and when we went downstairs for lunch I went over and sat at the press table and nobody would talk to me.

'McCarthy was smarmy. One day he played the piano for me, but wouldn't be photographed doing it. There was a kind of benighted charm about him, somebody trying very hard to be gracious. He came across as quite a ladies' man, I found, not what I expected. I expected a kind of nasty, rough, tough vulgarity, but he was actually quite soft spoken and clever in the way he projected himself.'

In 1951 Inge Morath moved to London, after marrying an Englishman, and started taking pictures for herself. 'After I had sold a number of my pictures and stories to various magazines, I returned to Paris and showed them to Capa. "OK," he said, "now you can join us as a photographer." I took any work I was offered. Since I was the greenhorn, mine were the smallest jobs. I started with a story for $100, about elderly gentlemen judging roses in the Parc de Bagatelle.

'I also continued to do research for other photographers and to edit their contact sheets, an excellent visual training. I learned most from the contacts of Cartier-Bresson, who photographed with extraordinary economy and precision. He made me look at images upside down, the way painters do, to judge composition. Capa, who was quick to recognise the potential in people and to challenge them to bring it out by themselves, sent me on assignments that varied from photographing a movie set to shooting a story on a Spanish woman lawyer, to working as an assistant to Cartier-Bresson. Before sending me off to Spain he said that I should also work at getting myself dressed like a lady. I took his advice, and my reward was the look on his face when I showed up in my first Balenciaga. It was still a long time before I would move out of my one and a half room digs, where a gas stove stood conveniently next to the tiny bathtub (just big enough to sit in), so that I could cook breakfast while getting washed. There was no storage room, so my suitcases, covered with borrowed rugs, served as a second layer of flooring.

'The people who worked in the Magnum office were of various ages and specialities, but all were enthusiasts. Monsieur Ringard and Georges Ninaud and Madame Presle in files, administration and accounting were older; editors varied in age, but I remember mostly young women, attractive and efficient, Hungarian like Capa and

English and American; and there was a flow of researchers who were mostly Americans trying to make a living in Paris for a while. Lunch was often prepared in the apartment kitchen, although on more affluent days we would go to a small bistro around the corner. The café downstairs was the most important meeting place. There trips were planned and jobs were discussed and distributed while Capa attacked the centrally positioned pinball machine. 'Capa was the boss because, for one thing, he kept on the lookout for stories for all the Magnum photographers. But equally vital were his experience, generosity, connections, aggressiveness, and the vision he had for Magnum, which kept us going. Since few of us were married, we had much time to spend together. We talked a lot, but rarely about photography. Our discussions were more often about politics or philosophy or racehorses, pretty girls, and money. We constantly looked at each other's work, and criticism could be tough if the work did not measure up to the expected standard. We had an immense appetite and desire to show the world as we saw it. I think there were some quite moral ideas too, that were coming out of the war: we really wanted to make the world a better place.

'Paris was our base, a beloved city. We could live as cheaply as we pleased, slum it or go to the most chic parties as Capa's friends, or on our own, as our work began to open doors. Every so often, generous, nice people like Irwin Shaw, businessman Art Stanton, or film director Tola Litvak passed through Paris and invited a group of us to dinner at an expensive restaurant. We went to the races at Longchamps. Capa regularly got hot tips from the concierge at the Hotel Lancaster and the rest of us bet a little, putting our occasional winnings back into the brown Magnum kitty if it needed it. It usually did.'[16]

Jinx Witherspoon has similarly fond memories of Magnum's early years in New York: 'We did quite a lot of socialising in those days. We'd visit the Algonquin and discuss photography non stop, pictures, travel, ideas and we would go to Julia's [Capas mother] for Hungarian suppers. Cornell came too. He was the little brother, a darkroom boy for *Life* for a long time, and suddenly started taking pictures himself.

'People didn't pay much attention to Cornell in those days because Bob was the great charmer and Cornell was quieter and struggling along. There were a lot of socialising lunches, two or three Martini lunches at the Algonquin, the 21 Club and Toots Schor. Capa did lead a very glamorous life, but he was usually broke. I don't think he ever had much money in his pockets, and few assets

as far as I could see. Julia had an apartment on the East Side, but he didn't live with her; he lived in hotel rooms.

'It was good for *Ladies' Home Journal* to have Capa; he had the most amazing friends – Hemingway, Irwin Shaw, Steinbeck, Picasso – and he always brought us ideas. A lot of them were foolish and probably over our heads financially, but some of them weren't. When he came into the office I think that I, like every other girl in the world, fell for him heavily. He had "bedroom eyes" and this wonderful Hungarian accent. He'd been everywhere, done every-thing and was glamorous, charming and aloof. I can remember sitting in a taxi with him, going to Julia's for supper, and I kept thinking "I wonder if he is going to hold my hand?"'

Werner Bischof, meanwhile, had set off on what he would describe as a 'grand tour' of Asia and the Far East. Like the best Magnum photographers, Bischof alternated between despair and anger at the superficiality and sensationalism of the magazines for which he worked and an idealistic, if perhaps naive, belief that his pictures were capable of changing the world, that by confronting misery and injustice with his camera he could provoke action. Misery he certainly found in India, as he explained in a letter to Rosellina from Bombay:

> I was prepared for poverty, for all sorts of things, but the hovels and dirt along the streets are beyond description, and the stench makes one want to vomit. I'll really have to pull myself together if I want to work well. On Monday, I start with the 'hunger story' [a serious famine ravaging the province of Bihar]. No easy task, for the government does not like evidence of this. I don't think anyone can avoid looking at these pictures of hunger, or that in time anyone will be able to ignore all my pictures. No, definitely not; and even if just a vague impression is left each time, in time this will create a basis that will help people distinguish between what is good and what is objectionable.[17]

Bischof's 'hunger story' was published in *Life* to great acclaim and prompted a letter of congratulations from Edward Steichen, the curator at the Museum of Modern Art in New York, who assured him that politicians would be forced to act. Steichen was right: Bischof's pictures so pricked the conscience of America that the US Congress was stirred to make a large appropriation of surplus wheat to help alleviate the situation.

Bischof was, of course, delighted, but he continued to struggle to reconcile the demands of art and those of conscience. 'In the last few

days I have been thinking a lot about my work in the context of my long trip,' he wrote from Calcutta.

What I see everywhere here with my own eyes and what impresses me is worth keeping a record of. But there is often something static about photographs that are not purely aesthetic, not so-called 'beautiful' photos, and one runs the risk of becoming detached from the colour and excitement of life to compose perfect pictures. I can't see any justification for my trip here and now, unless I am living entirely in 1951 and seeing people through the eyes of a man of this time. Granted – but why not take beautiful photos of a human story with a positive side? ... I believe we have a duty to tackle problems from our point of view with great concentration and judgement and shape the picture of our generation.[18]

While Bischof was away on his 'grand tour', George Rodger and Jinx were slogging across West Africa on a project financed by the Marshall Plan, the US-sponsored economic recovery programme that had been so successful in Europe that President Truman had extended it to assist underdeveloped countries. Rodger's brief was to photograph Marshall Plan projects and sell his pictures to US magazines to show the American people how well the money was being spent. The problem was, as George and Jinx soon discovered, that the money was being wasted everywhere. 'It was a horrendous job,' Jinx recalled, 'terribly, terribly frustrating and not at all glamorous, but at least it introduced me to political Africa. We flew from Brussels to Libreville in the Congo and were not well received by the colonial governors in spite of our impressive US credentials. We were treated with suspicion, as if we were spies sent to discover where all the Marshall Aid money had gone, what had happened to all the fantastic schemes to modernise Africa. But once we were in the field, which in tropical West Africa meant jungle or impenetrable forest, we were welcomed and feted. Visitors from abroad were an excuse for a party. Our biggest problem was the midday meal. All work stopped at noon and lunch in the bush consisted of five or six courses, each accompanied by its own special wine, everything flown in from France, of course. Pineapples could be growing all around us, but the pineapples we were served came from imported tins. And, as lunch stretched on into the late afternoon, our frustration grew as there was nothing to photograph but sleepy bearded men in tatty shorts lounging around a camp table loaded with plates, glasses and bottles. We soon learned to rise at dawn and

take all our pictures before the midday meal. As we moved from one steamy site to another in the Gabon, the Cameroons, Oubangui-Chari, French Guinea, Senegal and Sudan, I gradually became used to the bugs and midges, leeches and spiders, and all the creepy-crawlies that were our travelling companions. In the Gabon we were doing a story about the building of a new road into the interior, the Crystal mountains. There were about 100 kilometres of marshes and forest and swamp and no foundations whatsoever to build a road, nothing. It was all mud and thick jungle. We were staying with the governor in a little guest house. They had had 100 governors of the Gabon in 100 years, that's how popular the job was, and this particular governor certainly didn't like us and treated us like spies. At dinner on the first evening George said "All right, we have come here to photograph this wonderful road. Tell me, what are you going to find when you have built this road?" and the governor said "How do we know until we get there." It was a road that went nowhere and thousands of dollars were being spent on it. The equipment arrived and rotted on the beach because no one knew how to use it and there were no spare parts. It was a fiasco.'[19]

The highlight of the six-month trip came when they were working not far from Albert Schweitzer's hospital in Lambaréné and he invited them to visit. He sent several dugout canoes to collect them and the twelve pieces of luggage containing all the camera equipment. The canoes were rowed by lepers, some with no toes, some with no hands, one with only half a face, and Schweitzer was waiting on the beach to greet them with a jaunty 'Ah bien, bienvenues le Plan Marchemal!' They stayed with him for two weeks and Rodger forged a strong bond with the good doctor, who would receive the Nobel Peace Prize within twelve months. 'He and George really hit it off,' said Jinx. 'People would later try to make out that Schweitzer was a nasty man, very Germanic and pro-war, but we found him to be absolutely delightful and his theories about Africa were very good. His hospital was very primitive – no electric light, he had to operate by the light of paraffin lamps – but beautifully organised. He grew all his own food and veg and had incredible recipes for native vegetables. He gave us one of his huts and George did a big shoot which was published all over the world.'

Rodger's Marshall Plan pictures were less successful, to judge by a long, chiding letter from Capa addressed to him care of the Political Residency in Kuwait and dated January 1952. Capa spared no one, not even a respected founder member of the agency, when he felt the work was slipping and he basically told Rodger that his pictures were simply not good enough to titillate American editors. Capa

might have been particularly irritated because he had sent a cable to Rodger while he was in West Africa suggesting that he break off from his Marshall Plan assignments for a couple of weeks to photograph Humphrey Bogart, who was making *The African Queen* in the Belgian Congo. It would have been a lucrative assignment both for Rodger and for Magnum, but Rodger ignored the proposal, largely because he had no interest in movies. Indeed, when Capa's cable arrived he turned to Jinx and inquired: 'Who is Humphrey Bogart?'

Bischof was also under pressure from Capa, who was complaining that Magnum now had 'far too much material' on India. As a result, Bishof moved on to Japan, from where he made his first trip to cover the war in Korea. It was not an assignment he much enjoyed, judging by his letters to Rosellina:

We were a group of eleven correspondents from all parts of the globe that took off across the sea in a four-engined plane on the morning of July 5th, bound for Korea. Five hours later we landed in Seoul. The sight of the city was horrible, like Germany after the war, no house spared. The only illuminated block in these ruins was the press centre, hundreds of journalists. They looked to me like 'vultures of the battlefield'. The press centre shines until black-out like an oasis in the desert. The doors of the small offices bear the titles of the greatest newspapers in the world, *New York Times*, London *Times*, *Time-Life*, all the agencies like Reuters, Agence France Presse, Associated Press, United Press, just to mention the most important. Censors work through the night, teleprinters and telephones are busy all the time, and the constant arrival of couriers keeps all but the dead-tired awake ... The perfected, mechanical way America fights war is incredible: I have never seen anything like it. We drove four hours to the front in a jeep, and in the last two did not see a single Korean. Now to my work as such. My theme is: 'What happens to the civilian population in the battle zone?' Each unit has its own group of people to help the civilian population; in addition, some Koreans are also used, as helpers, interpreters, etc. I talked to the colonel in charge of this section, and he was delighted that I was particularly interested in this matter. He felt all reporters came to Korea only to send sensational accounts from the front.

Bischof accompanied troops to the village of San Jang Ri, in dense jungle just north of the 38th parallel, to observe the forced evacuation of the inhabitants to a refugee camp. 'Our interpreter

explained to the women that they should get themselves ready, but they said they were staying and would like to die there in their own houses. In front of a hut, in bright sunshine, I see a little living skeleton, a girl, absolutely covered in flies. Her mouth is half dried up; the soldiers trickle one drop after another through a rolled leaf into it, as our little girl lies naked next to her brother on the stretcher. Returning to the camp, we pass huts on which North Korean patriots have scrawled ideographs: "Maybe you think this has something to do with the United Nations, but everyone else knows that Washington has stolen the UN flag and draped it round your soldiers to conceal its real motives." Our little girl died shortly after arrival and was buried next to the refugee camp. The intern made a cross of wood and affixed the badge of the United Nations.'

Bischof thought his 'forgotten village' story was a powerful antidote to the gung-ho 'This Is War' pictures being shot at the front by the likes of David Douglas Duncan, who was making his name as a war photographer in Korea, but Capa cabled from New York that it had not sold well because it was 'too soft'. *Life* had long since given up the tradition of investigative reporting on which it had been founded and was only really interested in authentic on-the-spot action pictures that indicated the war against Communism was being won – it certainly had no inclination to publish a story on the suffering of the wretched civilian population. Bischof was furious. 'I must tell you I am thoroughly *irrité* at the moment,' he wrote to Rosellina. 'This military story gives me the cramps, and I'll tell Magnum once and for all that I'll not do such things again. I can't share Haasi's well-meant advice that one should try everything. There is only one reason: you cannot tell the truth.'[20]

His irritation with Magnum increased when he got back to Tokyo and discovered that the New York office had sent a bundle of tearsheets from *Illustrated*, *Epoca* and *Frankfurter Illustrierte*, all of which had published pictures he had taken in Japan, but none to his satisfaction. He immediately dispatched an angry letter to Capa, as if it was entirely his fault: 'In at least six cases the pictures have been badly cut, the texts mixed up or the pictures put the wrong way round, so that the Japanese writing and the interior as a whole is out of keeping with Japanese tradition. In future I want a stamp on every photo, as Cartier's pictures have, to say that it may be reproduced only with the original legend and without any cropping. That seems to me the only way to deal with the bad taste of many editors.'[21]

Despite his intention to tell Magnum 'once and for all' that he would do no more 'military stories', Bischof would make two further trips to Korea without ever resolving his differences with the

editors working with his pictures back in New York, or in the capital cities of Europe. As he confessed in his diary:

> I sometimes wonder whether I have now become a 'reporter', a word I have always deeply hated. I think that the concentration I used to put into my material has now shifted to the human aspect, and that is far more complicated because you can't plan it. In addition, I am concentrating on achieving the strongest possible statements by arranging and combining pictures. The worst part is that I can't get a satisfactory result from any editor, that basically it is the importance of the event which counts, rather than the way it is perceived.[22]

Ernst Haas had rather different ideas from his colleagues. He was not interested in photographing the shaky political world about him; he wanted to follow his own instincts and convey the world as he saw it. Haas was among the first to experiment with colour film, then a rarity. In the summer of 1952 he wrote to Capa: 'I am at work on an experiment with colour in New York. The results up to now are very much to my liking and I am very critical. The story is difficult to explain. Often it is only colour in the frame, details, walls, abstractions, compositions of insignificant things. You will be very surprised . . .' Actually, everyone was surprised. Haas had by then been living in New York for over a year and his unique vision of the city, capturing reflections in windows and puddles, floating flags and tattered posters and brightly coloured close-ups, would cause a sensation, moving photography into the precincts of Abstract Expressionism.

Inge Bondi recalls meeting Haas when he first arrived in New York: 'I remember Haas, a slender, lightly-stepping young man with a shock of hair that rose like cascades in a Chinese landscape. He entered the world of the grey flannel suit wearing a beige corduroy jumpsuit modelled on Winston Churchill's practical siren suit. Haas donned this for action. It had ease for bending down and photographing from the knees, and it had stretch for lifting his arms up high to photograph (then still mostly with a Rolleiflex) over his head, when there were crowds in his way. Haas had added to the Churchill practicality his own patch pockets over breast and hip for rolls of film, exposed and unexposed. The beige jumpsuit was custom made, probably his only one. It was like everything about Haas, a quality product carefully designed and functionally constructed.

'When he first came to New York and wandered the streets with

frustration, he complained he could not get the skyscrapers into his lens. There were five long months of non-shooting. Money ran short, Haas moved in with a photographer friend, Dennis Stock, and a kitten was all there was for cuddling. An assignment came in New Mexico for a Robert Capa conceived Magnum project [Generation X]. Haas suffered photographing co-operatively for a project, instead of for himself, but it opened unforeseen doors and he came back with pictures of surreal landscapes, new moons attached to earth in place of sky, Indians dancing, sun rays bursting through clouds, sold them to *Life* and with the proceeds purchased colour film to start photographing New York.'[23]

Haas's New York pictures were published in an edition of *Life* in 1953 with the following glowing introduction 'The many moods and marvels of New York have long captured the eye and challenged the imagination of artists. Although its landmarks have been recorded in countless ways, new discoverers are always finding fresh magic in the city's images. Wandering about New York daily for two months, Haas studied its vaporous views, polychrome patterns and shimmering reflections and photographed them so as to make the real seem unreal and inanimate forms come to life.'

Life usually only allotted eight pages to colour pictures, but for Haas they cleared twenty-four pages in two successive issues, establishing colour photography as the new mode of expression for photo-journalists and helping to overcome widespread resistance to colour photography as an art form.

LETTER from Robert Capa to George Rodger, addressed to The Political Residency, Kuwait, dated 16 January 1952:

Dear George,

I have been intending to write for the last six weeks, but not only was I constantly harassed but every day something new happened to postpone my letter . . . Altogether my trip was highly successful. I think I succeeded in clarifying and co-ordinating the functions of our two offices and I also succeeded in straightening out relations with a few magazines who had closed their doors to us in the last years . . . At the last moment I sold GX [Generation X]. All this meant lots of hustling because New York editors are stupid and scared and it takes five people to be seen at the same magazine before you can straighten out the smallest matter, for which finally they pay a ridiculously low sum.

I tried to get you assignments but assignments will come only if you stay there long enough and if your stuff is provoking enough so that even if the editors are not taking the story you do, they will give you an assignment on another one. You twice mention in your letter that your stuff should be shown to *Life* because they had a photographer working in your area . . . this is useless. *Life* will not buy anyone's story on a feature subject when they have their own photographer in the area. This is definitely Thompson's [*Life*'s managing editor's] policy, although we have straightened out relations so that when they do not have someone they will give us assignments much more easily than before. But even for this our stuff has to improve in quality. Often a story is quite sufficient for Europe but not so for US magazines, which have less space and less interest in the subject. Any story without newsworthiness or drama or exceptional photographic quality is half dead on arrival. I was present when your Christmas story arrived. The subject was too late for most US magazines and too literary. The photography was good but again, not exceptional enough to bowl anyone over who did not plan on the subject himself. It certainly will be sold, probably for Easter and probably not exceptionally well. This same story sold well in Europe where editors are not only hungry but they can quickly realise how to lay out and how to use a subject.

In New York I received your refugee text but only saw the pictures here. Against my better judgment I talked, as you asked, to Thompson about it, but he has had a piece from Jim Bell on the same subject not long ago so he was not especially interested. The text piece, not because I am not in agreement with it, is the best example of what you should not do. No magazine will print editorial conclusions instead of reporting. Eighty per cent of your piece was

ponderous, general and editorial, in the sense that columnists are editorial. I know that you felt very deeply about the subject and if you wanted to put your point over it should have been far more disguised – in fact, conversations, colourful bits and pieces, etc. But the worst part of it is that where your text was full of misery and drama, your pictures showed a fairly peaceful and nearly contented camp, certainly far more orderly and clean than the camps on the other side. So the two of them did not go together at all. Indeed the opposite, a relaxed text with very measured understatements and more dramatic pictures would have done the job . . .

I hope you will not interpret my criticism wrongly. I have fallen into the same mistake when I was far away, isolated and impressed, more than often, and I guess it is better to tell you so rather than let you go on repeating yourself. Also I shiver to think how opposite your ideas may become as soon as you move a few hundred miles away, in another, or any, of the neighbouring countries.

'So, generally, more drama in the black-and-white and lots of colour where colour is, is the first rule. The second is: that when Suez and Teheran are burning, the quiet middle between the two is not going to excite editors very much. If you want to do sad stories you have to get nearer to the news. A Suez story today would be worth five of your dead ones, assigned or not. The part of the world where you are is in the headlines, except for the part where you are moving yourself. There may be plenty of difficulties and sometimes it may be impossible to get the exciting part but you should get at least some of it and some of it would be enough . . .

Otherwise everything is going fine. The offices are far better organised and more peaceful than ever. The guys are all producing and the outfit is beginning to make sense. It would be terribly important to us that, during the year, we produce our best material and that each one of us does a few striking stories . . .

5

The Decisive Moment

VISITORS TO Magnum in the early 1950s, either to the scruffy New York office on 44th Street or the Paris office in Maria Eisner's old apartment on the rue du Faubourg St Honoré, rarely failed to be impressed by the sheer vibrancy of the place, the enthusiasm and dedication of the young staff, the heady mix of business and pleasure, the sense of being in the centre of the action, with cables received from, and dispatched to, photographers in far-flung and exotic corners of the world. In either office you were likely to run into an eclectic mix of Capa's friends – people like Hemingway, Steinbeck, Irwin Shaw, John Huston or Humphrey Bogart – who drifted casually in and out. If you were particularly lucky, you might run into Capa himself and be swept off to a long and noisy lunch, or to the racecourse, or to a party.

Nothing was ever as anticipated. A young photographer who arrived to show his work in the New York office, expecting to find a glamorous organisation, was confronted with a barefoot girl in jeans chewing gum at the switchboard, a narrow hallway lined with bicycles and a man sitting on the floor against one wall meditating. Convinced he was in the wrong place, the young visitor took the elevator back to the ground floor and started again.

'There was a certain yeastiness about the place,' Eve Arnold recalls, 'a sense of excitement that I have never felt before or since. We showed each other our pictures, talked, asked for advice, told each other what we were doing. It was really quite wonderful. Nobody really quite knew what was going on and we did things we wouldn't have the courage to do now if we were starting out. Nothing was fixed, nothing was formalised; you didn't know it shouldn't be done, so you did it. There was never enough money, never enough assignments to go round, never a certainty as to what we were trying to achieve. When things got tough, Capa would

throw a party. I remember one big party at the Algonquin. I think we were $5,000 in debt, so Capa spent another $5,000 on the party. Every editor in town came – and there were a lot of newspapers and magazines in those days – and he managed to generate enough business to cover the cost. Sometimes we'd go even further into debt, but nobody ever worried about it: you just went right ahead and did things. Capa would spend the whole night playing poker with the editor of *Holiday* magazine, and the man would have lost $1,500 and then in the morning Capa would turn to him and say "Listen, I've got this great idea for a series . . ."'

Nostalgic recollections of the carefree early days of Magnum tend to gloss over the continuing crises and internal dissension inevitable in an organisation made up of free-spirited, independent and sometimes temperamental people. In 1951 Capa had decided that Maria Eisner would have to go. She had made the fatal mistake, in Capa's eyes, of becoming pregnant and thus he felt she could not give the office her full attention. The luckless George Rodger, temporarily returned from Africa, was deputed to break the news to Eisner and arrange her severance pay. Capa, meanwhile, assumed the presidency, but quickly became bored with the amount of administration involved. In the spring of 1952 he resigned and asked Rodger to take over in an acting capacity until a vote could be taken on a permanent replacement.

'George hated being president,' said Jinx Rodger. 'He was pushed into it and it was very difficult for him. In a funny way, George was a bit of a loner, never terribly happy in crowds. He didn't like people shouting about what Magnum should do and shouldn't do. He would get very upset over the latest Magnum catastrophe and there were always, always catastrophes, which we found out about two or three weeks later when we got letters from the office. There was always something happening – hiring somebody, firing somebody, a job falling through, or we were broke. The French office was always having a *crise* – Henri was making a fuss about something or "Henri has gone over the top again". It upset George considerably. Henri and George always got on although they were opposites – the hysterical Frenchman and the quiet Englishman – but they didn't see eye to eye on Magnum business: nobody did.'

When Capa resigned he asked everyone to write to Rodger with their views about the future direction of the agency, a request largely ignored, to judge by Rodger's tart first circular letter, dated 26 April:

> He [Capa] asked you all to write to me personally. None of the
> photographers has done this except Fenno Jacobs [then a Magnum

stringer]. In the meantime, letters keep coming in to Capa from all of you and he has asked me to let you know that he will not be replying to any of them, either official or personal. They are, at the moment, all in my possession. However, I do not feel that I can undertake to represent you all unless I have your authority. Therefore I shall not be acting on any of the contents of these potentially controversial letters until I hear from you ... I would also like to point out that I can only accept this office on a very temporary basis. I have no desire whatever to run for Magnum presidency on a permanent basis and I make this offer merely to avoid a crisis and to help all of you make your individual voices heard.

There followed a veritable blizzard of letters with every kind of grievance being aired and virtually no agreement. A memo circulated from the New York office added to the general confusion and despair by claiming that Magnum was 'split down the middle'. Money, as so often, was at the heart of the problem. In New York such was the muddle that the advances and expenses drawn by photographers had been allowed to soar to more than $22,000 and had so enfeebled Magnum's bank account that one week it was no longer able to pay out the money owed to other members.

During the first week of June 1952, Capa, Rodger, Chim and Cartier-Bresson met in Paris to discuss how to bring order from chaos and how the crisis might be solved. Provided with detailed analysis of the figures from both offices, one of the problems soon became clear. From early on, Magnum had accepted 'stringers' – freelance photographers with no formal connection to the agency – but the stringer situation had been allowed to get completely out of hand – there were thirty stringers on the books of the New York office and almost fifty operating out of Paris. And while members were contributing the lion's share in commissions in both offices, stringers were taking up between 60 per cent and 70 per cent of the office time. The figures were telling: Magnum's commission from members in Paris amounted to 4,417,859 francs as against only 1,250,208 francs earned in commission from stringers. In New York members contributed $20,553 in commission as against $8,815 from stringers. Indeed, stringers were receiving such a good service from Magnum and paying so little for it that some members were talking about resigning from full membership and re-joining as a stringer.

As George Rodger pointed out in a letter to members dated 7 June, the figures 'don't make an awful lot of sense':

In our growing years we accepted stringers to augment Magnum's income and to create a sort of stable from which we could draw possible and future Magnumites. But this has got out of proportion now and we find our stringer service so considerable that, not only do stringers want to become stockholders [members] but some stockholders are saying that they want to become stringers. It puts a tremendous burden on our staff for small returns and the stockholders themselves suffer by not getting full efficiency in service for themselves for the organisation they created. Our staff must not be overwhelmed, at the cost of efficiency, by having to service several dozen hangers-on whose deficits, in many cases, far exceed the commission from their earnings. Naturally we have many promising stringers whom we would not want to lose. But the remainder must be weeded out, according to potentialities, until their number is manageable and we can handle them without detracting from the services due to ourselves.

Rodger took the opportunity to remind members of Magnum's original aims:

There may be a misunderstanding in some quarters, or perhaps a forgetfulness, of what Magnum originally set out to be. It is just as well, therefore, that I repeat our original precepts here so they are fully understood by everyone, especially by our two offices on which we depend and which must reflect our precepts and conceptions in all their actions.

Firstly Magnum never set out to be a commercialised profit-making business – any excess of income over expenses it was intended should be absorbed by reducing stockholders' percentages given to the organisation to provide for the services it should render us.

It was our intention that each one of us, standing on a common ground of integrity and human behaviour, should have in his work his individual freedom of operation, opinion and expression, and be severed from the possible restrictive biases of editorial policy which so often accompany a staff appointment.

It was our intention that Magnum should operate primarily for the benefit of the stockholders and the promulgation of their precepts . . . I must point out here that the four founder members still remaining agree that the above was our original policy, always has been and, as far as we are concerned, still is.

The situation was exacerbated by an alarming drop in the number of commissions from European magazines. 'I must tell you,' Capa reported to the New York office on 10 June, 'that there is a definite crisis in Europe at this moment. While until a few months ago we were pushing and asking for more stories to be sent over, now only the best are of any interest or use. Because of paper shortages the pages have shrunk, and there is a certain saturation of material. This will have to change part of our policy, but anyway at this moment it should be realised, and Europe should not be counted on but for minimum sales and of the best material.

'We just contacted *Match* and they are preparing a few assignments for Bischof. We will also continue to press Spooner. But please do everything from your side, because Bischof is still complaining that he hears very little and very scantily from New York. I know only too well that Bischof is in a complaining mood, but being one of the Number One assets of *Match*, even writing three times a week to him would be more important than many other things . . .'

Bischof had agreed to cover the war in Indo-China, where the French Army was engaged in an increasingly hopeless campaign against Viet Minh guerrillas, for *Paris Match*, despite a brief from the magazine which he described as 'objectionable' and which included a requirement to send back 'heroic shots' depicting 'isolation and bravery at remote outposts'. Although he made no secret of how much he detested the war, Bischof was intrigued by Indo-China:

'Hanoi is enchanting. Unforgettable the tranquil lake in the midst of the city with its graceful pagoda, the flower sellers with their bundles of long-stalked lotuses, and the boulevards where we sit in the evening, watching slim girls in white dresses with pitch-black unbraided hair cascading down their backs. We make long rickshaw tours of the Chinese quarter and see tigers, human figures, flowers and even whole houses being fashioned from multi-coloured paper – for religious festivals, not for amusement. The streets of the carpenters, locksmiths and tailors and then – as we near the barracks – the prostitutes' quarter, divided up according to military rank and guarded and controlled by the French army.

'In the evenings there is dancing on the roofs of the luxury restaurants. In the city centre, everyone moves freely and unarmed, while only a few kilometres outside the city an armed struggle for the rich rice harvest takes place under the cover of darkness. There is no front in Indochina; the population, the peasants, live in the midst of war, their villages are fortresses, and the fields in which they toil during the day are a no-man's-land at night. The Vietminh launch surprise attacks and are difficult to locate. The structure of their

forces is well known, as are their commanders and permanent strongholds. But they cannot be pinned down. They are so well disciplined that they have an amazing ability to disappear and then immediately reform again somewhere else.

'Just one example: Gian Coc, one of the countless villages in the vast expanse of the Red River delta, on the so-called "Canal des bambous". Shimmering rice paddies, as far as the eye can see, with peasants ploughing in their characteristic pointed hats and girls, up to their knees in the marshy ground, planting out the rice seedlings. The monsoon is over, the saturated air is crushingly hot and billowing clouds hang heavily in the sky. We had been walking for an hour, as the last post cannot be reached by vehicles. We were escorted through the paddy fields by troops with sub-machine guns. Though some distance off, their presence prevented me from enjoying the peace and beauty of this landscape. A few hours later, however, when I went to take a cool bath in the river after this hot day, the need to take precautions was brought home to me. I was just about to get into the water when a shot rang out. The bullet hit something close by and sent me running for cover behind a low earth bank.'

A couple of days later, on *La Rafale*, the armoured train that rattled between Saigon and Nha Trang and was frequently attacked (twice all the passengers were massacred), they stopped at a little village of mud and straw huts protected by a bamboo watchtower. For Bischof it was another 'forgotten village', much more interesting than the war, and he decided to stay on. 'The people here have suffered terribly from the war and are distrustful of strangers. When I enter the village, they hide and close their windows and doors – impossible to start photographing straight away. The children are the first who, out of curiosity, venture forwards and look at me. I do a drawing for them, and soon it becomes a game. Gradually the doors open – a smile here and there. As a gesture of greeting, a girl brings me an egg. The Saigon train passes through. I stay on. I need time, lots of time, for the village to get to know me and accept me; only then do I take out my camera . . .

'So here I am, sitting in my village, Barau, in front of a Moi hut with the delightful children and beautifully formed women, and observing the life around me. I want to make a story here, as a contrast to the war raging all around. Here there are no shops, nothing to buy, but every day the Chams – a dying race, originally from Malaya – come here from their nearby village. They bring salt, fish, live geckos, turtles, onions; in short, things from the sea that can scarcely be found here. The girls balance their wares on their heads

in tall straw baskets. They use the rails [along the railway track], supporting each other and dancing along the steel path. Their faces are more noble, more luminous, their skin a deeper bronze than that of the Moi.

'Today is a special day in Barau. Yesterday a woman died and a coffin is being made in front of the hut. The intact village community of Barau seems to me like an oasis in the midst of the cruel war. Here are birth, life, natural death.'

But the grim reality of the war was never far away, as he was to discover when, after his idyllic sojourn in Barau, he re-boarded the train. 'It was four a.m. in the deepest jungle. I had just put away my cameras, as we thought we would soon be in Saigon, when an explosion sent shockwaves through the whole train. We carried on a few metres before coming to a standstill. Immediately after the explosion the machine guns – our ones – began firing almost automatically. I took the cameras out again. Now mortar shells were bursting too, and the big gun was firing into the green curtain of the jungle. Ahead of us, about a hundred metres away, smoke was rising. The coaches stood skewed across the track, one man had been injured. The track had been torn away from under our coach, and underneath it was a deep hole. I ran over the roof to the passenger coach. There a small child was sitting, smiling at me. Fear and terror on the adults' faces, but a quiet, patient fear without hysteria. The father of the little child in the basket told me this was the third time he had been involved in an attack on the train.'

Paris Match, needless to say, was no more interested in the 'forgotten village' of Barau than *Life* had been in Bischofs 'forgotten village' in Korea. For Bischof it was the final straw. 'I've had enough,' he noted in his diary.

This story-chasing has become hard to take – not physically, but mentally. The work here no longer brings the joys of discoveries; what counts more than anything here is material value, money-making, fabricating stories to make things interesting. I detest this type of sensation mongering. I don't want to create the stuff you see in thousands of papers all over the world. Cheap thrills, idiotic stories that say nothing and ought never to be put on paper. I can see that this sort of work is not for me, and that I'm just no newspaper reporter. I'm at the mercy of the big newspapers. It won't do. I've been prostituting myself, but now I've had enough. Deep inside me I still am – and always will be – an artist.[1]

Bischof headed for home, arriving back in Zurich just two days

before Christmas 1952, having been travelling for nearly two years. It was his first opportunity to examine in detail all the exposed film he had shipped back to Magnum. Much of it did not meet his own high standards and was destroyed, not out of temperament but simply because the picture was not what he had intended. He believed that you first had to 'see' a picture in the mind before attempting to translate it into a photograph; when he felt he had failed he had no wish for the negative to survive. With time at last to organise his work, he produced a book on Japan and put together an exhibition, 'People in the Far East', which was a great success. His relationship with Magnum improved, in part because he had his first meeting with Cartier-Bresson, whom he revered, and discovered that the great man felt much the way he did about the problems of reconciling art and journalism.

Cartier-Bresson's reputation as the world's finest photo-journalist was cemented in 1952 with the publication *The Decisive Moment*, probably the most influential and significant book about photography ever written. He claims it only took 'a week or two' to write, but its elegant exposition would inspire generations of photojournalists around the world and bring new discipline and dignity to their craft:

> To me, photography is the simultaneous recognition, in a fraction of a second, of the significance of an event as well as of a precise organisation of forms which give that event its proper expression. I believe that, through the act of living, the discovery of oneself is made concurrently with the discovery of the world around us which can mould us. A balance must be established between these two worlds, the one inside us and the one outside us. As the result of a constant reciprocal process, both these worlds come to form a single one. And it is this world that we must communicate.
>
> But this takes care only of the content of the picture. For me, content cannot be separated from form. By form, I mean a rigorous organisation of the interplay of surfaces, lines and values. It is in this organisation alone that our conceptions and emotions become concrete and communicable. In photography, visual organisation can stem only from a developed instinct ... We work in unison with movement as though it were a presentiment of the way in which life itself unfolds, but inside movement there is one moment at which the elements in motion are in balance. Photography must seize upon this moment and hold immobile the equilibrium of it.[2]

'I think *The Decisive Moment* made people look differently at photography and gave it a value and dignity that was extraordinary,' says Inge Morath. 'It was the first time I had seen photography presented in that way. I remember Henri telling me: look first for composition and visual order and let the "drama" take care of itself.'

At that time Morath was working, at Capa's suggestion, as Cartier-Bresson's assistant. 'Capa decided that before he sent me off on big photo-essays on my own I should work for a while with Henri Cartier-Bresson as his researcher, translator and apprentice. We travelled mostly in Europe, rarely talked about photography, much more about the paintings we looked at everywhere, about books and the Surrealists, whose way of thinking had influenced him very much. He also had a keen interest in politics; the French paper *Le Monde* was required reading. When I did not have to work for him I photographed what I came across. At that time one had to stick a viewfinder on top of the camera to decide what lens to use. Henri gave me one produced by Leitz, called a Vidom, which he himself often used. It went from 35mm to 135mm; one could, according to the distance of the subject from the camera, adjust the parallax. What delighted Henri about this viewfinder was that if you looked through it, things appeared on the opposite side of where they really were, or, with a turn, one could see everything upside down. After some trial and error, the eye got used to judging a whole scene in this rather abstract way, one learned to watch the continuous movement inscribe itself in the existing geometrical patterns and press the shutter at the right moment – or at least what one judged to be just that. Naturally, this can in the end only be intuitive. "Your compass must be in your eye," said Henri.'

Travelling with Cartier-Bresson and his wife, Eli, was not always the most relaxing experience, largely because they quarrelled all the time. On one occasion Cartier-Bresson got so angry that he stopped their Peugeot at the side of an autobahn, jumped out and threw his camera away. It was left to Morath to go and find it. She also had to load his film, know where they were, why they were there, in fact know everything, carry the luggage and make notes for the captions. It was not an easy job since Cartier-Bresson was so secretive that much of the time Morath had no idea where they were going or what they were doing. Despite all this, she thought it was 'brilliant' to work with him and she was intrigued by his idiosyncrasies. He preferred to use rubber jam jar covers instead of lens caps, for example, and tied them to his Leica with a length of shoelace. She also discovered that he used red nail varnish to mark his favourite shutter speed and distance – 1/125 of a second and 4 metres.

While *The Decisive Moment* provoked lively debate about the nature and function of photo-journalism, Magnum was still grappling with more mundane issues. Rodger was in favour of solving the agency's business problems by creating a corporate structure with a small board of directors – a president who would oversee the running of the two offices, a vice-president and a treasurer. At a stockholders' meeting in December 1952 a compromise was reached – it was decided that Magnum should, indeed, have a board of directors, but that it should comprise the four founders – Capa, Cartier-Bresson, Chim and Rodger. Capa agreed to become nominal president once again, providing he did not have to deal with the members' day-to-day problems and it was decided that an editorial director should be appointed, based in New York. Capa was allocated $10,000 a year to cover his expenses travelling between New York, London and Paris to co-ordinate Magnum's activities and hustle editors for assignments. Capa later told his brother Cornell that he had been offered a salary to continue running Magnum. Cornell congratulated him and said it was about time his efforts were recognised. 'You're crazy,' Capa retorted. 'Do you think I would want to be employed by those bastards?'

Capa already had someone in mind for the position of editorial director – his friend John Morris, picture editor of *Ladies' Home Journal*. Morris was effectively one of Magnum's best customers and it was a measure of Capa's desperation that he would risk losing an important customer in order to acquire someone to run the office. Capa met Morris in the bar at the Plaza hotel to sound him out. He said he was prepared to pay Morris twice as much as anyone else. 'How much is that?' Morris asked. Capa said 'Twelve thousand.' 'But I'm making $15,000 now,' Morris protested. 'I'm sorry,' said Capa, 'it's the best I can do.'

Actually Morris was not too worried about the money. He knew and liked almost everyone at Magnum, was attracted by the challenge and was looking for new opportunities. He asked advice from Edward Steichen, the curator of photography at the Museum of Modern Art, and Ed Thompson at *Life* and both said that if he got on all right with Capa he should take the job. A few weeks later Morris and Capa met for lunch and Morris said he was on. They agreed his title would be 'international executive editor', to signify his authority over both offices.

In January 1953 the New York office threw a party to celebrate Morris's appointment. Capa, smiling broadly, got up on a chair, jerked a thumb at Morris and said, 'Well boys, from now on you take your problems to *him*.' The problems were not long in coming.

During his first week in the job, Capa telephoned from Paris to say that he had been called into the US Embassy and asked to surrender his passport. He was apparently told that someone had reported him as a Communist. Capa would have been more ready to surrender an arm or a leg. Without a passport he could neither work as a photographer nor fulfil his responsibilities to Magnum; indeed he was due to go to Italy in a couple of days on assignment for *Picture Post* to photograph the filming of *Beat the Devil*, which was being directed by his friend John Huston and starred Humphrey Bogart. Chim agreed to stand in for Capa and Morris hired a prominent civil rights lawyer, Morris Ernst, to try and sort out the problem. Ernst had successfully represented Margaret Bourke-White, two years earlier, when she, too, was accused of being a Communist.

After providing a lengthy affidavit in which he dwelled on his patriotic coverage of the US Army in the war and his familiarity with a number of important generals, the US Embassy provided Capa with a 'patchwork document' which enabled him to go to Italy and relieve Chim on the set of *Beat the Devil*. No one who saw Capa at that time would have guessed that he was in any kind of trouble. He was in high spirits and played poker almost every night with Huston, Bogart and Truman Capote, who was writing the script. If he had any complaint it was only that he and Capote were losing consistently to the other two players. Huston would later claim that at the poker table he won back most of what he was paying Capa.

In May, Morris Ernst contacted Capa to give him the good news that his full passport was being restored. The bad news was that Ernst had submitted a hefty bill of $5,400 for his services. No one ever established why Capa was targeted; Ernst would only say that he suspected it might have been a case of mistaken identity. 'Of course,' says John Morris, 'it could also have been a jilted lover. That kind of thing was happening so often at that time that one never really knew who was accusing who.'

By the time Morris paid his first visit to the Paris office as 'international executive editor' Capa was back in fine form. Capa ushered him in, introduced him to a raft of people, then whisked him off to a surprise lunch on the Seine on board a yacht which had just arrived from England with Capa's former girlfriend, Pinkie, and a group of friends. After lunch they sailed up the Seine. 'It wasn't a business we were involved in,' Morris would later recall with perhaps excessive lyricism, 'it was a story, a romance.'[3] Three hours later he was at the Longchamps racecourse being introduced to the writer Irwin Shaw and Sydney Chaplin, the son of Charlie. It was impressive proof of how Capa's legendary charm opened doors. 'It

took me ten years to be invited to certain parties,' Anatole Litvak, the Russian film director, once wailed. 'Capa started getting invitations after two weeks.'

In the same month that John Morris was appointed in New York, Jinx Witherspoon and George Rodger married in America and began an extended honeymoon courtesy of Standard Oil, who had commissioned Rodger to go round the world and photograph its oil installations. The issue of whether or not Magnum photographers should compromise their integrity by accepting commercial assignments apparently never bothered the early members. Rodger's only concern was that one oil installation looked very much like another; he solved the problem by making sure that whoever was turning the valves was wearing national costume to establish the location. After travelling for six months Rodger suffered a nervous breakdown in Beirut. Jinx was convinced it was caused by worries about Magnum. 'He had suffered periodically from blinding migraine headaches brought on by worrying about Magnum's finances and all these things built up. I also don't think he ever got over feelings of guilt about the death of Cicely and the baby. He was completely unable to work for the next six months. Fortunately we found a good doctor in Beirut who helped him get over it, but the headaches never went away completely.'

Morris, meanwhile, was 'cleaning house' in New York, getting rid of the bulk of the stringers. 'We had a tiny staff and we couldn't service the very disparate needs of all this group. They were not interchangeable bodies, like at *Life* where you had a list of twenty photographers available for a given story and to a certain extent they were interchangeable because they were all-round journalists. Magnum's people tended to work in very personal ways. Some were pretty good all-round journalists, some were obviously not. Henri, for example, hated assignments. For Henri, a good assignment was an opportunity to make pictures the way he wanted to. Ernst Haas, the same thing. Ernst was an artist who usually took a perverse delight in turning an assignment upside down or ignoring it entirely. He even joked about it. He was sent by *Life* to cover an air-raid drill and he was supposed to go into the basement with the people. Instead, he went on the roof.'

Not long after Morris arrived, the New York office moved to a basement at 17 East 64th Street, next door to the Wildenstein Gallery, much more in keeping, Inge Bondi considered, with Magnum's image. The front room was painted Wedgwood blue and the back room was yellow. The first photographer to be recruited in the new office was Elliott Erwitt, who later became one of the high-

earning stalwarts whose loyalty would ensure Magnum's survival through its frequent financial crises. Erwitt had got interested in photography while working in a commercial darkroom when he was still a student at Hollywood High School. After graduating he moved to New York, hustled for work as a photographer and just before he was drafted he met Capa, who promised him a job when he got out of the army. 'I joined Magnum about twenty minutes after I got decommissioned. I did not have any hesitation about it. To me it was a great honour. I joined because it seemed like a positive place to be, I had to make a living, I had a brand new wife, a child on the way and I thought I had to get serious and Magnum seemed to be a serious place, the most serious place for someone in my profession.'

As a Magnum photographer he soon started getting assignments from *Life*, but quickly discovered that getting an assignment was not the same as getting published. 'I think they were using commissions as a way of finding photographers who would develop along their lines. I always had a love-hate relationship with *Life*, mostly hate. In those days, before television, it was terribly important. Every Thursday when it came out was a great event. You had to see it to see what was going on. So to work for them was terribly important. Some of the best pictures I ever took were for *Life* but never got published.'

While Erwitt was taking an increasingly jaundiced view of *Life* magazine, a man who would become one of his best friends was being recruited on to the staff. Burt Glinn, a member of a well-connected staunchly Democratic family in Pittsburgh, was studying law at Harvard and writing and taking pictures for the *Harvard Crimson*. When a recruiter from *Life* showed up at Harvard, Glinn was asked if he would like to be a researcher. He indignantly inquired why anyone in their right mind would want to work as a writer for a picture magazine and thought no more about it. Not long afterwards he was asked if he would like to join as a photographer. He was mystified, but learned later that Wilson Hicks, *Life*'s picture editor, had for some reason decided that he needed a photographer from the Ivy League – a qualification apparently more important than the ability to take pictures. Luckily for Hicks, in Glinn he got both. While he was at *Life*, Glinn inevitably met Capa. 'When Bob Capa came into town, the *Life* staff were at his feet with awe and adoration – whatever Bob wanted to do they wanted to do. Capa was going to do an assignment for *Holiday* magazine about socialite skiing and I was sent to talk to him about technicalities of shooting on snow. Elliott suggested he use flash outdoors to compensate for shadows, which I considered to be one of the most

horrible ideas I had ever heard – Bob Capa with flash!' They met in a bar across the street from *Life* called the Three Gs. Glinn started to talk earnestly then looked up and realised Capa wasn't listening. 'You're not in the least interested in all this, are you?' he asked. 'Not really,' said Capa. 'Let's have a drink.' They soon became friends and not long afterwards Capa encouraged Glinn to join Magnum.

In Paris another would-be Magnum photographer by the name of Marc Riboud was discovering that considerable persistence was required to join the agency. Riboud was working as an engineer at a factory in Lyons. 'I was definitely not a good engineer, I spent a lot of time dreaming of other things and taking pictures at weekends.' He badly wanted to get out of the factory and was pinning his hopes on the fact that he had once met Cartier-Bresson. His older brother had survived Buchenwald and while he was convalescing after the war he was nursed by Cartier-Bresson's sister, Nicole. Through that tenuous connection Marc had briefly been introduced to Cartier-Bresson himself. When Riboud felt he was ready to join Magnum he caught a train for Paris, made his way to Cartier-Bresson's apartment and knocked on the door, only to be told that Cartier-Bresson was abroad and not expected back for six months. Riboud returned six months later, found Cartier-Bresson at home and showed him his pictures. Cartier-Bresson looked through them carefully and then advised him never to leave his profession because photography was such an insecure job. 'I don't think,' says Riboud, 'that Henri wanted to take responsibility for me.'

Heroically undaunted, a few months later Riboud decided to leave his job anyway and concentrate on photography. He telephoned Cartier-Bresson to tell him the news and Cartier-Bresson congratulated him, but still said nothing about joining Magnum. Riboud resolved to try a different tack, through Capa, but had considerable difficulty tracking him down; Capa was always abroad, or at lunch, or at the races, or too busy. Eventually he found Capa playing pinball in the bar under the Magnum office. 'Capa agreed to look at my pictures then just said "OK, come with us. *Allez!*" That's how I joined Magnum.'

In New York, meanwhile, John Morris was falling out with Capa. Fundamental to their differences was that Morris wanted Magnum to expand and Capa did not. Morris wanted to run Magnum like a news agency, assigning photographers to breaking stories and co-ordinating the two offices in Paris and New York, but Capa had no intention of going in that direction and his patience was running short, as can be seen from a testy memo addressed to Morris on 2 December 1953 which began: 'This is the same memo, which I have

written dozens of times, in general and in detail, but somehow there seems to be still uncertainty of how emphatically some of the things were meant, and how flexibly the others should be applied . . .' Capa went on to emphasise that Magnum was never intended to be a 'limitless, growing, commercial type of agency' and that the agency could only serve a limited number of photographers, probably no more than ten or twelve, as much interested in their work as in money. 'We are absolutely against any present enlargement of our offices and office budgets,' he continued. While accepting that the offices were 'somewhat short-handed', he suggested that administrative problems could be solved by greater efficiency and reorganisation. The budget was to be set at $36,000 a year for New York and $24,000 for Paris. Anticipated sales were $100,000 in Paris and between $150,000 and $200,000 in New York.

Morris was quick to reply: 'I am not in agreement with your contention that "we are absolutely against any present enlargement of our offices and office budgets." If you and the Board really mean this, then you have my resignation. But not before I explain to you why I feel so strongly . . . I am working steadily toward a goal of Magnum offices which can function without strain and give far better service to the photographers at the same time. And after ten months' study I am convinced that the only way this can be done is to add to the staff just as steadily as our finances permit.'

Morris did not resign, but neither did he win the argument, which would rumble on for years.

Although Werner Bischof continued to accept occasional magazine assignments – he covered the coronation of Queen Elizabeth II in June, 1953, along with Capa and Haas – most of his energies were devoted to planning his next great photographic project: an expedition along the Pan American highway into South America.

On 11 May 1953 he wrote to Robert Capa in Paris: 'My dear Bob, any time you need me, please call and I will be in Paris. I am sick of doing nothing and eager to leave for South America. It is the only place I am interested in – as far as possible from civilisation, back to nature.'

In September he set sail for New York on board the *Liberté*, out of Le Havre. He wanted to meet the Magnum staff and find some assignments that would help finance his South American trip. He was, it seems, not impressed with the photographers working out of the New York office. 'Our problem is we no longer have any good

photographers,' he wrote to Capa, then in London. 'However hard I look here in New York, I keep coming across the same names.'[4]

Bischof covered the fiftieth anniversary of the opening of the Panama Canal for *Life*, flew to Vancouver on an assignment for *Fortune* and got a lucrative job from Standard Oil to shoot roadscapes and highway construction around America, a series that would become well known as the 'Traffic Pictures'. It was while working for Standard Oil that Bischof wrote to Cartier-Bresson a letter that so impressed the Frenchman that he later circulated it as a memorandum to all members of Magnum:

Pittsburgh, January 9th, 1954. This week, an old friend of mine from Tokyo saw me at Fifth Avenue. He returned lately from his post as an analyst in the army and was very depressed at the development of the States since he had left four years ago. But what is it that makes it so different? Very superficial, I call it the 'assembly line' – everywhere this depressing, anti-individual feeling, this automatic way of living, of thinking . . .

There is only one great thing which is exceptional: the science, the research, the preservation of art. But these people, with few exceptions, are foreigners, are French, are German, or are so strongly bound to our way of thinking that it seems to me they are like an oasis in a desert of stupidly vegetating creatures guided by a . . . good or brutal thinking government. [We . . .] overrule human rights and [turn things around so] that everybody in the 'assembly' line is convinced it must be right. I do not know if it is so, because I know the Far East and will be forever closer to their philosophy . . . it is the emptiness of daily life, the dryness of human relations which Thomas Wolfe describes in his book *There Is No Way Back*.

Yes, there is no way back, the developing of industries, of the robot, can only go on, go on and destroy. Truly intelligent people will be [drawn in by] this monster and there is no hope to survive . . . The tragedy is that very few people have time, or take time, to think about that. It is also paralysing to see it, and please forgive me if I am not coming back with the record you expect. I am soon going on my great trip.

Yours, Werner.[5]

In February 1954, Bischof set off for South America. His wife, Rosellina, who was pregnant, accompanied him as far as Mexico and then flew home to Zurich, via New York. She would never see him again.

MARC RIBOUD talking in his apartment on the Left Bank in Paris: 'After being accepted into Magnum, I approached each of the four founders for advice. Cartier-Bresson earnestly advised me not to listen too carefully to the advice of Chim. Chim told me not to follow too closely the advice of Capa, and Capa told me not to take any notice of Henri's advice. So I was a bit mixed up and went to see George Rodger and told him what the others had said and he said 'Don't listen to any of them, only to me.' I understood at that moment that Magnum was a family made up of very strong personalities. But they did give me much other advice – how to get through an Arab crowd, how to change your passport when you go from Egypt to Israel, how to find a good restaurant in New York. All good advice, but nothing to do with photography.

'Not long after I joined, Capa told me to go to London to learn English. I stayed with a French friend of Henri's who took me around London. He had an English wife. Sometimes I had meals with them as I had very little money. They lived in Hampstead, on the 2A bus route, and I went out every day and discovered London. One day, I found I was running out of money and I asked Magnum if they would send me £20. Capa telephoned and told me I would get a call from a man with a Middle Eastern name on a particular day and that I was to do what he asked. Two or three days later I got the call, very mysterious. "Are you the friend of Capa? Can you be in a subway station on Wednesday, the day after tomorrow. There are two of us. What do you look like?" So I tell them, I am young and I have a camera. "OK, don't be late!" So I set off to get there and was extremely nervous and so was late. Finally I found two guys, and I thought, it can't be them, so I turned back and they said "Hi! Are you the friend of Capa?" I said yes and they said "Here it is. Goodbye!" and they were gone. It was my money, enough to keep me going for two to three weeks in London.

'Henri was very concerned about what I read, where I went, and he gave me addresses and names of friends. He would write letters to me once a week, telling me to be careful, that I might meet people in London who are right-wing. I remember answering him that he shouldn't worry because I am reminded at every corner crossing on the road to "Keep Left."

'Then I got a note to say that Capa was coming to London and I was told to call him at the Pastoria Hotel. He said "Come at 6 p.m. to the Pastoria, meet me in the bar." So I get there, I see Capa and I thought I would go and visit some editors because he said he would find some work for me. I had no work, although I was shooting a lot of pictures. Then the top editor of that time, Len Spooner of *Picture*

Post, came into the bar. Capa introduced me and said I was a good person and that Spooner should give me some work. Capa just browbeat Spooner into giving me work, saying I was a friend of Cartier-Bresson's, etcetera. Eventually Spooner admitted that *Picture Post* was doing a series on the best and worst of British cities and that they couldn't find anyone to cover Leeds. Capa leapt on it, saying that I came from Lyons which is another awful industrial city and therefore I was the perfect choice for the assignment to cover the worst of Leeds.

'Two months later, Capa was visiting London again and I was summoned to his hotel room. I found him having a bath. He seemed very depressed and talked a lot about the death of photography. Television, he said, was the medium of the future. I asked him what he was doing and he told me he was going to Japan. He was going to take a camera but he thought photography was definitely finished.'

6

Deaths in the Family

IN FEBRUARY 1954 Capa was invited to Japan to help launch a new photographic magazine, *Camera Mainichi*. He was skiing in Klosters with Irwin Shaw when the invitation arrived. 'I had made him promise not to get involved in any more wars,' Shaw recalled, 'and when the news of his new assignment reached him he merely told me that he was going to Japan for *Life*. When I asked him to bring back a camera for me, he glanced at me peculiarly, which should have warned me that he was not going to spend his time in the Orient photographing the peaceful rehabilitation of the Japanese civilian population. The last time I saw him was at the railroad station in Klosters, where he was serenaded by the town band as he climbed aboard the train with a bottle of champagne and someone else's wife.'[1]

It was to be a six-week assignment, all expenses paid, during which he could photograph whatever took his fancy and work for other magazines. Not only did *Camera Mainichi* offer generous fees for all the pictures they published; they also wanted Capa to use all-Japanese equipment, which they supplied and said he could keep at the end of the trip. It was an offer Capa could hardly refuse, even though he was becoming less enchanted with photography as a way of earning a living. Before he left for Japan he told an old girlfriend he would throw a big party on his return to celebrate the end of his career. He talked increasingly of photography being 'for kids' and of wanting either to write, or to take on some challenging business venture.

The truth was that Capa was becoming weary of Magnum, weary of having to write letters, weary of negotiating with penny-pinching editors, weary of the endless administration, weary of being the recipient of everyone's problems. It was no fun any more – there

were too many appointments he didn't want to keep, too many meetings, too many crises and too much responsibility.

'Capa was getting fed up and bored with himself,' says John Morris. 'He didn't really know what his future would be. He had dabbled in the movie business. He was actually a good writer, but wasn't disciplined enough in my view to take on a staff writing position and I think the movie business was too well organised by then. He had failed in his attempt to be an actor, he didn't really know what to do with himself and I think he had sort of had it in terms of photography, photo-journalism. But he got excited all over again when he was in Japan where he was having really good times. His letters were full of optimism, even his last one.'

Inge Morath remembers his leaving Paris:

A group us of us went down to the café under the Paris office to say goodbye. We had seen each other off to many places for many years, but somehow we were all sadder at this occasion. I really felt he didn't want to go on this assignment; he seemed sad and that was very unusual for him. Capa worked hard on the pinball machine and mused about getting old – past 40. He was going to be 40 and he always used to say 'I can't be 40, how can anybody be 40? I don't know how I am going to do it.' What would he do as an old man, he kept muttering. We all embraced in the dark, wet street, wishing *'Bonne chance, mon vieux'* to a man who had been brother and father to us all. Then he went off into the night with Chim.[2]

Capa left for Japan on 11 April and was delighted with the reception he received. He travelled to Kyoto, Nara, Osaka, Kobe and Amagasaki, thoroughly enjoying being in a country he described to a friend as a 'photographer's paradise' and unaware that mundane events would soon interrupt his idyll.

At the end of April, Howard Sochurek, the *Life* photographer covering the war in Indo-China, learned that his mother was ill and asked for permission to return to America. In New York, Ray Mackland, the magazine's assignment editor, had lunch with John Morris and asked if Capa might be willing to stand in for Sochurek, since he was in the area. Morris did not think Capa would be interested, but said he would ask. Without waiting for a reply, *Life* sent a cable to Capa offering him a $2,000 guarantee for a thirty-day assignment, plus expenses from Tokyo and a $25,000 life insurance policy.

'I got Bob on the wireless,' managing editor Ed Thompson

explained, 'and said "Well, look you don't have to do this and I know you won't if you don't want to, but if you want to take a whack at this for a month or so, why, how about taking Howard's place in Indo-China?" I didn't try and talk him into it, but he had an idea for a story based on that movie *Bitter Rice*, with Silvana Mangano, where he was going to juxtapose in the form of an essay pictures of peasants in the Delta against the military activity.'[3]

When Capa said he might be interested, Sochurek was instructed to stop off in Japan on the way home to brief him. They arranged to meet in the bar of the Tokyo Press Club at 6.30 on the evening of 29 April. Capa showed up an hour and a half late and did not bother to apologise or explain. Sochurek was irritated, but was soon captivated by Capa's charm. He had much to explain about the war in Indo-China. First, Henry Luce, the founder and publisher of *Life*, believed it was America's patriotic duty to support the French at all costs and did not want his magazine to carry any negative reporting about the war. A few months earlier, while Luce was on vacation, *Life* had published a sixteen-page feature, with photographs and text by David Douglas Duncan, suggesting that 'ineffective French tactics and ebbing French will' made it likely that Indo-China was 'all but lost to the anti-Communist world'. French staff officers were portrayed as enjoying 'banking hours', long siestas and lazy weekends while more and more of the country was being lost to the Communists. The issue almost provoked a diplomatic incident, with the French Foreign Ministry describing it as 'defamation and slander'.[4]

Luce was furious and ordered Ed Thompson to produce some 'positive' coverage of the war to repair the damage. It was in these circumstances that Sochurek was sent out. Unfortunately for Henry Luce's desire to promote the idea of heroic French troops fighting to protect Vietnam from the Communist hordes, Sochurek arrived just in time to witness preparations for the greatest débâcle of the war, when Ho Chi Minh's forces inexorably encircled the last major French garrison at Dien Bien Phu.

Sochurek told Capa that the war was a disaster, that constant guerrilla attacks and booby traps made it almost impossible for correspondents to take basic precautions to protect their own lives. They talked until well after midnight and when they parted Sochurek was unsure whether or not Capa had made up his mind to go.

Two factors decided Capa. First, he needed the money. The $2,000 offered by *Life* was not exactly a fortune but it was a guarantee, a fee he would be paid, as he put it, just to 'sit on his ass in

Hanoi'. Every picture published would earn him extra money and if he was in combat he would get more. Morris had cabled from New York: PRICE SUBJECT TO CONSIDERABLE UPRAISING IF BECOMES HAZARDOUS. The second factor was that Capa was worried that his reputation as the greatest living war photographer was being eclipsed by David Douglas Duncan, who had made his name in Korea and whose pictures from Indo-China were constantly being compared to Capa at his best. Capa didn't like it. There may have been a third reason for him to go. His friend Irwin Shaw was convinced Capa partly took the assignment to disprove the 'semi-official allegations' being bandied about in McCarthyite America that he was a Communist sympathiser.

The day after meeting Sochurek, Capa cabled John Morris in New York to say he was accepting the assignment. Morris, suddenly worried, got through on the telephone that night and told him not to feel that he *had* to go. 'I hoped he would turn it down but when he agreed, it really spooked me and so I went home that night and called him in Tokyo. I think I got him in the press club, it was not a good connection and I felt I was shouting across the Pacific. I said "Bob, you don't have to do this, it's not our war." I remember saying that very clearly. He said "Don't worry, it is only a few weeks." And off he went. He wrote me a note after that saying he was sorry he was so harsh with me on the phone and so on. In fact he hadn't been harsh with me, it was just the fact that we were shouting at each other to make ourselves heard over the terrible connection. I think he understood fundamentally that there were times when I had tried to get him to do a story that he just knew instinctively wasn't worth the risk. This time I was trying to tell him that there was something about this story that wasn't worth the risk.'

Capa's letter to Morris emphasised, in his fractured English, that he was only going because he wanted to: 'I much appreciate your calling, but be assured that I didn't take the job from a sense of duty but with real great pleasure. Shooting for me at this moment is much fun and possibly shooting on a very complicated subject but down my own alley even more so. I know that Indochina might be only sheer frustration, but somehow it should be one story anyway.'

Another reason Morris was concerned was that he was convinced that Capa would never cover a war in which he could not identify with the side he was on. Capa had good friends in the French Army and was respected by the French command, but Morris thought it extremely unlikely that he would have any sympathy with a French colonial war. 'Capa had already said that he didn't want to cover any more wars so I was really shocked when he took the assignment. I

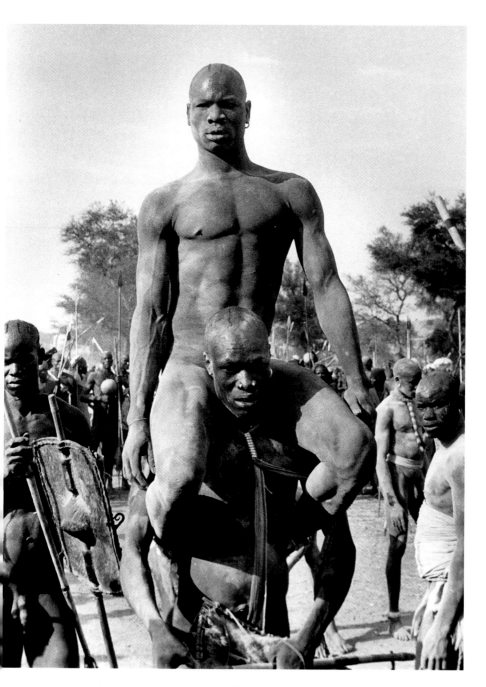

GEORGE RODGER
Tribesman carries victorious Nuba wrestler, Kordofan, Southern Sudan, 1949

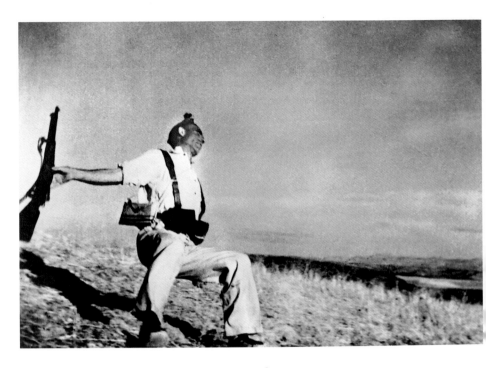

ROBERT CAPA
Dying Loyalist soldier, Cordoba Front, 1936

CORNELL CAPA
JFK

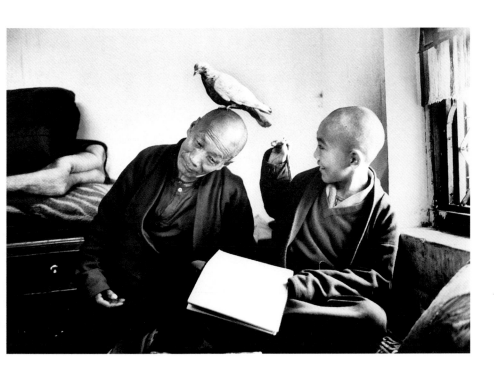

MARTINE FRANCK
Lamas, Nepal

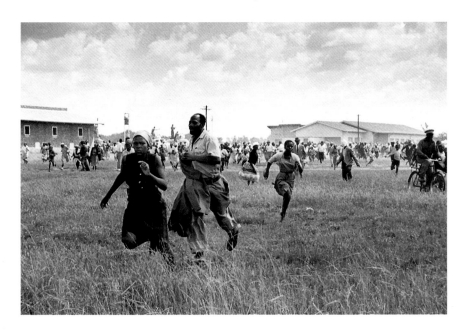

IAN BERRY
Sharpeville massacre, South Africa

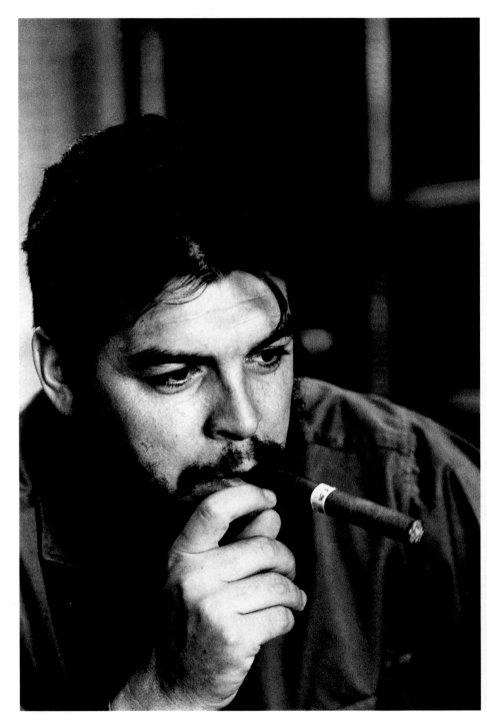

RENÉ BURRI
Ernesto Che Guevara, Havana, Cuba, 1963

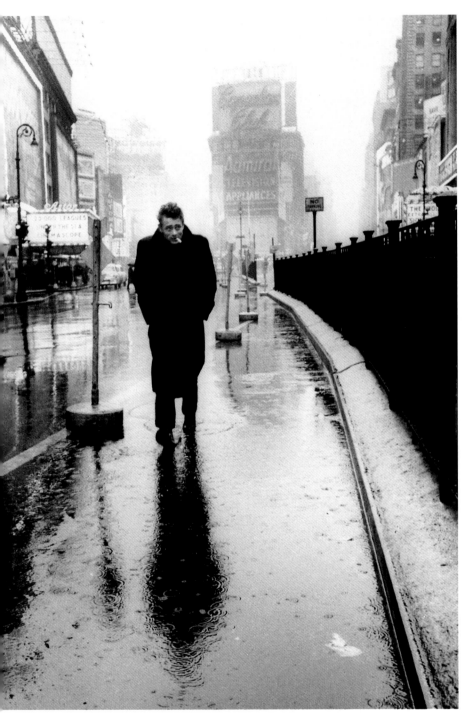

DENNIS STOCK
James Dean, Times Square, New York City, 1955

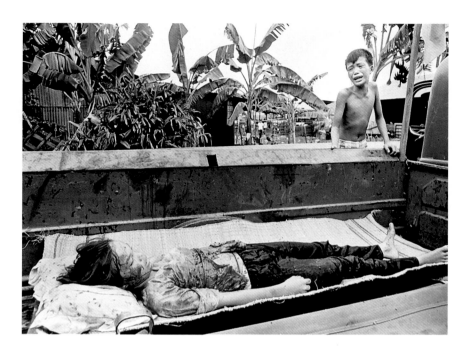

PHILIP JONES GRIFFITHS
Boy weeps over the body of his dead sister killed by U.S helicopter gun-fire,
Saigon, Vietnam, 1968

CONSTANTINE MANOS
Aunt at funeral of her
nephew killed in Vietnam,
South Carolina, 1966

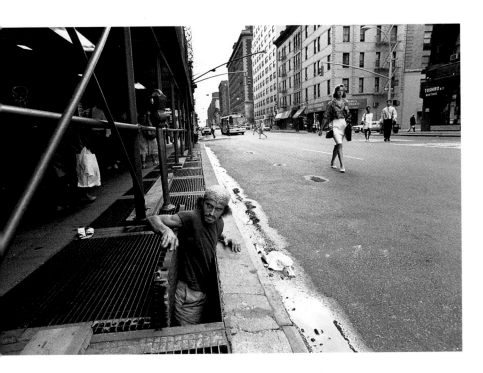

EUGENE RICHARDS
Panhandlers, New York City

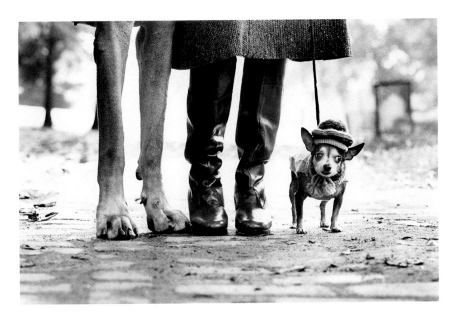

ELLIOT ERWITT
New York City, 1974

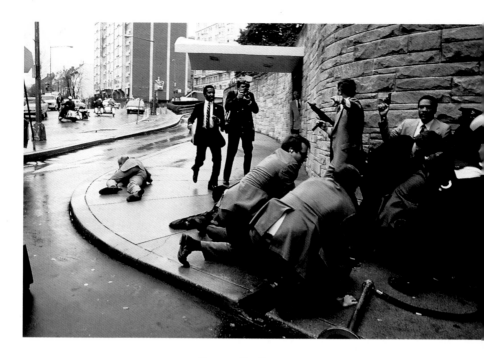

SEBASTIÃO SALGADO
Reagan assassination attempt

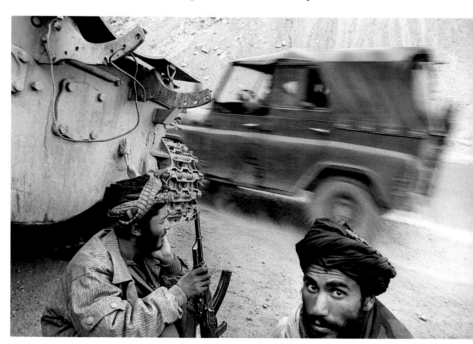

CHRIS STEELE-PERKINS
Taliban soldiers, Afghanistan

am afraid he took it mostly because it was a way to make some money. The money wasn't even that great, it was pitiful in that respect.'

Capa had to wait several days for the necessary visas and did not arrive in Hanoi until 9 May, just a day after Dien Bien Phu had fallen and thousands of French soldiers had been taken prisoner. 'Here I am in Hanoi,' he wrote in disgust to the Paris office, 'and the story is over before I could have touched my cameras.' Capa certainly wanted to stay long enough to earn his *Life* guarantee. He covered the arrival in Laos of wounded French soldiers evacuated from Dien Bien Phu, looked round the Red River delta and toured Hanoi photographing the sights. On Monday, 24 May, accompanied by *Time* correspondent John Mecklin, he flew to Nam Dinh where General René Cogny, the commander of the French ground forces in north Vietnam, was on a morale-boosting visit to French Legion troops. Over lunch the two journalists were invited to accompany a unit on a mission the following day to destroy two small forts along the road from Nam Dinh to Thaibinh, twenty miles to the east. That evening, in the bar of the decrepit Modern Hotel, they met up with Scripps-Howard correspondent Jim Lucas and sat around drinking and swapping stories. Capa was upbeat. 'This is the last good war,' he proclaimed. 'The trouble with all you guys who complain so much about French public relations is that you don't appreciate that this is a reporter's war. Nobody knows anything and nobody tells you anything, and that means a good reporter is free to go out and get a beat every day.'[5]

A jeep picked the three of them up at seven o'clock next morning. Capa, the seasoned campaigner, carried along with his cameras and film a flask of cognac and a thermos of iced tea. They joined a task force of some 2,000 soldiers in a convoy of 200 vehicles and while they waited to be ferried across a river on the outskirts of Nam Dinh, Capa assured his companions that the day would produce a 'beautiful story'. He was going to be on his best behaviour, he said. 'I will not insult my colleagues and I will not once mention the excellence of my work.'[6]

At 8.40, the leading vehicles came under sniper attack. French armour returned the fire as the convoy ground to a halt. Capa was surprised to observe that Vietnamese peasants walking along the road and working in the rice paddies seemed totally oblivious to the battle and carried on with their business as if nothing was happening. Ignoring a warning to stay under cover, he waded out into a paddy to photograph the peasants with the firefight going on behind them.

After a few minutes, the convoy started up again, only to be

stopped a few miles down the road when a truck ran over a mine. Four men were killed in the explosion, six wounded. This time the column came under both mortar and sniper fire. Lucas was later to describe the battle: 'Viet Minh mortars gouged at our column. Viet Minh snipers picked off an occasional straggler, and our own artillery roared back. Villages along the road caught fire as tanks sent shells crashing through them. An abandoned church that concealed snipers was destroyed. The Viet Minh lay dead where they fell. Our own we carried back. Capa was everywhere. Once, under mortar fire, he loaded a wounded Vietnamese soldier into the jeep and drove him back to an outpost.'

Along the road there was a further delay when the convoy encountered two deep trenches dug across the road by the Viet Minh. Capa walked up to the head of the column to photograph the bulldozers and the captured Viet Minh soldiers who were put to work to make repairs. While his two colleagues joined a French officer for lunch, Capa chose to keep working and then took a nap in the shade of a truck. After lunch they heard that advance units had finally reached Doai Than, so they jumped in their jeep and drove forward to witness the razing of the fort. They arrived to find a small, run-down crenellated structure surrounded by barbed wire and thick vegetation. Engineers were already planting explosives around the base of the walls.

Mecklin takes up the story:

A couple of hundred yards past Doai Than the column was stalled again by a Viet Minh ambush. We turned into the field and talked to the sector commander, Lietnant Colonel Jean Lacapelle. Capa asked: 'What's new?' The colonel's reply was a familiar one: '*Viets partout*' [Viet Minh everywhere.] As the column began moving again Capa climbed on the jeep for a shot. A truck loaded with infantry behind us tooted vigorously, but Capa took his time: 'That was a good picture,' he said as he climbed down. But the column halted again almost immediately. This was at a point one kilometer beyond Doai Than and three kilometers short of the final objective, Thanh Ne. The road was three or four feet above the paddies and here served as a dike for a little stream which ran along the right side . . .

The sun beat down fiercely. There was firing in every direction: French artillery, tanks and mortars behind us, the clatter of small arms from woods surrounding a village 500 yards to our left, heavy small arms fire mixed with exploding French shells in another village 500 yards ahead and to our right, the sporadic ping

of slugs passing overhead, the harrowing curr-rump of mines and enemy mortars. A young Vietnamese lieutenant approached us and began practising his English, which was limited to a laboured 'How are you, sir? I am good.' Capa was exquisitely bored and climbed up on the road, saying 'I'm going up the road a little bit. Look for me when you get started again.' This was about 2.50 pm.'[7]

Mecklin thought the situation was too dangerous for anyone to be wandering around, but he had observed earlier in the day that Capa was in his fifth war and was an expert in judging risks. For a brief moment Capa stood behind the jeep, as if waiting for a lull in the fire, before venturing out. He walked quickly up the road to where it curved to the left, then jumped down into the ditch at the side of the road. He photographed a French platoon advancing through the tall grass, then clambered back on to the road to take a few more pictures of soldiers hanging about by their vehicles, waiting for the convoy to start moving again. With nothing much happening, he decided to catch up with the platoon in the paddy field. He shot two more pictures, the last he would ever take. Climbing up the grassy slope of a dike, probably to photograph the soldiers from a different angle, he stepped on an anti-personnel mine.

When Mecklin and Lucas heard that Capa had been injured, they ran forward to find him. He was lying on his back, still breathing, with a Contax camera clutched in one hand. His left leg had been virtually blown off and there was a gaping wound in his chest. Mecklin called Capa's name and saw his lips move, but no sound came. A French officer had already flagged down an ambulance, but by the time he arrived at a field hospital five kilometres away, he was dead. He was forty years old, and the first American correspondent killed in Indo-China.

In the Magnum offices in New York and Paris, it was hardly surprising that the news of Capa's death was greeted with stunned disbelief, since earlier that day it had been learned that Werner Bischof had been killed in Peru. It was at first assumed that the two incidents had become confused. Bischof was travelling up into the Andes with a Swiss geologist and a Peruvian driver. The three of them were in a Chevrolet station wagon driving along a treacherous, slippery mountain route between Chagual and Parcoy when the truck slid off the road and plunged 1,500 feet to the bottom of a deep gorge. All three were killed instantly. The accident happened on

Sunday, 16 May, but it took nine days for the news to reach New York. One of the last pictures Bischof sent back would become one of his best known – a little Peruvian boy striding along a mountain path playing a flute.

Allen Brown, who joined Magnum as an office boy in 1947 and was by then in charge of the mail room, was the first to read the cable containing news of Bischof's death. 'I had to read it five times before I believed it. A few weeks before I'd been with him when he bought cameras, camping gear and the Land Rover that he shipped to South America. His wife, Rosellina, was pregnant, and just before he left she told Werner "This is no way to raise a family".'

John Morris will never forget how he heard the news: 'I happened to be teaching a workshop at the University of Missouri the week before Capa died. We finished on the Sunday night and on Monday morning I was awakened in my hotel room by a call from Inge Bondi in New York. She was in charge of the office while I was away. I was coming back to New York that day and she said, "John I have terrible news. The Swiss consul has just called. Werner Bischof is dead." She said his car had run off a cliff in Peru and they had just found him. I knew that his wife, Rosellina, was just about to give birth. I said to Inge "Does Rosellina know yet?" and she said she didn't know. I told her to try if possible to hold back the news from the wire services until she could get hold of her doctor. In fact, that was the day she gave birth and I don't know whether Inge succeeded or not. I then decided to get back to New York as fast as I could, so I flew back that afternoon and my wife met me at La Guardia and when we got home an hour later, the phone was ringing. It was a *Life* researcher in the foreign news department and she said "I guess you've heard the terrible news?" and I said yes, thinking she meant Werner and she said "Do you mind if I ask you a few questions?" and she began to ask me about Capa. I said "What's this about Capa?" and she said, "I thought you said you'd heard the news." I said I'd heard the news about Werner Bischof. "Oh," she said, "Bob Capa died today. He stepped on a land mine." That was just too much for one day.'

Cornell Capa was in upstate New York working on an extended photographic story on retarded children and had been invited to dinner in a teacher's home when the telephone rang. It was *Life*'s distraught assignment editor hoping to break the news to Cornell before he heard it on the television or radio. In a daze, Cornell returned to the dinner table and asked his hosts to turn on the television for the seven o'clock news. 'It was the first flash,' he

recalled, 'complete with his picture: "The legendary war photographer, Robert Capa . . .' The first reality of the awful truth hit.'[9]

The news spread rapidly. Ernst Haas, on assignment in Africa, received two telegrams simultaneously.

That they should both die was impossible was my first thought. It took me years to believe it. It was the kind of blow that kills or creates, that makes or breaks you. I thought of Capa and all he had done for me. He wanted me to fulfil myself and he understood what fulfilment meant better than anyone else. When I made a first big "success" with a story of New York in colour, I knew that I would be in demand by editors here, that everything would be easy for me if I came to the States. But Capa said "Why do you want to be praised? It's a bore. Go to Indo-China." He wanted me to make it difficult for myself. He knew that was the only way to learn.[10]

'When Capa died I had just come up from Georgia,' Eve Arnold recalled, 'where I had gone to do something on the civil rights movement and I hadn't seen a newspaper in days. I called home and my husband asked me if I had seen the papers. He said, "I hate to have to tell you over the phone, but Capa has been killed and Werner Bischof has died in an accident." I just turned round and found out where Cornell was and then went up to the house where the mother was. Cornell was there, Ed Thompson was there and other friends. I no longer clearly remember, it was such a horrendous night. Julia was, understandably, beside herself. It was a terrible, terrible, night.'

Cartier-Bresson heard the news when he returned to Paris from an assignment in Rome: 'I came back early by train and as I walked in the telephone rang. Ratna jumped up to prevent me from taking the call and I heard her say "What? What? Capa? No!" She knew about Werner, that was why she had jumped to the telephone. Obviously we hadn't thought such a thing would happen, but thinking about it afterwards I realised it was right for Capa to die in such a way, as an adventurer. Poor Capa, one of the last times I saw him was crossing Regent Street in the middle of winter. He had to go and discuss Magnum business in New York and needed an overcoat so he was going to Aquascutum in Regent Street. He took the cheapest coat he could find because he had no money.'[11]

John Steinbeck and his wife Elaine were in Paris, where they had arranged to meet up with Capa on his return from Indo-China. A telegram was put under the door of their rented house on the avenue

de Marigny saying that Capa had been blown up by a land mine. Steinbeck went out and walked the streets for hours, then came back and penned a moving epitaph for his lost friend:

The greatness of Capa is twofold. We have his pictures, a true and vital record of our time – ugly and beautiful, set down by the mind of an artist. But Capa had another work which may be even more important. He gathered young men about him, encouraged, instructed, even fed and clothed them, but best he taught them respect for their art and integrity in its performance. He proved to them that a man can live by this medium and still be true to himself. And never once did he try to get them to take his kind of picture. Thus the effect of Capa will be found in the men who worked with him. They will carry a little part of Capa all their lives and perhaps hand him on to their young men.[12]

The Sunday after Capa's death a memorial service was held for him and Bischof at the Quaker Meeting House in Purchase, New York. Many of the great names in photography and journalism came to pay tribute. Ernest Hemingway was in Madrid and could not make it, but sent a simple note: 'Capa: He was a good friend and a great and very brave photographer. It is bad luck for everybody that the percentages caught up with him. It is especially bad for Capa. He was so much alive that it is a long hard day to think of him as dead.'

When Capa's body was returned to the United States it was suggested that he deserved burial in Arlington National Cemetery, but his formidable mother objected vociferously. 'Not my son,' she said firmly. 'He was against war and shouldn't be buried among military men.' A private burial service was held in the Quaker cemetery at Amawalk, in Westchester County, New York. Only the immediate family and a few members of Magnum attended. One of the wreaths was from a bar in Hanoi where Capa had taught the bartender to mix a proper Martini.

Capa's death left Magnum in disarray and the anguish felt by everyone was reflected in a letter from Chim to his colleagues:

My Dear Magnum Family, The lump is still in the throat and the dust not settled yet. The blow is hard, and the reaction slow to come. Somewhere, however, there is a faint reasonableness coming, and the realisation that the reality has to be faced. I am grasping for words in order to be as clear to express my thoughts – which are not. The clichés are too easy, and phrases that 'the living must go on' are just around the corner. If we are all numb at

present, it looks like that soon enough we will have to face it. So we have to go on, keep together and avoid the stunning effects of our sorrow. Maybe, through this we will help ourselves and find strength to keep and develop Magnum – a home for all of us . . . For the time being, it is extremely important that when the first shock will be over, we all go on performing to the best of our ability. I wanted to write those few words, just to let you know what is in my mind . . .
Your Chim.

It was a month before Rodger heard the news:

I was returning out of Africa, travelling by way of the Nile, which is a slow but interesting journey. But this time it was slower than usual on account of a strike in Khartoum which stopped the river boats and left me stranded for two weeks south of the Dinka country. It was a long and sweaty wait. Eventually an old stern-wheeler took me and carried me into the Sud where, for several days, it monotonously slapped at floating islands of payras and Nile cabbage raising clouds of mosquitoes. We chugged on, day after crawling day, until eventually I reached Shellal where the river boat meets the train for Cairo. It was intolerably hot in the railway coach and the metal buttons on my bush jacket burned into my skin. An Egyptian news vendor walked in the hot sand beside the line and I bought a month-old copy of *Time*. I opened it at random, too hot to take an immediate interest. Then, suddenly, the world stood still. I couldn't believe the cruel outcry of the print: Bob Capa was dead. As though this were not shock enough, I read in the same issue that our gentle, sensitive, talented Werner Bischof was dead also.[13]

The Rodgers hurried back to Paris, where they learned that Cornell Capa had resigned from *Life* and joined Magnum, bolstering morale considerably. Cornell had lived in his brother's shadow all his life and had no expectation of filling his brother's shoes at Magnum – no one could do that – but he felt he could in some way help the agency fill the vacuum left by the tragedy. MY DECISION TO JOIN IS PERSONAL, FIRM AND UNCONDITIONAL, he cabled to the Paris office. IT IS BASED FULLY ON BELIEF OF IMPORTANCE OF MAGNUM IDEA AND LOYALTY TO FRIENDS. Cartier-Bresson and Haas sent a joint reply: WONDERFUL, WONDERFUL, WONDERFUL.

There were those who believed that Magnum could not survive without Bob Capa, that without his extraordinary inspiration and leadership the agency would simply collapse. He was the innovator

and visionary and the man everyone looked to for direction. He had also left Magnum in a state of organisational chaos; he had never seen the point of paperwork when he could keep everything in his head. What saved the agency more than anything else was a sense among the photographers that they could not let it die, that they owed it to Bob to keep going. Cornell's joining was important symbolically and a vote of confidence in the future.

At an emergency meeting in Paris attended by Cornell, Chim, Rodger, Cartier-Bresson, Ernst Haas and John Morris it was agreed that the first priority should be to bring in a structure and sense of order. But who should replace Capa as president? No one present wanted the job, but in the end Chim reluctantly agreed to take it on. In reality, he was the only choice. He might have been shy and quiet, but he was an excellent organiser and manager and, unlike Capa, he was cautious and prudent.

One of the problems under Capa was that only he knew what was going on and in an effort to keep photographers informed about who was doing what John Morris began sending out regular newsletters. In the September 1954 letter he noted that Eve Arnold was photographing a musical comedy and had an assignment in the Caribbean, Cornell had just returned from a *Holiday* assignment in England, *Holiday* was also considering devoting an entire issue to the pictures Cartier-Bresson had recently shot in Russia (in fact *Life* eventually bought them for a princely $40,000); Burt Glinn was working on food assignments in Seattle for *This Week*, Ernst Haas had just completed shooting promotion stills for the film *Moby Dick*, Erich Hartmann was photographing landscapes in New England, Marc Riboud was in the West Indies, George Rodger had a $5,000 advance for a trip to India and Chim's story on Gina Lollobrigida's wardrobe had been bought by *Life* for $500.

Attached to this circular was a less comforting letter from Chim addressing the problem that had haunted Magnum from its inception – bickering, jealousy and in-fighting:

At first we behaved magnificently – but inevitably there came a letdown – when the body refused to work more hours and the spirit flagged into bitterness. So now there are some signs that we are tearing ourselves apart, in jealousy and mistrust. We *must* not let this happen. We have come through too much together. We cannot falter now, when we have already proved to the outside that the principle of Magnum survives . . . Let patience and humor replace irritation and anger. Let us share the problems of our future rather than dwell on misfortunes of the past. Magnum is

something of a miracle by its very existence. And miracles require continued faith.

Under Morris, who had been given responsibility for extracting Magnum from its financial problems, the agency actively sought commissions to shoot publicity stills for movies. They were particularly lucrative contracts, since studios would routinely agree to employ a Magnum photographer for weeks on end at $500 a week, plus expenses, whereas magazine assignments, at $100 a day, often only lasted two or three days. It was a good deal, too, for the studios, as Magnum's prestige helped place the pictures in magazines, sometimes garnering publicity for an otherwise mediocre movie.

Dennis Stock, who had moved to Los Angeles from New York and was specialising in covering Hollywood, said that Magnum photographers had a special advantage because they were never intimidated by the stars. 'I would spend weekends with Humphrey Bogart, getting drunk with him on his boat. He liked me because I could give as good as I got. He'd say to me "Fuck you" and I'd reply "Fuck *you*".' Sunday afternoons Stock would usually attend the informal party director Nicholas Ray hosted in the garden of his bungalow at the Château Marmont and one week Ray introduced him to a shy young actor by the name of James Dean. Stock had never heard of him, but they chatted amiably and Dean invited him to a sneak preview of *East of Eden* which was to be held later that week in Santa Monica. Stock was stunned by Dean's performance, recognised that he would be a major star and suggested doing a story on him. Dean was delighted and and they agreed that Stock should take pictures in Dean's home town of Fairmont, Indiana, and in New York, where his career had begun. It was on this trip that Stock took perhaps the most famous photograph ever of James Dean, shoulders hunched, walking through the rain in Times Square.

Subsequently they became good friends. 'I last saw Jimmy when I'd just come back from an assignment in Europe and he told me he was going off in his Porsche for the weekend to a race meeting. He asked me to go with him and I said "Sure, I'd love to" but then some instinct told me not to and I looked at him – I can't explain it to this day – and said "Oh, I'm sorry, I forgot. I can't." He went off that Friday night and I was having dinner with a mutual friend when the bartender came up and said "Jimmy's dead".' Dean was killed instantly when his car careered off the road outside Los Angeles on 30 September 1955.

John Morris was continuing to agitate for Magnum's expansion – he wanted to set up a syndication operation marketing Magnum

photographs to newspapers around the world – and was becoming frustrated by what he saw as Chim's excessive caution. In August 1955 he circulated board members with a proposal to greatly increase the size and scope of the agency, again threatening to resign unless he got his way. Chim sent him a cable asking him to 'soft pedal everything' until there was an opportunity to discuss his proposals at the upcoming annual meeting. George Rodger was similarly alarmed and expressed his concerns in a letter to Morris dated 5 September:

I do think you are trying to do too much and Magnum itself seems to be growing into a great big beautiful thing that, as far as I know, none of us on this side particularly wants to have. To me, it is already hardly recognisable. Progress and development is fine, of course. But it is the direction it is taking that worries me. After all, this syndication business is a form of commercialisation that is foreign to Magnum and the cost of it is frightening. Has there really been time for a thorough financial checking? It all seems to have gone so fast. That is why I let Chim add my name to his cable asking you to soft-pedal everything until there had been a chance to discuss it all in conference. I really do think that Chim and Henri are right and that something of that magnitude, that involves us in so much expense, should be explored much more carefully before we commit ourselves. But it already seems to be too late for that.

Do you remember, John, way back, when I first spoke to you in New York about your joining Magnum, and you told me your only misgiving was that you were no business executive – that at LHJ you never had to think of costs and financial matters? That was a doubt in your mind. There was, at the same time, no doubt in anybody's mind that you were one of the top ranking picture men. What worries me now is that you have so much executive business that I don't see how you can possibly have time to look at our pictures.

So please, please, John, be careful and don't expand us to bursting point. Of course it would be good to have our incomes increased, but surely there must be ways of doing it without having to risk so much. Larger premises, high salaried personnel and so much of your time, seems so costly ... Don't read anything into this that isn't meant to be there. My confidence in you is as high as ever. I just wish you wouldn't try to do so much ...

With love from us both, George.

Morris's confidence in Magnum was undoubtedly boosted by 'The Family of Man' exhibition, which opened at the Museum of Modern Art in New York in January 1955. The most popular and acclaimed exhibition of photography ever assembled, no less than 14 per cent of the exhibition's 503 pictures were credited to Magnum members, past and present, more than any other publication or agency with the exception of *Life*, which was given credit for all the pictures it had published, whether by staff photographers or not.

At the board meeting held in Paris between 17 and 24 September 1955, Morris's expansion proposals were quietly sidelined without prompting his resignation and approval was given to a new 'Member Photographers Agreement' with twenty-two clauses binding the photographers and the agency to each other and setting the agency's cut of fees at 36 per cent. At the same time, stringent new guidelines were drawn up for joining the agency. Capa had tended to invite anyone who took his fancy to work for Magnum and even after his death the recruitment was haphazard in the extreme. But in 1955 the board set up the procedure that exists to this day – a requirement for aspiring members to submit portfolios of their work for approval at each stage, from nominee through associate to full member.

René Burri, who joined Magnum that year, just slipped under the wire. Born in Switzerland in 1933, Burri drifted into photography from art school and attended the same college as Werner Bischof, who was by then something of a hero and would occasionally visit to lecture. When he graduated, Burri took his pictures to show Bischof and received a gratifying letter from Bischof saying he'd shown Burri's work to Capa, Chim, Haas and Cartier-Bresson and they had all liked it. Bischof advised him to keep working and promised to contact him when he returned from his forthcoming trip to South America. When Burri heard on the radio that Bischof had died he worried that his photographic career was over before it had begun, but he continued taking pictures and occasionally had them published. Towards the end of 1954 he photographed a Picasso exhibition in Milan, mounted the pictures himself, wrote an accompanying text and had it published as a small booklet. With the optimism and enthusiasm of youth, he decided that Picasso would like to see it and so he hitchhiked to Paris from Zurich and knocked on the door of Picasso's office. The artist's secretary came out to ask Burri what he wanted and told him it was impossible to see the great man. Burri called every day for a week before he finally accepted that he was not going to get to meet Picasso, but tried to make something of the trip by calling at Magnum's office on the Faubourg St Honoré. 'I introduced myself to a secretary sitting at a desk in the

tiny apartment with a little elevator and finally, a woman came and said 'Yes, I heard your name, Werner mentioned it,' and she looked through my pictures and said they were very nicely printed up. It took her about thirty seconds. Then she asked to see my contact sheets and she looked closer, took a yellow pencil and marked some and said, 'Print these up for me.' I left, thinking she had only done this to get rid of me and so I sent them and about two months later I got an envelope, opened it and pulled out a copy of *Life* magazine. I wondered why they had sent me a copy of *Life* and there were my pictures with the credit, René Burri, Magnum. It was a while before it sank in.'

Through Magnum, Burri met and fell in love with Bischof's widow, Rosellina, whom he would later marry, taking on Werner's children as his own. Rosellina was close to Cartier-Bresson and the three of them were walking along the Seine one cold winter day when Burri took a photograph of Cartier-Bresson. Cartier-Bresson was not pleased and wrote to Burri asking him never to do such a thing again. But their friendship survived, probably because Burri did his best to emulate Cartier-Bresson in every way, using the same camera, driving the same car and copying his technique. 'I learned a terrific amount from Henri, just by being around him and observing him. I would produce contact sheets for him to critique. I remember him turning them upside down to study the composition.'

Chim, meanwhile, was clearly feeling the burden of his administrative duties as president. On 1 December 1955 he was obliged to circulate a detailed four-page letter to all members explaining the new stockholders' and photographers' agreements and the new by-laws. 'It took a long time to put together all these important looking papers,' he began, 'but finally here they are, duly enclosed. Some of the formulations may seem complicated and obscure but these are the results of legal minds and, apparently, are needed for legal reasons. Please do not be unnecessarily disturbed by them.' He ended with a rally-the-troops plea: 'Our future experience will prove the validity of our concepts and we will be able to correct them with all the feeling of goodwill and respect for each other, which is the base of our organisation. So come in and let's work together for a better future and a better MAGNUM. Sincerely, David R. Seymour.'

In September 1956 Rodger wrote to Henri Cartier-Bresson suggesting that Chim should be put on the payroll.

I would like to ask your opinion about Chimsky. Do you know if he has been getting any financial compensation for all the work he

has been doing on behalf of us all? I wanted to talk to him about this when he was over here but thought I would wait until I had asked you about it. I feel that Chim's work – his executive work – is vital to all of us and to the continuance of Magnum as a whole . . . I would like to suggest that we ask Chim if he would devote a percentage of his time to Magnum executive affairs in return for a fixed salary. (Not the fantastic $12,000 that was voted to Capa, but something in relation to his earnings.) This should also include one trip to New York each year expenses paid. Chim is the only person who can look after our financial and business interests and can keep John from being too expensively ambitious. We can ensure his dominance over John by voting him extraordinary presidential powers. This is not because I distrust John. I have full faith in his integrity. But I do not have confidence in his judgement and, though he is excellent editorially and in the promotion field, he lacks the ability to weigh up the business possibilities of his pet projects and could easily wreck us by being, in all good faith, over ambitious or not far enough sighted. Chim weighs everything up meticulously and is gratifyingly cautious over financial matters. Let me know please what you think.

On 22 October Chim wrote to Rodger from the Hotel Inghilterra in Rome, expressing his desire to talk things over with Rodger before the annual general meeting in November and admitting that the burden of presidency had occasionally been heavy: 'My executive functions were more involving in the past year than you could realise from the outside. Also they were more frustrating than you can imagine. But there is no doubt we are coming to the meeting in a good, healthy state, without crises which usually took up all our time and attention in past meetings. The problem of new members is less acute now because after the growing up period, having reached a level of organisational importance which makes our global operation possible, we can be extremely selective and slow in accepting new members . . . The main problem right now is to take a hard look at all the problems of all of us as individuals and figure out how our organisational set-up should function in service and support of Magnum members.'

The Middle East was rarely out of the world's headlines during the last six months of 1956 and Magnum was heavily involved in events there. René Burri was on an assignment in Prague for the *New York Times* when, in July 1956, the Egyptian leader Gamal Abdel Nasser

proclaimed to a cheering crowd in Alexandria that the Suez Canal had been nationalised, symbolising for Egyptians the liberation of the country from British imperialist influence. Chim telephoned Burri from Paris and told him to get to Egypt as quickly as he could, since he had a Swiss passport and was most likely to be allowed into the country. Burri managed to get on the last tanker through the Canal, and to smuggle his film out with a Swissair pilot. He was delighted with his ingenuity until he got back home to Zurich and discovered the film had been delayed. 'I had Chim screaming at me over the telephone, warning me never to darken the doors of Magnum again. "I don't care if you have to swim, crawl or walk," he shouted, "but you must never miss a deadline."'

With the world's attention focused on events in the Middle East, the Soviet Union took the opportunity to crush the uprising in Hungary, where the reformist prime minister Imre Nagy had promised to introduce democracy, and the people had taken to the streets to fight the occupying Russian Army. Erich Lessing was one of the first photographers to get into Budapest after the uprising began in October. In a car borrowed from a friend he drove from Vienna towards Budapest, was stopped about forty kilometres outside the city but managed to talk the Russians manning the roadblock into letting him through. He stayed to the bitter end, until Russian tanks rolled into Budapest, smashing through the barricades on 5 November and the world listened with horror to that unknown voice on a crackling radio: 'Help Hungary . . . help . . . help . . . help.'

Lessing recalled the bizarre routine for journalists covering the uprising: 'Street fighting is not like war. There were about five or six hot points in town where you knew there would be fighting, so you would go to one of them in the morning and when you had had enough of bullets flying around you would go back to the Duna, the former Bristol Hotel, for lunch, where everybody would ask you what was going on and the waiter would come up and say "Mr Lessing, we have an absolutely perfect goulash on the menu today." Life continued in the hotel as if nothing was happening and after lunch you went back to the fighting.'

Like all the correspondents in Hungary at that time, Lessing felt a deep sense of personal commitment to the story and he was so appalled at the way his pictures were used by magazines in both Europe and the United States that he eventually turned his back on photo-journalism. 'I did not want to cover any revolutions or any wars any more [after Budapest]. It makes no sense. I had thought, Capa said so too, that by taking pictures we were showing what the

world is like, that you can at least in a small way influence behaviour and the course of politics. But every journalist in a shorter or longer time knows this is not true – the most horrible war pictures will never end wars. By showing revolution you do not help the revolution nor do you do the contrary, you just document it. I'm not even so sure – though it would be anathema to say it – that it's so important to document it because that doesn't change anything and I am not sure that a document that doesn't change anything is a valid document.'[14]

The Suez crisis rumbled on all through that summer until, in October, Israel mounted an attack on Egypt, dropping paratroopers and crossing the border in armoured units. Burt Glinn was returning to his room at the Hotel 52 on 52nd Street in New York as the night clerk was listening to the news. 'I was young enough to know I should move really fast. I knew someone at El Al and telephoned him and told him I wanted to get on the next plane to Tel Aviv. This was about two o'clock in the morning but the office was manned because they had heard what had happened. I got the last seat on the plane and got to Tel Aviv in time for the last two days of the war. It was a silly war; journalistically most wars are silly. When I got up next morning I was exhausted and did not know what to do, but in the lobby of the hotel was a sign "All journalists going on the Suez Canal trip should pick up their picnic lunches."

'I hooked up with a journalist friend, Homer Bigart, who worked for the *New York Times*. Homer was a very courtly man, not like a dashing war correspondent at all. He always wore a jacket, stuttered a bit, and worried about strange things like getting Vitalis hair tonic and baseball scores while he was on foreign assignments. Nevertheless, he was a great correspondent. He said there was no point in going down to the Canal Zone with all the other journalists, so we found a map and looked for a place that hadn't been captured and decided to go to Gaza. We had a lot of difficulty finding a taxi driver willing to take us but we eventually found a taxi with Hebrew writing all over it. The driver's name was Shlomo and we had to promise to buy him a new cab if it was destroyed. So we set off and could soon hear gunfire and realised we were in Arab-held territory in an Israeli taxi covered with Jewish writing. Shlomo was pretty uneasy and kept looking over his shoulder to see if we wanted to turn back, but we kept going. We were probably very foolish, but for us it was a great adventure.

'On the outskirts of Gaza we suddenly found ourselves surrounded by Arabs. We stopped the cab and got out, very nervous, but discovered the Egyptian Army was nowhere in sight and most of

the Arabs around us wanted to sell us cigarette lighters with Nasser's picture on them. One small boy with glaucoma eyes tried to sell Homer a terribly cheap carpet but he just patted him on the head and said he didn't think he would buy it because he was sure it would never fly.

'We walked into Gaza just as the Israelis had taken the city. We were right on the spot and I got some of the few pictures of the war. I remember Bob Capa telling me that the greatest secret about taking pictures in a war is to get up in the morning, decide what you are going to do and do it. He said you can always talk yourself out of going down a road, but if you commit yourself and go, you'll get your pictures. That trip to Gaza proved he was right.'

Glinn's flight to Tel Aviv had stopped off in Athens where, to his surprise, he had found Chim in the airport bar, trying to get to Cyprus. Chim had been in Greece to photograph the lighting of the Olympic torch before it made its way to the Games in Melbourne, but now, always emotionally close to events in Israel, he wanted to cover the war and had told friends he was hoping to find a jeep and drive across the Sinai desert. 'I talked to Chim on the telephone in Nicosia,' recalled Erich Lessing, 'and I said to him please don't go. It's stupid, it makes no sense. It's not going to work out, don't go. We'd had enough deaths, you know, and I thought the whole thing made no sense. So why get into a crossfire, it was a badly organised story from all sides. But Chim desperately wanted to do it, physically he wanted to prove to himself and to everybody else that he could do the same thing as Capa. It didn't work out.'[15]

By the time Chim arrived in Port Said the fighting was over. He photographed the mopping-up operations and civilian life in Port Said – among his last pictures was that of a small boy running from an enormous tank in the streets – and with the truce supposedly in force he went off with *Paris Match* photographer Jean Roy in a jeep to cover the exchange of wounded. A British lieutenant-colonel saw them barrelling down the road, flanked by Suez on one side and the Sweet Water Canal on the other. He waved to them to halt, but the driver of the jeep gave the V for Victory sign and roared on. About 1,000 yards further on they came to an Egyptian outpost. The Egyptians claimed later that an officer had 'risked his life to halt the jeep' but it did not stop and a few yards further on a machine-gun opened fire. Chim and Roy were killed instantly and the jeep plunged into the Sweet Water Canal. It was 10 November 1956, ten days before Chim's forty-fifth birthday.

Late that Sunday night a telephone operator finally reached John Morris in New York. Burt Glinn was on the line from Israel, very

excited. Morris could hardly understand him and said 'Calm down, your photograph of the Israeli soldier is on *Life*'s cover next week.' 'You haven't heard,' said Glinn. 'Well, brace yourself. I think Chim's been killed.' Then he read the Reuters dispatch. Twenty minutes later another call arrived from Trudy Feliu, Magnum's bureau chief in Paris, saying that Chim's death had been confirmed by the French Ministry of Defence.

Time correspondent Frank White wrote to Trudy Feliu to tell her what had happened: 'We joined forces in Athens. David had been up at Mount Olympus shooting the Olympic torch ceremonies and in general seeing Greece again. He was very fond of the country. But the problem of the moment was to get out of Athens. We were all fairly desperate to catch up with the action. Most of us were trying to get to Israel. Transportation in that direction proved impossible. We then considered trying to get to Cyprus and from there tying up with the Franco-British invasion force. Dave joined the rest of us in chartering a Greek Airlines DC-3 for Cyprus. We stayed at the Ledra Palace hotel in Nicosia. The place was a madhouse of frustrated correspondents. Characteristically, David was cool and reserved, spent his time studying dispatches, evaluating what was going on elsewhere, appraising events. Though there was nothing in it photographically, he attended all the allied briefings. Before dawn Monday morning, he covered the take-off of French paratroop forces and later that day the return of the transport pilots. On Tuesday, *Newsweek*'s Ben Bradlee, David and myself negotiated ourselves a flight to Port Said on French Admiral Barjot's plane. Our accreditation with the French forces came through that night and we left by plane for Port Said early Wednesday morning. Though we were not with the original invasion forces, we were in Port Said well ahead of most correspondents. Almost immediately, Bradlee, Dave and I picked up on *Match*'s Jean Roy. Roy was a professional freebooter first; a photographer second. He'd liberated two jeeps and a truck, procured gas by signing chits over the name 'Pétain, maréchal de France'. He offered to show us the remains of Port Said. The three of us took him up. For the next 40 hours or so, Roy drove us through the streets of Port Said. There were dead bodies all over, food riots, some sniping, prowling allied tanks, patrols and a seething, starving mass of hostile Egyptians. Dave must have known what he was letting himself in for, Ben Bradlee and I made no secret of the fact that we were scared to death. But David, the quiet rational man, the intellectual, the man whose family was wiped out in Warsaw, said nothing. He just kept on making pictures. I remember many occasions when we had driven up to particularly nasty food

riots, areas where French and British troops had not yet been but where we had been warned that everybody still had arms. Dave would have already made two, three or a dozen pictures of the scene, but in each case David kept shooting in spite of our entreaties to leave. When making pictures he seemed to be an entirely different man. He kept saying "This is a great story". I got the impression that he felt this made him somehow impervious to risk. Later on Thursday Bradlee and I left Roy and David together. They were already talking about going down to the Canal. Bradlee and I had to get out to Cyprus to file.'

White said that Chim was to be buried in the British cemetery at Port Said as it was impossible to bring his body out at that time. The problem was that there were no coffins available but the Paris office contacted *Match* and asked them to use their influence to send two coffins to Port Said. *Match* put pressure on the French government, as a result of which the French Navy agreed to send two coffins from Cyprus to Port Said. The bodies were returned by the Egyptians on Wednesday, 14 November at about 5 p.m. Military honours were bestowed and a small group of correspondents gathered outside Port Said at the British cemetery for a service. The British didn't know Chim was a Jew and so his friend Bill Richardson of the *New York Post* spent the rest of the afternoon searching the Muslim city of Port Said for a rabbi, finally finding the only one administering to the forty or so Jewish families still remaining.

Richardson later wrote a moving tribute to his friend:

Chim was one of the quietest and gentlest of men, whose enormous compassion translated itself through a camera lens into some of the most human and touching pictures of our generation . . . It was so ironic that it should have happened here. Chim's speciality was not war. Not because he was not a very courageous man, for he was. But when those who had known him well for 10 years and more heard the news, two pictures flashed through their minds. One was that of Chim himself, a small figure, bespectacled and with the most gentle eyes and a quiet way of speaking that fortunately never mastered the harshness of New York's accent. And that second picture, of a small child with the poverty of postwar Greece written on his face and features and on his frail body. Before him, shining and secure, was a pair of shoes – just a pair of shoes, but this was something more momentous in his pathetic little life than anything he had ever known. For he had never owned a pair of shoes before. The Nazis saw to that. And the bright pride and confusion and happiness was something one

could never forget. Only a man of very great faith in man and compassion could have taken that picture. And although Chim had photographed armies and the great and glamorous of Paris and Hollywood, those who knew him well will always carry that image of his picture of a child victim of oppression who had finally got his first pair of shoes.[16]

Ironically, Chim died on the day originally scheduled for the annual meeting. He had postponed it because so many photographers were away covering events in the Middle East and Hungary. A grieving Cartier-Bresson sent a note round to all the European photographers: 'I will not express here any word on our feelings; we share them all as your own cables and telephone calls have proved. Although deeply shaken, Trudy and the whole Paris office have carried on quietly what had to be done immediately, while we asked all photographers to continue the work they had started. The Magnum meeting will take place in due time and everybody will be kept informed. In the meantime, we will continue in the spirit we *all* have started. Henri.'

'David was basically an unhappy man,' said his sister, Eileen Schneiderman, 'torn in himself and lonely despite the glamour of his career and the many friends that he made wherever his assignments took him. He never married, and only shortly before the end of his life did he establish a semblance of a home in Rome, in an old palazzo at the Via degli Orsini, where he began to assemble his books, objets d'art and trophies from his travels.'[17]

LETTER from George Rodger to John Morris dated 3 June 1954, from an address 'In a swamp, The Sudan':

My dear John,

I think that in three or four days there may be an opportunity to mail letters again, so I am writing this in the hopes that occasion really will arise. Of course we should have been in Beirut now had it not been for the strike which the Sudan Railways insist was an Act of God and not their responsibility. We were strikebound for 15 days in that little tropical cul-de-sac called Juba. We tried every way to escape but without success. We planned long detours by truck to the sandy regions of Darfur to escape the swampy territory to the north. But the waters of the Bahr el Arab, swollen by the rains, cut the route and we had to abandon it. Rain on the cotton soil between Mongalla and Bor successfully blocked that route also. Then the main road to East Africa, by which we had come, was cut when the ferry across the Nile ran aground and broke its propeller. That was the last avenue of escape and, with its closing, there was nothing we could do but resign ourselves to the heat and the humidity and the stench of our equatorial prison.

This became so boring that we decided to enliven things by going on a white rhino hunt. The white ones are bigger and better than the black ones, weighing between three and four tons each and standing about six feet at the shoulder. I was fairly successful with these but could not get closer than some 25 yards and stalking them through the heat of the day after a nine-mile hike across rough country covered with thorn scrub took the edge off my original exuberance. The very first one charged when the click of the Contax gave my position away and this is very upsetting when there is nothing but thorn bushes around and no trees to climb. Unfortunately, the native tracker who was with me spoiled the head-on picture by dashing out in front of me and, in the general noise and confusion, the rhino sheered off, never to be seen again. However, there were better things to come because, going round the edge of an anthill, I met a very large bull rhino face to face. I don't know which one of us was the most surprised. I knew he was there because the tracker and I had gone up to the anthill which was directly in the path of the rhino and down wind of him, hoping to intercept him. He came right up to it, on the opposite side from us and, when I heard him moving round, I moved round too. Unfortunately I misjudged his direction and that was how we met – face to face. Now that is a very terrifying thing. I had the impression of being faced by an irate mountain with something like the spire of Cologne cathedral stuck on one end of it. If he'd just put his head down and taken two paces forward, I would

have been a kebab. Instead, he snorted at me and his breath smelled sweet and musty like a cow that's been eating silage. He made a few passes with his horn, just stropping it I thought in preparation for the slaughter, stamped on the ground and kept letting out stertorous blasts through his nostrils . . . I think the old stinker was just trying to frighten me the way he carried on but I gambled on the fact that all rhinos are very short-sighted and, even at a range of ten feet, he might think I was a tree trunk or something if I didn't move. So I stood very still and managed to get his portrait in colour before the action started. My native tracker, knowing more about these things than I, saw that he had made up his mind at last and, taking up a hunk of rock, hurled it full at his face, thereby getting in the first punch. By good luck this hit him with a loud crack right on the horn and probably upset his line of thought. He backed away and then set off into the bush making an extraordinary noise like an express train going through a tunnel. Now if this picture is OK it is just what I needed to make up my big game story . . .

We are now hoping to reach Cairo about June 15, with luck, and Beirut a few days later. You can reply to this by return to Beirut but don't write any later or you will miss us. We don't want to stop longer in Beirut than absolutely necessary.

Please send $1,000 to Beirut – Bank de Syrie et Liban.

With much love,

George

7

The Saga of Eugene Smith

ON 5 APRIL 1955, Magnum Photos distributed a press release announcing with considerable pride that W. Eugene Smith had joined the agency. Smith was widely acknowledged as a genius, the master photo-essayist of his generation. He was a big, barrel-chested man who declared that his mission in life was nothing less than documenting, in words and photographs, the human condition. Unfortunately he was also troubled and troublesome: mentally unstable, temperamental, addicted to drugs and alcohol and fiscally irresponsible. It is now part of Magnum legend, although not quite true, that during his brief association with the agency he brought it to the brink of bankruptcy.

John Morris is generally blamed for recruiting Gene Smith into Magnum after he walked out on his contract with *Life* magazine: 'I admired Gene very much. We'd worked together at *Life* before the war. When a British cruiser intercepted a German passenger liner in mid-Atlantic in 1939 the captain gave orders for her to be scuttled and everyone on board went over the side into lifeboats. They were picked up by the British and brought to New York to be interned on Ellis Island. I was sent over to interview them with Gene Smith. We took the ferry from the Battery and joked about it being our first overseas assignment.

'When he quit *Life* I knew he would come to Magnum and I was happy to have him. He was the kind of photographer Magnum admired, a very serious and dedicated photo-journalist, but I didn't realise how profoundly troubled he was, that he had been in a mental hospital. I suppose I should have known, but I didn't. I also didn't know how profligate he had become, or that he didn't really want to do routine stories any more.'

'Everybody knew that Gene was a costly friend and would be a costly member as well,' said Ernst Haas. 'People at Magnum are very

good people. They loved Gene very much, but you see, within the organisation, it is a problem to have difficult people.'[1]

Cornell Capa claims that Morris pressured Magnum's conscience, pride and tradition to persuade members to accept Smith: 'Eugene Smith tested Magnum. He tested John Morris, he tested the photographers and he tested the organisation without ever really integrating.'

'He was kind of whacko and off the wall,' said Burt Glinn. 'But he was worth dealing with if you could. What was difficult was the fact that no one *could* deal with him. It was said of Gene that the worst thing you could do for him was to do him a favour, because he will resent you ever afterwards.'

'We wanted to embrace him because he was a true colleague in the best sense of the word and a great inspiration to us all,' said Dennis Stock. 'The great, great stories were done by people like Smith because he felt a responsibility to the subject. We would have given him anything he wanted if we could possibly afford it, but he was a loner. I think we just parted like a marriage that doesn't work out, that's all.'[2]

W. Eugene Smith – he liked to joke that the W stood for 'Wonderful'; actually, it stood for William – was born in Wichita, Kansas, in 1918, and grew up during the Depression, when drought turned Kansas into a dust bowl and ravaged the economy. He started taking pictures at the age of fourteen with a Brownie borrowed from his mother and thereafter wanted to do nothing else. His father, formerly a successful grain dealer, was ruined by the drought and shot himself in a hospital parking lot when Eugene was eighteen. In a desperate effort to save his life, the hospital asked Eugene to give a transfusion direct into his father's body, but the older man died while they were still connected. Afterwards, Smith drove to Wichita High School to complete an assignment for the yearbook and only when he had safely taken his pictures did he faint. Work, thereafter, would always take precedence over every other event in his life.

Smith was devastated by his father's suicide: he dropped out of university and headed for New York, where he found a job with *Newsweek*, but he was fired because of his dogged insistence on using a small camera. In 1939, at the age of twenty-one, he was offered a contract with *Life*. It was the magazine every aspiring young photographer dreamed of working for, but Smith was singularly unimpressed and was soon antagonising the editors by challenging their choice of his pictures, arguing about the way they were

presented and making no secret of his contempt for the superficiality of the assignments he was offered. In 1941 he decided his contract was too oppressive to endure a moment longer and he resigned, despite being warned by the picture editor that he was jeopardising his entire career and would never again be allowed to work for the world's most powerful picture magazine. Smith, who had by then accumulated more than 40,000 negatives, was blithely unconcerned, but realised he had made a mistake when, after Pearl Harbor, the United States joined the war. Despite a passionate hatred for war he desperately wanted to cover the action and *Life* would certainly have offered him the best opportunity to get overseas.

He first applied to join Edward Steichen's US Navy Photographic Group but was turned down after a final review by a committee of three admirals which stated: 'Although Smith appears to be a genius in his field, he does not measure up to the standards of the United States Navy.' It was, Smith quipped, a 'fine compliment'. In the summer of 1942 he finally got a job as a war correspondent with Ziff-Davis Publications and was sent to the Pacific. The stunning pictures he took during his first assignment prompted the editors at *Life* to swallow their pride and ask him to return. He refused three times, but was eventually persuaded and in May 1944 he returned to the Pacific as an accredited *Life* correspondent, producing some of the most powerful images of war ever to appear in the magazine.

Smith not only recognised the potential influence his pictures could exert, but also wrote prolifically about his craft. 'Photography is a small voice, at best, but sometimes one photograph, or a group of them, can lure our senses into awareness . . . Someone, or perhaps many, among us may be influenced to heed reason, to find a way to right what is wrong.

'Each time I pressed the shutter release, it was a shouted condemnation hurled with the hope that the pictures might survive through the years, with the hope that they might echo through the minds of men in the future, causing them caution and remembrance and realisation.'[3]

'In combat,' recalled Ed Thompson, 'he came to believe his mission was to make a statement against war itself.' By this time Smith was using prescription drugs heavily and was scaring his colleagues by the risks he was taking. 'Most certainly I did not cover this war to give people a thrill,' he would write later, 'and I certainly received no thrill from it myself. I wanted pictures of the emotions of war, that would reach and grasp people by the throat until the nature of war was forced into their thought channels – I wanted somehow to make those people think, and think enough until they

were determined that there should be no more wars . . . I must do everything that is in my physical and mental power to add my straw to the prevention or delaying of the next war.'

Despite himself, he also admitted to recognising the terrible fascination of war: 'Sensually there is something magnificent and beautiful in war – the slow jogging of these damp, helmeted men against the eerie light of flares, the silhouette of smashed buildings, the flame-throwing tanks with a burst of spectrum, the sight of planes falling before patterns of long tracers, the twinkling of anti-aircraft fire – these are magnificent sights until you think.'[4]

He was covering his thirteenth invasion when he was severely injured on Okinawa. 'I was . . . standing and composing a photograph of our men taking shelter behind rocks, in shellholes or wherever, during a mortar barrage. I was working the "accidental", waiting for the shell to fall that would complete the composition. Instead, the shell landed within a few feet of me . . .'[5] The blast smashed his camera against his face, breaking the roof of his mouth, and metal fragments tore into his left arm and upper back. He was flown to the naval hospital at Guam and repatriated to the United States to recover.

After the war Smith's reputation as a photographer grew rapidly. An exhibition of his war photographs at the Camera Club of New York in 1946 propelled him, in many people's eyes, into the mystical realm of genius. 'You make photography what it best is, heroic actuality,' a critic wrote to him, '[You] have a real grandeur, a terrible humanity, and an absolutely achieved reality.'

Back at the offices of *Life* in New York, Smith's increasing fame did not make him any easier to deal with: he wanted more money and was even less inclined to tolerate any restrictions on his freedom, although he indignantly denied being temperamental, explaining that he was simply attempting 'almost impossible heights of reportage'. Sent off on assignment to cover the life of a country doctor in middle America, he disappeared for weeks and ignored all the telegrams from New York ordering him to get back. He stayed for twenty-three days, following the doctor like a persistent shadow, at first 'photographing' without film in the camera so his presence would be accepted and eventually unnoticed. When he finally chose to return and was given a somewhat hostile reception, he flew into a rage, hurled all the prints into a wastepaper basket and stalked out. They were rescued, of course, covered many pages in *Life* and came to be regarded as a classic photo-essay, changing the course of photo-journalism from narrative to interpretive comment, documenting not just what the doctor did but who he was.

'I am an idealist,' Smith admitted. 'I often feel I would like to be an artist in an ivory tower. Yet it is imperative that I speak to people, so I must desert that ivory tower. To do this I am a journalist – a photojournalist. But I am always torn between the attitude of the journalist, who is a recorder of facts, and the artist, who is often necessarily at odds with the facts. My principal concern is for honesty with myself.'[6]

Ed Thompson thought that if Smith was sent to cover another war he would almost certainly be killed, and refused his demand to be sent to Korea. 'You can't prevent me from committing suicide if I want to,' he snapped. 'No,' Thompson retorted, 'but you can't do it on a *Life* expense account.'[7] Actually Smith frequently threatened suicide, particularly when he was broke. The editor of *Popular Photography* once lent him some money to dissuade him from killing himself and was disagreeably surprised to find him at an American Society of Magazine Photographers function a few days later, spruce in a tuxedo and in apparently high spirits.

In 1949, after completing another unforgettable photo-essay, on life in a Spanish village, Smith suffered a nervous breakdown. He was found wandering in Central Park and sent to Bellevue hospital. Ed Thompson got him transferred to a private clinic. Everyone who knew Smith was convinced that he saw himself as a tormented, saintly, martyr-hero figure suffering for his art. It was a role he played to the hilt: he drank to dangerous excess – usually a bottle a day – and became addicted to amphetamines soon after the war. Nothing, not children, not wives, not lovers, not editors, was allowed to interfere with the single grand obsession of his existence – his work. He felt personally responsible for the strength and integrity of his pictures and fought constantly for more control over their selection and layout.

In 1954 Smith was sent to Africa to photograph Dr Albert Schweitzer's leper colony at Lambaréné. He became, as always, completely obsessed with the story, viewed Schweitzer as a man cursed with mortality and a reputation for greatness and returned with strong views about how the story should be presented. When he discovered that two pages of the twelve originally allocated for the story had been dropped, he promptly resigned.

Ed Thompson never really wanted the Schweitzer story anyway. 'I was cool to the idea because the subject had become a kind of cliché. Gene wanted so badly to portray the doctor that I agreed he should have a chance. Schweitzer did not turn out to be the father figure for whom I think Gene yearned. He was autocratic and obstructionist. Schweitzer, upon receiving a written Smith threat to

leave, gave Gene more leeway, and the focus shifted more to the leper colony and the village around it. By this time Gene no longer trusted the excellent *Life* photo lab to make prints. He was taking weeks of night and day work, and finally only produced his prints after we heard rumours that *Look* was scheduling a Schweitzer story.'

None of the layouts we made satisfied Gene, so I decided we couldn't go on pasting up photostats forever. He later said 'I would have preferred silence to what appeared'. He did not demand silence at the time. I had told Smith that we would give the essay twelve pages. We didn't often have twelve pages of space available, though, and one week, when I was away, my deputy found ten pages and used them for the Schweitzer essay. The dropping of two pages was an insult to Smith and he resigned immediately.

Apart from this fairly typical reaction, the real problem was that he had come to think, he said, that Schweitzer should have been only the departure point for 30 to 60 pages, or perhaps an entire issue, on Smith's yet-to-be-photographed Africa. He wrote to me: "I believe it to be my misfortune that you were not present" but that was nonsense. I was convinced that he was about ready to leave the magazine anyway.[8]

Smith claimed that he was blackballed by all the major magazines after his second resignation from *Life* and succumbed to a bout of depression. In March 1955, John Morris telephoned and invited him to lunch, having previously convinced Cornell Capa that Smith should be invited to join Magnum. 'The problem with Gene,' said Morris, 'was that the only magazine that could support him in the way he had been accustomed to was *Life* and he had burned his bridges there. They were always ready to take him back, but he didn't want to go. So when Stefan Lorant came along and held out this promise of an assignment on Pittsburgh, I swallowed the bait, which was the stupidest thing I ever did. I had no idea, of course, that Gene was going to see this as so crucial in his life or that through this one story he was going to try to prove he didn't need *Life* any more.'

Stefan Lorant had edited a number of important magazines, among them *Weekly Illustrated* and *Picture Post* and was widely respected for his pioneering use of photographs. He had recently turned his talents to producing popular books, notably 'pictorial biographies' of US presidents, and had signed a deal with the Allegheny Conference for Community Development in Pittsburgh

to produce a book marking the bicentennial and industrial rebirth of the city. Over breakfast at the Westbury Hotel in New York Lorant told Morris that he wanted Gene Smith to be the photographer on the project and offered a $500 advance on a fee of $1,200. 'It was a ridiculously small sum of money,' said Morris, 'but he excused it by saying it was all his budget would allow, which was nonsense.'

Lorant had already been warned against using Smith by Ed Thompson, who had said 'If you want to have a headache, take him,' but he envisaged only one chapter of pictures and did not imagine that Smith would need to spend more than a couple of weeks in Pittsburgh, perhaps three weeks if the weather was bad.

No one could foresee that Smith would obsessively turn this mundane project into a mammoth photographic study of the city far beyond Lorant's requirements, or indeed the requirements of anyone. Instead of spending two weeks on location he spent five months; instead of producing no more than 100 pictures, he produced more than 13,000 and occupied eighteen months printing them. No one could foresee that the strain would bankrupt Smith, bring him to the brink of madness and dangerously drain the meagre coffers of Magnum. Ed Thompson later sourly characterised the Pittsburgh project as Smith's 'revenge on *Life*'. Smith's biographer, Jim Hughes, described it as 'the central photographic essay of his life'.

A Pittsburgh businessman and amateur photographer who was out of town offered Lorant the use of his house on Grandview Avenue, high up on Mount Washington, with fine views across the city. Lorant took the top two floors and offered Smith the ground floor, which conveniently included a darkroom in the basement. When Smith arrived in his big green station wagon – he called it Ophelia – and began unpacking one trunk after another, including a gramophone and a collection of records he would play at full blast all night, Lorant did permit himself to wonder why he needed so much gear. 'I said to myself "This fellow comes for two weeks?"'

Smith devoted the first month of his stay to research, reading books about the city's geography and history, wandering the streets, exploring the highways and byways. He took very few photographs but was already somewhat at odds with Lorant. The problem was that Lorant had clear ideas about what role he wanted photographs to play in the book, what pictures he wanted and what he wanted them to say. Not long after Smith arrived, Lorant had handed him an itemised list of his picture requirements not dissimilar to the shooting scripts Smith had been given at *Life* – he treated both with equal contempt. They would never resolve their differences, because

fundamentally Lorant only wanted a competent photo-journalist to produce competent photographs. Smith did not want to produce competent photographs: he wanted to produce art.

For a while, relations remained civil, as Smith explained in a letter to John Morris on 20 April: 'This project goes slowly and is yet not well. Although there are slight indications that Lorant and I are with differences in directions and intent, so far the relationship has been pleasant. It is going to take at least four more weeks to finish here, damn it.'[9]

Since there was no indication when Smith was likely to be available for other work, Magnum cancelled the jobs it had tentatively lined up for him and began turning down other potential assignments. Smith wrote to his brother Paul on 1 May: 'They keep calling me about potentials, yet I cannot accept them until I can complete this damn job, which I shall complete properly if it is literally the last one I ever do . . .'

Getting his own back on *Life* was still very much on his mind:

Ultimately this story financially will be quite profitable and further will prove to *Life* that I can do it without them. And this will make it more likely that they will be willing to pay my demands in both money and control of pictures. They think I will wilt and come creeping back, and this I will not do for *Life* or life, because it would mean defeat and they would leap to their advantage to twist my integrity into mockery, making me weaponless and setting photographers as a group considerably back. If I can stick it and make it – and damn it I can – they need not know of my dragging arse and quivering guts.[10]

Smith soon found he needed an assistant and hired the services of a young man named Norman Rabinovitz he had found working in the Pennsylvania Room at the Carnegie Library. Rabinovitz: 'I spent four or five hours a week for a period of about two months going around with him. We spent a lot of time not shooting but doing a great deal of talking. At the time, he seemed very disillusioned with the stories people had made up about him – I think he felt he could not live up to them. He carried with him an article from his local newspaper which he used to explain to people his feelings about himself. I did not act as a photographic assistant, but only as someone who knew Pittsburgh and could get him into places. But I watched him photograph. One evening I went back with him when he processed the film. After it dried, he took it to the light table and chose the three or four frames he wanted to use. He had a

remarkable eye. He could look at his negatives for a day's shooting, or a week's shooting, and clip out the frames he felt said what he wanted to say, and just discard the rest in the wastepaper basket.'[11]

By this time Smith was taking large quantities of Benzedrine to help him work round the clock and he was suffering from alarming side-effects, as he explained in a letter to his brother on 17 May:

As I was loading film in the dark, or faintly green-lit room, I suddenly realised I was standing strange, that the top of my body was bent almost sideways parallel to the table, and that I was having clumsy difficulty loading the film . . . I forced myself upright, forcing greater concentration, and tried to continue . . . It became a horrifying experience, of me knowing the mechanics of what I was doing, with difficulty and fogged effort of concentration – and a kind of amnesia, or hallucinations, or something, for I could remember what I was doing (mechanically), but a strange unawareness of where I was, what place and for whom, and why, and the place, the basement, and a hundred vague locals, there were people surrounding me – just vaguely, talking to me, or making walking sounds upstairs, or somewhere expecting me. These people, all of my life, my family, my subjects, all somehow from the fusion of my history, more of them dead, frequently and almost invariably needing something from me, or of my obligation, or of my love. And I kept on trying to load, and trying to realise where I was; slowly sorting out that this person was dead, that person had [passed] out of my life, that these were my kids and couldn't be here. And that vaguely, tomorrow, I had to be doing something with great urgency. This kept on, I couldn't straighten out people, or place, or situation. Strange movements flickered in the faint green light and I slowly analysed that it was the room moving and in the fog dream reality . . . I felt it likely that I was going to die. Perhaps I did, for I was lying on the floor, looking at the near bright spot of the green safelight . . . Somehow I got upstairs, somehow I wrote the farewell apology for my failure, to I think especially the kids, and somehow I got almost all the way into bed.[12]

On 20 May Smith's station wagon, parked near the Mellon Institute, was broken into. Five cameras, ten lenses, and a box of exposed film addressed to his wife, Carmen, were stolen. Smith wrote a strange, despairing, mad letter to his brother Paul the following day:

Tra-la, tra-la; tra la, la, la: now is the time to dance to the bend-

me-yea. Tripping, tricking, balls kicking fate – cameras, lenses, oh yes what a fate. Now is the time to dance to the bend-me-yea. Broken locks, a taken box, a month's work gone – hey pay, say gay, me for a hunk of clay. This night, is a night, oh yes, a night, oh what a night, yes what a night – this week has been. Yea, yea, now is the time to dance to the bend-me-yea. Nay. Laughter, laughter, shroud the tragic, and whimsy be thy name. Fate, it not only reigns, but it gores. Ah yes, that film that working the nights into long days I did develop, I did complete, and from exhaustion I did collapse. That film (the second half of it, about 500 pictures) all packed and boxed and ready for mailing, was stolen from my car yesterday.[13]

Local newspapers and police were asked to send out urgent messages asking for the film not to be destroyed, but to be returned anonymously. An empty camera bag was recovered from a trash can, but no film. Two of Smith's Leicas turned up in a pawn shop, although he was forced to suffer the indignity of buying them back for $40. One contained a roll of partially exposed film with a number of pictures which the thieves had stupidly taken of each other. They were eventually arrested and the rest of Smith's equipment was recovered, but the exposed film was never found, despite a search of the city dump ordered by the mayor and carried out by a team of luckless sanitation workers with rakes and shovels.

On 31 May Smith wrote to Inge Bondi: 'I must continue with this Pittsburgh project from nearly halfway back to the beginning.' In the same letter he turned down a $1,000 fee to photograph television personality Arthur Godfrey for the *Saturday Evening Post* because he was still involved in Pittsburgh. He also didn't like the fact that the *Post* insisted on keeping the negatives, regarding them as an integral part of the purchase. As he explained to Bondi: 'Negatives are the notebooks, the jottings, the false starts, the whims, the poor drafts, and the good draft – but never the completed version of the work . . . The completed version – a print – should be sufficient and fair return for a magazine's investment, for it is the means of fulfilling the magazine's purpose . . . Negatives are private, as is my bedroom, my children, and my prints may be gazed at by the public, if they care to do so.'[14]

Anxious to make up for the missing prints, Smith would work every day on location then spend most of the night developing film, with music blaring at full volume, to the fury of his neighbours. Sometimes he went a full forty-eight hours without sleep, bolstered by Benzedrine. A friend occasionally came in to clean and cook for

him, otherwise his diet comprised largely dehydrated mashed potatoes and whiskey. What little money he had left, or was able to borrow, he spent on records, drink and drugs.

John Morris visited him in Pittsburgh and was worried by both his physical and fiscal health. 'I realised what trouble we were in when I saw what state Gene was in. He didn't appear to be in poor mental condition, or anything like that, and he talked well, making plausible arguments, but I was concerned nevertheless, despite his assurances that everything was going fine. The trouble was that we kept advancing him money and we didn't have any. At one point he was in debt to Magnum to the tune of about $7,000 and that represented most of our capital at that time.'

On 22 June Smith was obliged to leave the Mount Washington house and sent Lorant a cheque for $75 to cover his telephone bills with an explanatory note that 'exhaustion and the harassment of this project situation, and the really desperate financial situation, has made me delinquent in such details as keeping full and precise accounts of these calls – however, I would rather just pay them than to have them become a source of friction.' He moved into an apartment in Shadyside, for which he paid $180 in advance. A friend built him a darkroom in the tiny bathroom.

Lorant was understandably becoming concerned about the time the project was taking, but was more or less happy with the pictures and the fact that Smith appeared to be sticking to the script. The problem was, Lorant complained, that Smith would fall in love with everything, would go to take a picture at the Pittsburgh Screw and Bolt Factory and stay for a week. If the lighting was not right for an exterior shot, he used a compass to figure out where the sun would be at various times of the day then returned when he thought it would be better. Proud of his virility, he also liked to demonstrate his fearlessness. When he was photographing a blast furnace he was warned by one of the workers that when the plugs were opened, molten metal and gases would spew out and he would need to duck; on the contrary, he carried on shooting pictures apparently oblivious to the scorching heat. On another occasion he caused consternation by following steelworkers out along a girder high up on a construction site.

It was evident as the weeks passed that he was becoming possessive about the project and beginning to view the book as more his than Lorant's. He was shooting more and more pictures every day, everything from street signs to city council meetings, from union strikes to assembly lines. He sent a picture of himself to Lorant with the suggestion that it would be useful for the jacket.

Smith left Pittsburgh on 7 August in his station wagon, having borrowed more money to pay for new tyres and repairs, and returned to his wife and children in the family home in Croton, New York. He took back with him some 11,000 negatives, which did not include, of course, those he had already discarded. The editing was a mammoth, almost hopeless, task. On 22 August he wrote to Jaquelyn Judge, editor of *Modern Photography*: 'I sit here at a ping-pong table surrounded by the hundreds of contact sheets and each time I pick up a sheet to examine it and am reminded of one more good, above-valid picture that should be printed, I sink deeper in the desperate gloom.' In a letter to his brother he said: 'How I staggered and dragged through Pittsburgh and yet managed to accomplish this, I don't know. Yet the proof is here in this rich aura. I'd rather it be destroyed in its entirety if I cannot continue to complete it.'[15]

Lorant was desperately trying to get the book finished, commuting between Pittsburgh and his home in Lenox, Massachusetts, and getting increasingly frustrated at his inability to secure any prints from Smith. John Morris was also worried because he realised that Smith wouldn't be earning another cent until he had fulfilled his contract with Lorant.

To try and move things along, Morris decided to find a printer for Smith. Jim Karales, a young photographer from Ohio, had recently called at the Magnum offices to show his portfolio but had not found any work and was making plans to leave New York when Morris telephoned him and asked if he would like to earn $50 a week making prints for W. Eugene Smith. Morris claimed that most young photographers would give their right arm for such an opportunity; Karales was not sure he wanted to go that far, but agreed to take the job and was told he would probably be needed for about two weeks. Karales took the train up to Croton, was met by Smith at the railroad station and was given his two-year-old daughter's bedroom.

Karales's two-week assignment was extended week by week, then month by month. Before he left Croton he would produce some 7,000 perfect prints, which Smith edited down to a 'final selection' of 2,000 pictures to be enlarged and finished.

On 1 September, Smith asked Magnum for more money. He provided John Morris with a detailed list of his debts, which showed that he needed $6,466.25 just to settle the bills due at the end of the month. It included more than $850 in unpaid taxes, $538 for mortgage and loan payments, $1,000 owed to camera stores, nearly $700 for doctor and pharmacy bills and $900 owed in back pay to

their housekeeper. On 10 September, Morris cabled Chim in Paris requesting him to authorise a 'further advance' of $4,000 for Smith. Despite his concerns that the agency could ill afford to make such large payments to a member earning so little, Chim reluctantly agreed, but emphasised that no more Magnum money was to be loaned to him.

Smith did not want to be distracted by boring matters of finance and by now was talking of the Pittsburgh project in epoch-making terms. On 3 October he wrote to his brother: 'I shall create history . . . and influence journalism from now on. My immediate reaction is, who the hell, piss, shit, damn and crap cares! I do, a little, but it is secondary to a lot of other things . . . So I got no money. Tomorrow I need money . . . Tomorrow is a day and the living will be a lie, and the defeated are lost, will be as dead as the dead they are.'[16]

Later that month he applied for a Guggenheim fellowship, describing his project as a 'photographic penetration deriving from study and awareness and participation' aimed at transmitting a sense of the city's character 'even unto the spirit'. He made it clear he was months from completion: 'Unrelieved dedication in the darkroom in the making of the prints will require an unpredictable length of time.'[17]

In Magnum's New York office, patience was wearing thin. The agency's newest and most indebted member was self-evidently disinclined to tear himself away from his obsession with the Pittsburgh project just to earn money. At the end of September, Smith turned down two assignments in a single day, claiming the fees were too low. One was a simple advertising job for $500, the other was a major proposal from *Collier's* to shoot an eight-page essay on the theme of peace for its Christmas issue and for which the magazine was offering a handsome $4,000.

Smith apparently had no hesitation in declining the work, even though money was so short in the Croton house that there was sometimes barely enough food to put on the table for the children. Jas Twyman, the Smith's devoted black housekeeper, went out every day to work for other families in the town and split her $12 day's pay with Smith, despite her irritation that he always seemed to be able to scrape enough money together to buy bottles of whiskey.

When John Morris visited the Smiths at Croton he was so appalled by their plight he tried to renegotiate the original contract with Lorant, pointing out that Smith had only earned $500 for six months' work. Lorant was unsympathetic. He had paid Smith for two weeks' work and he had only expected two weeks' work. But, Morris responded, he has produced thousands of prints. Lorant said

he didn't care 'two hoots'. He didn't ask for thousands of pictures and didn't want thousands of pictures – just enough for the single chapter he had originally envisaged. It was not, he pointed out acidly, a book by W. Eugene Smith, it was a book by Stefan Lorant.

On Thanksgiving Day, Smith wrote Morris a long, rambling letter:

> ... I ain't nothin' but cold, grey and fogged, and bitter without sweets. I have lived my day, tried my trial, let me die, victim of the normal law which does not allow for transfiguration. Circus music is the theme, 'See the daring ox with bird-size wings try to thread the needle at a thousand prints an hour while doing a triple outside loop – all to be done in a Turkish bath.' Stretcher bearers standing by – stretch my strength, stretch it, stretch it mighty more than man. John Henry, give me back your hammer. I am the storm and I war with eternity, and there is no goddess as prize and I would protect the emptiness from the fiery dragons. St George, second floor, inside room – and a bottle of gin ... Camera, camera, what do you do – and I damn your eye, damn your wink, damn your memory – for with all of that you still can't think.[18]

Smith's published output for the whole of 1955 extended to just four pictures – a portrait of a black schoolteacher for *Ladies' Home Journal* (the one assignment he had for some reason deigned to accept); a photograph from the Pittsburgh project used in *Fortune* (apparently without Lorant's knowledge), a photograph of flooding not far from his home picked up by *Life*, and his famous picture of his children, 'The Walk to Paradise Garden', used in *This Week*. Smith's total income for the year was $2,582.78. His indebtedness to Magnum was still hovering at around $7,000.

'The Walk to Paradise Garden' was virtually the first picture Smith had taken after returning from the war and had been chosen as the final print in the 'Family of Man' exhibition, epitomising the exhibition's benevolent, sentimentalised view of humanity. Often criticised as saccharine and schmaltzy, it would become one of the most popular photographs ever taken and was used on everything from birthday cards to tombstones to advertisements for Ford cars. Much was read into the image – that it represented Adam and Eve walking into the Garden of Eden or that it was a graphic recreation of the moment of birth – but it was probably its unspoken promise of a better life to come that made it so popular with the public, even while many photographers considered it to be Smith's worst lapse in taste.

By January 1956 Smith's relationship with Lorant had deteriorated to such an extent that each was threatening to sue the other. Henry Margolis, a lawyer representing Magnum, was demanding $18,225 from Lorant for all the work done in the darkroom subsequent to the original assignment, while Lorant had declared his intention to seek 'very substantial damages, which may run at least as high as $50,000' unless Smith delivered the remainder of the pictures without delay. After weeks of negotiations, a compromise was reached: Magnum dropped its brazen claim for extra pay in return for Lorant allowing a set of Pittsburgh pictures to be published in a single magazine, before the book appeared.

In July Morris showed a selection of the pictures to the editors at *Life* and negotiated a fee of $10,000, with an advance of $2,500 prior to publication. Well versed in the difficulties of working with the highly strung Eugene Smith, the *Life* editors insisted on the repayment of the advance if the layout could not be 'completed to mutual satisfaction'. Smith wasted no time letting the magazine know that it was not going to be an easy ride. He wrote to Ed Thompson to warn him, somewhat ominously, that he had no intention of limiting himself to thinking in terms of merely 'twelve or twenty-two' pages and that to do justice to the subject, 'forty or more' pages would be required. Thompson turned down Smith's offer to lay out the pictures, but suggested that he should work with Bernie Quint, an assistant art director at the magazine, to design the pages. Smith agreed.

By this time the Pittsburgh project had virtually taken over the whole of the ground floor of the Smith family house in Croton. The dining table was permanently spread with pictures, the bathroom was used for washing prints and the living room became an exhibition space, with a constantly changing selection of pictures pinned up on four-by-eight cardboard panels. Jim Karales was still there, making one print after another, Smith's wife had been recruited to finish the prints and one of the children took over responsibility for mixing the hypo and developer.

Smith, meanwhile, was shuttling back and forth to New York to work on the *Life* layouts. Quint recognised that the magazine would never devote forty-plus pages to a subject like Pittsburgh and thought he had got this across to Smith over the weeks they worked together. The pictures were eventually condensed into eighteen pages, but before taking the provisional layouts into the managing editor's office, Quint made sure that Smith approved.

While Smith and Quint waited, Ed Thompson looked carefully through the layouts. 'Well Gene,' he said finally, 'I don't know

whether I can give you all this space right now, but what do you think of all this?'

'I don't like it,' Smith replied. Quint's mouth dropped open. He had been working late into the night, night after night, to ensure that Smith was happy with what they were doing. Now he felt he had been completely betrayed. Smith, of course, was impervious to the other man's feelings. Rather than prolong the discussion, Thompson wearily suggested that Smith should take the layouts home and come back in two weeks with a suggestion of how it should be made to work.

Two weeks passed without a word. Thompson then telephoned and offered to make the trip to Croton. When he arrived, he found Smith waiting for him with layouts occupying no fewer than sixty pages. Thompson tried to explain that *Life* never had sufficient space to give sixty pages to a single story. Smith refused to accept it.

They arranged to meet the following day at the Magnum offices in New York. Smith didn't show up. Thompson telephoned him in Croton to ask him where he was and he explained he didn't have any money for the train. Thompson, exhibiting extraordinary patience, told him to borrow some money and he would meet the train and repay him straight away. When Smith finally arrived in New York he had brought none of the layouts with him.

Thompson eventually took over designing the pages himself, reducing the layout to a manageable six spreads, but Smith's demands could never be accommodated. He argued over the choice of every picture, its size, position and relationship to the other pictures. He bombarded Thompson with long, rambling letters attempting to justify his objections and explain his motives. In the end, the inevitable happened: furious at the magazine's unwillingness to understand his position, or to appreciate his artistry, Smith pulled out, refused to allow his pictures to be published and sacrificed the $10,000 fee. 'I think Gene is worth all the anguish,' John Morris wrote to Ed Thompson by way of apology. 'I recognise in him something which I don't fully comprehend, but simply feel – and feel sure – is there.'[19]

Smith's Pittsburgh pictures were offered to *National Geographic, Holiday* and *Esquire* and were turned down by all three. Morris eventually managed to sell the pictures to *Look* for $20,000, only to have the deal fall through when the exasperated Lorant refused to write any accompanying text. 'That I got *Look* to offer $20,000 for the story,' said Morris, 'was pretty incredible.'

That Christmas, Morris discovered that the Smiths had nothing to eat and drove over to Croton with all the ingredients for a traditional

Christmas dinner. 'They were pretty much destitute,' he said. On 25 January 1958, Smith wrote Morris a despairing letter: 'I have been a misfortune to Magnum from the day of being part of Magnum, and I am now in a far worse position than I was at the beginning to be anything but a handicap to Magnum. My failure has been so devastatingly monumental, twisting so dangerously about both our necks, that I believe there is no other course than resignation.'[20]

Morris talked Smith out of resigning and got him an assignment that he felt able to accept, in Haiti, to take pictures of an experimental drug therapy clinic for a pharmaceutical company.

In the May 1958 issue of *Popular Photography* W. Eugene Smith was named as one of the ten greatest photographers in the world. Henri Cartier-Bresson and Ernst Haas were also on the list, along with Philippe Halsman, Ansel Adams, Richard Avedon, Alfred Eisenstaedt, Yousuf Karsh, Gjon Mili and Irving Penn. Smith was almost certainly the only one in that illustrious group up to his ears in debt and unable to get an important portfolio of pictures published, although that same month *Popular Photography*'s sister publication, the *Photography Annual*, not only agreed to devote thirty-eight pages to his monumental Pittsburgh essay but, more importantly for Smith, to stick to his layout. The fee was only $1,900, less than a fifth of what *Life* had been prepared to pay, but Smith was more than consoled by having control.

It should have all gone smoothly, but of course it did not. This time the problem was not with the pictures, but with the text blocks and captions, which Smith had agreed to write. Frequent inquiries as to his progress met with no response and the final deadline for delivering the text came and went with not a word being produced. Increasingly concerned, the editor of *Photography Annual* appealed to John Morris to intercede and Morris dispatched Dan Dixon, a Magnum employee, to Croton to see if he could help. Dixon reported back that Smith seemed on the verge of a breakdown. He was overwrought, living on Benzedrine and whiskey, wandering the house with music booming day and night and apparently incapable of coherent conversation, let alone writing. Morris knew that Sam Holmes, the young man who ran the Magnum library, had some experience as a journalist, so he, too, was sent up to Croton.

Between them, Dixon and Holmes got the text written. Smith agonised over every word and required his two young assistants to type draft after draft, but at least the *Photography Annual* appeared. Smith's pictures received mixed reviews – a number of critics compared the Pittsburgh project unfavourably with some of his

earlier work, exacerbating the sense of failure that was prompting him to seek solace in drugs and booze.

When Smith's colleagues at Magnum came to review the year, it seemed to many of them that the costs, both financial and emotional, of his membership were disproportionate to the benefits. During 1958, apart from the Pittsburgh photographs, the agency had only managed to place two of his stories – a set of pictures of his children and their friends playing by a lake which appeared in *Sports Illustrated*, and another, taken four years earlier, of the funeral accorded to his daughter's dog, which occupied four pages in *Pageant* magazine. Many members expressed fears that Smith was quite capable of bankrupting the agency.

Smith was furious that his colleagues at Magnum were openly expressing doubts about him and prepared a sarcastic riposte: 'I stand thoroughly censured, I'm broke, desperate, tired – however, the censure is right, I am guilty. I trust that the photographers of Magnum are willing to stand on their public records. I trust that the photographers of Magnum are willing that I publicly evaluate them accordingly as they have achieved. I am not interested in their excuses accordingly to their private confessions. Their blames, including Smith, will not be of my concern.'[21]

In fact Smith never sent this missive, perhaps because he had already decided to resign. He penned a long, typically verbose, resignation letter addressed to 'Dear Friends' on Christmas Day, 1958 – perhaps an indication of how little he cared about family life:

Peacelessness, inner and outer, is of the cheer as we quaff of chopped loves and singularised bitters from the barrel with seven spigots, and each one here is clung to a whipped branch amid the storm shocked fruit of this family tree. Avoiding for a while the thirteen boxes – stacked seven and six. And I, being the trunk and the feeder roots, bend and wrath against certain torments of awareness from knowing part of all that is being rivened during this my season of perpetual and pernicious storms. And love is a life, a necessity, and a hunger and a pity; and love is a searching for the beyond, and it is compassion for those with half-torn hearts ... I resign with reluctance ... As for the money I owe to Magnum, it will somehow be paid in full ... I have much work to do, and much desire to do it.[22]

He concluded with a brief description of his plans to rehabilitate himself as 'an artist, a journalist, a father and a human being'. There was no mention of husband, perhaps advisedly, since in 1959, at the

age of forty, he could be found living in a loft in New York with a seventeen-year-old student and admirer.

'Gene was a perfectionist,' said Howard Squadron, Magnum's lawyer. 'He was driven, really driven, by a sense of mission. Many people with that kind of personality are a bit paranoid, or maybe a bit more. We bailed him out, did what we could for him. It cost Magnum a lot of money because he was never in a position to pay back what he had spent on the Pittsburgh project. I liken Gene Smith to Van Gogh, or somebody equally obsessed. It was typical of Magnum that even parting with him was a wrench, because everybody knew what a brilliant photographer he was and everybody tried to let him down real easy, but Magnum took a beating as a result. It was really impossible to work with him. With Gene you knew it was one step at a time into the swamp. Magnum had to advance him money to live, knowing he could never get enough money out of the job to repay. It was as decent a parting as you could have and I think he understood, too, that he couldn't continue to be supported in this way. Again I liken it to the great artists, whether it is Van Gogh or a great performing artist in the dance world: these people know that they are great artists and they really do feel it is unfair that the world doesn't subsidise them. It is not that they are unwilling to live in a garret, but after that they have to eat, have to clothe themselves, have to feed their families and here they are making an enormous contribution to the cultural life of the community and so why doesn't everybody realise this?'

Smith's failing health and increasing dependence on alcohol and amphetamines curtailed his prodigious output in the final years of his life, but he had one last unforgettable picture essay to complete – his photographs of the victims of Minamata, the Japanese fishermen and their families stricken by mercury poisoning from the Chisso chemical plant. Literally thousands of villagers in Minamata were poisoned, and several hundred died, after eating mercury-tainted seafood between the years of 1953 and 1960. He was never more emotionally involved with a story and Minamata became a personal crusade. Smith and his second wife lived for three years at Minamata, existing on $50 a week and a diet of home-grown vegetables, rice and whiskey. Smith's terrible, haunting picture of the crippled fifteen-year-old Tomoko Uemura being bathed by her mother was his last really famous picture, acclaimed as the *pietà* of the century and focused the attention of the world on a new phenomenon – the environmental disaster. Smith, typically, could not avoid becoming involved. When he was photographing a protest demonstration outside the factory gates six company thugs attacked him and swung

him by the legs against a wall. He was so badly beaten he nearly lost his eyesight.

Don McCullin met him in Japan and described him as 'a man who was in love with his photography, in love with his genius and with his art. He was a man of passion who took photography to extremes and what he saw and did was eating him away.'[23]

When his Minamata essay was nearing completion he returned to New York looking for a magazine to publish a fuller version than that which had appeared in *Life*. Unsurprisingly, his demand for an enormous commitment in terms of pages frightened everyone away.

W. Eugene Smith died in Tucson, Arizona in 1978, at the age of fifty-nine. Feeble, emaciated and white-bearded, he looked old beyond his years and had just $18 in the bank. He had gone out into the empty streets at seven o'clock in the morning to search for a lost cat named Baby; he fell, hit his head and died of a brain haemorrhage.

'He saw himself,' said Ben Maddow, one of his biographers, 'as the hero-martyr – the Prometheus of photojournalism – bound, of course, and tortured for his integrity.'[24]

LEONARD FREED talking in his studio in an artists' complex in Greenwich Village: 'I grew up in Brooklyn. My father was a floor-layer. I really wanted to be a painter but when I started painting in the basement of my parents' house my mother looked at what I was doing and said "Whaddya wasting your time with that? Kids in a kindergarten could do as well as that." I thought if my own mother doesn't appreciate what I am doing, why bother? She thought all artists died poor. I thought I should leave and go off into the wilderness, so I bought a rucksack and a sleeping bag. Originally I was going to go to Europe with an older woman I knew but she decided I was too young, so I just took off anyway. At that time people didn't travel much unless they were wealthy, but the whole first year [1950] I was travelling around I didn't spend more than $500, including my transatlantic fare.

'For two years I hitchhiked round Europe, sleeping rough, living out of a backpack. Sometimes I got a night's accommodation in a local jail when I could find no other place to stay. I fell in with a group of young people. A lot of them were disillusioned after the war. They had been in the Resistance, or the underground. It was a real eye-opener to see the sacrifices made in Europe, especially for someone coming from America who had sacrificed nothing much except bubble gum. In Paris I remember seeing Henri Cartier-Bresson's *The Decisive Moment* in a bookstore and the woman I was with got very excited about it, but it left me cold. I was not interested in photography at that time. But a painter who was in our group was making a bit of money taking photographs and selling them to a local newspaper and he invited me to watch him developing his pictures and I got interested because I saw it as a way of being able to continue to travel and make a little money to pay for it. I didn't know anything about photography, so I asked my friend to show me how to do it.

'Eventually I returned to New York to see what the situation was. I had no idea what I was going to do, but I met some people who knew who's what in photography and they suggested I should go and see Magnum. I went over to the Magnum office and met Inge Bondi – this was around the time Capa and Chim were killed – and she said I could hang around, look through the files and use the office. There was very little organisation at that time. I'd bought a $25 camera but in two years' travelling I don't think I had used a complete roll; I still had the same roll in the camera. I wasn't interested in taking pictures of my travels. I wanted to experience it directly.

'Magnum had a nice office off Central Park on the East Side. The

women who worked there were mostly girlfriends of the photographers and they were not paid a lot. It was more idealistic then, things were very simple and direct. You worked for a magazine, got paid, and that was it. It was less business and more creative. Most young photographers today are looking for the money, but money was not the main objective at that time. We had come out of the thirties and were looking for a better world. When I first went into the office I was wearing a jacket and I used to get magazines from a second-hand bookshop and I had a copy of the *Partisan Review* sticking out of my pocket. Inge was very enthusiastic and idealistic and she reached over and pulled it out to see what I was reading. It was only a little leftish magazine, but that influenced her thinking about me. She thought I was semi-intellectual, even though I never went to university.

'All this time I was taking pictures of my own, mostly in New York. I wanted to experience life and use the camera as a tool to get into situations and experience life. I went to see Steichen at the Museum of Modern Art and they told me he was very busy and would only be able to spare a few minutes to talk to me, but we ended up talking for about two hours. Steichen said he would buy three of my pictures for the Museum. I had a little darkroom in my parents' house but I couldn't get anything like the quality I needed so I never delivered them, but as far as I was concerned they were in the collection because Steichen said he wanted them. Alexey Brodovitch was teaching class and I went to his office and had a long talk with him and he said "What do you want from me?" I said "I would like to attend your class." He said "No problem, just pay the fee." I said I didn't have any money. He said he already had a student taking the monitor instead of paying the fee, so I couldn't do that. I started to walk out and he called me back and said I could join his class as long as I didn't tell anybody.

'I started to go and see editors of magazines, but they never had any time to talk to me. They were only interested in what I had got, and I had got nothing. It was a big moment for me, figuring out why some people had time to talk and others didn't. I realised that those people who gave me time were secure in their jobs and their thinking; all the others were insecure about themselves and their jobs.

'I wasn't really in Magnum, it wasn't that organised, but I could use it if I wanted to. For me it was a leap from being working class to the top. When I first went in I would get the assignments, usually little portraits, that no one else wanted to do. I would go in and talk to people and look through the files and then one day they asked me

if I wanted an assignment photographing a rabbi who was meeting the mayor. I thought that the rabbi would want to see me to talk about what kind of picture he wanted, so I arranged to meet him at the Temple Emmanuel. I was early so I thought I would walk around the block, and then by the time I had walked around the block I was late, so he was angry. When I got in he said "Let's go." I asked him where we were going and he said "Whaddya mean? We're gonna do the photo." I said that I thought he would want to talk about it first and he said "What's there to talk about? Let's go." I then had to tell him I didn't have my camera with me. He was *really* mad then. Actually, I did have a little Leica in my back pocket, but I was too embarrassed to use that; I had a Rolleiflex for portraits. The rabbi stormed off in a temper. I went back to Magnum and told them what had happened. They didn't care much; it was a job that no one wanted to do anyway. That was the beginning of my career. It was very embarrassing.

'Erich Hartmann was very nice to me. He was photographing Hasidic Jews and he took me into his darkroom and printed some of my photos. It was the first time I had seen my work well printed. Then Cornell took me on as his assistant. The first big project we did was in Philadelphia for *Life* magazine. A family had been kidnapped in their home by escaped prisoners and their story was to be made into a film and Cornell was taking the pictures. He taught me a lesson because he brought along a very, very expensive bottle of whiskey and all these famous actors and actresses were fighting to get a glass of it. I thought these people are making so much money they could afford to buy a bottle each for themselves, but they just wanted it because it was free. My father was always asked on his pay day to go and have a drink with his bosses, but he always said "No thanks, just give me the money. I can buy my own drink."

'Around 1970 in Magnum things started getting more organised and they said to me I would either have to join them or leave. So I applied to join and became a member in around '70 or '71. In the Inge Bondi days Magnum was like a little storefront church; you married into Magnum. Like a family, relationships could be difficult. There were many separations and divorces. People stayed because they decided it was to their advantage and people left because they decided it wasn't to their advantage. It is very difficult to talk about one's family. They were a very idealistic lot. There was a lot of money around. Magazines were in and paid a lot and photographers in those days were very important. Today we are shoved to the side and television crews are important. At that time, though, photographers were romantic figures making a lot of money.

'I am very close with all the Magnum people, but I have always been an outsider. I've never had any position in the Magnum organisation and I never say anything at the meetings. Some people enjoy politicking; I don't. I am not a leader, not a businessman. For me the whole idea of Magnum is that you can relieve yourself of many responsibilities and just go out and make photos.

'Two years ago I was in Papua New Guinea trekking alone through the jungle, through swamps and leeches and streams, the worst, most impenetrable jungle in the world with vines like barbed wire. It took three days to trek to the village. I saw them preparing for a tribal war, payback fighting, after one of them had been killed by someone from another tribe. Some were born at the time of cannibalism and head-hunting. They were people who never knew anything existed outside of their world; they thought they were the only people in the world.

'I was there partly for an assignment and partly for me, to experience what it is like to get to know a society and how it reflects on yourself, who you are, what it means. To be a photographer you have to be a child, always full of wonder, looking at the world with wonder. Making a photograph only takes a moment of time, but then you spend the rest of your life figuring out what it means.'

8

Censors and Self-Censors

A FTER THE death of Chim, Magnum temporarily lost its way. It was the second half of the 1950s, there was uncertainty and growing tension around the world and the comforting vision of 'The Family of Man' was proving to be an illusion. Without Capa and Chim the Magnum family, too, was proving to be fractious and unmanageable, with increasing disagreements between the photographers and staff and the photographers themselves. Some photographers, like Elliott Erwitt and Erich Hartmann started to supplement their income by taking photographs for advertising and company reports on a regular basis, exacerbating internal strife and raising doubts about Magnum's role and direction. Then came an episode that questioned the integrity of the agency itself and led to a bitter split between the New York and Paris offices.

Kryn Taconis was a Dutch photographer who had been marketing his work through the Paris office of Magnum from the very early days, but had only formally become a member in 1955. A former leader of the Resistance movement in Holland during the war, Taconis was a humanitarian photographer who, like Chim, loved to take pictures of children. He photographed street urchins in Montmartre, sick children in hospital and the daily life of a small nomad boy in Lapland for Magnum's 'Generation Children' project – the sequel to 'Generation X' – but he made his name as an international photo-journalist covering a mine disaster in Belgium. On 8 August 1956 a devastating fire in a mine in Marcinelle, near Charleroi, trapped 276 miners underground. Frantic rescue operations continued for sixteen days, but only thirteen men were brought out alive. It was a tragedy that inevitably attracted the world's media and Taconis was appalled by the sensation-seeking antics of many of his fellow photographers. He shot very few pictures, but one of them, of an exhausted rescue worker against a background of

imploring hands reaching through the mine gates, seemed to sum up the horror of the occasion and won Taconis an award from the Art Directors Club of New York.

In July 1957, while in Cairo photographing Nasser, Taconis made contact with members of the FLN, the partisans fighting in Algeria for independence from France. The so-called 'dirty war' was a sensitive subject in France, with daily stories of atrocities, of French settlers being decapitated or hacked to death by Algerian nationalists. Taconis realised his association with a French photo agency could cause him some difficulties, so he wrote to his wife, Tess, in Amsterdam, asking her to send him new press credentials accrediting him to Magnum of New York. 'I think I am ripe for a lucky brake [*sic*] soon,' he added. He could not have been more wrong.

In August, Taconis's FLN contact gave him an assurance of access to cover the insurgent military operations in Algeria. Taconis hoped to be able to finish the assignment in time for his pictures to be published before the question of Algerian independence was reviewed by the United Nations on 17 September. Arriving in Algiers, Taconis was met by an FLN representative and spirited away to join the rebel forces' First Battalion. He spent a week with them, during which nothing happened apart from occasional alerts as French reconnaissance aircraft roared overhead. On the eighth day he joined a night attack on French forces around the village of Lacroix, but as the night was pitch black and no tracer bullets were used, he was unable to shoot a single frame. The following day he took part in what should have been an ambush of a French military convoy in the mountains, but the FLN waited all day and the convoy never showed up.

Taconis left Algeria without a single combat picture, but he did have the first pictures showing the FLN as a well-organised and well-trained fighting force which commanded widespread support from ordinary Algerians. One sequence of pictures showed women bringing steaming bowls of couscous to the rebel soldiers at the end of the day. It was exactly the kind of coverage which the French government wanted to avoid.

Since French newspapers and magazines attempting to publish features sympathetic to the Algerian nationalist cause were censored, it was at first decided, after Taconis's return to Amsterdam, to distribute the story anonymously. Tess Taconis took charge of printing the pictures while John Morris hastily put together a story based on Taconis's account of his stay with the FLN. Entitled 'Life with the Algerian Rebels: Photographer Spends a Fortnight with the FLN in "Free Algeria"', it began: 'The man who took these pictures

is an experienced European photographic-journalist who must remain anonymous . . .'

Meanwhile, Taconis's scoop was causing considerable consternation in Magnum's Paris office. The 'Algerian question' was the cause of great political tension at that time and Cartier-Bresson became convinced that the agency risked being closed down, or even bombed by right-wing extremists, if it went ahead with publication. He did not consider it to be a question of ethics, but of politics, and wrote to John Morris telling him not to bring the Taconis pictures into Paris under any circumstances. While Cartier-Bresson got the support of most of the Paris office, in New York there were dark mutterings that the integrity of the agency was being compromised. For the Americans any kind of censorship was abhorrent, but self-censorship was even worse.

In truth, the story was not being received with much enthusiasm by editors. Some were worried by the photographer's anonymity; some complained that the pictures lacked action. John Morris tried to solve the first problem by agreeing that Taconis could be credited without mentioning Magnum and the second by talking up the enormous human interest potential of the pictures. But the Paris office remained deeply unhappy and after a meeting called by Cartier-Bresson it was agreed that the distribution of the story should be temporarily suspended.

'The situation in France was such,' said John Morris, 'that I was advised not even to bring the story personally to Paris, so I arranged to mail a duplicate set of prints anonymously. In Paris we discussed it and I went off on a sales trip but only got as far as Switzerland when I was called back with a message from Paris saying we must stop all sales.'

Another meeting was held in the Paris office, ironically on the very day that the Algerian question was being discussed at the United Nations, at which Taconis was told that the consensus within Magnum was for killing the story but that the final decision would be left to him. It was no more than lip service to his independence and Taconis knew it: reluctantly he accepted the majority decision, but wrote a bitter letter to Cornell Capa, who had taken over as president from Chim, expressing his regret at the agency's lack of courage and concern that such self-censorship would gravely endanger its credibility. Within a couple of years Taconis had resigned from Magnum; few of his colleagues were left in any doubt it was as a result of his lingering disgust and shame that an agency that trumpeted its morality and independence should so readily sacrifice both to avoid trouble. It remains an embarrassment today.

'He was very upset, very upset,' Cartier-Bresson admits. 'So were we, but it was not possible because in those days one would have had a *plastique* [bomb] through the door. One has to put oneself back in the political situation at that time. A dirty war was being fought, with constant bombing by the Algérie Française people. The Magnum offices were next door to a police interrogation centre and from the yard of our office we could hear people shouting, most likely being tortured. I was against the Algerian war and intended to testify with photographs but someone at *Match* warned me that I would be put in the hands of the French military. Kryn was a close friend and we encouraged him to make contact with the FLN and it was a shock to us all when we realised that publication of his pictures would most likely have meant plastification of the office containing the archives of all Magnum photographers.'

'Was it reasonable for the whole future of Magnum to be put at risk for one story?' asks Marc Riboud. 'We were all against the war in Algeria, but it was a very emotive subject at that time. Everyone was worried about reprisals. People were worried that the government would try and close us down. Even if we had distributed from another office they might still have tried to take it out on us anyway.'

'Well it was a very terrible problem,' says Erich Lessing. 'How much are we submissive to outside pressure, how much are we trying to be witnesses of our times, but only half-witnesses because we are very, very careful not to get in the way of official policy? You lose your soul very fast; it is very difficult to keep up the pretence afterwards when someone can always point the finger at you and say "Remember".'[1]

Cartier-Bresson's case was not helped by a long interview he had given to *Popular Photography* in May 1957, just a few months before he was agitating for Taconis's pictures to be withdrawn. 'The important thing about our relations with the press is that it provides us with the possibility of being in close contact with life's events. What is most satisfying for a photographer is not recognition, success and so forth. It's communication: what you say can mean something to other people, can be of a certain importance. We have great responsibility and must be extremely honest with what we see. The photographer must not censor himself while shooting and the magazines, when they use our material, must keep the general spirit which prevailed at the time of the shooting ... Everybody in Magnum has full liberty; there's no doctrine, there's no school, but there's something that unites us very strongly – I can't define it; it may be a certain feeling of freedom and respect for reality ... Nobody in Magnum decides for the other what he should do.'

George Rodger concluded that Magnum was missing Chim. 'It was unfortunate that Magnum's leaderless position in Paris was so precarious just as the whole of France was in turmoil over the "rebels" of Algeria. It would have been suicide to distribute an anti-French story. It would have brought the wrath of the Republic crashing down on us. Kryn realised this too late, but I don't think he ever recovered from his disappointment.'[2]

Ironically, Rodger was having censorship problems of his own. The indefatigable Jinx usually travelled with him everywhere – a year earlier they had driven across the Sahara in a Land Rover – and she recorded his frustration about working in Palestine. 'We lived with the refugees just outside Jerusalem for nearly six months and had a fabulous story, but no one would run it. George sent a message to Henry Luce – there was a connection inasmuch as Luce's father was a missionary in China and my father was a missionary in Syria, although they didn't actually know each other – and Henry Luce was terribly upset that they couldn't run the story and wrote to George in Beirut apologising. The only magazine to run the story was in Germany, of all places. George thought it was terribly unfair what was happening to the Palestinians. We photographed the farmers driven out of their lands – they could look across the fence and see their land being cultivated by Jewish settlers. It was a dreadful situation and we got awfully tied up with it. George felt very bitter about it, the Zionists and the propaganda back in America.'

In fact Rodger had long been irritated by what he saw as Magnum's obsession with Israel:

Sometimes the ideology of Magnum went a little too far. The whole world knew that the Israelis had annexed Palestine in 1947 and driven out the Arabs. Nevertheless, Capa, Chim and other photographers insisted on photographing the promised land and distributing the pictures all round the world. They earned a lot of money. I was on the other side, insofar as I was an Arabist working with the Palestinian refugees. I knew that their houses had been destroyed. My version of these facts was never published because the editors of the American magazines were nearly all Jewish.[3]

Elliott Erwitt was having a happier time in Moscow where, on a routine assignment for *Holiday* magazine, he got the first sensational pictures of Russia's new inter-continental ballistic missiles. He had planned to cover the 7 November parade while he was in Moscow and some instinct had prompted him to take a developing kit with

him when he left the United States. Luck, he likes to say, is part of his budget. On the day of the parade he casually attached himself to a Russian television crew, passed through three rings of security and got himself a grandstand view of the parade, facing Lenin's tomb, just as the giant transporters carrying the missiles, making their first public appearance, rumbled past. 'The important stuff was over in ten minutes, so I just slipped away through the crowd as quickly as I could and returned to my room at the Metropol Hotel just round the corner. I sent a telex to New York letting them know I had something special, developed the film in my room and then got out of town as quickly as I could and caught a plane for Helsinki. *Time* arranged a makeshift lab for me in Helsinki and the pictures were soon distributed all over the world. I got several magazine covers out of it.'

Moscow was a lucky location for Erwitt. On another occasion, a few years later, he was the only American photographer covering de Gaulle's state visit to Russia. 'I was there at the French Embassy with all the other dozens of photographers taking the usual handshaking pictures and when it was all over I went back to my hotel and took my shoes off and suddenly thought I should not have left. So I put my shoes on again and went back to the Embassy. There were only a few people still there, the event was over, so I just walked in and opened a few doors and then opened one door and there was the entire Soviet government sitting down with de Gaulle and chatting. Nobody looked up so I just walked in with my camera and started taking pictures. Nobody said anything and after a while I got up and left. It is very important to know when to leave. No one took any notice. I went back to my hotel and called *Paris Match*, who could hardly believe it. They broke their cover waiting for my pictures.'

In 1957, on Magnum's tenth anniversary, *Popular Photography* reported: 'Magnum feels quite strongly that it has almost reached its optimum proportions in terms of the number of office workers to the number of working photographers. And while young photographers who have some special talent will always be seen, no essential changes in the numbers of the group are planned for a long time to come.' The magazine claimed, rather picturesquely, that members of Magnum tested the suitability of applicants by asking themselves this question: 'If this man preceded me on a journey to Bali or wherever, would I still be welcome or would he have pushed around so many people, made so many tempers raw, that I'd be thrown out on my ear?'

Wayne Miller, who had worked for two years with Steichen putting together the 'Family of Man' exhibition, evidently passed the

Bali test, as did the formidable Bruce Davidson, both of whom joined Magnum in 1958. Wayne Miller had originally been asked to join Magnum in 1947 by Maria Eisner but he was busy with his own work and 'did not understand the concept of such an agency well enough to agree to join'. When he joined in 1958, because he felt he 'needed more contact with the outside world', he never considered any other agency because Magnum, with its status and personalities, was 'the Cadillac of the profession'.

Although he was one of the first Americans to photograph Hiroshima after the dropping of the atomic bomb, Miller was the very antithesis of the hard-nosed photo-journalist. 'The Family of Man' had shown him the miracle of everyday family life and he had spent the three years prior to joining Magnum photographing his own children, producing a book called *The World Is Young* which Steichen himself described as a 'beautiful exploration of childhood' and a 'new landmark in photography'.

Bruce Davidson was one of the many young photographers on whom *The Decisive Moment* had exercised a profound influence. A girl in his class at college, where he was studying photography, had a copy. 'We sat together in the living room of the girls' dormitory looking at Cartier-Bresson's pictures. We entered his world, where the visual rhythms and silver tones gave us a feeling of life and a sense of the creative spirit. She read me part of the introduction: "I believe that, through the act of living, the discovery of oneself is made concurrently with the discovery of the world around us". It was then that I fell in love for the first time, with the girl and with Cartier-Bresson. I thought that if I could take pictures like his she might like me . . ."[4] He bought a second-hand Contax but by the time he got round to showing his pictures to his girlfriend she had fallen in love with the professor, so he was left with only Cartier-Bresson.

While he was serving in the US Army he was stationed at SHAEF headquarters in Paris and took some of his pictures into the Magnum office to show his hero. The great man looked carefully through his contact sheets, then patted him on the shoulder and told him to keep working. Back in New York working as a freelance, Davidson was sitting on a bus going down Fifth Avenue when he suddenly saw Cartier-Bresson in the street. He jumped off, ran after him, tapped him on the shoulder and reintroduced himself. Cartier-Bresson invited him to come up to the Magnum office and within a year Davidson had joined the agency.

On 29 April 1958, Cornell Capa circulated a memo to all 'Magnumites' to warn them once again, with weary predictability, that the finances were in a mess. The agency had made a loss of

$17,000, yet was spending money as if it was highly profitable – nearly $4,000 had gone on repairs to the Paris office and the annual meeting in New York had cost another $9,000. 'Temporary personal hardship' had persuaded the Magnum board to agree to a maximum loan of $5,000 to Eugene Smith, but three years later the board members discovered that he actually owed the agency $7,000 and not a cent had been repaid.

This notwithstanding, the following day John Morris distributed a second memorandum containing ambitious plans for a thirteen point expansion plan to build Magnum into the 'world's greatest professional organisation of photo-journalists'.

George Rodger was appalled at the prospect. 'I can't help but feel great concern over John's memo,' he wrote to Cornell.

It is so unrealistically optimistic and I don't know that it is pointed in the way we want to go. Do we want to be the "World's greatest professional organisation of photo-journalists"? It seems rather far from the original concept of Magnum and much has been written in the past, especially by our wise old Chim, warning against the dangers of empire-building . . . I am fully in sympathy with his long-range viewpoint, his aims and ambitions. But surely this is not the time to try and put them into effect. He has great talent which we all appreciate but somehow we must attach a sheet anchor to him so he doesn't drift off out of sight of all reality.

Rodger had begun to think of Magnum as primarily a huge machine which the photographers had to work to feed. He met with Cornell Capa in Paris in September and together they deduced that every Magnum photographer would have to pay $22,000 a year just to keep the machine running. It was evidence to Rodger that the photographers were essentially being run by the office, rather than the other way round. He was very much in favour of Magnum returning to its roots, to a simple facility for a few photographers to free themselves to work as they wished, and he mounted a vigorous letter-writing campaign to opppose Morris's plans. Do we really, he asked his friend Henri, want Magnum to be a 'supersonic, plush-lined photo-news agency that is bigger and brighter than all the rest and that costs the photographers half what they earn to maintain?'

'I feel a despair at what Magnum has developed into,' he wrote to Cornell Capa on 24 November 1959.

Naturally the slap-happy days of our infancy could not continue,

fun though they were. They had to die a natural death and be buried by changing times, progress and keeping up with the world's demands. But surely the spirit of the old Magnum should not die, and our precepts, founded so long ago and maintained through our adolescence, should not be lost sight of with maturity. I feel we are losing sight of them. I feel that money is all that matters now.

In the old days Magnum was 100% for making the world a better one for all photographers to live in. It was for that that Capa conjured up Magnum. Magnum was to be run by the photographers themselves as a service organisation to sell their material and make their lives easier. But now, what we have dreaded for a long time has definitely come to pass – that old cliché about the office running the photographers rather than the photographers running the office. It is there now and I can no longer condone it. With our great top-heavy, cumbersome overheads, our lives, instead of being simplified, are vastly complicated. Photographers must pay, pay, pay to keep the organisation going . . . Cornie, can't we curb this great upsurge somehow – this almost fanatical striving after kudos and power – and just become, once again, a less flamboyant service organisation concerned mainly with the sales and promotion of pictures that members like, and are most fitted to take? There is a feeling in Europe now, which I share, that Magnum isn't interested in pictures unless they bring in big money. For the furtherance of photography as an art, which was another of Magnum's principles, it is surely essential that those who take them have a certain peace of mind and are not continually hounded by rising deficits, increasing overheads and mounting percentage deductions which sometimes make it difficult to operate at all? . . .

One might ask, why not leave Magnum? But why should I? My heart is in Magnum and has been for a very long time. I have not been able to keep up in recent years. That is obvious. But I cannot help but feel that Magnum has drifted away from me rather than I have drifted away from Magnum . . .

In truth, George Rodger's pious hope that Magnum would further photography as an art was endangered much more by harsh reality than by John Morris's expansion plans. The fact was that many photographers recognised that editorial assignments alone would not be able to keep Magnum afloat. Not only was editorial work increasingly hard to come by, but the fees were more or less static at a time when industry and commerce were beginning to pay

handsomely for advertising photography and for pictures in annual reports. Lee Jones, a magazine picture editor who was hired in 1957 to co-ordinate Magnum's coverage of the Queen's visit to the United States, stayed on to help generate commercial work. She went through the list of the Fortune 400 top companies, extracting the names of executives who might have a need for photography, and hustling them for work.

For the purists – or, as Jones said, those 'prepared to live like monks' – it was anathema, but for the realists it was simply accepting that the only way Magnum could survive was by taking on commercial work. Jones was astonished by Magnum's amiable chaos: the archives were in disarray, prints and negatives were frequently lost, filing was haphazard and accounting was hopeless. Photographers would routinely send out a member of staff to collect their laundry or shop for a dinner party and charge it to Magnum. 'Every time the station master stood up and said "This is no way to run a railroad",' said Jones, 'he got run over by the train.'

On the one hand she remembers Magnum with enormous affection; on the other as a place where staff were routinely abused. 'People who worked for Magnum really worked hard. It was always under-staffed, there was very little leadership. A photographer would go into the library and throw a tantrum and finally somebody would come in and say "So-and-so is doing it again" and I would go in and literally have to yell at him to shut up because he was stopping people from working. Odd people were hired . . . photographers would get very involved and want their ex-girlfriends, or room-mates to be given a job. An extraordinary bunch of people worked for Magnum, some of them very, very talented and almost all of them very hard working, but a lot of them very misplaced in what they were doing. But there was so much work to be done on a daily basis that the heart of Magnum – the library – got very little attention.

'There was a lot of frustration, lots of blow-ups, with people walking out saying it wasn't work for a grown-up. Photographers would literally throw tantrums, they would lie on the floor and drum their heels or bang spoons on the table. There were photographers who only knew how to operate by tantrum or threat. Yet at the same time it was a wonderful, crazy club and the club mattered much more than the making of money, in a way almost more than the photography itself. It was made up of people who had found each other and needed each other very badly because they wanted to paddle upstream and they couldn't do it alone. It had a wonderful kind of zaniness to it – on a perfectly ordinary day, Elliott would

come in wearing a top hat, Burt Glinn would be wearing some furry thing he had picked up somewhere and George Rodger would show up carrying a spear from New Guinea just because they felt the atmosphere needed a little cheering up. That persisted for a very long time . . . there was a wonderful gaiety to the early Magnum, as well as irresponsibility.'

In July 1958 another crisis flared in the Middle East. A group of young Iraqi army officers, inspired by Nasser, staged a coup and overthrew the pro-Western regime in Iraq by assassinating twenty-three-year-old King Feisal, his uncle, and the prime minister, thereby setting in motion a chain of events that led to American marines landing in Beirut and British paratroopers being sent to Jordan.

Burt Glinn was on assignment in northern Italy for *Holiday* magazine when he saw huge headlines in the Italian papers saying the King of Iraq had been assassinated. With some difficulty he got through to Magnum in New York and the office agreed he should follow it up since it looked likely that the US was going to send marines into Beirut. He dropped everything and made his way to Naples, where he talked his way on to a US Navy transport and arrived in Beirut after the first wave of marines had landed. Fortunately, the barman at the St George Hotel confided that the US carriers offshore were going to land another wave and so Glinn rushed down to the shore to cover it, even going to the trouble of wading into the surf and 'ruining a good pair of trousers'.

'It was very curious. The crucial link between the rebels and the press, and even the rebels and the government, was the barman at the St George Hotel. If you wanted to visit a rebel stronghold or HQ, you spoke to him, he could fix anything for you.' A couple of days later word came through that paratroopers were due to arrive that afternoon at the airport. Glinn was busy taking pictures of the troops disembarking from their aircraft when he saw, mincing down the ramp, a woman in a floral dress, a matching parasol and high-heeled shoes. She caught sight of Glinn and screeched 'Oh good, Magnum's here.' It was his friend Molly van Rensselaer Thayer from the *Washington Post*.

'I didn't have any idea what Molly was doing there but I did know she had wonderful contacts and she proceeded to do a wonderful fixing job for me. All the journalists in the world were trying to get into Baghdad. Every time I suggested it might be a bit tricky, as I was a Jew, she'd just say "Never mind that, dear." First

she urged the US ambassador, who was a friend of hers, to persuade the Syrians to issue us with forty-eight hour visas for Iraq. Then after scouting round a bit and talking to the concièrge of our hotel in Damascus she discovered there was a bus leaving for Baghdad the following day and she contrived to get two seats on it. It was a dreadfully unreliable-looking thing and we had a twenty-four-hour drive across the desert facing us, but Molly was completely undaunted. The passengers were a very mixed bunch and included two young women claiming they had a night-club engagement in Basra. "There are no night clubs in Basra," Molly snorted. "You know what they are!" When we got to the border, the border guards really didn't know how to cope with the arrivals. The dancing girls were not allowed in, but Molly and I were let through. When we arrived at the bus station in Baghdad, the oil wells were burning, the military coup was raging and many Westerners had already been killed in the streets. The Ministry of Information had been alerted that Molly was on her way and so we were met and spirited away to the Intercontinental Hotel. I was just congratulating myself on the fact that we were going to be the only Westerners there and thinking how ironic that such a scoop should be obtained by a Jew when we walked into the lobby and ran into a whole crowd of press people we thought we had left behind in Damascus. They had all managed to get in by air. My old room-mate, Stanley Karnow from *Time* sidled up to me and said "If NBC or *Life* send two more Jews into Baghdad, we can have a *minyan*.'"

On his way back to the United States, Glinn stopped off at the Paris office and learned that two rather down-at-heel Latinos had recently called at the office offering to escort a photographer to meet Fidel Castro, then a guerrilla leader plotting to overthrow the Batista regime in Cuba. Glinn immediately volunteered 'I usually say "I'll do that" before I think of the consequences and it is only when I am on the plane that I think, "Jesus, what have I got myself into here?" I was told to meet up with some people in New York, who briefed me on how to approach the story. I was told to dress like a tourist, not carry too many cameras, and instructed to go to this particular hotel in Havana where I would be picked up and taken into the hills to meet Castro. I went to Havana and waited three or four days but no one contacted me. I hardly dared go to the bathroom for fear of missing the call. In the end, I discovered that I was either in the wrong hotel, or they had called at the wrong hotel. It was a comic opera and never worked.'

On New Year's Eve back in New York, Glinn was at a black tie party with a lot of other correspondents at the writer Nick Pileggi's

home when someone got a call to say that Batista was fleeing Cuba and that Castro was expected to enter Havana in a couple of days. Glinn immediately left the party, hurried back to his apartment to change and pick up his cameras. He telephoned Cornell to tell him what he was doing and ask for some money. Cornell did not have enough, so he borrowed from his neighbours and was able to give Glinn a wedge of dollars when he stopped by on his way to La Guardia. Glinn caught the last flight to Miami, where he arrived at two o'clock in the morning and booked a seat on the first flight leaving for Havana. His plane was the last to arrive before the rebels blocked the airport runway with oil drums.

'I checked into a hotel close to the presidential palace and didn't really know what to do or where to go from there. I had hardly put my cameras down when I heard shooting in the street. I looked out of the window and saw people were running around with very strange old guns and I saw a French journalist called Bob Henriques from *Jour de France* and Lee Lockwood, who was working for a German magazine, and realised to my annoyance that if they were on the street, then I had better get out there too. People were shooting at everything, there was a general strike and no real food or facilities. People were getting killed but I got the impression that nobody knew who they were shooting at.

'By that time, the correspondents had started to make contact with one another, but our numbers were still small and all we could do was exchange notes and compare rumours. The question on all our minds was how we were going to find Castro, who was still in the hills but no one knew where. Eventually a few of us clubbed together and got a car and started driving south to find Fidel. We drove for a day and a half and finally reached a city that was plainly waiting for his arrival, so we waited too and, sure enough, met up with him. Then it took another six or seven more days to return to Havana. Following Castro was very unpredictable. There was a complete lack of organisation and no question of keeping to any schedules. Castro himself was very whimsical; sometimes he would ignore a town that had waited days to see him, sometimes he would stop somewhere where he was not expected and give a speech lasting fourteen hours. We got to spend some time with him; he made himself available and attempted to communicate in rudimentary English. Those first few days before Castro reached Havana were idyllic, like a revolution ought to be. The convoy going in was made up of anything on wheels, dozens of civilian cars and a couple of tanks. Sometimes Castro would stop at a gas station, take out a roll of money and pay for everyone's petrol in the convoy. He never

objected to having his picture taken, was always perfectly amenable.
Thousands upon thousands of people were waiting to welcome him
in Havana. There was joy on the streets and lots of excitement. I
went on ahead to get pictures of him arriving and the crowds were
so thick that I lost my shoes. A wonderful story to cover, a dream
assignment.'

At the annual general meeting in January 1959, Cartier-Bresson
issued a warning note about Magnum's increasing commercialism:
'We have to be very careful in the development of our operation and
not accept jobs wishing them through, just for the sake of money,
because this will kill our sensitivity and integrity.'

This notwithstanding, Cornell's last report to the board as
president (he handed over to Ernst Haas), dated 4 January 1959, was
decidedly upbeat:

'Dear Friends,

'This is a very easy and happy report to make, it closes for me a
period of four and a half years of tragedies and crises, where the
struggle was sentimentally and physically personal and inseparably
entangled with Magnum's existence.

'I know how much Bob cared about Magnum, and what it meant
to him, while he lived. I also know how Chim felt about it and what
a valiant fight he put up to keep the floundering ship of Magnum
afloat. It had to be kept afloat after he was gone.

'In Magnum we have photographers and not businessmen. Bob
was an idealist gambler and as such knew some things about money,
mainly in large, round figures. Chim had a methodical mind and had
previous experience living on a shoestring; his figures were sharp and
neat, as was his person. They both applied their personal way of
finance to Magnum, each in its proper stage of development,
gambling first, then applying cool thinking to clear away the rubble.

'I will never forget my short exchange with Chim on the occasion
of one of our great crises, on my return from Argentina. Chim
chastised me about neglecting to think about Magnum's problems
during my five months of absence and not supporting him
sufficiently during that tough period. I answered him that it was
tough enough to work down there, I had written several times
whenever he asked for anything, but I felt that my work-contribu-
tion was the most important thing for Magnum, not my writing.
Then I finished my reply kiddingly by saying: "Come on Chimsky,
why do I have to think about it, as long as you are here?" He looked

at me, as only Chimsky could, and said: "This will not do . . . this is not enough, you must *know*."

'Now I understand much better the position Chim was left by all of us, supporting him only when we had time and letting him do the thinking and worrying, each of us adding a little bit of our own to his corporate ones.

'Well, as I said, this is a happy report to make. We are here and working, each in his own way, earning more money, our offices are functioning in a decent surrounding and without squabbles and our deficit is a negligible one.

'Of course there are problems, old ones, new ones, simple and complicated ones. Magnum, being the lead horse of the pack, will always have the most problems from the inside as well as the ones thrust upon it from the outside. We have the undisputed leadership in the photographic field, which brings more obligations than pleasures or money . . . We cannot duck it.

'We have weathered the storm. A period of tightening the sails. A further fusion of spirits and gaining additional individual strength took place. The ship is ready to sail on and it is time for new minds and hands to start afresh in a new era . . .'

In his letter accepting the presidency, Haas wrote an eloquent summary of his attitude to photography: 'I feel a responsibility towards the image as much as a writer feels for the word . . . I am in search for images which reflect myself as much as they reflect the subject matter. I am not interested in shooting new things – I am interested to see things new – in this way I am a photographer with the problems of a painter; the desire to find the limitations of a camera so I can overcome them.

'My search is to find combinations of awareness and in them a combination of intellect and poetry. I am fascinated by dynamic time and the change from a three-dimensional world into a two-dimensional image with a four-dimensional awareness. How can anyone living today not be affected by it I don't understand.'

On 31 January Morris's weekly newsletter to all the photographers noted that Henri was working in New York and had featured in a gossip column which twice managed to misspell his name: 'Henri Cartier-Brisson, the famed photographer, made his first picture-taking tour of New York's nightlife Friday. He photographed Durante at the Copa, the showgirls at the Latin Quarter, the people at Chez Vito and El Morocco and then the Dukes of Dixieland at the Roundtable. When Jack Mayher, the Syracuse clarinetist, learned this was Cartier-Brisson, he told his fellow Dukes: "This cat is to photography what Louis is to us."'

As always, Morris did his best to keep everyone in touch with what others were doing:

ARNOLD – Eve is trying for a story on atomic cancer research at Brookhaven atomic lab, Long Island; and she is watching developments in the Virginia school integration crisis. As of the moment, we do *not* plan to cover the first 'token' integration of Negro students in Norfolk and Arlington on Monday, for the simple reason that we see no way we can compete with the mass mobilisation of photographers by *Life* and the news agencies.

BURRI – René sent off to Paris a nice little story taken last weekend on Simeon, the boy King of Bulgaria, who is now a student at Valley Forge Military Academy near Philadelphia . . . he may get a *Life* assignment to follow Algerian oil by train from the desert to the sea coast . . . beyond that, he will cover the interment of the Aga Khan in a new mausoleum at Aswan . . .

DAVIDSON – is shooting Arthur Miller

GLINN – has an assignment in St Moritz

LESSING – is cooking a number of big projects and definitely wants to cover the Foreign Ministers' meeting on Berlin. He may cover the world ice hockey championships at Prague

MILLER – we are hoping Wayne can get an advance story on the movie he is shooting (*On The Beach*) in Australia – or a tangent such as the Australian heat wave (its effect on A. Gardner?)

RIBOUD – suddenly it appears that Marc *could* be on hand for Eisenhower's visit to Acapulco to meet President Adolfo Lopez Mateos of Mexico

SMITH – maybe I can persuade Gene to do something on the Haitian mardi gras and there are rumours that Castro will go next to Haiti – if so we will be there.

On 25 July Morris's newsletter reported 'the big news from Moscow' – that Elliott Erwitt had got some 'really extraordinary pictures' of Nixon and Khrushchev. This was the famous altercation when the Russian leader and the American president got into a heated exchange, in a model American kitchen at an exhibition in Moscow, about the relative merits of their differing political systems. It started when Khrushchev swept his eyes over the kitchen and loftily claimed that all Russian homes would soon have the same shining, labour-saving appliances.

Erwitt: 'I was in Moscow to take pictures of refrigerators for Westinghouse at the American pavilion . . . Khrushchev and Nixon were walking around the fair, no one knew where they were going,

there was no plan, so I took an educated guess and figured that they were probably going to be at this particular place and sure enough they came and they were just acting out their nonsense in front of me so I could follow the conversation. [Erwitt speaks a little Russian.] Nixon was talking about how much red meat we eat as opposed to the Russians, who eat only cabbage, and that sort of thing and at one point Khrushchev told Nixon to go screw his grandmother – that bit was not translated. One of my pictures was used in Nixon's campaign to show what a tough guy he was pointing his finger at Khrushchev and proving he could stand up to the Soviets and so on. I'm pleased with the picture, I think it is a nice picture, but I am not terribly proud of the use that was made of it. But what are you going to do? You just take the pictures.'[5]

Magnum's big domestic assignment in 1959 was to cover the making of *The Misfits*, a film starring the three most famous talents of the day – Marilyn Monroe, Clark Gable and Montgomery Clift – which was being directed in the Nevada desert by John Huston to a script written by Arthur Miller, then still married to Marilyn Monroe. It was the story of three roistering cowboys who made a living riding in rodeos and rounding up wild mustangs to sell for dog food, whose lives change when they meet a girl (Marilyn): Clark Gable becomes her lover, Clift her soul mate and Eli Wallach her friend. *The Misfits*, the last movie for both Monroe and Gable, would become the best photographed film in history, including not just the shoot but the off-screen dramas – the painful break-up of Marilyn's marriage to Arthur Miller, her frequent breakdowns, Montgomery Clift's troubled personal life and the heart attack Clark Gable suffered shortly after the shoot which eventually cost him his life.

Lee Jones had the idea of negotiating an exclusive deal to photograph the movie. When she heard that it was soon to begin shooting, she contacted Frank Taylor, the producer, and suggested that Magnum photographers working in pairs should cover the making of the film from beginning to end. She argued that such a high-profile movie would attract photographers from all over the world and turn the set into a nightmare. If Magnum had exclusive rights, it could shoot the publicity stills as well as satisfy the demand for pictures and stories from magazines and newspapers across the world, thereby protecting the film-makers from unnecessary hassle. There would be no loss in creative diversity since Magnum would send a different pair of photographers to the set every fortnight to bring their own perspectives to bear and the film-makers would have the comfort of knowing that the film was being covered by some of the world's finest photo-journalists.

Frank Taylor liked the idea, not least because his female star was in a notoriously fragile state and was proving unable to cope with the photographic riot that surrounded her every move. Taylor also knew that Eve Arnold was one of the few photographers Monroe genuinely liked and trusted. Magnum was obliged to make some important compromises to clinch the deal, notably agreeing that all contact sheets featuring Gable or Monroe would be submitted to them for approval before being used.

The project started well, with everyone in good spirits, and the first two Magnum photographers to visit the set in Reno were Cartier-Bresson and Inge Morath. Lee Jones said Cartier-Bresson 'huffed and puffed' a bit before agreeing to take the assignment, but she suspected he was secretly happy to do it. They arrived late in the day to find everyone, apart from Marilyn, at dinner. Cartier-Bresson took a seat and put his camera on an adjoining empty chair. When Marilyn finally arrived everyone stood up and she was introduced to the photographers. She was just about to sit down next to Cartier-Bresson when she saw his camera on the chair. 'Please,' he said mischievously, 'would you give it a benediction?' Marilyn pretended to sit on the camera while everyone laughed. Thereafter Cartier-Bresson delighted in showing his friends the Leica that had been 'blessed' by Marilyn Monroe's rear.

Both Morath and Cartier-Bresson were captivated by Marilyn. Morath photographed her rehearsing a dance scene in the moonlight and concluded that it would be virtually impossible to take a bad picture of her. When shooting moved to the crap tables in the Nevada Club, Cartier-Bresson and Morath were intrigued by the faces of the compulsive gamblers around them. 'Cartier-Bresson was particularly taken with a very short, elderly lady who could barely reach the chrome levers of the slot machines. She was playing two silver-dollar machines at once, occasionally dipping into a purse crammed full of bills, dressed in a blue and white polka dot dress, and a proper straw hat over a face full of grim determination. Cartier-Bresson himself was cool and impeccable in a light blue shirt and a tan jacket, carrying only two small cameras, completely unobtrusive and unwatched. His eyes saw everything in the large room. Occasionally he became interested in a face or situation, and drifted like smoke to a vantage point, automatically and quietly. At odd times the camera came up to his eye and the meaning was caught. Unlike most other photographers, Cartier-Bresson never thought of altering a situation or a pose, and never intruded.'[6]

Inge Morath met Arthur Miller on set. She had never met him before but was familiar with his work and had seen a production of

The Crucible in Paris with Yves Montand and Simone Signoret. 'In the light of *The Crucible* I imagined he would be a very serious man, but the first time I saw him, he was swimming back stroke in a swimming pool in Reno, telling a funny story about a guy with shoulder pads. Later we all went to a spaghetti restaurant and he regaled the whole table with funny stories.' Morath was one of the few people on the set not to realise that Miller's marriage to Monroe was in trouble and when she was interviewed about her experiences for *Marie Claire* magazine she said she thought things between them were fine. Some time after the marriage was formally ended, Inge Morath met Miller again in New York when she was asked to photograph one of his theatrical productions. In 1962 they married and moved into the Chelsea Hotel before setting up home on a farm in Roxbury, Connecticut.

Before Cartier-Bresson left Reno he taped an interview with a local journalist. It was clear he had fallen under Monroe's spell:

When I saw her bodily for the first time I was struck as by an apparition in a fairy tale. Well, she's beautiful – anybody can notice this – and she represents a certain myth of what we call in France *la femme éternelle*. On the other hand, there's something extremely alert and vivid in her, an intelligence. It's her personality, it's a glance, it's something very tenuous, very vivid, that disappears quickly, then appears again. You see it's all these elements of her beauty and also her intelligence that makes the actress not only a model but a real woman expressing herself.[7]

After Inge and Henri left things began to go wrong. The atmosphere on the set soured, Marilyn became increasingly difficult and stressed and delays began to accumulate. The desert location for much of the shooting was sixty miles from the Reno base, the heat was intense, and Marilyn seemed worn out. By the time Eve Arnold was due to take her turn down in Reno, Marilyn had taken an overdose of sleeping pills and been hospitalised in San Francisco. Eve travelled on the same plane with Marilyn when she returned to the set after she had recovered. In the end Eve stayed on the set, at Marilyn's request, for two months. 'Twice during the filming she tried to take an overdose. Her marriage to Miller was just about over, she was often late and her coach, Paula Strasberg, would be sarcastic. She would never talk to me about her problems. I remember when I showed up, she was coming back from hospital in San Francisco, where she had just been pumped out. I saw her in the back of the plane but I made myself small because I didn't think she

would want to start talking on her way back from hospital. Better next day, I thought. She got off the plane – there were banners saying "welcome home" and lots of publicity business – and I sneaked down the steps and when she turned round and saw me she ran over to me, hugged me and said "I'm glad you're going to be here." The next day she said she was going to see the rushes and asked me how she looked. I said she looked wonderful, which she did, and she answered "I'm tired. I've been on this film for six months. I'm thirty-four years old. Where do I go from here?" She would talk like that but she would never say anything specific.'

Ernst Haas, who was with Eve on the set, spent most of his time photographing the wild horses and ignoring the humans: 'All the people who were on the film were misfits – Marilyn, Monty, John Huston, all a little connected to catastrophe, Gable not saying much, just being Gable. It showed how some stars are like stars in heaven that are burned out. The light is still travelling but the star is gone. They were actors playing out the allegory, then seeing it in life. It was like being at your own funeral.'

It was Elliott Erwitt's unenviable duty to try and get a group shot. It kept getting put off and so he rigged up a set with ladders, boxes, stools and parachute silk, and worked on it for three days, refusing to tell anyone what it was for. On a day when all seemed to be going smoothly he invited everyone to the unveiling and the picture got taken rather in the manner of a *Vogue* fashion shoot, with Huston on a stool, Miller on a tall folding ladder, Frank Taylor under the ladder, Marilyn on a stool, Clift on an electrician's box and Gable standing. 'The job was very enjoyable,' said Erwitt, 'because the whole set-up was so disorganised. Marilyn was in a very disturbed frame of mind and Huston spent all night playing cards, smoking and drinking. It was total chaos. This is what gives the photographer so much freedom to work. Photographs are always more interesting when the subjects are taken off guard or not where they should be.'[8]

Magnum's promise to allow Monroe to approve all her pictures inevitably caused problems. Marilyn marked the pictures she didn't like with a grease pencil, but then the contact sheets were submitted to the unit publicist, who sent them to the studio publicist in Los Angeles, who finally forwarded them to Marilyn's personal publicist. By the time Magnum got the contact sheets back there were simply not enough approved pictures to make a story. Eve Arnold ended up visiting Marilyn every day for a week at her home on the East Side of Manhattan to persuade her to approve more pictures, which, finally, she did. By then it was known that her marriage to Arthur Miller had broken up and her house was under siege from paparazzi.

Eve often felt sorry for her. 'I always tried to make things easy for her because she was a valiant creature, she really was. She was an ebullient, funny, witty woman when I first met her, but there was a strain of underlying sadness towards the end of the period that I knew her. She never talked to me about the Kennedys. She called me up the day before she was due to go to the Kennedy birthday party and asked me to go with her. I'd done so much with her by then and I thought "Oh God, not another one" so I said no, I couldn't do it. I was sorry, of course, afterwards. She wasn't mad at me, she understood. She was always very easy with me, very pleasant, sweet; never, ever did I feel there was a problem.'

At Magnum's annual general meeting in January 1960, Morris finally lost the expansion argument. It was decided that Magnum should set up 'a strict administration that will aim for a light and supple operation, but which must be in consonance with the times and markets we are working in, and concerned with the welfare of *all* its members; a group (photographers and office), based on the human and intellectual development of its members, helping each other in their particular needs with clear, vivacious, lean thinking; its expansion taking place only in an organic growth, with quality as an aim.'

A few months later, Morris reported that while commercial work was brisk and the agency's prestige remained high, editorial work had suddenly slumped. In February the New York office picked up less than $3,000 in fees from magazines and there was not a single sale of an 'IP' (independent production) story; in Paris magazine sales netted a total of only $1,629 – less than one third of the office expenses. Morris chided the photographers for not covering the biggest earthquake in modern history at Agadir, the troubles in South Africa and the civil rights demonstrations in the southern states of America. The agency's exclusive on the 'Death Row cellmates of Chessman [murderer Caryl C. Chessman] at St Quentin had collapsed because of political pressure on the governor and warden: 'we are still, however, hoping to get a "last picture" of Chessman himself.'

In 1960 'The World As Seen By Magnum Photographers' exhibition opened at the Smithsonian in Washington and later toured Europe and Japan. In a foreword to the catalogue the venerable Edward Steichen heaped praise on Magnum as marking 'the establishment of an important and far-reaching force in documentary photo-journalism . . . This unique association of free-lance photographers is continually and persistently following the course of events wherever they happen on this globe. Today they are

among the ranking contributors in the reporting and documenting of
the human aspect of timely world events, which, tomorrow, become
timeless visual affirmations of history.'[9]

The whole Magnum organisation, Steichen added optimistically,
backs up every member and every member backs up the whole
organisation. Would that it were so.

EVE ARNOLD talking in her flat in London's Mayfair: 'The first time I photographed Joan Crawford was in 1955 when she was publicising a film called *Autumn Leaves*. I met her at a dress designer's place in New York. When she arrived she had two little poodles, one on each wrist. She kissed each one on the mouth, then gave them to a secretary, kissed me on the mouth and said "Let's go take some pictures!" She was completely drunk. Every time I photographed her subsequently she was gone the whole time, drunk every day. She drank 140 per cent proof vodka, but she carried it very well and vodka, of course, doesn't have an odour.

'She walked into a dressing room where she was to try on some clothes and stripped, totally nude, and insisted I photograph her. I was too inexperienced to know how to deal with it. I don't know if I would know what to do today; I was certainly scared witless in those days. The reason for the stripping, as far as I could figure out, was that she had done a number of blue films which showed up from time to time in various parts of the world and she just loved being photographed in the nude. Still, it is one thing to do it when you're in your twenties, quite another to do it when you're in your fifties.

'I photographed her but forgot I had colour film in the camera and then had a problem getting it processed. I couldn't risk taking the film to a processor because I was worried the technicians might make copies and sell them and I had never processed a roll of colour film myself. I went to the nearest Kodak place, bought the chemicals and the assistant told me how to use them. I was terrified that if they didn't come out she would think I had purloined them. So it was very important for them to be right and luckily for me, they were fine. A few days later she called me and asked me to meet her at the 21 for lunch and when I walked in she held out her hand and I gave her the little box of transparencies. She held them up to the light, one by one, then leaned over the table, kissed me and said "Love and eternal trust, always." That must have been a line in some film she was in, I imagine.

'About five years later I read somewhere that Crawford was broke and I was on my way to *Life* to talk about whatever it was they wanted me to do and I suggested doing a story on her. She was making what was to be her last big film, *The Best of Everything*. When I called her and told her that *Life* had agreed to a story she said she wanted editorial control. I told her that it wasn't possible and she got very stroppy. I said I was sorry but I just didn't think we could do it that way and she just said "OK, you think about it." That night she got Henry Luce, head of *Life* magazine, out of bed to tell him that that Arnold woman wouldn't give her editorial control. He

was furious and he got Ed Thompson, the managing editor, on the telephone and said "Let her have whatever she wants, just let me get some sleep and get her off my back." So Thompson called me next day and told me what had happened. I said, "Don't do it. It's the wrong thing to do. She wants this story badly, I'm sure she'll call back." So we agreed to wait until noon. At about nine o'clock California time she called and said she would do it. Then she said "Dahling, if I don't like what you do, you'll never work in Hollywood again!"

'It turned out to be an extraordinary story, one of the most intimate I have ever done. She said she wanted to show her public the energy and dedication it took to stay at the top. If she was going out in the evening, she would start getting ready in the morning. Two masseuses would come from Elizabeth Arden to massage and polish her up and she wanted me there to photograph it. I got her lying on a table with a masseuse at her head and a masseuse at her feet. It really was quite extraordinary. She wanted to show her eyebrows being dyed and show she still had a good figure. She did things I wouldn't even put in the story. One day, when we were doing this, she sent out for a hot wax depilatory for her legs and wanted me to photograph it, but I was not about to use that.

'The first time I photographed her, when she stripped, she had talked venomously about Marilyn Monroe, who she'd just seen at the Actors' Studio. "She didn't even wear a girdle," she said. "Her ass was hanging out. She is a disgrace to the industry." I had already photographed Marilyn several times by then and later that year she called me over to the Waldorf to talk about a story she wanted to do. At the time she was under suspension from Twentieth Century Fox. When I got there she opened the door wearing a black diaphanous négligé and holding a hairbrush. She said she had a woman coming to interview her and asked me to sit with her during the interview. When the woman arrived she said to her, "Do you mind if I brush my hair while we talk?" The woman says, "No, of course not" and bends down to scribble something in her notebook. When she looks up, Marilyn Monroe is sitting there brushing her pubic hair!'

9

The Che Diaries Affair

IN MARCH 1960 the world was shocked by the news from South Africa of a massacre of black civilians by white police in the township of Sharpeville, about thirty miles outside Johannesburg. Sixty-nine people were killed and 162 injured in an unprovoked bloodbath. Only one photographer was present to record South Africa's shame: he was a twenty-six year-old Englishman by the name of Ian Berry, who was a staff photographer for *Drum* magazine. The pictures he took that terrible afternoon of terrified men, women and children fleeing from the guns of the police were published around the world and focused international attention on the plight of black people living under apartheid in South Africa.

'March 21st was my day off. It was a day of protest against the pass laws organised by the Pan African Congress and I was at home when I heard on the news that someone had been shot outside Sharpeville. I went into the *Drum* office to see what their contacts had heard but all the staff were out apart from a sub-editor, Humphrey Tyler, and no one had called in with any information. So Humphrey and I borrowed the editor's car and went off to see what was happening at Sharpeville. When we got there we found spotter planes were circling overhead and about fifteen press cars were waiting on the outskirts of the township.

'The police drove past in armoured vehicles, which were not uncommon at the time, and the press followed, but we were twice stopped and threatened with arrest for being in the township illegally. In those days no whites were allowed into the townships without permits. Many of the correspondents in our group were novices to South Africa drafted in to cover the developing tension and in the end all of them turned back. But Humphrey and I thought we couldn't be far from the centre of the township, so we decided to continue following the police at a discreet distance. We

came to a police station surrounded by wire fences with fields on two sides and roads on the other two. The armed vehicles went into the compound and we drove on to waste ground round the back, unobserved.

'Humphrey stayed in the car, but I got out to see what was happening. My guess was that there were two to three thousand people there, but they were spread over a large area and with people no more than three or four deep at the fence it didn't seem an enormous crowd. The demonstrators I talked to showed no hostility. The cops were some distance away inside the compound and there wasn't much to photograph. I was concerned about being spotted and arrested for very little photographic return so I walked back across the waste ground to the car, leaned in and said "Maybe it's worth telephoning to find out if anything else is going on."

'Suddenly there was shouting from the crowd. I turned and started to walk back across the compound. The cops were now standing on top of their armoured cars waving Sten guns and when I was about fifty yards away they opened fire into the crowd. I can't say for sure that nobody lobbed a stone, but I do not believe a threatening situation had built up in the time it took me to walk to the compound and back. The cops were in no danger. I can only assume that they came out with the intention of teaching the crowd, and in the process, black South Africa, a dreadful lesson.

'People started to run in all directions, some towards me, some away. The majority of the people who were killed were running away, around the side of the compound. A woman was hit immediately beside me. A boy ran towards me with his coat pulled up over his head as if to protect himself from the bullets. I fell to the ground on my stomach and started taking pictures.

'The shooting stopped, and then it started again. When it stopped for the second time, a man stood over the woman next to me and touched her. He lifted his hand and hesitated for a moment and looked at it, covered in blood. I thought I would be shot myself if I didn't get out and I ran back to Humphrey in the car. We took off. We were quickly lost and although nervous about people wanting to take revenge on a couple of whites, we asked a man the way out. He readily told us and we left.

'Neither of us thought we had been witnesses to a definitive moment in South African history, although that is what it proved to be, and we didn't know how many people had been killed. But *Drum* was closing an issue the next day and we rushed back to the office thinking "Wow, what a great story for the magazine." I hurriedly processed the film and made prints for Tom Hopkinson,

the editor, who was on his way in. There were no great pictures, but there were plenty of images documenting the event.'

To Berry's fury and frustration, Jim Bailey, the owner of the magazine, arrived at the office, took one look at the pictures and told Hopkinson not to run them. Hopkinson naturally protested, but Bailey was adamant that *Drum* would be closed down by the government if they published Berry's pictures. Hopkinson took Berry to one side and advised him to send his pictures to Camera Press in London, without delay, which he duly did.

Sharpeville was to prove a turning point in the struggle against apartheid. It shattered the uneasy peace that had prevailed: strikes, pass-burning, demonstrations and riots became commonplace and an unofficial war was declared between township dwellers and their white rulers. As the liberation struggle, led by the Pan African Congress and the African National Congress, caught the imagination of the oppressed black community, whites panicked: share prices collapsed, capital fled the country and more and more white voices called for a republic to be established, free from interference by Britain or the Commonwealth.

The police had carried out dozens of arrests at Sharpeville and Berry made his pictures available for the defence when their cases came up in court a few weeks later. The police at first claimed that they had only fired single shots in a single ten-second burst. But in one of Berry's pictures a police officer could be clearly seen standing on top of an armoured vehicle reloading an automatic weapon. The police further alleged that they had fired in a moment of panic because they feared they were going to be overrun; but Berry's pictures showed the crowd running *away* from the compound as the shots were being fired and the contact sheets proved there was a second round of shooting. All the charges against those people arrested at Sharpeville were dismissed.

For Berry it was ironic that his Sharpeville pictures made him famous, for he was the first to admit that they were far from the best pictures he had ever taken. Born in Lancashire in 1934, he was just seventeen when he first arrived in South Africa, a restless teenager with an urge to travel and the offer of a job as an assistant to Roger Madden, an industrial photographer who had once worked with Ansel Adams. Berry learned the basics of photography from Madden between humping bags and setting up lights, then moved on to a mobile portrait studio – driving around in an old American La Salle, setting up a sheet and lights in one village after another and photographing locals who came in from the surrounding farms to have their pictures taken.

A spell working for a Sunday newspaper in Johannesburg aimed at a black readership politicised Berry and opened his eyes to the civil rights movement opposing the ever more repressive legislation being brought in by the Afrikaner government. 'This was a time when the average white had no communication with blacks and I was viewed by my white friends as being very eccentric, working for what was perceived as a black newspaper. Other journalists thought I must be a Communist. I was very quickly brought face to face with a few realities of being black in South Africa and the problems of working with black journalists. After work, for example, we couldn't go to a restaurant for a meal together or go for a drink in a bar. If we went off on an assignment that involved an overnight stay, the company car would drop me off at a hotel in town, the black reporter would have to go into the local township to try and find some place to stay and the driver would sleep in the car.'

After an unsuccessful stab at freelancing, Berry joined the liberal *Rand Daily Mail*, a forceful and outspoken critic of apartheid, where his political education was completed before he moved to *Drum*, South Africa's brave attempt at a black *Life* magazine, then being edited by the legendary Tom Hopkinson, former editor of *Picture Post*. Hopkinson was to be the biggest single influence on Berry's life and career, encouraging him to trust his own instincts and helping him to refine his skills as a photo-journalist. It was Hopkinson who advised Berry to make contact with Magnum when he decided to quit *Drum*.

To Berry, being invited to join Magnum was a 'dream come true' particularly as he very nearly blotted his copybook with Cartier-Bresson. 'Although there was a procedure for joining – nominees and associates and all that – really all you had to do was to be OK'd by Henri. This involved going down to the bistro below Magnum [where Capa had played pinball] and letting him look at your snaps. I'm afraid I rather screwed things up. I have always been a tea drinker, even though I was living in Paris, where everyone drinks coffee. When the waiter came along I thought maybe I could impress Henri by ordering coffee, only for him to order tea! Anyway, I showed him my prints and he looked at them, huffed around a bit and took off. William de Bazelaire [the Paris bureau chief] called me a little later and said "What did you do? You've really upset Henri. He hates your guts. It's not going to work . . . but I'll try and persuade him to see you again. What on earth did you do?" I told him. Apparently my mistake was to show him prints, which I shouldn't have done, but no one told me this. Henri didn't like to look at prints, he liked to see contact sheets so he could see

how your eye developed. Anyway, next day I had another session with Henri and I took along contacts, instead of prints, ordered tea, and I was in!

'The beauty of Magnum in Paris in those days was we had this small office, it was very close-knit. We helped each other with editing, the staff were all involved; it was family, really. The archivist had been there from the word "go" and he knew every photograph that anyone had ever taken so that when somebody came in to buy something, he could produce the picture immediately. I used to go up to the office at night, alone, and pull out the contact prints of other photographers to study them and learn from them. It was the best education I could have had.'

Across the Atlantic the attention of the New York office was focused on the upcoming presidential election and the glamorous Democratic candidate, John F. Kennedy. Eve Arnold was commissioned by *Harper's Bazaar* to photograph the wives of the candidates – Nixon, Humphrey, Kennedy and Johnson. She travelled to Washington with an editor from the magazine carrying the suits and dresses the magazine wanted them to wear. Eve tripped over Nixon's notorious dog, Checkers (the subject of his famous 'Checkers speech' in the 1952 campaign) as she was leaving the Nixons. The dog, she recalls, looked old, ill and moth-eaten. Of the four wives it was Jackie Kennedy who exhibited most style.

I was impressed with her because she refused to wear the dress the editor brought, insisting, and rightly, that her own Givenchy suit was absolutely perfect for her. When we discussed the picture I was to take, I suggested that we take it with Caroline. She was not pleased and kept saying 'Why does everybody want me with the baby?' Actually, the press had not yet gotten to her, and except for the occasional newspaper picture, there hadn't been much about her in the media. I said that I had four pages, one for each of the ladies, and she, the youngest and prettiest, would be bound to get the lead page, especially if she had the baby. I added 'It will help get votes.' She didn't reply, but went to the door to admit Kenneth, her hairdresser. He had flown down from New York to do her hair for the picture. They went upstairs to get her ready and when they came down, she was carrying Caroline. 'Where do you want us?' she asked. The light was coming from the back of the house, so I suggested we go there. Sitting on a couch were two men. One was interviewing the other, but I was not paying

much attention. I was reading the light. Mrs Kennedy asked me if it was all right. I nodded. She jerked a thumb at the two men, indicating that they were to go upstairs. They rose and started to walk out. The younger of the two opened the door, then turned and walked back, held out his hand to me and said 'I'd like to introduce myself – my name is John Kennedy.'[1]

In the week that President Kennedy took office, in January 1961, nine Magnum photographers, led by Cornell Capa, mobilised to produce an 'instant book' on the first 100 days of the Kennedy administration. With JFK's stirring inaugural address still ringing in the ears of the nation, teams of writers and photographers went out to report on how the 'new generation' was carrying the torch which they had been passed, picking up the new president's promise: 'For my part, I shall withhold from neither the Congress nor the people any fact or report, past, present or future, which is necessary for an informed judgment of our conduct and hazards ...'

The book was Cornell Capa's suggestion and the idea was to illustrate the most important elements of the inaugural address. Each chapter was to go to press separately and it was planned that the book would be in the stores by the 110th day. The photographers involved were Capa, Cartier-Bresson, Elliott Erwitt, Burt Glinn, Inge Morath, Marc Riboud and Dennis Stock, along with Constantine Manos and Nicolas Tikhomiroff, who were both prospective members of Magnum. The brief was to deal with social and economic problems as well as to cover the first presidency to mix politics with glamour: they shot government food packages being handed out to an unemployed miner, an Ecuadorian mother drinking water from a pump donated by the United States, a presidential assistant on Capitol Hill urging a congressman to support a Kennedy initiative ... Capa covered the White House and Cartier-Bresson travelled with Bobby Kennedy through the South as he set about tackling civil rights. Everything went smoothly until, on the ninety-seventh day, armed Cuban exiles staged an invasion at the Bay of Pigs, throwing the production of the book into disarray.

Although not involved in the book, Bruce Davidson was also in the South working on a subject that would occupy much of the new president's attention during the early part of his administration – the struggle of black Americans for basic civil rights. Davidson had been commissioned by the *New York Times* to cover the Freedom Riders: young demonstrators who were systematically breaking segregation laws on buses in the deep South. Davidson joined the Riders in Montgomery, Alabama, not long after they had been attacked by a

white racist mob. 'We boarded a Trailways bus at the station. I photographed the Freedom Riders surrounded by grim National Guard troops and a dozen police cars. Solemn soldiers stood in the aisle with fixed bayonets. The riders started singing "Freedom, Freedom" and the bus pulled away from the depot, passing jeering whites who lined the streets. During the hours that the bus travelled the deserted tree-lined highway, there was concern that snipers might fire on the bus. The riders quietly sang freedom songs to dispel their fears. When the bus reached Jackson they were arrested and taken away in police cars.' Davidson was profoundly moved by their courage and returned the following year, financed by a Guggenheim fellowship, to continue covering the civil rights struggle.

In Brownsville, Tennessee, I was arrested one night by the local sheriff for taking pictures of a black couple dancing at a jukebox in a small restaurant in town. They took me to the jail where they questioned me for an hour. They wanted to know if I was a Communist or a civil rights worker. I told them I was a photographer on a grant to take pictures of the South. The sheriff said they had had trouble with 'agitators' and said 'Get out of town before we have to stomp you!'

A few weeks later I joined ten integrated marchers retracing the steps of a postman who had been killed by a sniper's bullet when he walked down an Alabama highway carrying a sign 'Eat at Joe's, Both Black and White'. I walked with the marchers, taking pictures of them and of the angry youths who followed close behind. When the marchers rested, the youths came closer. One black marcher sat at the roadside, surrounded by some white youths, talking to them. One youth struck a match and dropped it beside the marcher's head, but he kept quietly talking. Carefully, I slowly brought the Leica to my eye, made a couple of exposures, and stood there looking at the ground, hoping they would not attack us.[2]

At the time he was working on the 'First 100 Days' project, Costa Manos was not formally a member of Magnum, although he'd taken his pictures into the Magnum office in New York in 1951, when he was seventeen years old, having travelled up from his home in South Carolina on a Greyhound bus. 'I had always wanted to be a photographer and had always wanted to be a member of Magnum. The work of Cartier-Bresson was a great influence. When I was still

a teenager I remember going to great efforts to find out what kind of
film he used. It was an English film called Ilford. I went to my local
camera store and asked them if they had it and they said they had
never heard of it, everyone was using Kodak, so I had them order
some Ilford film for me from New York. I was fanatical about
quality and a certain kind of look that I was trying to get.'

Manos was both determinedly ambitious and precocious: at the
age of nineteen he got himself appointed as official photographer to
the Boston Symphony Orchestra during the Tanglewood season, a
commission which led to a book, *Portrait of a Symphony*, which was
published while he was in the US Army, working as a staff
photographer on *Stars and Stripes*. After working, on the Kennedy
book, Manos went to live and work in Greece, to photograph village
life in his parents' native land. 'In the middle of the period I was in
Greece I drove to Paris in a little Volkswagen and took with me
some prints of my Greek work to show to the Magnum office. They
asked me to leave them behind, which I did and returned to Greece.
I remember exactly where I was when I heard that I had been
invited to join Magnum in 1963. I was in a very isolated village on
the top of the mountains in the island of Kárpathos, near Rhodes.
One of my rules of thumb was that I would only work in a village
where there was no electricity, because they were more primitive.
This particular village was remarkable, because not only was it very
isolated but they still had customs that had died out in most other
parts of Greece, such as the women wove fabric from which they
made their own dresses and the local bootmaker made everyone's
shoes. It was also one of the last villages where almost everyone
played instruments. A girlfriend of mind in Athens was forwarding
my mail and one day there was a letter from Magnum Photos in
which they said there had been an annual meeting and I had been
invited to become an associate. I was just absolutely thrilled, of
course, but I had no one to share my joy with.'

In 1961 Ernst Haas left Magnum amicably, partly because he didn't
feel the agency at the time was particularly well equipped to handle
colour, partly because he was having trouble making ends meet and
partly, he explained, because he'd grown tired of 'holding hands and
dancing in a circle'. That same year Edward Steichen showed Haas's
latest colour work at 'The Second Photo Journalism Conference in
the West' at Asilomar, California and asked the assembly to rise as a
mark of respect, saying, 'In my estimation we have experienced an
epoch in photography. Here is a free spirit, untrammeled by

tradition and theory, who has gone out and found beauty unparalleled in photography.'

John Morris also resigned from Magnum in 1961 after a stormy meeting at Cornell Capa's apartment at which it was more or less agreed that his job had become too much of a burden for one man. 'It was,' says Morris, a 'case of mutual disaffection. I think I was the only member of the staff who felt free to talk back to the photographers. In magazines, photographers worked for the editor; at Magnum, the editor worked for the photographers. Having worked on the other side, I could always see the editor's point of view and I think sometimes Magnum photographers thought I was a bit more of a critic than their salesman.'

That summer Magnum went in for a prolonged period of navel examining. Elliott Erwitt circulated a questionnaire asking members 'Why are we in Magnum?' 'Is it because it's practical and we'll all be rich? Is it because we want to be listed on the same sheet as HCB? Is it a hobby? Is it a habit? Is it plain laziness? Is it for the value of our name as a bargaining point? Is it for the glory of our external image? Is it because we are selflessly interested in the future of photography? . . . Is it the historians of our time bit? Is it for the convenience of having a place to hang one's hat? Is it because it is a good place to bend a captive audience's ear, staff and photographers, with our triumphs, troubles and frustrations? Is it because you are too much in debt to quit? Is it because we stand for a certain quality, human and photographic, and can impose it best together? Is it all of these or just some of these? Or none of these?'

He was asking, he explained, because he felt that Magnum was 'drifting relatively conceptless' into 'stupid, destructive and, in most cases, infantile' antagonism between the photographers, and between photographers and staff. He reminded everyone that 'Selflessness, as much as it can be practised within our individual make-up, is an essential Magnum ingredient. When there isn't enough of it, a concerted effort must be made to overcome the green monster of jealousy and greed to attain a minimum standard of collective spirit . . . The past has shown that the intensity of Magnum's happiness is directly related to satisfying production and subsidising financial problems . . . we must pay the price of our past irresponsibility and weakness.'

Cartier-Bresson responded promptly and distributed his reply to all members:

Elliott had, I think, a good idea to provoke each one of us to sum up his position in and towards Magnum. Personally, I will answer

positively NO to all his questions except to the one before last and the one before that. "Are you in Magnum because you are too much in debt to quit?" Yes, I am in debt toward a certain conception of photography, toward what Capa, Chim, Werner and a certain number of present Magnum members tried to build.

Is it because we stand for a certain quality, human and photographic, and can impose it best together?' Yes, Magnum offers the possibility of being alone and at the same time not isolated. But apart from some very rigorous and sensitive work being done, I am fully aware of the considerable *conformisme* (French) and lack of intellectual or visual foundation of a good deal of the Magnum production. This *conformisme* limits our pride in being in Magnum.

On the other hand, I appreciate very much the efforts being made to reorganise our sloppy administration and shameful promiscuity with regard to money. *Salut*, Henri.

Perhaps as a result of Erwitt's questioning, Magnum produced a brochure that year reaffirming that members were 'dedicated to continuing photojournalism in the tradition established by the three Magnum photographers who have died on photographic assignments of their own choice'. But within the agency there was continued friction between the staff and the members, as evidenced by a sarcastic memo to the president from a woman employee: 'I believe the era of "house mother" has outlived its day. This has implied that some *one* person on the staff has to take care of the complaints, bruises and whims for all of Magnum. It is really impossible to perform such a job as this efficiently except on a full-time basis. Furthermore, I see no reason why people who are supposed to be adults should be pampered with such a figurehead as "house mother". Do you?'

Lee Jones confirmed that the staff were often required to mother the photographers: 'It was not unusual for somebody, who was being paid a fair amount of money to do an editorial job, to spend his or her day getting ConEdison to turn the gas back on because some photographer couldn't pay his bills. There was a lot of that kind of thing. It could have a very strong binding effect, but in the long run it was detrimental because it got the photographers into the habit of simply passing their problems on to Magnum, in some cases their financial problems. This idiosyncrasy became almost a trademark and it made Magnum an extremely difficult place to work: enormously rewarding, but enormously difficult because the role of the bureau manager was to try and mediate between this extraordinary tribal

unit and the commercial world. I would have to deal with a photographer who wanted me to tell an editor to go fuck himself and then lunch with that same editor who told me to tell the photographer to go fuck himself.'

At the photographer-to-photographer level, things were not much better. When Wayne Miller took over as president, he vividly recalls, there were difficulties of trying to get an agreement between the Paris and New York offices. 'The tendency was for the Paris office to say that we should fire anyone in the New York office not doing a good job and New York said the same thing about Paris. At times it got vicious: an individual would take it upon himself to fire somebody and demoralise everyone. On one occasion I had worked very hard with Marc [Riboud] to resolve some problem and got him to agree a certain course of action. Then I returned to New York and got Cornell to also agree. Then I talked to Marc about it on the telephone and he said, 'No, we didn't agree on anything like that!' So I went back to Cornell to confirm his agreement and he, too, in his elliptical Hungarian way, denied we had agreed on anything. In the end I found that we didn't actually have to have agreement, we just had to get people together to talk and they could still go home with their own thoughts, but we would have some new middle ground that we didn't have before.'

Miller remembers another mini-crisis when Inge Bondi decided to award herself a pay raise. It was not unreasonable, since no one at Magnum was paid a decent salary, but it had not been approved by anyone. Miller pointed out to her that she couldn't just arbitrarily give herself an increase, but when he got nowhere he called Burt Glinn in to help. The three of them ended up in a dusty little back room in the New York office yelling at each other. Finally Bondi announced that her psychiatrist had said it was OK for her to get a raise. 'OK, OK,' said an exasperated Glinn, 'I'll tell you what we'll do, Inge. You get your psychiatrist and I'll get mine and we'll let them work it out.'

When Charlie Harbutt, a member of the Scope agency in New York, was invited by Cornell Capa and Wayne Miller to join Magnum in 1962 he said it was like earning a 'merit badge', but he was amazed by the animosity between the offices. 'There was an attitude of great mistrust between the French and the Americans. Most of the New York photographers were Jews and most of the Paris photographers were upper-class French. Basically, whatever the nationality of the president, the office of the other nationality would not do what he wanted.'

Meanwhile, the battle between art and commerce raged on.

Cornell Capa, with typical Hungarian modesty, claims that he introduced commercial photography into Magnum:

Yes, I was the guilty fellow. In 1960 I photographed a story for *Life* on the birth of a small compact car, the Falcon, and I had great fun doing it. When old man Henry Ford died they had 47 engineers working for the Ford Motor Company and by the time I did my project in 1960 they had 13,000. I kept coming across these guys in white shirts and I eventually conceived the idea of having the smallest car in the world with 13,000 engineers to parent it. It was a funny idea. So I cooked up a picture of having 13,000 white shirted engineers standing behind the smallest American car. The *Life* story was only four or five pages, nothing, but I had some fantastic pictures of how a company of this nature works, the technology, and I sold the idea to Ford to make it black and white, a 16-page annual report. That was the beginning of using our kind of photography for annual reports. Of course it caught on like wildfire and today people are making lots of money out of it.[3]

Disregarding the fact that both George Rodger and Werner Bischof accepted commercial work in the early 1950s, Inge Morath was taking pictures for a New York advertising agency a full year before Capa was involved with Ford. 'It suddenly occurred to the agency, and probably also to others, that they wanted their ads in the style of documentary photography. They turned to Magnum and of course Henri Cartier-Bresson. When he declined, I was asked. I accepted the job because I had just bought my apartment in Paris and needed a lot of money. The assignment was very well paid and it was interesting work – a complete campaign for Bankers Trust about New York. In the end they even made it into a small book. It wasn't reportage and I did not use models, who seemed too stilted, I just asked my friends. Together with the art director I discussed the situations and then I photographed them. The wonderful thing about it was that I always did it in a very short time and I was proud of that. I prepared the scenes and then the actual shooting took me five minutes. The art director was very irritated. He said: "This is too short, we pay you too much!" I replied that I had been thinking about it for an entire week. The campaign was a great success.' But Morath soon found she was thinking too much in advertising images and stopped doing commercial work as soon as she had paid for her apartment.

Cartier-Bresson made no secret of the fact that he did not approve

of what he saw as the commercialisation of the New York office. 'What is most satisfying for a photographer,' he noted 'is not recognition, success and so forth. It's communication: what you say can mean something to other people, can be of certain importance . . . The photographer's task is not to prove anything about a human event. We're not advertisers; we're witnesses of the transitory.'

When the New York office relocated in 1962 to 72 West 45th Street, there was no money to fix the place up, so Lee Jones and a decorator friend had the idea of painting the word 'MAGNUM' in huge letters on the wall next to the door. 'Photos' was omitted since in the US it smacked of drugstores and and photo albums. One day Lee heard a commotion outside and discovered Cartier-Bresson, on his first visit to the new office and incensed by what he saw as a nod towards the values of Madison Avenue, standing on a chair with a felt pen and adding the word 'Photos' after 'Magnum'.

Undoubtedly the best thing to happen to Magnum in 1962 was the launch, in London, of a free colour magazine to accompany the *Sunday Times*. Despite derision and hostility, and predictions that it would be a disaster, other Sunday newspapers soon followed suit, opening up lucrative new editorial markets. From the start, the *Sunday Times Magazine* led the field and established itself as a vehicle for photo-journalism of the highest quality. Inevitably, that meant employing Magnum photographers.

One of its first cover stories featured Eve Arnold's pictures of Malcolm X. Several years earlier Eve had convinced *Life* to commission a photo-essay on the Black Muslim movement. Being white and a Jew hardly endeared her to the Black Muslims, but she somehow persuaded Malcolm X to co-operate and over a period of two years followed him from Washington to New York to Chicago, the only white face at Black Muslim rallies where cheering crowds were assured that 'the devil is a white man'. Eve got used to people screaming 'White bitch!' in her face and having cigarettes stubbed out on her clothes. 'As I walked through the crowd they would polka-dot me with cigarette burns; I learned to wear wool rather than cotton or silk because wool doesn't burn.' Lincoln Rockwell, the head of the American Nazi Party, showed up at one of Malcolm X's rallies in Washington and when Eve took a picture of him he whispered, 'I'll make a bar of soap out of you.'

Despite all this, she was impressed by Malcolm X. 'I thought he was brilliant and sincere in what he was doing, but he was also wily and Machiavellian and an opportunist. He was extraordinary, he could prove anything with sheer sophistry. I remember being with him in Chicago when he addressed the students at the University of

Chicago and kept talking about how the white man had enslaved the black man. Somebody in the audience asked about Arabs and he went on to prove that Arabs had nothing to do with slavery. I was with him the whole time and when we got in the car afterwards I said to him "How did you come up with that idea about the Arabs?" He laughed and said "They bought it, didn't they? I can sell them anything I want to."

'Another time we went to have dinner in one of the restaurants owned by the Black Muslims on the eastern seaboard. He ordered for me and this pie arrived and it was delicious, mashed up something, and I said "Is this sweet potato pie?" All the waiters froze and Malcolm was obviously furious. "It's made of white beans," he said, as though I were a cannibal. Afterwards I discovered it was the worst thing I could have said. Sweet potatoes were considered soul food, the kind of food given to slaves, and they never ate slave food, on principle.'

When Eve finally produced her Malcolm X essay, the editors at *Life* got cold feet. They sifted through the pictures nervously and kept saying 'Nobody knows who these people are – why should *Life* do a story on them?' One young editor offered the view that the pictures could have been shot in Africa. 'But they were taken in America,' Eve pointed out, 'and it is precisely because no one knows who they are that you should publish them.' The feature was first made up as twelve pages, then ten, then eight, and constantly postponed. When eventually it was laid out for the magazine, someone noticed that the last picture, of Malcolm X's wife and daughter at prayer, was above an advertisement for Oreos chocolate cookies with the copy line 'The greatest chocolate cookie of them all'. To Eve's absolute fury, *Life* pulled the feature, rather than the advertisement. The magazine never published her Malcolm X pictures, although they were subsequently sold all over the world, most notably to the *Sunday Times Magazine*.

John Hillelson, an agent who had represented Magnum in London since 1958, says the launch of the colour supplements heralded a new era, with different magazines competing for the services of Magnum photographers for the first time. Until then, Magnum was not well known in Britain and there was so little interest in photography that when he wanted to set up an exhibition of Bischof's pictures, the only venue he could find was the Building Trade Centre in London. Hillelson's relations with Magnum photographers were mixed and under some strain because of his conviction that they tended to take advantage of him and his wife, Judith, who ran the library.

'Meals and floors were provided, our home was open all hours of the day and night to Magnum people. Film would be fetched, photographers would be met at airports, photographers' children would be met at airports, photographers' children would be put up until they had to go to school. In retrospect, this was one of the pleasures of being associated with Magnum, but there were times when one felt one was being put upon. Magnum photographers, however endearing they might be, were extraordinarily self-centred people and would take advantage of people without any qualms whatsoever.'

Judith Hillelson remembers searching London for a miniature saddle that would fit a Pyrenean mountain dog that Elliott Erwitt had bought for one of his children and photographers coming back from the disaster at Aberfan [when a school was engulfed by slurry from a slag heap] tracking coal dust through their house, dumbstruck by the horrors of what they had seen. Ernst Haas used their flat to edit a story about England commissioned by *Queen* magazine. 'He was here for days and days and was getting lunch, supper and tea from me and somewhere along the line a person who was working with him said "Judy says come to supper" and he turned to me and said "Who's Judy?" He had been in my house for days, using my sitting room, scorching my furniture by the gas fire, and didn't even bother to find out my name.'

In 1963 René Burri took the picture of Che Guevara, leaning back and smoking a cigar, that became not just a symbol of the Cuban revolution, but an icon of the protest movement in the 1960s. Burri's picture of Che appeared in books and magazines around the world, on posters and T-shirts everywhere. Once, years later and for his own amusement, he tried to take a picture of his picture, which was framed and hanging in the lobby of a bank in Havana, and was promptly arrested.

Ian Berry, meanwhile, was discovering that being a member of Magnum did not necessarily mean that the world was at his feet. When, in November 1963, the government of Iraq was ousted by a military coup, Berry, flush from his success at Sharpeville, was determined to be the first photographer into Baghdad. All the airports were closed, so he made his way to Beirut intending to drive across the border, only to discover the borders were closed, too. With remarkable ingenuity and perhaps some foolhardiness, Berry decided to charter his own aircraft in the hope that once over Baghdad he would be allowed to land. The only problem was that

the only aircraft available was a Middle East Airlines Viscount and the charter fee was several thousand pounds. Undaunted, he agreed to pay the bill and took off, the only passenger on the flight. 'It seemed to me like a reasonable gamble. I figured if I was the only person to get in, I would really scoop the pool!' The inevitable happened: permission to land in Baghdad was flatly refused and Berry was obliged to return ignominiously to Beirut, several thousand pounds poorer. He got in the following day on another charter, this time with a number of other correspondents who shared the cost. In fact, it was all a waste of time and effort. The coup was over by the time they arrived and Berry ended up sitting in a hotel room in Baghdad disconsolately photographing the television coverage.

In 1964 Magnum recruited two very different new photographers. Marilyn Silverstone, based in Delhi, and Bruno Barbey, the son of a former French ambassador. Silverstone was a Wellesley graduate who had fallen into photo-journalism almost by chance and quickly made a name for herself. She had left for Delhi in 1959 for what was intended to be a short trip but had been captivated by the country and would eventually end up staying in India for fourteen years. Barbey was born in 1941 in Morocco, where he spent his childhood and began his career as a photographer with a black and white photo-essay on Italy for a book which brought him to Magnum's attention.

Barbey recalls with nostalgic affection the intimacy of the Paris office in his early days at Magnum: 'I remember at lunchtime the head of the library, instead of going out to a restaurant, cooked fried eggs in the office. We had this very nice relationship. Whenever a photographer was passing through we'd all go out for lunch and spend all afternoon looking at photographs. This is something we still do, but there are so many of us now that we lose contact, we don't know each other as well as we did in the past. There was very good contact then. We would help each other with editing and always show our work to each other. I remember spending an afternoon helping Marc, who had just come back from China, edit a story. This is a fantastic asset, helps improve your eye. You learn, you give them things and they give you things. It is very stimulating to be surrounded by talented people you respect.'

Marc Riboud was, by then, an old China hand. He had spent five months there in 1957 after he had a met a Chinese writer who was a friend of Chou En-lai and who had interceded on his behalf to get

him an entry visa. He returned in 1965 to document the first stirrings of the Cultural Revolution, and to photograph Chou. 'I was with a journalist called K. S. Karol, who had repeatedly applied for an interview with Chou. We had been in China for about two months and we were told we would get an interview when we arrived in Beijing. We waited for three weeks in Beijing, then gave up and caught a train for Shanghai. As soon as we arrived in Shanghai, we were told to return to Beijing for the interview. We sat around all day in a hotel, had dinner and then decided to go to bed because we were exhausted from the travelling, but our interpreter said we must not go to bed on any account and that a car would come and pick us up at eleven o'clock. The car duly arrived and we were driven to the People's Palace in Tiananmen Square. The streets were very dark and there was no one about. When we entered the People's Palace we were met at the top of the stairs by Chou En-lai himself and taken to a large room with a number of armchairs and two secretaries, who would write down every word that was said, and an interpreter. Despite the august surroundings, it was all rather simple and straightforward.

'Chou was intrigued that we had been to America and told us a story about how, at a peace conference on Indo-China in 1954, he had been presented to John Foster Dulles, the US Secretary of State, and how he had gone to shake hands but Dulles had ignored him, leaving him standing there with his hand outstretched. As he described it, I recognised that it had been a moment of pure humiliation and loss of face in front of the other world leaders at the conference. Apparently Dulles had vowed never to shake the hand of a Communist and Chou's views on America and Americans were ever after coloured by this churlishness.

'The whole meeting lasted about three hours. I sat a bit further away to get a good perspective. Chou took us back to our car at about three o'clock in the morning and a local photographer took a picture of me shaking hands with him before we left. I always carried that picture with me in China. It came in very useful. Once it even got me out of jail.'

In 1966 Cornell Capa got together with Rosellina Bischof Burri and Eileen Schneiderman, Chim's sister, to set up the International Fund for Concerned Photography. Its aim was to 'encourage and assist photographers of all ages and nationalities who are vitally concerned with their world and times'. A year later the first exhibition, 'The Concerned Photographer', was held in New York, featuring the work of Robert Capa, Werner Bischof, David Seymour, Leonard Freed, André Kertesz and Dan Weiner, and drew

big crowds. Barely a month after the exhibition opened, there were 'concerned' citizens groups springing up everywhere.

Around this time Bruce Davidson was beginning his monumental work on East 100th Street, returning to the same block in Spanish Harlem day after day with a four-by-five camera photographing the minutiae of everyday life in one of poorest areas of the city and winning the trust of the people by handing out prints. The idea came to him when he was struck by the notion that America was sending up lunar probes and exploring outer space before solving any of the environmental problems on the ground, particularly in the urban areas.

I thought the environment was very important and wanted to go into the centre of the inner city and photograph one block, one molecule of this complex metropolis we live in. I wanted to see the texture of the rooms, to see out of windows, see space, rooftops, people . . . to really *be* there, not just pass through.

Sometimes I had to force myself to go on the block because I was afraid to break the painful barrier of their poverty. But once I was there and made contact with someone and felt connected, I never wanted to leave. Women called to me from their windows and children said 'Hi, picture man.' Every day I appeared with my large bellows camera, heavy tripod and box of pictures. Like the TV repairman or the organ grinder, I became part of the street life.[4]

'East 100th Street' would be hailed as a major achievement in the history of documentary photography and prompted the *New York Times* to publish three separate reviews: one was enthusiastic and applauded Davidson for giving the people of East Harlem the attention usually only accorded to the upper classes; one was ambivalent, and one was harshly critical, accusing Davidson of exploitation and creating a 'dark journey into purgatory' by responding to the 'visual provocativeness' of the area. The accusation of exploitation, making a living out of poverty, famine and conflict, was a familiar refrain that often bothered Magnum photographers over the years. There was no resolution to the problem: for every argument in favour of faithful documentation in the interests of history, there was a counter-argument about exploiting misery and mayhem.

Sometimes assignments could start as artistic projects but end in blood and tears. Charlie Harbutt was in the Middle East in June 1967, on assignment for *National Geographic* to 'follow the footsteps

of Jesus' when he suddenly found himself covering the Six Day War. He had, of course, sensed that trouble was brewing and had seen plenty of tank movements, but he had no intimation that Israel and the Arab states were on the brink of all-out war when *Newsweek* asked him to photograph General Moshe Dayan, Israel's military strategist. He made an appointment for eight o'clock on the morning of 6 June. The evening before, Harbutt was in the Sinai, photographing the violinist Itzhak Perlman performing for the troops. The commanding officer tried desperately to persuade him to stay the night, but Harbutt was adamant he had to get back to Tel Aviv to keep his appointment with Dayan. 'Besides, I didn't want to sleep in the desert; I wanted to go to bed in my nice room at the Hilton.' Next morning, still unaware of what was happening, he turned up on time to photograph Dayan but was told that the general was 'busy'. It was understandable: the war had started that morning. Only then did Harbutt realise why the Israeli officer in the Sinai had been trying so hard to persuade him to stay the night. He made up for that lost opportunity by hitching a ride on a half-track to the fighting in Gaza and was the only photographer to get any film out in time to meet the Wednesday deadline for European news magazines.

Ian Berry arrived in Tel Aviv not long after the war had ended to cover the continuing Arab/Israeli tension. He had been told that Cornell Capa was in Israel organising an exhibition and that it would be diplomatic to introduce himself. Over breakfast in his hotel, Capa told Berry he was wasting his time, that it was a non-story and he should pack his bags and go home, but Berry refused to be deterred. He got himself accredited to the Israeli Army and eventually persuaded them to take him out on patrol along the border. 'I was told I could take pictures of anything, except a big piece of equipment covered with a canvas bag mounted on the front of the APC. I thought it was obviously very high-tech weaponry and I became intrigued by what it might be, so I decided to try and get a picture of it. Next morning I crept out very early and hid at the side of a track waiting for the patrol to pass hoping the thing would be uncovered, but there was nothing doing. On the third morning I was in luck: I could see the patrol approaching and that there was no canvas bag covering the equipment. As they got closer I could see what it was – a chair. Sitting in it was a Druse Arab! I soon realised that his job was to spot mines: the poor bugger was highly motivated because if he didn't pay attention, he would be the first to be blown up.'

Berry later made contact with mayors in some of the Arab

settlements and took pictures of Israeli soldiers blowing up houses in retaliation for kids throwing stones. Word of his activities must have reached Cornell Capa. One evening Berry was having dinner alone in his hotel when Capa walked in, completely ignored him and sat down at a table in the far end of the restaurant. Later, on the way out, Capa stopped by Berry's table and said 'I hear you've been playing footsie with the Arabs.'

When Harbutt returned from the Middle East he was elected American vice-president in time to preside over a furious row between the Paris and New York offices which opened old wounds and led to great hostility between the photographers on opposite sides of the Atlantic.

In October 1967 it was announced that Che Guevara, by then perhaps the world's most famous guerrilla leader, had been shot and killed in Bolivia. Not long after his death Magnum was offered the opportunity to acquire his diaries. What seemed to many members in New York to be a remarkable opportunity to publish an important historical document (and make money at the same time) was viewed in Paris as crass and immoral opportunism of the worst kind. The deal was assailed as politically unacceptable and financially questionable and the authenticity of the diaries was in doubt, yet New York persisted in the teeth of bitter opposition from Paris – at one point the French photographers threatened to shut down the Paris office in protest.

The diaries were brought to Magnum from Bolivia by a sometime adventurer and photo-journalist called Andrew St George. St George was well known to Magnum and was actually listed as an associate in 1962. He was mentioned rather acidly in one of John Morris's newsletters as early as 2 April 1960: 'The "definitive" story of the progress and problems of the Cuban revolution by Andrew St George, which we have been promising to European editors for more than three months, remains undelivered, although St George has had an incredible succession of valid reasons for delay . . .'

St George claimed to be a friend of both Castro and Guevara, although René Burri remembers Che saying to him, 'René, tell your friend Andy if I ever catch up with him I'm going to do unpleasant things to him.'

Life correspondent Lee Hall first met St George when he was covering the Castro revolution. 'I was up in the Sierra Maestra with Castro when Andrew and a CBS correspondent flew from Florida in a light plane and landed on a deserted grass strip that the Castro people had mined. The CBS guy was flying the plane and was such a bad pilot that when he landed he skidded all over the runway and yet

somehow managed to avoid the mines. Andrew and I got to know each other at that point because there wasn't much else to do. He was freelancing as both a writer and photographer at various times. He was a Hungarian who had changed his name to St George because he thought it sounded glamorous. His allegiance and alliances were extremely confused but with him you never knew if, because of all his connections, he might come in one day with a real scoop.

'Not long after Guevara's death Andrew showed up in my office in New York with a collection of documents he claimed were the diaries of Che Guevara. On examining them, and having other people at *Life* examine them, we decided they were probably spurious. As I recall, they were a collection of handwritten notes. Andrew wouldn't show us much of them until we made a formal offer but the authenticity of the material began to diminish the more people looked at them. His connection with the source of the diaries was never clear. I don't ever remember him claiming he took them off the body of Che Guevara, but he indicated he had gotten them from the Bolivian authorities. He must have had some connection with a US agency that was powerful enough to allow him to do that. Why else would the Bolivians have given them to him? He claimed they gave him the diaries because they wanted money. They wanted a great sum and it would go into the pockets of the Bolivians who had captured and killed Che. We asked Andrew "How do we know they are authentic?" and he pretty much said we would just have to take his word for it. I can't remember if we made an initial offer – I think we might have been talking about $100,000 – but in the end we decided not to touch them because of his inability to give us a shred of evidence that they were genuine. We'd almost got stuck on Clifford Irving's Howard Hughes hoax and so we were more than usually cautious. I think I got a call from Cornell later asking me whether I thought they were genuine and I told him I had no idea but that *Life* was not touching them.'

Having been turned down by *Life*, Magnum was probably St George's next port of call. Even though the diaries had no photographic interest, he gambled that his friends at Magnum might be interested in marketing the material. St George contacted Burt Glinn, whom he had met in Cuba. Glinn told him that any decision could only be made by the photographers as a group. In fact the consensus among the photographers in New York was that if the diaries were genuine it was an opportunity not to be missed. It was decided to ask Don Skankey, an ex-editor at the *Saturday Evening Post*, to fly down to Bolivia to check St George's story and try to

establish the authenticity of the material. Skankey soon reported back that there was a lot of cloak and dagger stuff going on and that the Chinese Communists, the French, the Russians and the CIA all seemed to be involved. He had not been able to actually see the diaries and the price was going up all the time.

Meanwhile, word of the venture had reached the Paris office, where there was universal opposition. Marc Riboud, the French vice-president, was outraged that Magnum would even entertain such a deal and René Burri, who felt particularly involved because of his Che Guevara pictures, threatened to resign if it went through. Soon the telex lines between the New York and Paris offices were burning with accusation and counter-accusation. The French photographers bitterly accused their American colleagues of supping with the CIA; the Americans asked the French how they could adopt such a high moral position after the Taconis affair. The Americans claimed the French were only objecting because it was believed the diaries portrayed Regis Debray, the darling of the French intellectual left and a friend of Che Guevara, in a bad light. The French said that St George could not be trusted in the light of what Che had said about him to René Burri and that the risks involved were unacceptable. The New York office had been subsidising losses in Paris for some time and felt it had the right to run its own affairs.

To overcome moral objections there was talk of donating funds to Bolivia for building schools out of the proceeds of publication. On this basis, George Rodger, Eve Arnold and Ian Berry offered their support to the deal until they learned that there was a risk that the money would end up with the Bolivian government.

The following day Rodger and Berry cabled the New York office: WE WITHDRAW SUPPORT COMPLETELY AND REFUSE USE OF OUR NAMES IN ANY CONNECTION WITH DEAL EXCEPT ITS IMMEDIATE DISSOLUTION.

Harbutt replied on 10 November: SINCE NEITHER MARC NOR RENÉ HAVE COMMUNICATED DIRECTLY WITH ME IN PAST WEEK IT IS IMMORAL YOU NOW ASK ME SUPPRESS DEAL BECAUSE UNACCEPTABLE PRESSURE STAFF AND PRESS. INSIST YOU EXERCISE EXECUTIVE RESPONSI-BILITY COME NEW YORK. CHARLES.

Rodger responded immediately: CHARLES I WANT MAKE THIS AS GENTLE AS POSSIBLE BUT I CANNOT ACCEPT YOUR CABLE. I REQUESTED YOU DISENTANGLE MAGNUM PHOTOS FROM GUEVARA DEAL EIGHT DAYS AGO. RENÉ AND MARC WARNED AGAINST IT THREE WEEKS AGO. HOW DOES YOUR CONTINUED REFUSAL TAKE OUR ADVICE MAKE OUR ADVICE IMMORAL? BUT THIS INSIGNIFICANT IN VIEW YOU SPLITTING MAGNUM

PHOTOS DOWN THE MIDDLE, NOT AMERICANS VERSUS EUROPEANS, NOT
LEFT VERSUS RIGHT, BUT THOSE WHO UPHOLD ALL MAGNUM PHOTOS
HAS STOOD FOR IN PAST TWENTY YEARS AGAINST THOSE WHO DON'T.
YOU ENDANGERING ENTIRE EUROPEAN OPERATION OUTSIDE CRITICISM
RISING. PHOTOGRAPHER AND STAFF RESIGNATIONS THREATENED. I
REFUSE ADD TO EXPENSE YOU ALREADY INCURRED BY GOING NEW
YORK ONLY TO REITERATE WHAT I ALREADY SAID IN LETTER AND
CABLES AND WHICH I UPHOLD INFLEXIBLY. AGAIN I SAY STOP IT, STOP
IT, STOP IT. IF YOU CANNOT YET UNDERSTAND GOD HELP US.
DISTRIBUTE ALL MEMBERS SQUADRON, HENRI, ERNST. AS EVER. GEORGE.

On Saturday, 11 November Cornell Capa sent a cable to the Paris
office: DIARY CONFRONTS MAGNUM EXECUTIVES WITH GREATEST
RESPONSIBILITY WHICH IT MUST SHOULDER AND FACE JOINTLY. THIS
MEETING IMPERATIVE NEW YORK NEXT 72 HOURS. On 2 November
1967, an anguished George Rodger wrote to Cartier-Bresson
complaining about 'the shoddiness and the turpitude of the whole
deal . . . There will be repercussions – law suits undoubtedly –
definitely world-wide criticism of incriminating nature. Can you see
Che Guevara's wife, whom we are doing our best to rob of her
heritage, sitting back and doing nothing about it? Can you imagine
the reaction in the French press when it is known that Magnum
Photos is in collaboration with the inquisitors of Regis Debray. It is
too awful to contemplate . . .'

Rodger to Capa, on the following day: CORNELL DEEPLY SHARE
YOUR CONCERN. MARC AND RENÉ VETOED DIARIES DEAL AT BIRTH. I
FOLLOWED WHEN I LEARNED FACTS. WE ARE RESOLUTE IN UPHOLDING
MAGNUM INTEGRITY AS SET BY BOB CHIM HENRI AND MAINTAINED FOR
TWENTY YEARS AND HAVE NOTHING TO ADD TO VETOES THAT WOULD
JUSTIFY ADDITIONAL EXPENSE OF NEW YORK TRIP. PLEASE SEE MY
LETTER TO LEE AND CABLE PRO HARBUTT TODAY. PLEASE TRANSMIT TO
CHARLES AND BURT. LOYALLY, GEORGE.

By the time Marc Riboud flew to New York at the head of a
protest delegation the deal was already falling apart. Skankey was
running up huge bills in Bolivia, had only managed to see a few
pages of manuscript and was no closer to establishing authenticity.
Expenses incurred in the project had already rocketed past $20,000
and Magnum had nothing to show for its money but a great deal of
bad blood. It was finally agreed that Magnum should bow out, but it
would be a long time before the differences over the Che diaries
affair were forgotten. And after all the fuss and bother, Castro
eventually made the diaries available to the entire world free of
charge.

'It was,' says Burt Glinn with admirable restraint, 'a fiasco.'

RENÉ BURRI, talking in his studio one floor below the Magnum office in Paris: 'At the end of 1958, Magnum hired a new editor, a young guy from *Paris Match* called Michel Chevalier. He was very dynamic, always wanted to send us off to do things. We were sitting drinking at the Deux Magots one day and Michel suddenly pulled out an Air France ticket and said it was for me to go to Cuba to cover the revolution. I had just come back from six months in Argentina, Peru, Bolivia, Brazil and the Amazon and I wanted to go skiing, so I refused. Michel said 'You will regret this for the rest of your life', but I insisted that there was no story. When I got back from skiing, the first thing I saw was this huge headline 'Fidel Castro on his way to Havana' and I realised I had blown it. Burt Glinn had gone in and covered the whole story of Fidel's entry into Havana and I had missed it completely.

'But four years later I got another chance and this time I took it. *Look* magazine called me up after the Bay of Pigs and asked me to leave for Cuba straight away. I practically got up from the dinner table, flew from Zurich via Prague on a Russian Aleutian, but the plane was delayed and I thought I was going to arrive too late. On the way into Havana I started taking pictures of the students and tanks through the window of my taxi and those were the pictures that were eventually used, not those of the big parades taken from a grandstand.

'I met Che through an American woman reporter who had contacts at the Ministry of Industry. He was the Minister and we spent three or four hours with him there on different occasions. I took the famous picture of him leaning back in his chair smoking a cigar while he was being interviewed. My impression of him was that he was very cocky, although I suppose I was cocky too at that time. I remember him in his combat outfit arguing furiously with the reporter about American policies, but it gave me time to do my work. He was like a caged tiger, pacing up and down, and every now and then he would bite the end off another cigar.

'I liked him, yes, I did like him. He had a kind of alertness about him, aggressive in a kind of way but at the same time observing. He didn't mind my being there, but he didn't help me a bit. Although it was obvious he was a true revolutionary, I didn't really have any sense that I was in the presence of someone who would become a legend, or any idea how significant that picture would become. To me, Che was just another famous person, one among many that I had photographed.

'While I was in Cuba, Henri showed up. Everywhere I went I kept running into people who told me that my associate had just been

there and finally we met. He was staying at the old Hotel Inghilterra in a different part of town. In those days there was no traffic, no cars, nothing and it was possible to walk everywhere and I had some of my greatest experiences just walking around with him, learning and looking. Even though I was doing all right, I knew I could learn from him. On one occasion we were out together and came upon a group of militia women forming up outside a building. They didn't like to be photographed, but Henri approached one of them and started taking pictures. I was worried that he would get his skull smashed by a rifle butt, but he eventually walked away smiling and dancing like a little fox and I was astonished to see the militia woman had a benign smile on her face. I asked Henri what he had done to defuse the situation and he just said "Oh she was a bit annoyed, so I made her some compliments and told her she was the most beautiful militia woman I had ever seen. Things like that." If it had been me, I would probably have been marched off straight away under arrest, but Henri had this strange ability to get away with things.'

10

Vietnam

AMERICA'S LONG nightmare in Vietnam worsened considerably in 1966 with the arrival in Saigon of a garrulous and cantankerous Welshman by the name of Philip Jones Griffiths. Perhaps more than any other photographer covering the war, Griffiths showed Americans what the war was doing to the people of Vietnam. His thesis, articulated in an angry book called *Vietnam Inc.*, was that the war was destroying a society from which America could usefully learn, that everything happening in Vietnam was being done against the will of the people, that 2,000 years of tradition were being replaced by an alien materialistic democracy.

Vietnam Inc. was one of the most powerful photographic testaments to emerge from the war; it shattered many of the myths about Vietnam and had a devastating affect on the American perception of what was happening in that faraway country. It was what Griffiths wished. 'To me, there is no point in pressing the shutter unless you are making some caustic comment on the incongruities of life. That is what photography is all about. It is the only reason for doing it.'

Despite the years he spent in Vietnam, Griffiths never considered himself to be a war photographer. 'I think it is obscene to get interested in war in the way some people do. Some people get off on war; I never got off on war. I always thought that soldiers running up and down hills firing at each other was the most boring aspect of what actually happened in Vietnam. What was really important about Vietnam was the efforts by one society to subjugate another society and the resistance of the subjugated. I suppose Vietnam was such an interesting war for observers because there was that constant clash between soldiers and civilians, which probably one would not have got in some other war, including World War II. When *Vietnam Inc.* was first published in America I had within a month an

enormous mail bag, letters from all over the country. The main thrust was "My God we're killing people we should be emulating". I knew then I'd succeeded, when people were writing that. The major flaw was that the book was published in 1971, because how do you end a book about a war that has still to be resolved? When the book was published, President Thieu made the classic statement "There are many people I don't want to see back in my country, but believe me, Mr Griffiths's name is at the top of the list". I was expelled and never allowed to return.'

Philip Jones Griffiths was born in 1936 in Rhuddlan, a small town in north Wales. He acceded to his parents' wishes that he should embark on a respectable career by studying chemistry at university with a view to becoming a pharmacist. In fact, he had no intention of being anything other than a photographer and began picking up work with London newspapers and magazines as soon as he had graduated. He learned about news the hard way: he recalls lying on a rooftop in Rome for days, covered with sacks, waiting with a long lens to get a picture of some errant industrialist. By the early 1960s he was travelling extensively, and was increasingly aware that he needed some back-up organisation. He met Ian Berry in Pretoria in 1965, talked about joining Magnum and became a nominee the following year, despite the fact that the Paris office contrived to lose all the pictures he submitted in his portfolio.

'The Paris office at that time was seen as the holder of the flame, carrying the torch in the sense that they were doing the great work, the important photo-journalism that was Magnum's core. It wasn't making any money, of course, that was being left to those rather uncouth cousins across the Atlantic. If you were in Europe, you formally attached yourself to the French office. But what happened to me was that after being taken on, I simply got on the next plane and went to Vietnam.

'Everything I had done at that point I realised was just a process of getting ready for Vietnam. For three years I had been working on assignments and I wanted to do something for myself, something meaningful. That was always the big attraction of Magnum for me. All you ever needed was a suitcase with a few changes of clothes and a camera bag and you just wandered the world, you never had to come home, you just went from place to place to place. The idea of being a wanderer was electrifying for someone who had come from a little village in Wales, where most of my relatives had never travelled more than twenty miles away from home in their lives.'

The first American fighting soldiers – 3,500 US marines – had been committed to Vietnam in the spring of 1965, ending the

Americans' farcical role as 'advisers' to the South Vietnamese forces. As the war escalated steadily, more and more troops were sent in and anti-war protests spread across American campuses.

'When Philip arrived in 1966,' his friend and colleague, Murray Sayle, noted,

you could still make out the crumbling French observation towers of the previous war, overlooking enamelled green rice paddies, small boys and straw hats, city girls floating along in the exquisite *ao dai*, that most ethereal of female garments. But by then the landscape was already bomb-cratered and scarred at every crossroads with sandbags, bunkers and barbed wire. Gigantic American trucks tore up fragile roads and scattered shoals of Vespa riders and the skinny, sweating drivers. The tree-shaded boulevards of French days were crowded with two seemingly different species of the human race: tiny brown Vietnamese and huge pink Americans, a daily visual reminder that a big, powerful country had come to make war in (or, as Philip said, on) a small, insignificant one.[1]

Griffiths felt an immediate affinity with the place and the people and it did not take him long to decide that the outside world was being told lies about Vietnam. 'There was this blanket truth about the country that you were told, and anybody with an IQ over 25 would realise that there was something wrong with this truth, that it didn't make any sense, that things didn't add up. You were told about the war and what the Americans were doing and their aims and goals – you were told all this but you didn't have to be very smart to realise that it was full of holes. At that time the US philosophy was still bent on winning hearts and minds by making inroads into the Vietnamese social infrastructure. The US commitment was building up rapidly, but movement and accessibility was still easy and large sectors were declared Viet Cong free to convince the US public and the world at large that the war was being won. I was always sceptical and was never considered to be a team player. To me there was a basic flaw in American thinking. How do you know you are winning? How do you know for real? Here was a new bourgeoisie being formed at great speed by those intent on creating a society directly opposite to the traditional one. The Vietnamese say that looking and understanding is much more important than caring about the surface. The Americans were completely blind to the subtleties of the Vietnamese language and the fascinating structure of Vietnamese society.

'All these elements drew me to the country and strengthened my will to stay on, but what ultimately made me addicted to the place was the desire to find out what was really going on, after peeling away layers and layers of untruths.'

Griffiths was appalled by the way the Vietnamese were treated and saw them as innocent victims of American imperial stupidity, as he made clear in *Vietnam Inc.* He both wrote and designed the book, as well as contributing all the pictures, and he used sarcasm to devastating effect. The caption to a picture of uniformed Vietnamese children in a ward full of American casualties reads: 'Orphans visit a United States Army hospital to sing and dance for the wounded men whose predecessors were responsible for these children's parentless status.'[2]

He went out with a platoon from the First Cavalry which opened fire on the first farmer it saw. They missed. 'The next farmer was not so lucky. Soon he lay dying among the ripening rice in a corner of the paddy field, the back of his skull blown away. He was somehow conscious, making a whimpering sound and trying to squeeze his eyes more tightly shut. He never spoke and died with the fingers of his left hand clenching his testicles so tightly they could not be undone. "Got him in the balls, knew I hit him," cried the boy from Kansas, until someone took him to one side and explained that they do that to relieve the pain elsewhere.'

Griffiths claimed that the Americans mutilated bodies. One colonel wanted the hearts cut out of dead Vietcong to feed to his dog. Heads were cut off, arranged in rows and a lighted cigarette pushed into each mouth. Ears were strung together like beads. General George Patton III carried a skull about at his farewell party.

In September 1967 Griffiths accompanied a unit on a mission to Quang Ngai. As they approached a fortified village called Red Mountain they lost two men in a grenade exchange. Several armed Vietcong were killed, the village occupied and about fifteen women and children rounded up and herded together. The Americans then withdrew and called in an artillery strike. Griffiths said to the captain, 'Hey, what about those civilians? They'll be killed.' The captain looked straight back at him and said 'What civilians?'[3]

If Griffiths thought he was going to make a fortune from covering the Vietnam war he was sadly mistaken. In his first year he got a cover in the *New York Times*, one story in *Look* and a single picture in *Newsweek* and the *Toronto Star*. He was told time and again that his pictures were 'too harrowing'. Vietnam was said to be a 'photographers' war' since the US government offered the media free and uncensored access to the front line in the hope of selling the war to

the folks back home, but Griffiths was getting so little published he was virtually ignored by the US Army's sophisticated press information service and thus was unable to obtain the facilities offered routinely to more important correspondents. At first he could not understand why Magnum seemed incapable of selling his pictures. 'Looking back on it now, I have often wondered why this was. If you take out of the equation the possibility that I was an unknown quantity, what you end up with was the fact that in those days, Magnum was very much two fiefdoms. The attitude of the man running the Paris office was "This is a French war, we don't want some Welshman covering it", so that virtually no pictures were sold out of Paris. In New York the feeling was "We don't want some Commie Limey denigrating the fine work that our fighting men and women are doing in Vietnam." I don't want to exaggerate and say that no pictures were ever sold – I did do a couple of small jobs in those first two years – but very, very little was published.'

(Burt Glinn says Griffiths's claim that he was viewed as a 'Welsh Commie' by the New York office is 'absolutely outrageous', every member of staff was fervently anti-war and strenuous efforts were made to sell his pictures.)

When he had first started working as a photo-journalist Griffiths often wondered how he would react when first confronted with danger. Vietnam answered all his questions. 'I never presented myself to the US authorities as brave or gung-ho, demanding to be sent to the hottest fighting areas. In fact I considered myself not in the least brave and I hated pain. I always thought it was important to see just what the dangers were: the worst thing you can be is foolhardy, so you weigh the risks up very carefully. I never saw much real action on the operations I went on in the first few months. There was a strange safeness about it. You saw the wounded, you saw that people were getting killed and you were constantly made aware of how dangerous the situation was, but it didn't *feel* dangerous. As far as I was concerned I was in some tropical paradise surrounded by extraordinary beautiful people and wonderful food and for the most part it seemed almost incomprehensible to me that there could be any danger in a place like this. That was how I personally felt, but I was not stupid, I knew this was Vietnam and I knew there was a war going on. In November I went on an operation and we were pinned down. I was almost curious myself to see what would happen. The answer was, nothing happened. I was conscious of how organised I was, maybe a legacy of my pharmacy training, but I never put a foot anywhere without mentally calculating: if the bullet comes from the left, then I'll jump down there; what will happen if the worst

happens; which way am I facing; which is the best place for cover, etcetera. Now I thought, does this concern for staying alive blot out one's ability to notice the things one should be noticing? I actually don't think it did.

'I was with a unit of the First Cavalry in Binh Dinh province. When you arrive at such a place you are always a bit of a curiosity, nobody quite knows who you are, it is all a little bit confusing. The trick is to get the pictures, so you have to hang around a little bit, get to know people, eat and walk with them, do what they do. Now this, for me, was the big problem because most of the time I didn't know what they were saying. Americans do speak a different kind of English from that which I am used to speaking. So there we were up in the hills, in a beautiful part of Vietnam, and people were being brought in to be interrogated – horrible methods of interrogation, psychological torture. Anyway a suspect finally cracked and admitted that there were indeed VC hiding out in a cave some miles away. Now, I looked at the guy and if I were casting a film about Vietnam, I would immediately have cast this man as a liar, he practically had it tattooed on his forehead. Anyway, the guys are getting steamed up, talking about getting the gooks, kicking ass and all that and I'm saying "Are you sure he isn't lying?" No, trust us, we're the professionals, we'll take him along with us so he'll run the risk of an ambush just like us. So, we go, take a platoon of a dozen guys – one of them asked me how much I got paid for doing this job and when I said nothing, he told me I was crazy – and so off we go and finally stop near this cave and they opened up on us. There was a lot of confusion but I was OK and only one person was hurt, took a flesh wound. I was very proud of the fact that when the first shots came, I jumped immediately into a little ditch and was OK. I was very pleased about it because it was the first time I had had to do it and I did it right, so that gave me a bit of confidence.'

By the autumn of 1967 Griffiths was in severe financial trouble, so short of money that he frequently had to decide whether to buy a meal or a roll of film. He could no longer afford to stay in the Hotel Royale, the place in Saigon where all the correspondents gathered, and moved in with a Vietnamese family. Money was so tight that he would walk several blocks to save ten piastres on a bottle of mineral water. The troops would take out packs of Hershey chocolate bars on patrol to give away to the kids. When Griffiths found a soldier burying his supply of Hershey bars because they were too heavy to carry, Griffiths emptied a sandbag, filled it with chocolate bars and carried it back to Saigon with him to supplement his meagre rations. Salvation arrived in the form of a cable from Russ Melcher, the

bureau chief in Paris, asking him to go Cambodia to cover Jacqueline Kennedy's forthcoming visit. Griffiths, who had become a master of brevity in his cables, in order to save money, replied: CASHLESS PLEASE ADVISE. Melcher sent back: 'HAVE 1,200 REASONS FOR GOING TO PHNOM PENH.' Griffiths assumed that the Paris office was telling him they had got a $1,200 guarantee for his pictures, so he borrowed some money, bought some film and got a plane to Phnom Penh.

There was considerable gossip at that time that Jackie Kennedy intended to marry the British peer, Lord Harlech. He was believed to be accompanying her on her visit to Cambodia and thus media interest was intense. When Griffiths arrived in Phnom Penh he found the media contingent extremely disgruntled: the Cambodian authorities were insisting that Jackie's visit was private and were making life as difficult as possible for any photographers who tried to get near her. In the end, a compromise was reached. Correspondents were invited to a press conference at which it was announced that Mrs Kennedy would be travelling up to the temple complex at Angkor Wat the following morning and that a photo-opportunity was available. An aircraft would leave at 7 a.m. to take any interested journalists to Angkor Wat, where they would have half an hour to take photographs of Mrs Kennedy and then be flown back to Phnom Penh. No further facilities would be offered.

As soon as Griffiths heard the plan, he rushed back to his hotel to pack a bag then jumped into a taxi and asked the driver to take him to Angkor Wat – a 200-mile drive through the night. At the first ferry crossing, he was amused to see another taxi with a *Stern* photographer curled on the back seat who had obviously had the same idea. Griffiths booked into a little hotel and joined the press party the following morning, to the great displeasure of the organisers, who realised he had not been on the plane from Phnom Penh. He was told he would not be allowed to stay in Angkor and to ensure that he didn't, his taxi was instructed to drive back to the airport between the two buses carrying the press party. But Griffiths was nothing if not persistent. 'I saw a little side road leading away at 90 degrees so I told the driver I'd give him more money and we took off down this little dirt road and just kept going. It happened so fast I don't think they even noticed. We hid under a tree and waited, and sure enough, about half an hour later I heard the plane taking off. We just went back into town.'

Griffiths was halfway through breakfast at his hotel when two Cambodian plainclothes police officers, in sunglasses and crisp white shirts, arrived and told him he would have to leave. Griffiths

protested that he was a tourist and simply wanted to look round the temples, but the police already knew who he was and how he had evaded the return flight. For a while he refused to leave, but then the taxi driver appeared and said he had been told his vehicle would be confiscated if he didn't take his troublesome passenger back to Phnom Penh.

Reluctantly, Griffiths agreed to leave after he had finished his breakfast. The cops waited politely, made sure he got into the taxi and waved him off. As they turned the first corner, Griffiths saw another photographer with cameras all over him, walking along the street. 'Stop a minute,' he said and got out and asked the photographer where he was from. He was French, from a press agency, and had arrived in Angkor by bus from Bangkok looking for the other media. Griffiths told him they had all gone back to Phnom Penh. The Frenchman was mortified and asked Griffiths if he had any idea how he could get there. 'Certainly,' Griffiths replied happily, 'you can have this taxi.'

With the taxi and the photographer returning safely to Phnom Penh, Griffiths walked back to the hotel, put his cameras into a little airline bag and bought himself a pair of Bermuda shorts and a straw hat so that he could pass as a tourist. Later that day he found a rickshaw driver whose brother happened to be in the police and who knew Jackie Kennedy's itinerary. In this way Griffiths was able to show up an hour ahead of Jackie and look for places to conceal himself in advance. Three days later he was hiding in the ruins of a temple when Jackie's entourage arrived and she stepped out of a limousine with Lord Harlech. Indicating they wanted privacy, the two of them began climbing the temple steps. Griffiths knew that it was going to be the picture everyone in the world wanted, so he set off to waylay them, crawling on his stomach, the way he had learned in Vietnam, through long grass to a suitable vantage point. Jackie and Harlech sat down together on a bench, she put her head on his shoulder and he gave her a perfunctory kiss. Griffiths was disappointed there was not more passion on display, but he had still got some great pictures.

'They got up and left, so I turned round and – here it was just like in the movies – I'm crawling away with my airline bag on my back and my straw hat on my head and suddenly there is a pair of shiny black shoes right under my nose. I look up and there is this Cambodian secret service guy looking down. He is wearing an immaculate suit and he says to me "So how is the war in Vietnam going, Mr Griffiths?" I am feeling like a total fool, crawling on the ground, covered in ants and dust, so I stand up, brush myself down

and say "You'll be pleased to hear that the Americans are losing." "Good," he said, "I thought so" and off he went. I realise now that they knew all the time that I was there. I thought I had been so clever fooling them, but they could have jumped me at any time. I think what it amounted to was that [President] Sihanouk wanted the publicity, but couldn't be seen to allow it.'

The money Griffiths made out of the Jackie Kennedy pictures enabled him to return to London for Christmas, and he was depressed to discover that his friends had a very different picture of the war, from the media coverage, than he had from the ground. In January 1968 he lunched with Godfrey Smith, editor of the *Sunday Times Magazine*, and leaving the restaurant saw on the evening paper billboards that the long-awaited Tet offensive had begun. He was on a plane next morning, heading back for Vietnam.

This time it was problematical whether he would get in. All flights to Saigon, where Vietcong suicide teams were shooting it out with American troops in the streets, had been halted. Griffiths got as far as Bangkok where, by chance, he spotted Walter Cronkite, the veteran American correspondent, at the airport. Griffiths got talking to him and discovered that the US military had arranged a special flight to get him to Vietnam; Cronkite graciously offered him a lift. Once there, he had to decide between going to Khe Sanh or Hué, a decision he picturesquely likened to choosing between bedding the two most unattractive women he could think of. He decided on Hué, where a battle was raging to recapture the city from Vietcong, and flew in through a firestorm on a US helicopter. On his first day in Hue a marine standing alongside him was shot dead by a sniper, the bullet penetrating a gap in his flak jacket.

Griffiths spent a month in Hue, covering the savage fighting which enabled the Americans and South Vietnamese to finally recapture the city. One of the unforgettable images he carried away with him was of an American general in a military hospital trying to shake hands with a wounded soldier without realising that both the soldier's arms had been blown off. 'He wanted to give the kid a purple heart and in the end he just laid it on the boy's chest. Can you imagine an image like that? That is the great thing about photography, there is nothing in the world that is not important to see and photograph. The profession of photography is anti-elitist. There are very few professions where even when you are at the top, a household name, you might still be standing on a draughty street corner with your feet getting wet and cold, waiting for something to happen. At that moment you are on the same level as a homeless person, standing on a street corner, begging. In most professions, the

higher up you go, the more likely you are to go around in a chauffeur-driven car.'

Although by then Griffiths was accredited to *Life*, he remained unhappy with Magnum's ability to sell his pictures. In the spring of 1968 he went on a risky operation with a patrol attempting to cut the Ho Chi Minh trail. It was a very dangerous thing to do, inasmuch as the North Vietnamese Army had radar-controlled anti-aircraft guns and were able to shoot down a lot of helicopters. 'I did it because I knew it was going to produce a lot of important pictures that would sell. Our patrol found a stockpile of Russian trucks, weapons and ammunition, the first ever found in South Vietnam. And I had pictures. I got them. I got American soldiers driving down the Ho Chi Minh trail wearing Russian helmets and waving AK rifles that they had just found in the stockpile. Magnum never sold one of those pictures, not one ever got sold until years later. It was unbelievable.' One small consolation was that a large stash of Hungarian stewed beef had also been found in the stockpile and Griffiths carried off as much as he could.

Griffiths's second period in Vietnam at least enabled him to crystallise his ideas for the book he had long planned. 'It was very tumultuous, lots going on. Vietnamese society was in turmoil, people were transported out of the country areas into the urban enclaves "for their own safety". Their society was breaking down under the impact of American culture but they were being assured that at least they were safe. After Tet, they were not even safe any more. Great disillusionment therefore set in and I found it a very interesting time photographing the discontent and turmoil in the urban enclaves. As a photographer you see things first hand, things that haven't been filtered through some process of manipulation, so the more you see, the more – hopefully – you understand. The more you understand, the more you see, and in this process you become wiser. That is the principle. I had started to order my thoughts about the war while I was back home between trips and by the time I came to write it all down I had a very clear idea of what to put in the book.'

Griffiths expected that *Vietman Inc.* would get him barred from re-entering Vietnam but he was somewhat surprised by just how badly the authorities wanted to keep him out. At one point he asked the Vietnamese wife of a friend to find out who he would have to bribe and how much he would have to pay for a visa and she returned with the information that an immigration official told her it was more than his life was worth to let Griffths in. To make certain he

did not slip through, his name was listed in immigration records under P, J and G!

Although Griffiths spent the most time in Vietnam, many other Magnum photographers covered the war, notably Don McCullin, who was briefly in Magnum in 1967 but soon realised he was too much of a loner to be part of a co-operative. At the time of the Tet offensive, the Paris office got McCullin a handsome guarantee from *Stern* but failed to tell him that Griffiths was also on his way back to Vietnam. McCullin was held up in Hong Kong waiting for a flight into Saigon and eventually got to Hué only to discover, angrily, that Griffiths was already there. The two men, who had formerly been friends, had a furious argument about who should be covering the story. McCullin mistakenly believed that Griffiths had been sent to Hué because Magnum did not have enough faith in his ability.

They did not speak for years afterwards, yet they became two of the best-known and most important photographers of the war, with a shared sensitivity and compassion for the Vietnamese that did not extend to each other. Both men knew, significantly, when *not* to take a picture. 'The first man I ever saw executed,' McCullin wrote, 'was in Saigon at dawn. It was a kind of public display by the government of the day. I looked at the man at the stake, screaming and shouting anti-American slogans. He was a street bomber, which most of us didn't have any sympathy for, but I thought if they were going to kill this man, or carry out any kind of sentence on him, it should be done in private. It shouldn't have been a public Gilbert and Sullivan display of theatrical execution. So I kind of walked away and I heard a man, who later won a Pulitzer prize as a journalist, not a photographer, saying "Great stuff! Did you get it?" And it made me ashamed.'[4]

Bruno Barbey recalls an expedition into the Mekong Delta towards the end of the war in the company of a French journalist, who was also a doctor and a veteran of Dien Bien Phu. They came across a group of drunken South Vietnamese paratroopers. The journalist began chatting to them but Barbey knew that discipline had broken down and suggested that they quietly extricate themselves. As they were leaving, one of the soldiers took out a revolver, fired a couple of shots over their heads and shouted for them to come back. They returned, reluctantly, whereupon a soldier took a skull out of his pack and insisted that Barbey take a photograph of them with the skull as a grotesque trophy. Barbey did so, and they were allowed to leave.

A few days later the journalist had an interview with the chief of staff of the Vietnamese Army, who was also a friend from Dien Bien

Phu days. At the end of the interview, as between friends, the journalist described the incident with the skull and said how shocked he had been by the behaviour of the troops. The officer shrugged his shoulders, murmured an apology and ushered his friend out, but then, it seems, immediately issued orders to find the photographer and confiscate the film.

Barbey, meanwhile, had gone off to cover the seige of An Loc, and was the only foreign photographer in the last cities to fall before Saigon. When he returned to Saigon, he was immediately picked up by the secret police, taken to a police station and interrogated by a senior officer who kept saying 'We want the film, we want the film.' Barbey had hidden all his negatives between his suit and his T-shirt and in order to save his An Loc scoop, he handed over the skull pictures and was told he could leave. He went straight to the airport, removed the An Loc negatives from under his shirt, packaged them up and dispatched them to the Magnum office in Paris. The pictures were published in *Life* a week later.

Marc Riboud, the old China hand, was the only Magnum photographer to get into North Vietnam during the war. 'There were about 600 journalists in South Vietnam and none in the north, so it was obvious for me to try and get into the north. It was very, very hard to get a visa. A couple of Americans from the *New York Times* had been there – Harrison Salisbury, the China expert, and another guy – but no photographers, except one.'

It took a year for Riboud to get a visa. He applied over and over again without success but then he met a French-Vietnamese girl living in Paris who shopped for the Hanoi regime, sending her purchases to North Vietnam via the diplomatic bag. She was not a Communist but had very good connections in Hanoi – her uncle was a government minister – and she recommended that Riboud send examples of his work direct to the prime minister. Riboud, nothing if not a diplomat, sent a portfolio of his pictures taken in China, which was supporting North Vietnam in the war. A few weeks later he was informed that his latest application for a visa had been approved.

'Living conditions in North Vietnam were incredibly poor, it was dusty, dirty, all the facilities had broken down. There was no water, no repairs carried out for years, but in the hotel they would bring water for you, only boiling hot; you couldn't get cold water. The food was simple, but quite good. I made the mistake of thinking Chinese and Vietnamese food were the same and was rebuked for being so ignorant. The work was hard because I could not get a car; occasionally I was able to hitch a ride on a jeep, but the ground was

very very hard and it was always extremely uncomfortable. Once I saw Jane Fonda posing on an anti-aircraft gun wearing a North Vietnamese helmet. I thought she was absurd and was stunned at her naivety.

'Air raids were frequent and I marvelled at the way the North Vietnamese people had learned to live with bombing and avoid casualties. On one occasion, I was crossing a river on a ferry when the bombing began. The ferry was crowded with jeeps and people and bicycles and was an obvious target to hostile aircraft, but I thought I would probably be OK because I could swim. When I mentioned this to one of my companions he explained that the pressure of a bomb exploding underwater would kill everyone in the river. The ferry journey seemed to take forever and when we got to the other side we all immediately jumped into waterlogged shell holes. The bombers were apparently targeting anti-aircraft guns which happened to be located quite near to the ferry. That night we slept in a small farm outside a city which had been evacuated. Next day we were taken to examine the damage inflicted by American bombers, but I found it all rather overwhelming and was not inclined to take any photographs.'

Riboud had only been in North Vietnam for about three weeks when, one evening while he was visiting a hospital, his interpreter hurried over in a state of great excitement and said they had to return to his hotel immediately so that he could put on a jacket and tie because he was going to be taken to meet 'one of our important leaders'. In the car on the way to the hotel, Riboud was told he was going to meet Ho Chi Minh. At that time there had been considerable speculation in the West about whether or not Ho Chi Minh was still alive and the attention of the world was focused on Hanoi after President Nixon had won re-election by promising to end the war in Vietnam.

'I was taken to meet the president in a former French colonial government building. His house was in the compound which was a little further on. We sat at a small round table and had tea together. It was the most casual thing. He spoke French. The first thing he said was "comment ça va?" as if we were old friends. It was very hard to imagine that the eyes of the world were on Ho Chi Minh and world leaders were hanging on his words and yet here we were having tea as if it was the most natural thing in the world. He talked French very well, elegant French. It was most natural and casual. He talked of Paris, of Lyons where I lived, of family life. He knew my wife was American and we talked of family, my children, small issues. I had been told beforehand not to discuss politics with him, but I knew he

had a weakness for Maurice Chevalier and French champagne, because that was what my friend in Paris was buying for him and sending to Hanoi in the diplomatic bag. He suggested that after the war the cities of Lyons and Hué, which had been destroyed by bombing, could be twinned and I promised to talk to the mayor of Lyons on my return.

'I understood very well that at first I should not take photographs. But after we got a bit friendly, I asked if I could take a few photographs and he agreed. So I took some pictures of him sitting at this marvellous little table on the veranda.' Riboud's pictures of Ho Chi Minh went round the world.

Photo-journalism helped change the course of the war in Vietnam. Nixon would later claim that the Vietnam war was 'the first in our history during which our media were more friendly to our enemies than to our allies', and certainly the American strategy of relying on the media to be 'part of the team' slowly disintegrated as the war progressed.

Nevertheless, Magnum often found it difficult to sell pictures from Vietnam, particularly in the early years of the war, and pictures by US military photographer Ronald Haeberle of the massacre of Vietnamese villagers at My Lai were not published until a year after the event. When they eventually appeared, in the Cleveland *Plain Dealer*, the resulting furore opened the way for ever grimmer pictures showing the price America was paying to curb the spread of Communism in South East Asia.

What Vietnam certainly did prove was that the still image is infinitely more memorable than the moving image. While it is hard to remember any newsreel footage from Vietnam, it is hard to forget the picture of that little girl with all her clothes burned off, or the police chief killing a suspected informer, or Don McCullin's portrait of that soldier with terrible staring eyes, or Philip Jones Griffiths's little boy looking into a truck where his sister has just been dumped. Vietnam also established the right of photo-journalists, like anyone else, to have a view about a war and express that view in their photographs.

The Magnum office in New York – both staff and photographers – was unequivocally against the war and as a result Lee Jones was convinced that their telephones were tapped. 'I don't think there was anyone within Magnum who felt the US should stay in and we were very unpopular at the time, particularly in Washington. They found it hard to believe that an organisation with offices in New York and Paris and a photographer like Marc Riboud in North Vietnam was

not in some way subversive. I had a woman friend who was very highly placed in the Voice of America [radio station] and when I went to visit her in Washington she insisted on going outside for a walk in the park, even though it was freezing cold. When we were out of earshot, she told me that the Magnum phones were being tapped and that the State Department was following the movements of many Magnum photographers.'

When Griffiths came out of Hué, Lee Jones spoke to him on the telephone and asked him if it would be all right to distribute a flyer showing his picture of the little boy who had found his dead sister. It was a bad line and she was never sure whether he positively agreed, but she did not hear him say no, so she had several thousand copies made and distributed. Staff put them into stores and handed them out on the street as part of the growing anti-war protest movement.

Even those photographers who did not cover the war could hardly escape it. Costa Manos was photographing the American southern states for a Japanese magazine and was driving through South Carolina when he passed a small, unpainted church with an army bus parked outside. 'I realised instantly that it was probably the funeral of a boy killed in Vietnam, so I stopped, introduced myself and asked the dead boy's grandparents if I could take pictures. They said yes and I did a little set of pictures. It was all over in fifteen or twenty minutes.' One of those pictures – of a black woman with tears tracking down her cheeks, grieving for her nephew – was published in *Look*. It came to symbolise the pain and suffering of the folks back home and won Manos an art directors' award.

Although Philip Jones Griffiths was not allowed back into Vietnam until many years after the war had ended, he could not stay away from South East Asia and was soon in Cambodia, covering yet another vicious and dangerous war for *Life*. This time he very nearly lost his life. 'I was on an operation about fifteen miles west of a city where government troops had been surrounded for some months and there had been reports that they were so beleaguered they had been reduced to cannibalism. This operation was to open the road and relieve the surrounded troops.

'We started off down the road and I just knew it was a trap, it was so obvious. There was this one, solitary tree about a kilometre down the road. There were APCs going through the rice fields on either side of the road, and a Cambodian officer with his swagger stick and his Ray-Bans and his girlfriend, followed by a motley group of soldiers who were also accompanied by various members of their

families. It was Fred Karno's Circus, it really was. I held back a really long time, I just felt in my bones that something was going to happen, then I thought, shit, and started trotting down the road to catch up. Sure enough, they had stopped under the single tree for shade. Cambodians pride themselves on pale skin and are always seeking the shade, but I thought uh-huh, I'm not going near that tree and a few seconds later the first mortar round landed and blew them all away. This was followed by the second, which landed a few yards further towards me, then a third. Everyone around me was getting killed or wounded and I wasn't touched, except maybe I got blown over. John Giannini, the photographer who was with me, got hit in the back by the third mortar, so I grabbed him and pulled him into a drainage ditch where we stayed for the next two or three hours with a battle raging around and above us. John was not fatally wounded, but he was pretty depressed at the thought of dying. We watched an APC get a direct hit and explode, with the occupants burning and screaming.

'By then morale in my little band of two was pretty low and we decided that we should move out, even though doing so would bring us in full view of the tree line where the fire seemed to be coming from. It was by now 4 p.m. and pitch darkness usually fell at 6 p.m. If we had waited for darkness, the Khmer Rouge would have got us or our own side would have shot us, thinking we were Khmer Rouge. We discussed it and agreed we had to leave the drain; the rest of the Cambodian troops with whom we had set out had withdrawn. I said "Look, we've got to get out," so we started to run, getting what cover we could from the embankment between the rice paddy and the road. They opened fire immediately and there were bits of road flying up all around me, so I dropped down into the paddy field, where the water was about a foot deep and the rice still quite young. At that stage I hadn't lost any of my cameras, so I put my camera bag on my back and crawled on my elbows with all these bits of lead flying over my head. John was behind me and I had to keep dragging him along, even though he told me to leave him behind. It sounded like a cheesy John Wayne script, you know "You can make it without me." I realised they could see my camera bag jutting up and that was why the bullets were getting so close, so I had to take it off and drop it into the water, which of course ruined my cameras. It took us quite a long time, because Giannini was getting weak through loss of blood. At one point he was holding on to my legs, so effectively I was dragging both of us along. At the end of the paddy field, we knew that we would have to climb over the top of the embankment to get to the safety of the opposite side.

When we finally got there, there was an APC on the road which we could use for shelter. We climbed on the APC and called out to the driver that we had wounded and wanted to get to a hospital but the driver wanted us off so much he pulled out his .45 and we had no choice but to get off. So Giannini and I jumped down and got back into the paddy field and made our way back to where I had parked my car in the middle of the village of Ang Snoul and I proceeded to beat all land speed records to get to hospital in Phnom Penh.'

'When I got back to the hotel I got into the lift, covered in mud, and an Australian doctor got in and when he saw me said, "Oh God you must have nearly been killed." I said, yeah, how did you know and he said, "I can tell by your sweat. I know the smell of sweat produced by fear. It smells completely different."

'Looking back on that whole incident I can remember there was a moment when photography, Magnum, Wales, the world all seemed terribly unimportant. What was important was that I was alive, and that came first. I don't think I felt scared. I didn't have any respect for those who would put an amulet in their mouths and believe that all the bullets would bounce off them, but on the other hand, when you believe in something and you have a job to do, a purpose, a mission, that can really overcome a lot of fear and trepidation.'

DAVID HURN talking in his cottage overlooking the river Wye at Tintern in Wales: 'I had no interest in photography until I was in the army, an officer cadet at Sandhurst. I found the lack of freedom very restricting. I discovered that the photographic society had its darkrooms off the camp, which presented an opportunity to get out in the evenings. Once I had joined the society I was more or less forced to buy a camera and start taking pictures.

'There are two good ways of learning to be a photographer. One is that you teach yourself. Two is that you have a kind of apprentice-ship with somebody who is really very good. You might get that at college, but at most of them you don't, because most colleges do not have photographers teaching. The problem with photography is that everybody can do it. Everybody has a camera and therefore everybody feels they can give advice. So you never normally get the advice which allows you to become good at it. So one of the problems of learning from people who do not know what they are doing, is that you get all this information which, at a later date, is then very difficult to get rid of.

'If you teach yourself, you don't have any of that bad information and you tend to look at things that you find interesting and take pictures of them. I very soon realised that that was the area of photography that I liked: being nosy, basically, and pointing a camera at it.

'One day I picked up *Picture Post* and saw some pictures taken in Russia by Henri Cartier-Bresson. I didn't know who he was but I thought his pictures were extraordinary. Here I was at Sandhurst being told that these people called Russians were our enemies, that they were stupid and thick, etcetera, and here was a set of pictures which showed Russians as ordinary people going about their business, going to school, to the shops, pretty girls on the street. That set of pictures had an enormous influence on me. After that all I wanted to do was go out and look at things that interested me and take pictures of them.

'I managed to get out of Sandhurst, with some difficulty, and got a job selling shirts at Harrods while I worked as a photographer in the evenings. I took up with a lot of bohemian lefties in the coffee bar society in Soho – Michael Foot, Ken Russell, Stuart Holroyd, Julie Christie, people like that. I was taking pictures of coffee bar life, the British weekend, things like that.

'When the Hungarian revolution started in 1956 I decided to go. I hitchhiked to Austria and got a lift on an ambulance into Hungary. I had bought a second-hand camera with a couple of lenses and I spent most of the journey reading the handbook. When I got to

Budapest I hooked up with other correspondents and the writer from *Life*, who had only one photographer with him and asked me to take pictures for him. It was great, charging round Hungary. All I had to do was follow the other correspondents to the right place and point my camera at whatever I saw. I got my pictures in *Life*, the *Observer* and *Picture Post* – my first ever published pictures.

'After that I started working for an agency as a paparazzo. Our first reading in those days was the Court Circular column in the *Daily Telegraph* which told us where the Royal Family was going, then we'd all rush off madly, take our pictures, get them developed and whizz them round Fleet Street. I got the only picture ever taken of Princess Margaret and Peter Townsend together. I heard that they were in Uckfield House, so I climbed over a wall and was skulking through the bushes on my hands and knees when I stuck my head up and suddenly there they were, no more than twenty yards away. Unfortunately I only had a long lens with me and they were too close, so I had to crawl back to get far enough away to focus, by which time they had walked out of range, so it wasn't a great picture. By then I heard police with dogs coming through the undergrowth, so I had to run for it. I just got back over the wall in time.

'By the mid-sixties, I was doing a lot of fashion. I had a contract with *Harper's Bazaar* and a studio next door to David Bailey, who became a good friend. We used to go round together with Shrimpie [the model Jean Shrimpton]. It was romantic and fun. I was still getting on and shooting the pictures I wanted to shoot, it was just that nobody was really interested in them. Through John Hillelson [Magnum's agent in London] I met George Rodger, who showed my pictures to Henri and I joined Magnum in 1965.

'To me joining Magnum was like being given a knighthood. The aura was phenomenal. What could be better than the people you most admire in the world deciding, as a group, to let you come and join them? In those days there was great camaraderie; if a foreign photographer flew into London, there'd be two English photographers to meet him at the airport and he'd always stay with one of them. That strong community spirit is missing these days. It has become far less that silly club it once was and there is something about a silly club that is very pleasant.

'What I think those early photographers had was an extraordinary sense of decency and humanity, which somehow, culturally, has become a little old-fashioned.'

11

End of the Glory Days

RENÉ BURRI remembers the precise moment when he realised that the best days of photo-journalism were over. He thinks it was as early as 1957 or 1958. He had been out all day chasing a news story in Greece and was sitting down for the first time in hours on a brown leather couch in the lobby of his Athens hotel, unloading his film and getting it ready for dispatch. The evening news flickered on the lobby television and Burri realised, with a mixture of incredulity and shock, that the selfsame pictures he had been taking all day were being shown on the television screen before he had even finished rewinding the film from his camera, let alone getting it to the airport. His images had yet to be developed, yet to be printed, yet to be distributed – and already they were out of date.

The introduction of new video technology in the 1960s undoubtedly hastened the decline of photo-journalism. While the public thirst for news remained undiminished, television was able to report events faster than any photo-journalist: television networks were out with the news, live and in colour, long before any magazine could hit the streets. The big picture magazines were caught in a double bind, with vital advertising declining as advertisers switched to television and postal rates increasing, making subscriptions less viable. *Collier's*, the *Saturday Evening Post* and *Picture Post* all closed amid much breast-beating by journalists. Other magazines changed their format, switched away from news towards lifestyle and celebrity features. Magnum sought new markets and at one time thought its salvation would lie in motion pictures – a subsidiary, Magnum Films, was formed in 1964 but met with limited success and was wound up in 1970.

In 1972 both *Look* and *Life* folded, signalling the end of the era of the big picture magazines. Philip Jones Griffiths, who by then relied on *Life* for much of his income, remembers returning home after an

assignment, picking up his mail and finding a letter telling him that *Life* had ceased publication. He realised with a sense of deep gloom that all his plans for the next five years had instantly evaporated.

With photo-journalism facing a crisis, even the most high-minded photographers were forced to become more pragmatic about the way they earned their living. More and more, particularly in the United States, turned to corporate clients as editorial work dwindled. Annual reports metamorphosed from drab documents filled with columns of figures to glossy full-colour productions featuring the work of the world's best photographers, earning three and four times as much as they were ever paid by magazines. When a Magnum photographer was hired to take pictures for the RCA annual report at $750 a day, a stockholder sourly observed that even Robert W. Sarnhoff, RCA's chairman, didn't earn that much.

Sadly, the new reality increased tension between the New York and Paris offices. European magazines were not as badly hit as their American counterparts and at first the Paris-based photographers barely noticed a drop in the market for their work. They were thus able to take the highest moral tone with New York, accusing their American colleagues of selling out and failing to keep the flame of Magnum's heritage alight. The New York office, in turn, blamed Paris for not making sufficient effort to sell American pictures. In a memo circulated in July 1967, Marc Riboud made a barely veiled reference to his transatlantic colleagues' venality: 'If the only concern of the photographers is to make individually as much money as possible . . . then let us all join Black Star.'

In 1968 Charlie Harbutt got together a group of photographers to work on a book he called *America in Crisis*. After almost a year abroad on foreign assignments, he had been astonished at the change in America when he returned home. Confusion had replaced complacency: there were student demonstrations everywhere, race riots, radical politics, flower power and increasingly violent opposition to the Vietnam war. Harbutt's idea was that Magnum photographers would work individually to document the unfolding of events in 1968 and he could hardly have chosen a more eventful year – the assassination of Martin Luther King and Bobby Kennedy, the rise of black power and rioting at the Democratic convention in Chicago. Harbutt was modestly pleased with the book when it materialised; the only sour note was struck when Marc Riboud refused to allow one of his pictures to be used – of a student protester sticking a flower into the barrel of a National Guard gun – explaining he had no faith in the project because Americans did not have the vision to be self-critical.

Paris had its own crisis in the spring of 1968 when students took to the streets, set up barricades and fought pitched battles with police. Bruno Barbey was there. 'I covered it day and night from the beginning to the end. It was exhausting. I would bicycle everywhere – at that time everything was on strike – and listen to the radio all the time. The radio network was very important because it had come down on the side of the students and was helping co-ordinate their activities. Television was also on strike so we made cine-tracts – simple 30-metre reels of film lasting two or three minutes – which we duplicated and sent to factories all over France so people could see what was happening in the capital.

'The biggest riot took place in the student quarter, on the Boulevard St Michel. One morning, people awoke to the sight of hundreds of cars which had been turned upside down to make barricades. At the beginning, you could work easily. Neither the students nor the police minded being photographed. But after pictures were published of the police beating students they started to become conscious of their bad image and at the end it was impossible to photograph them doing their jobs because they were afraid of a spread in *Paris Match* which would show their brutality. Although it was extremely violent, strangely enough only one person died – a Maoist who had been pushed into the Seine and couldn't swim.

'The students started covering their faces because the police were using photographs to arrest people, using the pictures as proof, so we put black strips over their eyes. But who can you trust? You're a guy in the middle of a riot, you can't trust anyone, so at the end it was difficult to work.

'At the beginning the people of Paris were sympathetic to the students, but as the city began to look like a war zone, with overturned cars and felled trees everywhere, there came a time when the Parisian could not go out of town for his weekend in Deauville or wherever because there was no petrol for the car and no trains, so the population started to become fed up and even some students started to leave for weekends and the whole thing fell apart.'

All the other Magnum photographers in the city at that time helped cover the story and even Cartier-Bresson could be seen on the streets towards the end of May, having hurried back from the United States and hitchhiked from Brussels. 'It was a wonderful story for photographers,' said Paris bureau chief Russell Melcher, 'because things were going on all over the place. We probably covered it much better than anybody else because television was on strike and the radio guys were more or less stuck in their cars to keep reporting

back. The only kind of mobile medium that was really any good was the good old Leica and a photographer running round the streets. I think Magnum pictures made the world wake up to the fact that it wasn't just a bunch of kids running around the streets, but that maybe we were at a crisis of modern civilisation. After all, May 1968 went down as being a month which caused an awful lot of thinking about what we were doing, how we were doing it. We had a whole bunch of very interesting student manifestations that year and also we had Prague.'[1]

The so-called 'Prague spring' actually began in January 1968, when Alexander Dubček became first secretary of the Czech Communist Party and in the months that followed introduced a series of liberal reforms he called 'socialism with a human face'. After remonstrating from a distance for several months, Leonid Brezhnev, the Soviet leader, ordered an invasion and on 20 August 250,000 Soviet troops entered Czechoslovakia. Desperate to defend their new-found freedoms, the Czech people took to the streets, fighting against tanks with old hunting guns, bricks and sticks and sometimes their bare hands.

Ian Berry was the only foreign photographer to get into Prague on the same day as the Russians. 'The invasion had been threatened for some time so I had already got a visa in preparation. On the day of the invasion I reached Heathrow at about 11.30 a.m. I couldn't get on to the Vienna flight as it was already full of journalists, so I got a flight to Munich, rented a car and started driving towards the nearest Czech border. At the first border post I got turned back by Czech border guards acting under orders. Before I got to the next one I met some other journalists who had been turned back and told me I was wasting my time, but I thought I would still try and, as luck would have it, the Russians had just taken over control of the post as I arrived. I had a cover story about attending an architectural conference, although the Russian officer could see I had a whole bag of cameras with me. He didn't seem to care and let me through. It was just a fluke. I arrived in Prague in the middle of the night and checked into a hotel so I could get on the street early next morning.

'Unfortunately, I could not understand the Free Czech Radio which would have told me what was going on, so I found myself operating mostly in the centre of town and running around like a headless chicken, not really knowing what was going on, depending on the Czechs in the street to tell me. They were very helpful and seemed to be unanimously against the Russians. There were lots of tanks on the streets surrounded by Czechs shouting insults, to the confusion of the Russian soldiers. Half the Russian troops were

Asians, with Russian officers; they didn't really know where they were – most thought they were in Germany – or what was going on. The first few days I seemed to be the only foreign photographer around and I was shooting away with a couple of Leicas under my coat. You had to move pretty fast because if the Russians saw you taking pictures they would shoot over your head and chase you up the street to try and get your cameras, but the Czechs would block them if they could.

'The only other photographer I saw was an absolute maniac who had a couple of old-fashioned cameras on string round his neck and a cardboard box over his shoulders, who was actually just going up to the Russians, clambering over their tanks and photographing them openly. He had the support of the crowd, who would move in and surround him whenever the Russians tried to take his film. I felt either this guy was the bravest man around or he is the biggest lunatic around.

'For the first four days I was there I didn't eat, literally. The hotel had closed its kitchens and I just drank water until eventually some Czechs took pity on me and gave me some food. I had to leave after a week to meet my deadline. I hid my film all over the car, behind door panels, inside the headlamps and hub caps. I need not have bothered; when I got to the border it was night and I was just waved through. I fell asleep driving back to the airport and skidded into a ditch and had to get a tractor to pull me out. I got to the airport only a few minutes before my flight left and to get my film I had to rip out the headlights, door linings and hub caps and throw them in the back of the car. It also had a big dent in the side where I had gone into the ditch, but there was not a word of complaint from Avis. Last year I was machine-gunned by Zulus driving a Budget rental car and got bullet holes along the side of the car and Budget tried to make me pay for repairs. I think I'll stick to Avis in future.'

The 'lunatic' Berry kept encountering in Prague was Josef Koudelka, then an unknown thirty-year-old Czech who would be acclaimed as one of the world's leading photo-journalists when his powerful photographic record of the invasion was published a year later. Koudelka was an aeronautical engineer by profession but a photographer by inclination, having learned how to take pictures as a small boy using a little Bakelite six-by-six camera. He had quit his job in early 1967 to concentrate on photography and had been in Romania photographing gypsies as the Russian threat built up. He arrived back in Prague only a few days before the invasion.

'I was woken up at night by a telephone call from my girlfriend, telling me that the Russians had arrived. I didn't believe her at first, I

thought it was a joke. Nobody believed it, nobody really believed it would happen and it was a complete surprise when it did. Eventually, she called me for the third time and told me to open the window and I could hear the planes flying over every two minutes. Luckily enough, I still had some film which I didn't use in Romania so I went on the streets. It was still dark so I was probably one of the first persons to see the Russians arriving. I lived close to the radio station and I thought that something might happen there so I went there and I started photographing.

'I don't think I even approached the event as a news photographer, I never photographed what you call 'the news'. What was happening in that time concerned me directly. It was my country, my problem; it concerned my life. I didn't know how much risk I was taking – I was just responding to what was happening. Some people told me I could have been killed, but I didn't consider it at the time. I knew it was important to photograph as much as I could.'

Whether or not Koudelka was risking his life, he was certainly not planning to sell or publish his pictures of the invasion; he was photographing for himself. Indeed, his pictures might never have been seen by the outside world had he not given them to a close friend, Anna Farova, who was highly regarded in photographic and art circles. In the spring of 1969, Farova was visited by Eugene Ostroff, the curator of photography at the Smithsonian. She showed him Koudelka's pictures and he was so struck by them that he asked if he could take a few back to the United States to show a mutual friend. The friend was Elliott Erwitt, who thought the pictures were sensational. Erwitt contacted Farova on Magnum's behalf and asked if there were more. She checked with Koudelka for his permission to release them. Koudelka knew little about Magnum, but Farova assured him that it was respectable and he agreed. Some time later Magnum dispatched an emissary – a doctor attending a medical conference – to Prague to smuggle the pictures out.

Koudelka thought little more about it until August 1969, when he happened to be in London with a visiting Czech theatre group he was photographing. 'I remember very well we went out one Sunday morning, the first anniversary of the invasion, and one of the people I was with bought a copy of the *Sunday Times* and there, in the magazine, were my pictures. Of course they didn't know they were mine and I couldn't say they were mine, but that was the first time I saw the pictures published.'

Magnum had sold the pictures to the *Sunday Times* in Britain and *Look* in the United States (*Look* paid $20,000) on the understanding that the photographer would not be identified, since Communism

had clamped down again on Czechoslovakia and Koudelka's freedom would have been severely jeopardised by selling patently anti-Communist pictures to the West. The *Sunday Times* credited the pictures to an 'unknown Czech photographer'. Thereafter the pictures were credited to 'P. P.' – Prague photographer. While he was in London, Koudelka met Elliott Erwitt and discussed a plan for Magnum to help him leave Czechoslovakia, should it become necessary. Back home in Prague, Koudelka became increasingly concerned that he would be identified as the 'unknown' photographer. When the Voice of America radio station announced that the 'unknown photographer' responsible for the pictures of the Soviet invasion of Czechoslovakia published in the West had been awarded the Robert Capa Gold Medal, many of Koudelka's friends began demanding to know if he was this 'unknown' photographer. In the end he contacted Erwitt and asked him to facilitate his departure. In his capacity as president of Magnum, Erwitt promptly wrote to the Ministry of Culture in Prague to invite Mr Josef Koudelka to Western Europe to take part in a project photographing gypsies.

Koudelka was given permission to leave the country for three months and flew to London where he met Erwitt, who had warmed up his contacts at the Home Office: Koudelka's application for asylum was granted immediately. David Hurn remembers Koudelka's arrival particularly well: 'Elliott phoned and said "Look I've got this young Czech photographer and he has a few rolls of film and he wondered if he could use your darkroom." So I said "Yes, of course he can." So Josef arrived, hardly speaking any English and as far I can remember I think he had 800 rolls of film. I don't think he left for about eleven years.'

Koudelka was instantly made an associate and taken to Magnum's heart since he passionately exemplified the very best traditions of the agency. He was a photographer's photographer; cared for nothing but taking pictures to please himself, was not interested in money or material possessions, was perfectly happy to sleep on the floor in the office, was not inclined to dabble in Magnum's savage internal politics and wanted only to be free to work without encumbrances. With his tousled hair, National Health spectacles, a bedroll slung across his shoulders and a battered Leica round his neck, he was once described as the 'Bob Dylan of contemporary photography'. He fervently believed that photographers produced their best work by staying on the road, so he got in the habit of travelling all summer and returning to David Hurn's darkroom in the winter to harvest the fruits of his toil, bedding down on the floor at night in a sleeping bag.

Not long after Koudelka arrived in Britain the Photographers' Gallery opened in London with an exhibition entitled 'The Concerned Photographer'. David Hurn had been invited and took Koudelka along as his guest. Afterwards there was a celebration dinner at a fancy London restaurant. Koudelka made his way there alone, got lost and arrived late and then found his entry firmly blocked by an elaborately uniformed porter who haughtily insisted that he could not enter without a tie. When Koudelka asked if he could borrow a tie the porter said there was no point as his shabby combat jacket and baggy trousers were not acceptable either. Word of his problem had obviously been passed to the guests inside, because suddenly the door burst open and a furious grey-haired man grabbed the porter by his lapels and shouted at him, 'He's better dressed than you! Look at you, you're dressed like a clown. If he can't come in, I'm leaving', whereupon all the other guests left too and gathered in a cheerful Greek restaurant just down the road that had no problems with Koudelka's dishevelled state. When Koudelka asked who had come to his rescue, he was told it was Henri Cartier-Bresson.

Koudelka says he has not a moment's regret about joining Magnum. 'This I remember very well. I was supposed to meet Elliott Erwitt and the night before, I was learning the future tense "I shall, you will, etc." because I knew he was going to talk to me about the future. He asked me if I wanted to be an associate member. I didn't know what it meant. I asked him what it meant and he explained and I was happy. For me, I can only say very, very good things about Magnum. I was very happy that I got in. I left Czechoslovakia and I found myself here, I couldn't speak the language very well, I didn't know anybody and suddenly I had a certain security and suddenly I discovered that I belonged to something, one of the best organisations for photography that exists in the world. It was very important for me, because immediately. I was part of something that was good, I got immediately a lot of friends there. So, if I travelled, it helped me a lot – people were not afraid to give me the key to a house where I could sleep, I was not going to steal! It was something: well, if I had got nothing else, I had a place [the Magnum office], nobody could kick me out from this place. Everybody could kick me out from wherever, but not this place, this was my place.'

On 30 January 1972, British paratroopers opened fire on rioters during a march in the Bogside area of Londonderry in Northern

Ireland, killing thirteen people and wounding seventeen others. It was an event which would become infamous as 'Bloody Sunday' and among the photographers present was a young Magnum nominee by the name of Gilles Peress, who captured the horror of that day with a picture of an anguished priest holding his hand to his head while standing over the body of one of the marchers. Peress narrowly escaped being shot himself. 'I had seen peasant riots and student riots in 1968 and that kind of thing,' Peress told the *Sunday Times* later,

> but to suddenly find myself in a situation involving paratroopers setting up an operation against the civilian population and shooting people . . . well, I still find the whole thing beyond belief. In real war situations there is a logic, but the insanity of that day, with soldiers not jumping the gun, so to speak, or losing control, but acting on a deliberate order to open fire, was crazy. It brought the IRA back into prominence in 1972; until then they had not been much more than a shadow of wishful thinking or fearful propaganda. It brought not only the Provisionals, but no-go areas and the creation of the militant loyalist Vanguard Party and the UDA. It was the end of the civil rights movement in Northern Ireland. In fact Bloody Sunday frightened the people off the streets and put a military conflict in their place.[2]

Peress said he first went to Ireland to 'learn to be a journalist'. He arrived in Belfast on 11 July 1970, at the age of twenty-four with a philosophy degree, borrowed cameras, very little English and an almost total ignorance of what was happening in Northern Ireland. Active in the student riots in Paris in 1968, he had become suspicious that rheteroic was obscuring reality and turned to photography as a means of documenting reality. His pictures of the social misery left behind in the aftermath of a failed strike in a mining town in the south of France impressed Cartier-Bresson and got Peress into Magnum in 1970. On the day he was accepted as a nominee someone suggested he should think about covering the Protestant marches in Northern Ireland; he was in Belfast the next day. Over the following ten years he would come to admire the people of Northern Ireland and make a significant contribution to coverage of 'the Troubles' without ever entirely resolving his role.

> You peel off layers that include the prejudices of a journalist relating to the reality of conflict. There is a process of doubting yourself and overcoming your limitations. If we can acknowledge that we are all subjective, we can come closer to some kind of

objectivity. Through the years in Northern Ireland I really tried to live on both sides of the barricades and to question my own feelings. I exposed myself to the different perceptions and found that perceptions are the trouble in Northern Ireland. They don't overlap, which is why there is no common ground or common language between the parties, whether they be the British Army, Loyalists or Republicans. Crossing these borders, exposing myself to the different perceptions, really it's one of the most painful acts you can subject yourself to. It is like being stretched to the limit.[3]

Magnum mobilised in force to cover the Yom Kippur war in October 1973. Although tension had remained high in the Middle East, the news that Egypt and Syria had launched simultaneous attacks on Israel on the holiest day in the Jewish calendar took the world by surprise. Cornell Capa was already in Tel Aviv organising an exhibition for the Israel Museum and was soon photographing the fighting in the Golan Heights. Micha Bar-Am, the former official Israeli Army photographer who had joined Magnum in 1967, was similarly on the spot. Philip Jones Griffiths was in London and left for the airport the moment he heard the news; Leonard Freed, also in London, only waited long enough to get an assignment from the *Sunday Times*. Bruno Barbey was in Phnom Penh, on his way home from China; when he heard the news from the Middle East he changed his flight destination from Paris to Beirut.

Griffiths arrived to find himself, photographically and emotionally, on stony ground. 'There were no pictures to be had, just maybe some of guys giving a victory sign. I was out in the desert and suddenly there was some incoming and nowhere to hide. Now, I always like to hide under tanks because you are pretty safe under a tank, until it moves, of course, and all these tanks kept moving. There is only one thing worse than being killed by a shell fragment and that is being crushed by a tank. I thought to myself, what am I doing here? All this has no meaning, it isn't part of me, this conflict isn't something I actually care about. Then, thank God, I was let off the hook, because I got back to Tel Aviv and an editor rang up and asked for a colour picture of a burning Arab tank for the following week's cover. I had to tell him that it was too late, that part of the war had been over for about ten days. He said "You may think we're pretty stupid here in New York but I'll tell you what I want you to do. I want you to buy a five gallon can of gasolene and put it in the trunk of your car and find a tank and burn it for us." At that moment I saw, with blinding clarity, what my duty was and I put the phone down and went to the airport and got the first flight home.'

(Some of Griffiths's colleagues at Magnum find this story hard to believe.)

When Bruno Barbey arrived in Beirut he found the hotels overflowing with frustrated journalists trying to get into Syria, but all Barbey had to do was make a telephone call. He knew a colonel in the Syrian Army, who had been trained at the St Cyr military academy in France; when Barbey arrived in Beirut he telephoned his friend, who promptly sent a car to pick him up at the border! Unfortunately, his assistance ended there. In Damascus Barbey found that the few journalists who had managed to get there were not allowed out of their hotel. When Israel pushed the Egyptians back beyond the Suez Canal, Barbey moved to Tel Aviv and covered the end of the war from the Israeli side.

With Israel exercising strict censorship, he had to use considerable ingenuity to get his film back to Paris. He had taken some pictures of Arab prisoners of war being used to collect bodies on the battlefield and clean Israeli tanks. He was certain that these would not be approved by the Israeli censors, so he slipped the negatives behind the label on one of the large envelopes he used to ship film. He submitted some film to the censor which he thought would be unobjectionable and had the satisfaction of watching the censor stamp the envelope 'approved'. But then he had an anxious time getting through to Paris to warn them not to throw the envelope away when it arrived.

In 1973 Marilyn Silverstone became the only member of Magnum to be ordained as a Buddhist nun. It surprised few of her friends, who knew she had been searching for something more meaningful in life than photo-journalism. She had been working as a professional photographer for nearly twenty years and had covered all manner of assignments, from the wedding of Hope Cook and the Maharaja of Sikkim, to the election of Indira Gandhi, and from the coronation of the Shah of Iran to the famine in India. Despite having her pictures published in leading American and European magazines, by the end of the 1960s she was beginning to sense a certain staleness and repetition in her work. Serious disillusionment set in in 1971 when she was dispatched by the *New York Times* to cover the war in Bangladesh. Because she was then living in Delhi she was able to arrive in the area long before the competition and sent back heart-rending pictures of the misery being inflicted on the people of Bangladesh by the rampaging Pakistan Army. More than two million people fled their homes to escape the fighting. It was a human

tragedy on an immense scale and Marilyn was furious when she learned that her pictures had been relegated to an inside page. Suddenly it seemed there was little point in her work.

She had long been interested in Buddhism and found a teacher in the celebrated Lama Khyentse Rinpoche. Marilyn joined his entourage, followed him to a remote monastery in Nepal and emerged five months later as an ordained nun. The first task she was set was to help raise money for a monastery, which has now been built near Kathmandu and houses 131 monks. Marilyn is one of three nuns living in the monastery, caring for some fifty small boys. She spends much of her time researching the vanishing customs of Rajasthan and the Himalayan kingdoms, but still takes photographs, mostly to illustrate the Chinese oppression of Tibet. In a newspaper interview in 1992, she vigorously denied the notion that that she had withdrawn from worldly affairs: 'I'm not retreating from the world – I'm bloody well in it! But the discipline has to have an altruistic end. The idea is to continue to form yourself so you can continue to do good.'[4]

In 1974 the *Encyclopaedia of Photography* described Magnum as 'a vital force in contemporary photojournalism', despite the fact that its members were becoming increasingly dependent on commercial work, photographing that year no fewer than fifty-one annual reports. Not long afterwards the magazine *35mm Photography* offered up some alternative definitions, among them 'a closed community of self-righteous monks, scorning any heathen not of its order' and 'a collection of prima donnas with a grossly exaggerated sense of their own importance and abilities'.

Curiously, the whimsical Elliott Erwitt was at that time disproving both monk and prima donna theories with a series of pictures of dogs and their owners that would draw smiles wherever they appeared. Perhaps only Erwitt could take such an unprepossessing subject and turn it into a hilarious essay published around the world.

As photo-journalism declined, so the aspirations of photographers joining Magnum changed. In the 1950s it was the ambition of every young photo-journalist to roam the world for *Life* or *Picture Post* or *Paris Match*, but the new generation of photographers seemed more intent on studying themselves than the world out there, more inclined to view themselves as artists rather than journalists. They adopted an approach which some called New Subjectivity (a reversal of *Neue Sachlichkeit* – New Objectivity – in the 1920s when photographers looked for new ways of photographing commonplace objects, often in startling close-up). Followers of New Subjectivity, interested in the excessive study of their own navels and Zen, found

little in common with Magnum, particularly as many of the 'concerned photographers' at Magnum were getting older and were becomingly increasingly concerned about making money to support their families and thus more inclined to abandon erstwhile youthful left-wing idealism.

While the division within Magnum echoed both the historical tension between photography as a form of communication and photography as art and the conflicting demands of aesthetics and journalism, Edward Steichen's view was unequivocal: 'When I first became interested in photography ... my idea was to have it recognised as one of the fine arts. Today I don't give a hoot in hell about that. The mission of photography is to explain man to man and each man to himself.'[5]

The philosophical debate was whether Magnum's future was about the creation, preservation and dissemination of important photographic images, or whether it was going to become a corporate entity, looking for fat profits in advertising and annual reports. Yet the reality was that Magnum would have collapsed years before had it not been for those photographers making substantial sums of money from commercial work. The problem was that even those photographers regularly engaged on commercial work recognised that essentially it was worthless, as Costa Manos explained: 'During the years I was a very successful annual report photographer for big corporations like Warner Communications, Travellers Insurance, multi-conglomerates. That's when I made the most money in my life, but I was not doing good photography. Very little is left from that kind of photography in terms of images, it is just stuff that you throw away, ultimately. That is what I was doing and those years, in a way, photographically, were lost years for me, empty years.'

The happy compromise was for photographers to use commercial work to finance their private work, but this did not accommodate those who viewed any kind of commercial work as a form of prostitution, among them Henri Cartier-Bresson. 'I've nothing against people who do advertising,' said Cartier-Bresson with barely concealed disdain; 'it is a profession like any other. But when you are a reporter, you stick to reporting.'[6]

Burt Glinn had a different view. 'I remember having my first real disagreement with Henri when he said something similar as we were walking down the Avenue Franklin Roosevelt. We were waiting to cross the street and Henri said something about how wonderful Elliott [Erwitt] was and how he wished he didn't take colour pictures and wished he didn't do ads. And I said, but Elliott has a family, he's

got kids, he's got to support them, he's got to do things for them. And Henri said, that's not my problem. Well, it is all our problems.'[7]

It would certainly have been a problem for Magnum, had big-earning photographers like Burt Glinn, Elliott Erwitt and Burk Uzzle not been prepared to dirty their hands aesthetically. Uzzle, who joined Magnum in 1967, had a solid background in journalism, started work on a newspaper in his home town of Raleigh, North Carolina and was the youngest contract photographer on *Life* at the age of twenty-three, yet he had not the slightest hesitation in switching to annual reports when journalism assignments began to dry up, claiming that the demands of commercial clients sharpened his visual skills. At the same time, he always carried with him a Leica loaded with black and white film for what he called his 'personal work'.

In the latter half of the 1970s Magnum had a veritable influx of new blood. In New York, Eugene Richards, Alex Webb, Danny Lyon, Mary Ellen Mark and Susan Meiselas joined. In Paris Jean Gaumy, Raymond Depardon, Richard Kalvar, Guy Le Querrec, Sebastião Salgado, Martine Franck and Chris Steele-Perkins were recruited. Not all were welcomed to the fold without dissension.

Kalvar and Le Querrec were both members of Viva, a rival agency to Magnum, in Paris. Le Querrec, a stocky Breton with a remarkable resemblance to the cartoon character Asterix, had made a name for himself photographing jazz musicians and was working, perfectly contentedly, in the social documentary field when Marc Riboud noticed his work and suggested that Magnum might be willing to accept him as a nominee. Until that moment Le Querrec had not thought of joining Magnum – he considered the 'mountain was still too high' – but Riboud's encouragement made him start to think seriously about it, particularly as Riboud had led him to believe that he was more or less being invited to join and his acceptance was little more than a formality. But Riboud also warned Le Querrec not to mention the 'invitation' to anyone else at Viva. Le Querrec made the mistake of disregarding this advice and told his friend Richard Kalvar, as well as another Viva photographer. All three decided they would apply together to join Magnum.

This might not have caused any real difficulty except that Henri Cartier-Bresson's second wife, Martine Franck, also worked for Viva. Cartier-Bresson was furious when he discovered that three of his wife's colleagues were trying to join Magnum and accused Le Querrec of trying to destroy Viva. When they submitted their portfolios to the annual general meeting in 1977, Cartier-Bresson spoke passionately against Le Querrec being admitted, referring to

his 'treachery'. To Le Querrec's anger, only his friend Richard Kalvar was accepted. 'Guy was pretty unhappy,' says Kalvar. 'I think he believed I should have refused the offer and from a moral standpoint I suppose I should have done. But for me it was a dream to even think about working for Magnum, so I only hesitated for about four seconds.'

When the dust had settled somewhat it was realised that Le Querrec had been given a raw deal and he was accepted on a unanimous vote the following year without having to submit another portfolio. Ironically, Martine Franck left Viva two years later and joined Magnum herself, after some agonising, in 1980. Le Querrec clearly bore no grudges, as he explained: 'It is hard not to feel pleasure, satisfaction, even pride, when you know you have been elected by demanding photographers to join Magnum, because they are, in my mind, the chevaliers, the knights who are bound in a quest to find the Holy Grail, seeking for something they wish to achieve. The day I was told that I was a chevalier of Magnum, it was like being dubbed a knight. It meant that the others had found me worthy.'

At the time Raymond Depardon applied to join Magnum he was one of the best-known photo-journalists in France, but he still had to go through the same rigmarole as everyone else. Born in 1942, Depardon grew up on his parents' farm in Beaujolais, started taking pictures when he was twelve and dreamed of becoming a photo-journalist. When he was sixteen he wrote to every photo agency in Paris – there were about twenty-five – enclosing four family snapshots and asking for a job. He was soon an enterprising paparazzo and waited behind a tree for hours to get a shot of Brigitte Bardot when she emerged from a clinic where her boyfriend was recovering from a serious illness. In 1960 he was sent to the Sahara to cover a French government experiment on the human body's resistance to extreme heat. While he was there he joined the search for seven young soldiers who had gone missing in the desert and he was with the party that found them: only three were still alive, very close to death. Later, in a French Foreign Legion fort, Depardon was told to hand his pictures over. 'I was aghast. I remembered all the conversations I had had with other photographers, that you never, never give up your film, even if your head is on the block. You hide it in your hat, your socks, your underpants – you eat it rather than give it up. So first I started to cry and then I lied, saying that I had already given the film to a soldier who was in the helicopter taking the survivors to hospital.' Luckily for Depardon he was not searched:

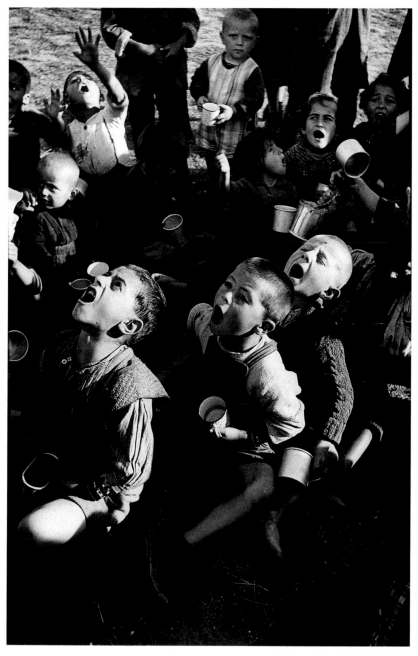

DAVID SEYMOUR
A group of children await food rations, Greece, 1948

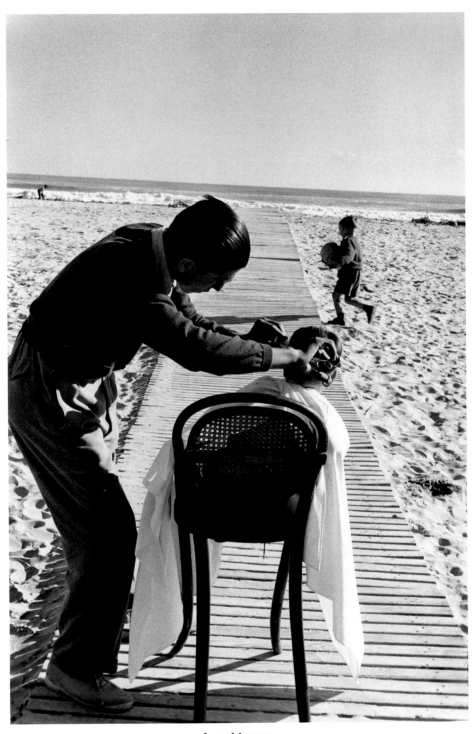

INGE MORATH
Young orphan is given a haircut, Valencia, Spain, 1957

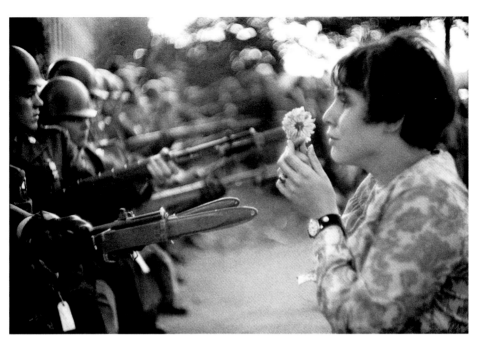

MARC RIBOUD
A woman holds a flower up to armed National Guardsmen, Vietnam Peace March,
Washington, D.C., 1967

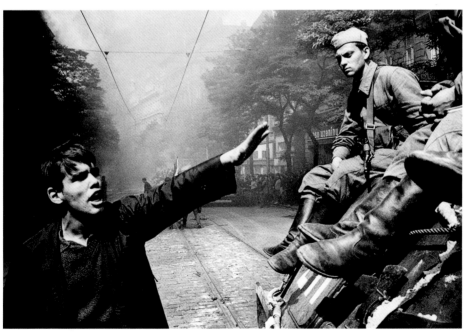

JOSEF KOUDELKA
A young Czech argues with Soviet troops as their tank proceeds through Prague,
Czechoslovakia, 1968

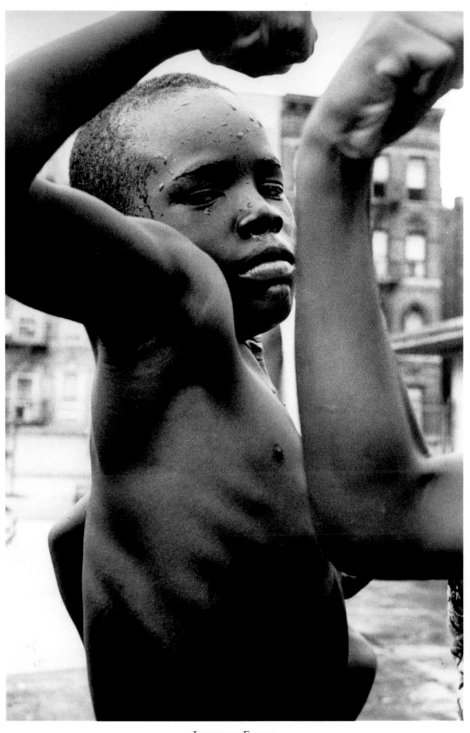

LEONARD FREED
Boys playing at being "toughs," Harlem, New York, 1963

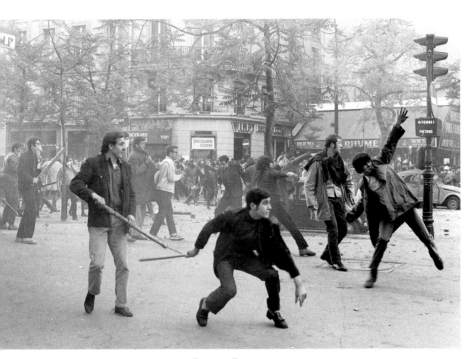

BRUNO BARBEY
Students on the Left Bank hurling projectiles at riot police near the Sorbonne, Paris, 1968

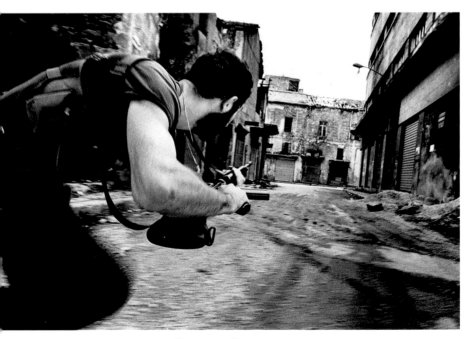

RAYMOND DEPARDON
Christian Phalangist militiaman fires in Beirut, Lebanon, 1978

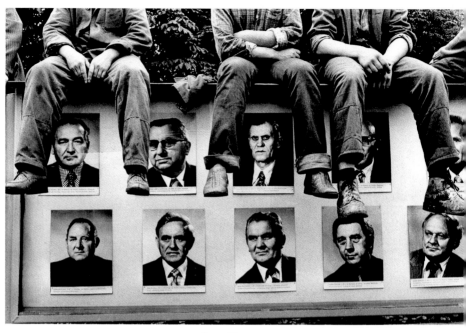

JEAN GAUMY
Strikers at the Gdansk shipyard, seated on a wall showing portraits of the "best-rewarded workers," Poland, 1980

MARTIN PARR
Boy in a phone booth during a rainstorm, England, 1998

SUSAN MEISELAS
Wedding, El Salvador, 1983

ABBAS
Sugarcane cutters, Morelos, Mexico, 1984

JAMES NACHTWEY
Hands of East and West Germans tearing down barbed wire from the Berlin Wall, 1989

PAUL FUSCO
James, a resident at the Ambassador Hotel for AIDS patients, San Francisco, 1993

he got the film back to Paris and his pictures filled a ten-page exclusive report in *Paris Match* a week later.

By 1966 Depardon was one of the hottest photographers in Paris. That year, with three photographer friends, he founded Gamma, an agency that quickly built a reputation for toughness, political commitment and aesthetic daring. Depardon covered all the big stories – Algeria, the Congo, Beirut, Vietnam – and in 1973 he won the Robert Capa Gold Medal for his work in Chile. Shortly before joining Magnum he spent almost two years covering the rebellion in Chad and looking for a French woman who had been taken hostage. He first tried to reach the rebels by crossing the desert on a motorcycle. When that failed, he went in on a plane carrying arms, waited for two months at a secret airstrip to make contact with the rebels, only to have his film seized. Eventually he rented a Cessna, found the woman and returned with an emotional filmed interview which ran for seventeen minutes uninterrupted on television, caused a public outcry and forced the French government to intercede.

It is a measure of Magnum's status that a photographer as famous and successful as Depardon should join the queue of aspiring nominees, but he had no doubt that he was making the right move at the time. 'After my experience in Chad I was emerging from just being an agency photographer, the type who snaps and sells, to someone who was very preoccupied with every story. I suppose I believed that Magnum would give me the opportunity to develop a social conscience and give my work depth and meaning, to develop aspects of my character and ability that were latent but undiscovered.'

In New York, the admission of Susan Meiselas into Magnum was the cause of considerable dissension. A New Yorker with a master's degree in education from Harvard and an active political conscience, she scraped in by only one vote, after some hurried manoeuvring behind the scenes which led her opponents to make dark and bitter accusations about the vote being rigged. 'Getting Susan into Magnum was very divisive,' admits Burt Glinn. 'Mary Ellen Mark didn't want her in and neither did Charlie Harbutt, but they couldn't quite express what their objections were, at least not satisfactorily enough for me. I felt on the basis of her work that she deserved to come in and I felt that was the only criterion. Charlie seemed to think there was something a bit unsuitable about Susan, but he didn't know what.' (Harbutt admits that he felt 'something was going on', but that he didn't think much of Meiselas's work anyway.)

Meiselas wasn't even sure she wanted to be a photographer when she joined Magnum. She'd been teaching photography to kids in the

South Bronx in the idealistic belief that the camera represented a means of expanding options for poor people, but she gave it up when she came to accept that photography's extraordinary potential was largely only available to those with the resources to take advantage of it. She abandoned teaching for a while to travel with, and photograph, a touring company of showgirls and strippers working the state fairs in New England. Briefly back in New York she got an assignment from *Harper's* to take photographs of delegates at a women's convention at Madison Square Garden. There she met Gilles Peress and got talking to him about what she had been doing. He suggested she should show her pictures to Magnum. Next day she bundled up her photographs, jumped on her bicycle, pedalled the thirty-six blocks to Magnum's office on 46th Street, dropped off the portfolio and pedalled back again. When she opened the door to her apartment, the telephone was ringing. It was Burk Uzzle, telling her to come back, he wanted to talk to her right away. Gilles took her portfolio over to the annual meeting in Paris and within weeks she found herself elected as a nominee.

'I remember thinking that I did not quite know what to make of it, it had all happened so quickly. I wasn't really aware that it was an honour; I was more fascinated by the dynamic of the group. I'd sit in the little photographers' room, it seemed like it was only about six feet by six feet, observing what was going on, who came crashing in from assignments; who sat there angst-filled, gnawing at themselves in their anxiety to find out what to do next; who spoke to each other and who did not. It was all very revealing.

'I was so ignorant about what to do that when I got invited to go to Cuba to work as part of a team of seven photographers, Burk Uzzle had to tell me what to pack in my suitcase. In January 1978, I picked up the *New York Times* and read an article about the assassination of Pedro Joaquin Chamorro, the publisher of Nicaragua's leading opposition newspaper and I began doing research about Nicaragua. One day Richard Kalvar came in and said "What are you doing, where are you going?" and I told him I was thinking of going to Nicaragua with a writer who never seemed to be able to make the time available. He said "Why don't you just go without him?"

'Getting on the plane was quite difficult psychologically. I knew how to pack my bags, in a sense, but I didn't know for what purpose. I remember being on the plane, circling above Managua, thinking what am I going to do when I land? What's my job? Why am I going to this place?'

Meiselas was then thirty years old. She had never covered a major political story, had no assignment, no plan; couldn't speak Spanish.

She did not even know how to get more film when she had used up what she had brought with her. Finally, she wired Magnum in New York and asked for ten more rolls. Burt Glinn dispatched 100, along with a 300 mm lens and the advice, having seen the first pictures she had sent back, that she was getting too close, dangerously close, to people who might not be at all keen to have their pictures taken. Meiselas herself admits that initially she was naive, but says she was so exhilarated by the challenge that she was oblivious to the emotional and physical hazards. Little by little, she says, it started 'to roll'.

With the exception of brief return visits to New York, Meiselas stayed in Nicaragua for more than a year to document the struggle of the Sandinistas against the despised regime of President Somoza and she was there when the country exploded into full-scale insurrection. After the victory of the Sandinistas she moved on to cover a similar, and equally dangerous, story in El Salvador, where she was injured when a car in which she and two colleagues were travelling struck a land mine. One of them, cinematographer Ian Mates, died from his injuries. For her work in central America she would receive numerous awards, among them the Robert Capa Gold Medal presented by the Overseas Press Club for 'outstanding courage and reportage'.

Susan meiselas talking in her studio in Mott Street, New York: 'I think it was on my third trip to Nicaragua in 1979. I wanted to find one of the Sandinista guerrilla camps that were up in the mountains and through various tip-offs and contacts I was told that if I was ever in Tegucigalpa, in Honduras, I could ring a certain telephone number and find a way of making contact. I crossed the border into Honduras, went to Tegucigalpa and called the number. I was told to go to a certain hotel and there I found two other journalists, an Austrian and a Colombian, waiting to make the same trip. We had no idea how it was going to be organised. All we were told was that we had to get from this hotel to this point where we would be picked up and taken somewhere else. We were driven to a little farmhouse on the border and then told that we were going to walk in with a small column of maybe eight guys carrying arms and supplies.

'At that point the Austrian dropped out. I don't know if it was because he was afraid or whether he was worried about crossing the border clandestinely. For my part, I decided that if that was the only way to go, that was the way to go. The fact that the Colombian, who could speak English, was coming, made a difference. I had the feeling that it would be OK, that we could do it.

'When they came to pick us up it was pouring with rain. There were eight of them and they all had arms and I was somewhat discomforted by that. I had never really travelled with anybody carrying weapons. I didn't want to carry a weapon myself, but I knew they had this mission to get us somewhere in safety. I didn't really know what we were up against, either. I didn't really know the kind of territory we would have to go through.

'We walked at night and slept under the trees by day. There was very little to eat, nothing fresh. I remember buying these little cans of intensely sweet condensed milk, which gives you a tremendous energy kick. I didn't know if we would make it. I don't remember if I had boots or sneakers, but whatever it was it was nothing fancy. It was very rugged and they kept up a gruelling pace. It is hard to walk at night; you keep stubbing your toes all the time. A little boy offered to carry my pack but I refused; it was a point of honour to carry my own shit. The men in the group did not talk to us much; I mean, no one talks much when you walk through that kind of terrain. They were very fearful of being detected. I remember hearing dogs barking, which was terrifying. You just focus on your feet and don't project in time. You take each step as it comes and you get somewhere. I had no idea where we were going.

'They cooked tortillas, which they would reheat and share with us. I remember very clearly a *campesino* bringing warm milk at one point

on the path. It was the first time I had ever had warmed milk and I could imagine it coming from someone's home. There were always people bringing a little of this or that, but there was also the fear that they might go back and tell the National Guard down in the village that there were these people wandering around. So the tension of the situation meant we didn't ask many questions, but just hoped we were going to get where the hell we were going.

'Our reception at the camp was very matter-of-fact. There was no celebration of the fact that we had gotten to the end. We were just relieved we had got to the end of the walk. I never did look at a map to see how far we had walked. Life at the top of the mountain was very mundane, pretty grim. It was a training camp and the *campesinos* would come up and down the mountain bringing food and messages about what was going on down in the valley. There was a daily routine of making breakfast and then doing exercises. They couldn't really do any fire practice because they would be heard. I remember them doing an exercise in hand-to-hand combat, but I doubt whether they ever used it. I don't think even they knew what the war was going to be like in the next stage. There were a fair number of women, which surprised me, as there had not been many in the September insurrection. I was very intrigued by the life, just the everydayness of it, and the people who had made this decision to leave their homes and families and security to come to this place.

'After I had been there a bit and gotten a sense of the daily life, I thought, now how do I get out of here? My sister was getting married in New York and I didn't want to miss her wedding but I wasn't really sure if I was going to be able to get out. I couldn't go by myself and no one seemed to be going out. But it all suddenly happened.

'One day news was brought up to the leader of the camp which caused a sudden burst of activity. They became concerned for our safety and said we had to leave. We decided to split up, because we were nervous of both being caught without the right paperwork; neither of us had visas to enter Nicaragua. The Colombian went off with the rest of the group and I was put on a horse with a peasant as a guide. They had miraculously worked out a network in which he left me at a point on the road and an hour and a half later somebody came by and had a signal where to look and then I was in a car being driven to the airport. Somebody working inside the airport passes me through immigration. I never stopped to get any bags, or anything. I left everything there. I got to Miami and caught the first flight to New York. I left Friday morning; Saturday morning I was at my sister's wedding. I looked like I came from a jungle, but she was

really pleased to see me. I was in a bit of a state of shock, the transition from where I had been was so abrupt.

'By then I was very connected to the Sandinista cause and the history of Nicaragua. Magnum told me there was no need to go back, but I wanted to see how things were going to play out. So I spent about ten days in New York getting organised and then returned to Nicaragua, arriving just before the final offensive in July 1979. I went to the opposition newspaper office to find out what was going on, and it seemed the next action would be around a place called Esteli. So I drive to Esteli and that day the government call a curfew, but I don't know about it. I arrive on the outskirts of the town which has got a military guard round it and they take me in for questioning because I am coming in an hour after the curfew. I said I made a mistake, I didn't know about the curfew, but they take me into custody anyway to be interrogated by the general of this town.

'This is the start of a terrifying time. He is interrogating me about why I am in Esteli and he thinks I know something. I proclaim my innocence but he doesn't believe me, so he holds me in custody and won't let me call out. I'm saying I've got to call my embassy and you're making a big mistake about me but he takes no notice. During the interrogation he reveals that he has just led an attack on the guerrilla camp in the mountains where I had been. I don't know if he knows that I was there; all I know is that he is giving me a very tough time and he is telling me about this operation and who they had captured, naming the people I had met.

'The interrogation goes on late into the night and finally he says "I'll tell you what we'll do. We'll put you in a hotel right outside the garrison and if there is an offensive tonight we'll know that you knew! And if there isn't, you can leave." That was the deal. The general must have thought to himself: why is a journalist appearing here? She must know something.

'So I'm in that little hotel and nobody knows where I am and for all I know the bloody Sandinistas are going to attack. I had no idea if they were going to attack, but at that point it was as likely as not that they would. The general didn't say what he would do to me if they did attack, but it was clear to me that I was a hostage. The worst thing was not being able to communicate with anyone.

'It was completely terrifying, probably the most terrifying moment for me in Nicaragua: waiting out the night and trying to figure out, well, Christ, if they did attack I was right there at the centre of where the attack would come. So of course I didn't get a moment's sleep that night. At 5.30 in the morning, which is just when the sun

breaks, the general came to the door and said I could leave. He told me he was surprised, that he was sure I had information.

'A few days later the Sandinistas attacked Esteli; it was the first town they took completely. I was with them when they had the town surrounded. Their kind of warfare was to advance through backyards, house by house, street by street. I was always some steps behind the front line, but there was a moment when I was following two people who were just showing me the path and hadn't realised that the National Guard had come back in and taken that corner. There was a very low barricade. I was zigzagging trying to keep up with these two guys, who were probably half my age and definitely faster, when a grenade landed two feet away. There was just that instant of recognition, then freezing for a moment. Times like that you can forget where you are and think what is happening is not real. I never had any illusion that anything was going to protect me, maybe just chance, but I remember I just darted across the street. Miraculously, it was a dud.

'Later I saw the general again. He was lying in a field, dead. I was told he had made a dash to escape in his jeep, leaving the troops to fight on, and had been killed then. The fall of Esteli was symbolic, the beginning of the end, because that evening Somoza took what he could and fled the country.'

12

A Crisis and a Shooting

THE 1980s began, as is entirely traditional at Magnum, with a serious financial crisis. On 30 January, Cartier-Bresson and Rodger circulated a note to all Magnum members:

We as sole surviving founder members of Magnum would like to draw attention to the danger with which we think Magnum is faced. We take into due consideration that times have changed but nevertheless if we do not take care, the prevailing attitude today will result in the destruction of us all.

At the Paris informal meeting on Monday, January 28, 1980, opinion was expressed that judgements should not be based on sentimentalities. Far beyond sentimentalities the danger comes from the totally unrealistic approach to our finances. One cannot spend money on high severance pay, rentals, unaccounted for telephone bills and new inexperienced staff and yet remain solvent unless all photographers are prepared to work and produce the income to cover the cost.

It was a perennial source of mystery and frustration to the members of Magnum that the agency never managed to make any money. Some turned it into a joke. Burt Glinn liked to say that Magnum was the only organisation in the world in which members of the board started to get nervous if they looked like making money, but it was rare, indeed, that any of them had cause to be nervous on that score since Magnum was almost *designed* to lose money. Any management consultant commissioned to examine the organisation would have thrown up his hands in horror and walked away, shaking his head in disbelief.

Magnum's proud co-operative structure, the fact that it was owned and run by the photographers, meant that the management of

the agency was always fundamentally incompetent since it comprised part-timers with little or no business experience. The obvious solution – to hire professional management – was never really an option, firstly because the agency could never afford to pay enough to attract top-level people and secondly because no manager in his right mind wanted to work for thirty-odd difficult, demanding and temperamental bosses. So it was that the business was poorly organised and increasingly outdated; while other agencies were looking towards computerising their archives, Magnum's archive was still in cardboard boxes.

But the essence of the problem was the photographers themselves. The joint plea from Cartier-Bresson and Rodger for all the photographers to work and generate income might have produced results from salaried personnel. But all the photographers were self-employed and secure in the knowledge that no member had ever been asked to leave. While there were plenty of photographers interested in making money, there were also quite a few, absorbed in their art, for whom money was the least consideration. It was an imbalance which would virtually guarantee that Magnum would continue to teeter on the brink of financial disaster, despite the efforts of the high earners.

In the spring of 1981 temporary fiscal assistance arrived from a very unexpected source – President Ronald Reagan. On 30 March 1981, President Reagan was leaving the Hilton Hotel in Washington, DC, where he had been speaking to an audience of industrial leaders, and was walking to his limousine and waving to the crowd when twenty-five-year-old John Hinckley fired six shots from ten feet away. Reagan was hit in the chest, along with Jim Brady, his press secretary, a secret service agent and a Washington policeman. Hinckley was pinned against a wall by secret service men as the president was thrown bodily into a car and raced off to George Washington hospital. Only one photographer was able to document the entire incident – Sebastião Salgado. The pictures he shot in those few seconds made an initial $130,000 worldwide for Magnum.

Popular legend has it that Salgado had borrowed a suit in order to be able to follow the president around and had been obliged to leave the hotel because his trousers were falling down. In fact, he had borrowed a pair of grey trousers and a blazer from Erich Hartmann.

Sebastião Salgado would soon be lauded as one of the world's finest photo-journalists: 'Not since Eugene Smith and Cartier-Bresson has there been a photo essayist of the magnitude of Sebastião Salgado,' *Rolling Stone* magazine observed; 'rarely has a camera illuminated subjects with such extraordinary depth and cathartic

power'. But in the spring of 1981 Salgado was still a nominee, having yet to submit a portfolio to be accepted as an associate. Born in Brazil in 1944, one of eight children, he studied economics at university to doctorate level and did not pick up a camera until he was twenty-six years old and working in Paris as an economist. Once he had started taking pictures he was completely hooked. He became a freelance photographer in 1973, joined Gamma two years later and Magnum in 1979, at the suggestion of Raymond Depardon. A month after joining Magnum, his wife gave birth to their second child, who had Down's Syndrome, providing Salgado with a powerful incentive to make money as a photographer in order to be able to provide security for his family, still then living in Brazil.

Salgado found the working environment at Magnum very congenial, with photographers helping and advising one another. Koudelka taught him how to edit his contact sheets and René Burri helped him find work with magazines. He was on assignment in the outback of Australia when he was commissioned by the *New York Times* magazine to shoot a cover story on Reagan's first 100 days as president. He arrived in New York, his first visit, still wearing his outback clothes.

'I had no correct clothes, no tie, or shoes or suit, and I was told that Mrs Reagan was very strict about dress protocol, so I had to borrow from Magnum friends. I flew to Washington on Saturday, covered some of the president's engagements, shot a picture of him in the White House on Monday morning and in the afternoon was due to take pictures of him addressing a conference at the Hilton hotel. I had accreditation to work inside the White House but no papers to work outside, so I couldn't go in the official press car. I got a ride in a big van filled with security men, who were very nice to me and made jokes about my accent.

'When we got there I took a few pictures of the president speaking and then I suddenly had a wish to go outside. I suppose I knew I was working on a cover story and wanted to get as many aspects as possible, but I don't know why I suddenly decided to go outside at that moment, it was just instinct. First I asked a security guy if I could go through a side door but he said that it was only for the pool photographers and I would have to go out through the front door. I realised the president was leaving so I started to run and put my camera to my eye and heard the detonations and started taking pictures.

'All the pool photographers were lined up behind the car getting ready to take the pictures they take hundreds of times, of the president getting into his car, but I sort of came inside the action and

got mixed up with the security guys who I had been in the bus with, who luckily recognised me. I shot one picture of the president at the moment when I was the only person going in the direction of the firing. Everybody else was trying to run away. It was pure instinct: if a story happens in front of you, you just do it. I got a picture of the president being pushed into the car and Jim Brady lying on the ground and the security guards jumping on Hinckley. I had three cameras and no motor drive and I was shooting by hand and I had the impression that the action was going too fast and I was going too slowly, but I was not. I got all the action. I shot seventy-six pictures in the minute that it was happening and when it was all over I felt a little bit lost because all the security men had gone and I thought "How do I get back to the White House, I don't even have the address?" In the end I got a cab and asked him to drive me to the White House where I called the *New York Times* to tell them what had happened and they told me to take my film straight round to the *Times* office in Washington to get it processed. My first reaction was that the story was finished because the president had been shot and that I would never be allowed to fly to Illinois with the president the next day, as had been arranged.'

Fred Ritchin, the picture editor of the *New York Times* magazine, swiftly became embroiled in a bitter dispute with Magnum over the pictures. Since it was a big breaking story, Ritchin had no hesitation in suggesting that the newspaper publish Salgado's pictures, rather than wait for the two and a half weeks it would take to get them into the magazine. Technically, the *New York Times* magazine had first publication rights since it had commissioned Salgado, but when someone from Magnum's New York office telephoned to ask if it was OK to sell the pictures in Europe, Ritchin agreed. What he did not know was that Magnum was already negotiating a deal with *Newsweek*.

Ritchin only began to smell a rat when he telephoned Magnum to ask for the full selection of Salgado's pictures to be delivered to his office and nothing happened. He kept telephoning, but no one would speak to him. Eventually he called Gilles Peress, who was a friend, and asked him to find out what was going on. Peress rang back to tell him Salgado's pictures had been sold to *Newsweek* for $75,000.

Ritchin was furious. Philip Jones Griffiths, in his capacity as president, informed Ritchin that since the newspaper had already published two of Salgado's pictures, the magazine had forfeited its right to first publication. 'I thought Magnum was being completely hypocritical,' said Ritchin. 'I told Philip I wanted to reserve a few of

Salgado's pictures for the *New York Times* magazine and if I didn't get that I would never work with Magnum again. Afterwards I lodged a formal complaint but never heard a word from those in command. That was really typical of my experience with Magnum. They are the best photographers around, they have the most interesting insights into the world, but they are the least civilised to work with. For a year after that I never put an assignment through Magnum – I just dealt individually with the photographers and held them personally accountable for bringing in the assignment and doing it right.'

Salgado was only vaguely aware of all this drama, although he would soon have his own difficulties with Magnum, notably when his first application for full membership was refused. He was by then well known, very highly regarded and becoming one of the agency's biggest earners, so it is perhaps understandable that he was deeply offended. 'I suffered a lot from this,' he recalled. 'I don't think my pictures were the problem; I think some people in Magnum wanted to teach me a lesson.'

The money Salgado made from the Reagan pictures not only allowed him to spend two years working in Africa but reestablished a tradition for Magnum photographers to embark on long, personal projects often resulting in successful books and exhibitions – a tradition unique to Magnum – and providing invaluable material for the agency's archive.

The two nominees accepted at the annual general meeting in 1981 could hardly have been more different. Abbas was a thirty-seven-year-old Iranian who used only a single name and liked to say he was 'born as a photo-journalist'. Certainly he had proved his credentials time and again, first for SIPA, then Gamma. He produced a definitive book on the revolution in Iran during which his knowledge of the local language came in handy: after the attack on the US Embassy at the height of the American hostage crisis Abbas overheard a mullah ordering all photographers' film to be confiscated. 'I said to my colleagues,' Abbas recalled, 'we better get out of here.' Abbas would go on to produce extraordinary books on Islam and Christianity.

Abbas' co-nominee in 1981 was Harry Gruyaert, aged forty, a Belgian whose interest in photography revolved almost entirely around colour and form. Gruyaert was not only lukewarm about photo-journalism, he had extreme reservations about accepting any assignments lest they distort his vision and personality. 'I think I was probably an unpopular selection,' he admitted. 'It was the first time a deliberate non-journalist had been elected and I think there were

those who thought it was the beginning of the end for Magnum when I was admitted. The disadvantage of belonging to Magnum is the danger that you might think that the only truth is Magnum, not look any further than Magnum. There are many photographers I admire that are nothing to do with Magnum. I think some photographers in Magnum relish the prestige that it endows and wallow in the heroic myth. I don't give a fuck about the myth of Magnum. I am only interested in people's work.'

When Magnum's gung-ho photo-journalists learned that Gruyaert had once spent three months in India, shooting every day, and had only exposed 150 rolls of film, their worst suspicions were confirmed. Philip Jones Griffiths led the opposition to Gruyaert's application. 'I thought accepting Harry Gruyaert was a turning point in Magnum's history. He was the first photographer to be taken on who did not include any black and white photography in his portfolio. That was a major step for us. And his work had nothing to do with what made Magnum Magnum; that is, he made no pretence of capturing the human condition. When I raised these objections I was accused of objecting to him on the grounds that he was French. So he was in.'

More serious, perhaps, was the fact that there were three resignations that year: Charlie Harbutt, Mark Godfrey and Mary Ellen Mark. Godfrey was a former *Life* photographer who had joined Magnum in 1973 and Mary Ellen Mark was recognised as one of the world's leading women photo-journalists, but it was Harbutt's departure that caused most anguish inside Magnum, particularly as he tried to persuade other members to follow him and join the rival agency he was intending to set up under the name of Archive Pictures.

Harbutt had been a member of Magnum for nearly twenty years and had twice been president, but considered the organisation had become 'soulless' and was heading in the wrong direction: 'The ethos of brotherhood had disappeared and the place was falling apart over what seemed to me to be stupid ego issues. Attempts would be made to solve our difficulties at the annual general meetings, but then one office or the other would immediately renege on whatever agreements had been made. What finally disillusioned me was a distinct move away from the journalistic-social traditions of Magnum towards commercial work. That was a real blow. The archive was being oriented towards colour, advertising and travel and away from journalism. I found myself part of a small group that did not want to go in that direction and I felt it was time to say goodbye to Magnum

in this different incarnation, which had nothing to do with where it began.'

Ironically, Mary Ellen Mark's departure coincided with the publication of *Falkland Road*, a book which established her reputation as a photo-journalist. For more than ten years Mark had been trying to take photographs of the prostitutes working in Falkland Road, Bombay, where women and transvestites display their charms in 'cages' along the road. She was fascinated by the place, but every time she tried to take pictures she was beaten back by insults and threats; sometimes garbage was thrown at her. Finally, in 1978, she determined to try somehow to enter the world of these women. 'Every day I had to brace myself, as though I were about to jump into freezing water. But once I was there, pacing up and down the street, I was overwhelmed, caught up in the high energy and emotion of the quarter. As the days passed, and people saw my persistence, they began to get curious. Some of the women thought I was crazy, but a few were surprised by my interest and acceptance of them. And slowly, very slowly, I began to make friends.'[1]

Several of the younger members, among them Alex Webb and Eugene Richards, gave serious consideration to defecting with Harbutt. 'Charlie asked me to become a member of his new agency,' says Richards, 'but I decided, having thrown my lot in with Magnum, to stay and so Charlie refused to speak to me for some time. This is a sign of what Magnum does to people. To me Magnum will always be about fine work, but fine work is often overshadowed by all this crap which eats the place up. It is such a shame that we keep on disrespecting each other.'

Burt Glinn's view was that Harbutt left because he was 'pained by the sight of a lot of people being mean to one another'. Elliott Erwitt saw no reason why Harbutt should go: 'The criticism about photographers taking on commercial work generally comes from photographers who don't know how to do it. That's my view. The thing about Magnum is that you can do whatever you want as long as you don't scare the horses or do anything dishonourable. I think photography is a marvellous craft and you can do it as a craft and you can do it as art, as a political thing, anything, as long as the work you do is not dishonourable. For me, that's OK. Now we have some hot-eyed liberals, revolutionaries, that think differently. That's OK too, as long as they pay their dues, as long as they support the organisation. We all engage in commercial work, even those who think they are doing something for the human race. Anything that sells is commercial . . . I don't think any one of us does anything he doesn't want to do. I think that is the key. If we were forced to do

something, then I don't think we ought to be in the organisation, I think we ought to become employees. Some of my colleagues conceal their commercial work as if it were a mortal sin. I think that is pompous.

'There is of course friction. Any group enterprise will cause a lot of friction. I think if everybody decided to walk across the park one day there would be a terrible conflict. It is part of the package, something you cannot avoid. Not necessarily between big earners and small earners. You can be less productive financially but more productive in other ways. When people are not productive either artistically or financially, I think that is when it doesn't really work. But if people are considerate, or somewhat considerate, it is not that big a problem. We have had problems with people who somehow think the world owes them a living – we've even had that with some good photographers, but people are not perfect.'

Erwitt's avuncular forbearance did not, unfortunately, withstand the test of another defection the following year. In June 1982 Burk Uzzle resigned from Magnum after fifteen years as a member and took the trouble to write to Philip Jones Griffiths to explain his decision:

My regard for the cooperative aspect of Magnum, its traditions and its membership is enormous. It's been a big part of my life since 1967. In the spirit of my respect for all of you and my affection for Magnum, I very much hope to make clear the issues of my resignation, effective June 25, 1982.

The point of my life as a photographer is to do the best work of which I am capable. The point of the Magnum tradition has been to build a cooperative between friends that is dedicated to the finest work possible. I don't believe that membership of Magnum is now compatible with doing the work I want to do. I'd like to tell you why: quality of representation and cost.

The longer I'm a photographer the more I want things done in a certain way – representation specific to my work and needs. The longer I'm in Magnum and the larger and more generalised it gets the more I realise it can only loosely fit many different people. To give even vague and token representation to many areas costs Magnum a lot of money.

Magnum's enormous cost is not equally shared. Six or seven photographers pay more than half the cost, and there is no minimum share a photographer must contribute, their use of Magnum's facilities notwithstanding. Therefore, the percentage is very high. So high, in fact, that Magnum photographers often

cannot afford to work in the editorial market – its traditional home.

Magnum's concept of management doesn't help. While photographer direction is of the essence, photographer management turns out to be amateurish, erratic and inefficient. Any consensus with 28 or 30 vocal minorities is hesitant and often doubles back on itself. It's too large a business to try and be all things to all people and do it efficiently without professional management.

The demands upon leaders, especially presidents, can be cruel. It consumes time, can turn friend against friend, and is emotionally exhausting. To change the Paris kingdom into a bureau and find and restructure staff in a diabolical political environment, to live through the resignation of a member dedicated at the time to the destruction of Magnum, to find a new office, to try and rally enthusiasm and belief in Magnum, to explore marketing options, to negotiate contracts, to manage, to hold hands, and on and on, is a lot to ask of a working photographer. Moreover, I suspect it's neither in the nature of our breed, nor in our working patterns, to be management professionals.

After all these years and annual meetings, I simply no longer have any hope for meaningful change . . . I simply cannot afford Magnum's percentage. It doesn't give me the representation I need. To spend so much money on not solving problems uses up too much of my life.

Yet, Magnum always survives as members and staff come and go with increasing frequency. There is certainly something about the place – for me it's been the friendships that endure among some very wonderful and gifted people. Among the people on this earth that I love, quite a few are in Magnum. I'll always treasure my years in Magnum with its special people; I wish Magnum only the best and hope our friendships will endure.

Sincerely, Burk Uzzle

One might have imagined this to be a perfectly reasonable, indeed affectionate letter, but resignations provoke hot passions within Magnum and Uzzle's was no exception. Elliott Erwitt responded with fury, perhaps because Uzzle owed the agency around $100,000:

Your sudden resignation, considering your past and present financial history with Magnum, is outrageous, even criminal. I also think that the style and timing of your resignation, with notice to our clients before us, is swinish, to be charitable.

The content of your letter to Philip is muddled, self-serving,

dishonest and immoral, particularly in its omissions. It is destructive to the organisation, whether conscious or unconscious, especially to the new members and staff, who may be less aware of the history and subtleties of Magnum and its members.

You were not a member in good standing at the time of your tacky self-righteous resignation, but a fiscally irresponsible member supported by the decency and unity of the organisation you pissed on. Consequently, you have no right to speak of ideals and principles and of the morals of past and present members and employees . . .

Eve Arnold tried to pour oil on troubled waters with an open letter to members dated 23 June:

Dear Friends,
I know that some of you are pessimistic about Magnum and its future. As one of the ancients among you, I want to go on record as being optimistic. In a world in which many marriages do not last 30 years, we, this disparate assorted international lot, are on our way to our 35th year! The current crisis is an opportunity – nay a mandate – for us to examine ourselves, take stock and to define our goals as well as our needs and to make bold decisions.

We now have more young vital photographers than ever before – we have a middle group of seasoned photographers, and we have the elders – and each of us has our seemingly irreconcilable needs in our chosen field. Our potential is greater than ever and our differences are enormous – but we are survivors and we will survive.

I have seen in this past year a lack of trust and an increasing lack of friendship among us. On danger of sounding preachy I beg of you to listen to each other – and to consider each others' needs and to try to find a working formula that will be as thoughtful of the photographer who bills the least as of the one who bills the most . . .

Burt Glinn was more philosophical than his friend Elliott: 'Burk left because he owed $100,000 and thought he would never pay it off if he stayed. He left so that he could keep all the money he billed for and could pay back what he owed. And he did pay it back. People leave; it is like sand in an oyster, they get irritated by things. If people have a tie that binds them to Magnum it is above money, it is about the principles of photography, about what photographers can do and achieve.'

To some extent Uzzle's formal resignation at the 1982 annual meeting was overshadowed by an assignment. Word was passed to the meeting in Paris that *Life* magazine, recently resurrected in a

smaller format, wanted Magnum to cover the siege of Beirut as the invading Israeli Army approached the city. Eugene Richards, who was on his first trip abroad and had never covered a conflict, found himself, somewhat to his surprise, putting his hand up to volunteer. His friend Alex Webb, who also never thought of himself as a news photographer, followed suit. Everyone present at the meeting pooled equipment for them and they were given a highly charged emotional send-off. Susan Meiselas was in tears as she hugged them both.

'It was one of the most special times I can ever remember at Magnum,' Webb recalled. 'It was very, very emotionally wrenching. I still feel pangs about it.' Webb was born in San Francisco in 1952 and became interested in photography while still at college. In his sophomore year he took a workshop conducted first by Bruce Davidson then Charlie Harbutt, who suggested he should think about joining Magnum. But he never thought of himself as a 'jump on the next plane' news photographer, which was why he was so surprised to find himself on his way to the Lebanon with Eugene Richards.

'We went straight from the meeting and flew to Larnaca, then took a ferry to Beirut. I found the city overwhelming. It was very difficult to work, very dangerous and frightening. My job was to wander round getting atmosphere pictures. I had a couple of difficult situations with shells dropping too close. I felt frightened and exhilarated at the same time. That's the startling thing about photographing a war – the adrenalin high is very, very intense. I was scared but I was also very turned on in a certain way.'

Eugene Richards, born in Boston in 1944, was probably even less well qualified than his friend Alex Webb to go to Beirut. Richards's work was most often compared with that of Eugene Smith and Robert Frank, whose seminal book, *The Americans*, published in 1959, showed America as a drab country populated by alienated, lonely people and changed the way Americans looked at themselves. Richards's vision was similarly unflinching. He focused on the poor and the disadvantaged, the homeless and the sick. When he was invited to join Magnum in 1978 his photographer friends at home in Boston warned him not to do it, that Magnum was a 'can of worms' and he would be 'eaten alive'. 'But I thought, what the hell, no one has ever asked me to the party before, so why not?'

In 1982 Richards's partner, Dorothea Lynch, was dying of cancer. They had agreed that her struggle should be documented in words and pictures – a project that would become a moving book, *Exploding into Life*. At the time of the annual meeting Dorothea was very sick, another good reason for Richards not to go to Beirut, but

he still volunteered. 'My actual memory of that time is very precise because it meant a lot to me. I remember, first off, being wholly terrified at what I was about to do. I called Dorothea and told her that I was going to be away a little longer, but the nicest thing about the whole episode was that Josef Koudelka is such an enthusiast and was so pleased for me that as a parting gift he poured a bottle of champagne on my head, which was wonderful. It was one of the things I carried with me, it sort of lightened the load. I was very moved by the reaction of the other members. Some didn't think I was the right person and tried to persuade me to change my mind. I sensed that they were worried that I had only taken the job on because I wanted to prove myself, which I hadn't. They expressed their concern very affectionately and sincerely, and I was touched by that.

'It was a hysterical trip. I had all this borrowed equipment and I had to meet Alex at the airport in Paris. I got on the train and some children swiped my camera bag, just grabbed it as the train doors closed at some station. It was an inauspicious start. There I was, a member of the most prestigious agency in the world on the threshold of a major assignment, and I'd lost my camera bag. As it turned out, it was a prank, but I didn't know that at the time. I had no idea where I was and so I went to a gendarme and asked him if he could accompany me to find the station and he said no, so I went back to every station and there it was, still on the platform.

'I was really quite alarmed when I got to Beirut because I had none of the skills I needed. I had never learned any languages and I was completely ignorant about other cultures. I had no idea how to organise press accreditation, I didn't even know how to rent a car, so I just walked around. In retrospect, it is amazing that I survived, but walking got me a lot of access I wouldn't have got in a car, although I got arrested a couple of times. Once the Syrians picked me up because they couldn't believe anyone would do anything so stupid. They drove me back to the hotel and dropped me off in front of a French woman photographer. They told her I was being returned for safe-keeping and that I shouldn't be let out again because I didn't know how to take care of myself. She thought it was terribly funny.

'Another day a young Palestinian kid, probably high on drugs, dragged me behind a pile of rubble. I thought he was about to rob me, or possibly kill me, so I asked him if I could take his picture. He agreed so I took him out from behind the rubble and posed him in full view of a Palestinian guard post, whereupon the soldiers grabbed him and bludgeoned him with their clubs, for breaking the rules of not being photographed, while I was able to walk away.

'At one point the hotel fixed me up with a car and a driver, but he ran away when we were shelled so the hotel fired him and I was back walking again. I felt very inadequate a lot of the time. I would go back to the hotel and the other photographers would all be regaling each other with their war stories and they always seemed to be where the action was, or so I thought. I had no idea if I was doing a decent job, although it turned out I was. I was also freaked out by the poverty of the people in the fox holes and the fact that I came back to the hotel every evening to sit down to a nice French meal, with great wines. Whole sections of the press corps never left the hotel; the only casualty was someone who got drunk and fell into the swimming pool.

'Photographers reacted very differently to the job of covering war. There were those who saw it as an adventure and a string of photo-opportunities and there were those who were able to comprehend the tragedy that was unfolding in front of their cameras and it infused their work. My own fear about volunteering for the job was that I would not be able to find the "language" to cover such an experience and that I might fall back on clichés. In the end I don't think I did it justice.'

Chris Steele-Perkins, also in Beirut, was always ready with advice and help and when Richards got a message that Dorothea was close to the end and he needed urgently to get out of Beirut, Jim Nachtwey, not even a member of Magnum at that time, offered to drive him to the Israeli border.

Richards arrived back in New York in time to marry Dorothea, a few months before she died in hospital. 'I felt very guilty that I had been away at a war when I should have been at home with her. I suppose what I learned was that I could do that kind of work if I chose to, but I also derived from it a kind of strength that enabled me to finish the work I had started with Dorothea. After seeing the wasteful death and destruction of so many people and so much property, it made the death of a single person somehow more understandable.'

A year later, Eli Reed, Magnum's only black photographer, was in Beirut when suicide bombers attacked the peacekeeping headquarters, killing 241 US marines and 58 French paratroopers. Reed, a former staff photographer on the San Francisco *Examiner*, had only recently joined Magnum and was determined to make a name for himself. By the time he arrived at the scene, the army had decided that only a few photographers would be allowed inside. 'I knew I had to get in there, so I just slipped in with the group whose names had been read out. I pride myself on not being shocked by much,

but this was different – the place was flattened. I had been in the building a week before and suddenly it wasn't there any more. Everybody was in shock. I began photographing everything. They were digging, trying to get people out. They told us not to photograph dead bodies, but I didn't take any notice – this was history and I wasn't going to miss the least thing. The important thing is the work, the sense of responsibility. You felt sympathy of course, they could have been people that you knew, but there was no question of being able to help. I would have helped if I could, but there was nothing I could do. I worked there until quite late in the day when they said they thought they had spotted another bomb, so we all had to leave. I was wandering around outside when some guy came up to me and asked me if I was Eli Reed. I said I was and he said "OK, your film belongs to *Newsweek*." The New York office had done its stuff and sold my pictures on the assumption that I would be there.'

When James Nachtwey joined Magnum in 1986 he was already one of the best-known war photographers in the world and a man being spoken about in the same breath as Robert Capa. In fact he eventually won the Robert Capa Gold Medal, for foreign reporting requiring exceptional courage and enterprise, no less than four times. Born in Syracuse, New York in 1948 and politicised by the sixties, Nachtwey got interested in photography when he was struck by the huge discrepancy between what politicians were saying and the reality as depicted by photographers around the world. He taught himself photography while driving trucks at night and learned journalism when he got a job on the *Albuquerque Journal* in New Mexico.

In 1981, as a freelance photographer, he flew to Belfast to cover the political turmoil and violence that accompanied the IRA hunger strikes and found his *métier*. 'I was very excited by Northern Ireland, by the sense of witnessing history from the ground level, as it affected the lives of ordinary people. Ten days after I got back to New York, I was on a plane to Beirut and after that I deliberately sought out conflict as a subject.' Nachtwey moved from war to war around the world – in central America, the Middle East, Africa, Asia and Europe – and won his first Robert Capa medal in 1984 for his coverage of the Lebanon. In the middle of a battle in the Lebanon he was pinned down by Druse artillery behind two burnt-out APCs and raced to safety by timing the artillery waves and figuring out when the gunners had to pause to reload.

Nachtwey is unusual in his readiness to admit that while he believes in the social value of his work, he is also attracted by the

adventure and the danger, the adrenalin rush that comes with risk. 'Being under fire is not like anything else, it is a unique experience. I don't think there are any parallels that I've found. There is a certain excitement in being that close to the edge and still operating, doing a job under those conditions and I think perhaps, early on, you really want to test yourself to see what you'll do, how you'll react. It really never changes because you have to prove yourself every time. The willingness and ability to expose yourself to danger and continue to do your job, and to try and do it well, is a personal quality. It is not the same thing as being born with blue eyes; you never know if it is going to leave you, or if you are going to have it that day. There have been many times when I have gone to bed at night thinking I cannot face going out on the streets again next morning, but when the morning comes I have always done it.

'The risk of getting killed in journalism is simply part of the job. If you have convictions about being a journalist and you have convictions about the events you get involved in as a journalist, sometimes you are required to put your life on the line. You never want to do it recklessly. I have taken a lot of risks, I have had a lot of close calls, but I have never gone out there with sheer abandon and put myself in danger for the sake of it. It was always for the sake of trying to communicate something. I seem to be able to function reasonably well when there is a lot of stress and a lot of danger. I never feel invulnerable because I am behind a camera, never. I am astonished every time I hear someone say that. I don't think a camera protects you from anything. When you see shells falling, you see people going down from gunfire, shrapnel, how could anyone possibly feel that a camera is going to protect them? What really happens is, because you are concentrating so much on working, it takes your mind away from the danger. You have to make a decision yourself. What are you going to do? Are you going to protect yourself, or are you going to go out and expose yourself to get your job done? I think that the ratio between exposing yourself to danger and your sense of trying to accomplish your purpose is a very personal ratio and it differs for every individual and you cannot place a value judgement on it for anyone else.'

When Philip Jones Griffiths invited Nachtwey to submit a portfolio to Magnum in 1986 he did not hesitate. 'I had originally become a photographer, inspired to pick up a camera, because of the work done by Magnum photographers. I thought they upheld the highest traditions and I wanted to make a contribution. For me, the most important thing about Magnum was the challenge and

inspiration of the photographers, their commitment and their vision of the role of photography.'

Around the time that Nachtwey joined, Sebastião Salgado was deeply involved in his mammoth 'work' project, documenting the daily toil of life in developing nations. In 1986 he brought back to Paris an astonishing set of pictures taken in Brazil, in a crater lined by ant-like figures covered with mud, crawling up and down rickety ladders with bags of dirt to be sifted for gold. 'I first heard about the mine in 1980. Security was controlled by the federal police to prevent the gold going on to the black market and I applied several times for permission to visit the area but was always refused. In 1986 there was a change of regime at the mine, it became a co-operative, and I realised the moment had come to get in, so I took a commercial flight and hired a taxi, actually a pick-up truck, and just drove out there and got permission to work.

'I'll never forget when I came to the edge of this huge hole and looked down and saw those 50,000 guys working there. I tell you, the hair on the back of my neck stood up. All I could hear was the sound of their picks. It was an extraordinary moment, I never expected it to be like this. The instruments these guys were using to dig were completely primitive – no machines, no engines. When I saw, I thought, Jesus, Mary and Joseph, what is going on here? It was so incredible. They worked normally very early in the morning, 4.30 a.m., when the light was just dawning. It was necessary for me to make some technical decisions when I was shooting because there was a lot of dust, just before the rainy season, lots of clouds in the sky and not really any sun coming in and you have all this light over the clouds, but no shadows so it was very grey light and I had to push one stop my film. It was really very, very interesting.

'I stayed four weeks, living with the men in a hammock in the barracks. It was quite a violent environment, with lots of fights due to the lack of women and alcohol, and tension was very high. The nearest big town, Marabar, was about 180 kilometres away, but in those days there were no roads. The land on which the mine is located is partly owned by the Brazilian government and partly by a private company. The company is hated by the workers because they are so badly exploited and any strangers on the site are immediately thought to be company spies. When I first started to work there, very few people would speak to me because they were suspicious. But on the second day of shooting, one of the mine's policemen came up to me and said "Hey, foreign guy, what are you doing here?" I replied that I was not foreign, I was Brazilian. The cop refused to believe me and insisted on seeing my passport. When I

said I did not have it with me, he called a companion and grabbed hold of a chain and started swinging it menacingly. By then a crowd had started to gather, shouting insults at the policemen, who they hated. I was arrested and escorted away with a policeman carrying a machine-gun on either side of me, up the hill to the police station. The commandant, fortunately, was sensible, soon sorted it out and and freed me immediately. When I got back to the mine I was cheered and clapped by the miners and after that I was completely accepted.'

Iran was a big story throughout the 1980s and occupied much of the attention of Magnum photographers, including Jean Gaumy, a sprightly Frenchman who had applied to join in 1977 with considerable trepidation simply because he did not think he would be accepted. Gaumy visited Iran six or seven times over a four-year period. 'For me it was an opportunity to discover the true meaning of what Iran was, to be in a hot news place and really find out about it. I had listened to friends and colleagues at home, all of whom had an opinion on Iran, so my head was buzzing with received information, but when I got out there I knew I would have to find out the real story for myself. Abbas told me not to believe anything I read in the newspapers about Iran and he was perfectly right. I found it very exciting, discovering an entirely new and different way of life.'

In 1987 Magnum opened a third office, in London, largely at the instigation of Chris Steele-Perkins and Peter Marlow, two young photographers who lived in London and wanted representation closer to home than either Paris or New York. Steele-Perkins had worked as a photographer for a student newspaper while he was at the University of Newcastle upon Tyne. By the time he graduated with an honours degree in psychology he was hooked on photography and immediately started freelancing, soon moving to London, where he met Koudelka, who suggested he submit a portfolio to Magnum. He was accepted as a nominee in 1979, sailed through as an associate in 1981 and became a full member in 1983.

Peter Marlow was also a psychology graduate who turned to photography as a more interesting way of earning a living, even though he knew nothing about it. Backed up by a portfolio borrowed from a friend who was a wedding photographer, he persuaded Cunard to hire him as a photographer on a cruise ship. When he got on board he had to ask the other resident photographer how to focus his camera, but he survived for six months taking 'happy snaps', then joined Sygma and covered all manner of stories from doorstepping Princess Margaret to the revolution in Iran to the

race riots in Lewisham. He worked with Nachtwey and Don McCullin in the Lebanon and found them 'awesomely fearless', particularly Nachtwey. 'When Jim wanted to get a good spot for a picture in the face of Israeli artillery, I wanted to dive into a hole in the ground. It didn't take long for me to realise I didn't want to be a famous war photographer.'

Marlow had been friend and rival to Steele-Perkins for some time and when Steele-Perkins announced he was joining Magnum, Marlow immediately followed suit. At the first meeting he attended as a nominee in Paris, he was invited to drinks at Henri Cartier-Bresson's apartment. Josef Koudelka and Robert Doisneau were among the other guests and Marlow was overwhelmed. He can clearly remember sitting on the floor and Cartier-Bresson turning towards him to ask him what he was working on. 'I couldn't speak,' he recalls. 'I was completely choked.'

In 1982 he was accepted as an associate but he was rejected at his first attempt to become a full member. It was a huge blow. 'The meeting was in New York that year and I can remember Abbas and I were both being considered at the same time. We went to some awful movie on 42nd Street to try and pass the time while they were considering our fate. When we came out of the lift back in the office I knew it was bad news. I felt the vibes immediately. Abbas had got through but I hadn't. I was taken into the photographers' room by Chris [Steele-Perkins] who explained that they all thought I was wonderful, but that it was not the right moment for me to become a member and all that stuff. I said "OK, if that's the way you feel, bugger that, I'm bloody leaving!" Chris, to his credit, said "Fine, OK, leave!" and that sort of pulled me up a bit and I began to realise it was not quite the end of the world, although I was extremely upset about it, no doubt about that. There are always one or two photographers around who are helpful if someone wants to get their head sorted out and in my case it was Costa Manos, who was extremely kind to me. I can almost remember the conversation we had word for word, it was so caring and helpful. In the end I realised that what I had to do was not to try to please these people but try to do my own thing. That was what Magnum is about – promoting individuals, pushing people to be themselves.'

Marlow was still an associate when Steele-Perkins first mooted the idea of a London office. Both were enthusiastic, not least since neither of them got along particularly well with Magnum's London agent John Hillelson. After combing through the figures they concluded they could probably bill considerably more than the £20–30,000 being generated by Hillelson. The Paris office billed

fifty times that amount and both Marlow and Steele-Perkins felt London could match Paris, given the means. The British-based photographers, including George Rodger, who was by then retired, were all keen on the idea. When the proposal was put to the annual meeting in 1986 it was passed by a small majority.

The London branch of Magnum opened for business with only one member of staff, Neil Burgess, a filing cabinet, a computer, two telephone lines, a $25,000 line of credit from New York and a tiny office just off the Gray's Inn Road, behind the *Sunday Times* building. Burgess, who had been running a gallery in Liverpool, could be forgiven for having doubts about the prospects: when he looked over Steele-Perkins's projected figures for the London office's first year, he discovered the year had only three quarters instead of four. This notwithstanding, the office was more or less an instant success and never had to call on the credit line available in New York. Indeed, it was so successful that three years later Magnum opened a fourth office in Tokyo, providing, for the first time, a home base for the celebrated Japanese photographer Hiroshi Hamaya, who joined Magnum in 1960, and Hiroji Kubota, one of the few photographers in the world to be granted free access to China, who had been involved with Magnum since 1970.

In the year the London office opened, someone was eventually found to take charge of the Paris office, which had been without a bureau chief for some years. Richard Kalvar, as vice-president, had run the office, an experience he described as 'terrible'. 'I didn't know anything about running a business. When I took over we were losing money and I didn't know how to handle it, how to make us stop losing money, so I had to learn about running things, dealing with personnel, dealing with money. It was extremely onerous.' It was Kalvar who finally persuaded François Hebel, a personable Frenchman who was running the Arles festival of photographic arts, to take over as bureau chief.

Hebel thinks he was hired because the photographers believed he was young enough to be manipulated. They would soon discover they were wrong. 'When I arrived I found there was no fax machine, just telephones, a telex and an e-mail facility that only Jimmy Fox [who had moved to the Paris office from New York as 'editor-in-chief'] knew how to use. I realised a fax was vital and sent someone out to buy the cheapest one he could find, when suddenly Kalvar protested that it was a decision that needed to be discussed by the photographers. I just said "Fine, if that's how you feel I'll go back to my old job."

'Everything was really paralysed at Magnum at that time because

no action could be taken without talking to a significant group of photographers. In the eighties, when all the other agencies were expanding and making money, Magnum was going downhill and I could see no reason why Magnum had reached the state it was in, other than the fact that the photographers were running it. Magnum had this image of itself that was just paralysing everyday life. The principle was that Magnum had to remain Magnum, yet by remaining Magnum they were doing the opposite of what Capa did, which was to invent a new trick every day to keep Magnum alive.

'With the help of the other staff I tried to change the attitude to corporate work by getting Salgado, Koudelka and Gruyaert to photograph a big industrial complex, which was a wildly successful project and generated a lot more work. Magnum Paris had done corporate work before, but had been rather arrogant and offhand about it, insisting they didn't want that sort of work, but at the same time they wanted the money it could generate to invest in their own projects. I think there is a fundamental difference in approach between the New York and Paris offices. First of all, they are Anglo-Saxons and we are Mediterraneans; but not only that – we are also French and tend to be perceived as less businesslike and more intellectual. Magnum photographers are not more difficult to deal with; as human beings they are a little more irrational than others, but their irrationality is part of their strength. The London office was fortunate because it was created with no heritage of past bad habits.'

While the bombastic Philip Jones Griffiths was roundly accusing the Paris office of degenerating into nothing more than a commercial photographic agency, New York, too, was having its problems. In 1987 the office moved to Spring Street in SoHo, much against the wishes of Griffiths, who thought the agency should try and buy a property while the market was languishing. When Griffiths failed to get his way, he declared that he would never set foot in the new office and he never did, although he frequently asked other members what it was like. At the time the American vice-presidency was shared between Susan Meiselas, Alex Webb and Eugene Richards, an arrangement Richards described as a 'farce'. 'I was very embarrassed to be caught up in it, getting involved in all the internal politics and squabbles. Factions formed behind each of the three vice-presidents, causing resentment.'

The staff was also less than happy. Elizabeth Gallin, who had been hired in 1981 to run the library, was discovering that her job was impossible: every photographer had a different idea of which pictures should go into the library and the use to which they could be put. 'Some photographers treated you decently, but others treated you

like a piece of garbage. The one thing most staff members at Magnum will tell you is that you could never do enough for the organisation. You would work late on Thursday and Friday, then come in on Saturday and Sunday, too, but you would always be behind with the work.

'On Friday afternoons we'd get a six-pack of beer and some pretzels and sit down around a table in the library to discuss the week and what was going on. One time, before we moved to Spring Street, someone brought some hash cookies in and I unwittingly ate one and got into an argument with Philip Jones Griffiths and called him an arrogant bastard, whereupon he did not speak to me for two years.'

Gallin finally left when Gilles Peress angrily complained that his pictures of Salman Rushdie – the last to be taken before the fatwah – had been sold to *Newsweek* without a guaranteed fee. In front of all the other staff, he shouted at Gallin that she was running the library 'like a post office' and that it was not good enough. She resigned on the spot. Not long afterwards the New York editorial chief, Bob Dannin also resigned, thoroughly disillusioned. 'I loved the job, loved the excitement, but I didn't love the people, especially the photographers,' he said. 'Magnum is a kind of party, in the political, not the fun, sense, a bankrupt Communism, riddled with conspiracy, lack of resolve, cut-throat egotism, secrecy, character assassination and rumour-mongering, teetering on the edge of collapse from inefficiency.'

The year 1987 was, of course, Magnum's fortieth anniversary and should have been celebrated by the publication of a major book, but the project was bogged down in a welter of bitter disagreements. The idea of producing a book to mark the anniversary had first been mooted two years earlier but had immediately run into problems, largely because no one could agree on anything – what kind of book it should be, who should edit it, how the pictures should be selected, etcetera. Some photographers did not want their pictures to be displayed alongside those of other photographers they did not like; some wanted to have complete photo-essays included; everyone wanted more of their own pictures to be included than anyone else's. The New York office believed that Paris was trying to hijack the project; the Paris office believed that the New York office was trying to take over. 'It was another fiasco,' says Burt Glinn, who took over the presidency in 1987 and was thus heavily involved in trying to bring all the parties together.

At last it was decided that each photographer should supply fifty pictures and that the final selection would be left in the hands of the

venerable Robert Delpire, director of the Centre National de la Photographie in Paris. At this, Philip Jones Griffiths promptly washed his hands of the whole project, declared it to be corrupt and refused to allow any of his pictures to be included. 'All my worst fears were realised. We had a ludicrous situation. When the dummy was laid out, the New York photographers realised they had a very bad showing, so someone would jump on a plane and go to Paris and try to redress the situation, then return next day and say "Well, I couldn't do anything for you guys, but I got the number of my pictures up from four to ten." So another photographer would go to Paris the next day to try and do the same thing. In the end it became a horrible game to see who could get the greatest number of pictures in. It brought out the worst in us, I think, and I was glad not to have been a part of it.'

Meanwhile, Fred Ritchin, who had been commissioned to write an essay on the evolution of Magnum, had the temerity to mention that a question mark had been raised over Robert Capa's famous 'moment of death' picture. This, perhaps predictably, so enraged Cornell Capa that he lobbied for Ritchin's entire text to be dropped. Other photographers felt that Ritchin had not been sufficiently flattering and wanted changes in his manuscript, but some of the younger photographers heard what was going on and threatened to withdraw their material if Ritchin was censored. 'It was a very disillusioning experience,' says Ritchin. 'I was appalled at the bitchiness and in-fighting between the photographers, the sibling rivalry between people who had never really grown up and reached maturity. Perhaps the way photographers live and work stunts their emotional growth.'

Burt Glinn pacified Cornell Capa by persuading Ritchin to make a few minor changes to his text and to write a letter to Cornell to apologise for hurting his feelings. Meanwhile, Delpire's selection of pictures was causing tremendous heartache and Glinn was shuttling backwards and forwards across the Atlantic in a vain attempt to reach a consensus among the photographers. It was not easy: Bruce Davidson, for example, was demanding the same number of pictures in the book as Cartier-Bresson. Glinn finally got the dummy approved in Paris and carried it to London, where it was argued over for an entire day, then took it to New York. Final agreement – if such a word can be applied – was reached only after several conferences with open telephone lines between New York, Paris and London.

The result *In Our Time: The World As Seen By Magnum*

Photographers was published two years late, in 1989, and was hated by almost all the Magnum photographers.

Martine Franck, a member of the book committee, sent a memo to the New York office: 'All the photographers in Paris who have seen the 40th anniversary Magnum book are absolutely appalled by the atrocious colour printing and find it totally unacceptable.' The printing was eventually redone which shows, she said, what you can achieve 'if you shout loud enough'.

'Virtually everyone thought it was a disaster,' says David Hurn. 'If you discussed the book with fifteen other photographers, you wouldn't get two with the same opinion. In fact the miracle of *In Our Time* is not that it is good or bad but that it was put together at all.'

Unhappiest of all was George Rodger, who discovered that his involvement in the founding of Magnum had been dismissed in a couple of sentences and that he had, according to the text, 'remained in the wings' and 'refused all responsibility'. Neil Burgess wrote an angry letter to all Magnum members: 'Everyone here has been shocked and dismayed by the shabby way in which George Rodger is treated . . . something has gone seriously wrong and George at least deserves an explanation and an apology.' Burgess included a copy of George's report to stockholders in 1952, which made carefully considered proposals about the philosophy and future of Magnum, to show the extent of his involvement.

François Hebel was not surprised by the furore: 'Magnum photographers thought they were special and so they should act special. In fact, each of them is irrational. It was just a question of getting them together and explaining things and this was not done, so it was true that each of them was checking how many pictures the other had and on what topics. What is more natural for people who are ambitious, to try to be the best in their line? Then, also, it was a collective project. They are strong individuals; if you ask strong individuals to run a group they will panic.'

Ironically, despite the misgivings of the photographers, *In Our Time* was a big success in publishing terms. It made a profit of more than $200,000, remains in print and led to a string of other books and exhibitions, including *Magnum Cinema*, *A l'Est de Magnum* and *Magnum Landscapes*. 'I don't think there is any other agency in the world,' Martine Franck points out with some pride, 'whose members have published so many books and organised so many exhibitions.'

There is hardly a photographic institution in the world that does not have at least one copy of *In Our Time* and it is viewed as an

invaluable source of visual reference for its great number of memorable images which have become cultural icons. If there was a complaint from the public it was that the book comprised single pictures with no particular cohesion, rather than photographic themes in the manner of Magnum's classic photo-essays. One critic described the exhibition which accompanied the book at the midtown gallery of New York's International Center of Photography as 'a grotesque travesty – exactly the kind of decontextualised mish-mash of imagery the organisation's founders banded together to defend themselves against'. It was a three-ring circus with something for everybody, ponderous and trivial 'like a Barnum elephant in a tutu'.[2]

By this time Magnum photographers had moved on to another internecine dispute involving the morals and ethics of the agency – whether or not they should participate in a book project on a 'day in the life' of China. The 'day in the life' photographic books had been an enormous success but were generally regarded with suspicion by Magnum photographers as nothing more than public relations exercises designed to promote the country concerned. This was particularly true of 'A Day in the Life of China', which was sponsored by Kodak, a company hoping to build a large factory in China.

Under normal circumstances Magnum would have had no difficulty turning down an offer to participate, but the opportunity of getting into China was very tempting, although some photographers argued strongly that they should only take part if they were allowed to cover subjects like human rights and Tibet. 'I think that is completely stupid,' says Sebastião Salgado. 'Before A Day In The Life of China there was A Day In The Life of the Soviet Union and I was the only photographer from Magnum who went. Nobody wanted to go, so I went. As far as I'm concerned, that doesn't matter. I think we have to get away from this idealising of Magnum; it is not a monastery, nor is it a military academy, there are no set rules to tell people what they must and must not do. I think there has only ever been one rule guiding Magnum and that is the rule of anarchy – it is because of this anarchy we have been able to do so many things.'[3]

Abbas agrees: 'If as a journalist you feel strongly about something, sometimes you have to get your hands dirty. I got my hands dirty in Iran many times. It did not mean I had to compromise. If you wanted to get into one of those bloody trials you had to smile at an ayatollah. You knew he was a bastard and you wanted to kill him, but you smiled at him to get in there.'[4]

In the end seven photographers decided to go, although it was not

a great success, largely because of restrictions imposed by Chinese 'minders.' René Burri and Abbas returned home via Beijing and observed the student demonstrations in Tiananmen Square but decided that it was not worth staying to see what transpired. 'The first day, it didn't look all that credible,' says Abbas. 'I thought, well, it's China, Mao's country, so I personally did not believe too much in the students' movement. But the second day, when I saw them writing slogans, putting up flags, etcetera, suddenly it was like Iran, like Poland at the beginning of the revolution – people wanting freedom, writing things, getting courage. I should have stayed but I left after the last march because there was a consensus among journalists that with Gorbachev coming [Gorbachev was due to visit Chinese leader Deng Xiaoping on 15 May 1989] things would quieten down. In fact, I left three days too early. Then it started all over again and I have been regretting it ever since.'[5]

Another Magnum photographer, Patrick Zachmann, was in China working on a personal project on the Chinese diaspora and he photographed all the vital events leading up to Tiananmen Square. His presence generated great excitement in the Paris office, where François Hebel mobilised a team which worked day and night to edit, process and market Zachmann's pictures. Even Henri Cartier-Bresson, the agency's oldest 'China hand', came in to help with the editing. Zachmann, who never considered himself to be a 'front-line' photographer, eventually left when Stuart Franklin, from the London office, arrived in Beijing.

Franklin stayed to cover the horrific events of June, when Chinese troops moved into Tiananmen Square to crush the student uprising, and took what would become one of the most famous images of the decade – the lone student standing in front of a column of tanks and blocking their advance into the square. He was staying in a hotel overlooking the square, which had been cordoned off on the day after the troops moved in. 'No one was allowed on to the street so we went up on to a balcony, two or three floors up, to work from there. We could see a bit of the square and Tiananmen Avenue very clearly and we could see the army had taken over the square completely. I photographed what I could. I had already seen students being dispersed by soldiers, then the tanks began to move out of the square and a young man from the hotel side of the road suddenly jumped out in front of them and started a conversation with the tank driver and then climbed on top of the tank. Then some friends or colleagues came out from the side of the road and pulled him away and he disappeared in the crowd and the tanks moved off. All this

happened within a few minutes. I had no sense of this being an important picture.

'I packed my film in a packet of tea and gave it to a woman attached to a French television crew who was leaving for Paris, and it arrived safely. I felt in a way my picture was less important than the manner in which the student demonstration had been represented in the press. It was seen as a violent demonstration against Chinese authority. In fact it was one of the most non-violent demonstrations I have ever seen, considering what they were up against. I felt that somehow I wanted to get across the sense that this wasn't an ordinary event, that this wasn't an ordinary demonstration, that this was a significant act of defiance.'

Marc Riboud was also in China at that time and had photographed the early student demonstrations before continuing on his travels. 'I was visiting a mine that had been sunk by the British in the nineteenth century. I had more or less just spotted it while I was driving past in a car. I had wanted to see a modern mine but couldn't get permission so went back to this old mine. The manager and workers had seemed very friendly and smiling; I was invited to lunch and told that I could photograph. The machinery was very old; the most sophisticated and modern piece of equipment they had was a kind of two-headed shovel contraption. I spent the afternoon taking photographs until the police arrived in a jeep and hustled me back to the office, where I was told I was under arrest for industrial espionage! I was then interrogated and asked to show my papers and there was lots of telephoning back and forth and lots of people coming in and out. They threatened to take away my interpreter's ID, which would effectively have ruined his future – without an ID he would not even have been able to take a train journey. They wanted to take away my passport but I insisted that it was the property of the French government and if they kept it, it would cause a diplomatic incident and they would be responsible.

'I was very nervous that they would telephone Beijing and discover that I was one of the photographers who had helped publicise the scandal of Tiananmen Square. We sat around for what seemed like hours awaiting developments. There was a large machine-gun in the corner of the room and I joked with the interpreter that I hoped they weren't going to use it on us, but he didn't seem to think it was very funny. Then I remembered I still had a photograph of myself shaking hands with Prime Minister Chou En-lai. I produced it for the police and my interpreter explained that I was a friend of the prime minister, although they didn't seem too impressed and remained adamant that I should not

have been at the mine. But then they saw my plane ticket to Shanghai in my wallet. I don't suppose they had ever seen a plane ticket, never mind been on a plane, and in China the custom is that if you don't give three or four days' notice before cancelling a plane ticket, you forfeit it. I suddenly thought that this might have an effect so I waved my plane ticket and warned them that if I missed the flight they would be held financially responsible. One of them took the plane ticket to his superior in another office and three minutes later he was back, telling us we could leave. Money is very important in China and they were afraid they would have to pay for the plane ticket. We shook hands on it and I said that since we were now friends I should take some pictures of them, which I did, with the machine-gun prominently in the background! Lieu, my interpreter, was really anxious to get away by then, so we left.'

In March 1990 the 'In Our Time' exhibition opened to critical acclaim at the Hayward Gallery in London, with posters from the 1988 annual meeting in Paris showing everyone present covering their faces with their hands, perhaps gently ribbing Cartier-Bresson's famous disinclination to be photographed himself. The *Sunday Times* art critic, Marina Vaizey, while enthralled, raised a question that constantly troubles the photographers themselves: 'Have these starving people, these slum dwellers, these prostitutes and the insane, given their consent for their plight to be shown not just as news, but in an art gallery? It is a curious thing that somehow, in these hundreds of photographs, almost all of which are concerned with the human condition, the terrible is so gorgeously memorable.'[6]

Photographers find themselves on the trickiest ground when trying to defend themselves against charges of exploitation. Cynics say that Sebastião Salgado made more money from his Brazilian goldmine pictures in a month than all the hundreds of miners will ever make, collectively, in their lives. Salgado makes no apologies. 'I don't have problems with my conscience that I photograph people who are starving, that I photograph people who are poor or people from the Third World. I am not responsible for them, it is not me that made them poor, not me that exploits them. I believe photography must deal with these problems in a way that provokes a discussion, that makes people realise that the rich countries are dividing the world up among themselves.'

Jim Nachtwey says covering war is justified because it keeps communication open at a time when all other forms of communication have broken down. 'I take the side of the people caught up in the middle. From the beginning that is where I wanted to photograph, but the enduring reason for doing it is to communicate.

The bottom line in war is death and mutilation and if people don't understand that about it I think it is impossible to understand anything else about it.'

'It is incredibly important to be a witness,' says Alex Webb, 'but at times I sometimes wonder, well, we've seen so many pictures of dead bodies, what does it mean to society at large? I'm sceptical of too much posturing on the part of photographers about what their pictures are going to do. All those pictures of dead Rwandans, for example, maybe they just encourage certain racist attitudes towards Africa. I am not saying by any means that one shouldn't be a witness to these, but it is important sometimes to think about what the act of witnessing actually means.'

STEVE MCCURRY talking in his apartment in New York: 'I was born in Philadelphia in 1950 and started work as a photographer on a newspaper in 1975 after I had graduated from Penn State. When I started seriously thinking about joining an agency, there was really only one, and that was Magnum. It not only encompassed the whole history of photography, it had produced the work I most admired, so I decided to go for the best.

'I've never really thought of myself as a war photographer, but I have often found myself covering wars. I guess I've been to Afghanistan sixteen times. The first time I was hanging out in north Pakistan, freelancing, no particular assignment, and I met some refugees who told me about this war that was raging just over the other side of the mountains. They said I should get over there and tell their story to the world. They agreed to take me over the mountains. I dressed as a Mujahedeen and they told me to pretend to be a deaf-mute if we were stopped. The Afghans had quite fair complexions so it was easy to disguise myself. It took three days to cross the mountains, walking at night. They stopped only to pray. Once I had done the trip a few times it got easier, although it was sometimes difficult to get back into Pakistan because I had crossed the border illegally. Twice I was arrested. I think they didn't know what to make of this American dressed as an Afghan, filthy and unshaven; they thought I might be a spy or a gun-runner. The second time I was held for five days and shackled by the legs, even though I had not tried to escape. I had to pay the jailer to get food and was very nervous that I would be deported, but in the end they just let me go.

'Once I was with a group of Mujahedeen who had overrun a Russian base and were using it themselves. After three days there, a plane flew over at night and dropped a bomb no more than fifty feet from where we were sleeping in the old barracks. The blast was so great that it not only blew the windows in, but the frames too, filling the room with dust and smoke. I stayed with the Mujahedeen all the time; I was sympathetic to their cause and found them very friendly and relaxed. Going into Afghanistan was like going back into the medieval past; once you were there, there was no sense of the outside world. One time I got so sick I had to be brought out on horseback. It took three days; I really thought I wasn't going to make it out alive.

'Once I was in a hotel in Kabul and at two o'clock in the morning there was a knock on the door and someone shouting "Control! Control!" I shouted back "UN! UN!", but whoever was outside tried to open my door. I got up, dressed and turned the light on. I didn't open

the door but then saw that someone was using a bayonet to cut open the screen over my window. I realised the only thing I could do was let them in and on no account piss them off because otherwise they would shoot me. At that time there was a lot of shooting at night, so a couple more shots wouldn't make any difference. I opened the door and two Afghans came in and ordered me to go into the bathroom while they went through my things. They both had AK47s, so I was resigned to the loss. They took one of my bags and started piling stuff into it – my radio, sleeping bag, some of my camera equipment – and then took off. Luckily I had hidden most of the cameras, exposed film, travellers' cheques and passport the night before, so they didn't get that. I took what was left and hid it behind a pipe in a kind of boiler room with trash cans. Then I left the hotel to get help. When I finally got back to my room it had been robbed again – somebody had seen me leave and had really cleaned the place out.

'On another occasion I was with a group of Mujahedeen and we had been driven up into the hills after a pre-dawn raid by the army. There was no food, no water, no cover, just bare rocks. We were there for three days. On the third night we tried to go down into the village to get some supplies but it was encircled by tanks with flares going up periodically, so we were forced literally to crawl on our bellies between the tanks at one o'clock in the morning. Then someone dropped their rifle, it made a hell of a noise and the tanks just started firing wildly into the night towards the sound. We just got up and legged it across open terrain with flares lighting up the whole valley. I realised then that I was totally helpless: I didn't know where I was, I couldn't communicate with anyone as no one spoke English, I was totally on my own in that hostile place. The following afternoon, the tanks withdrew from the village and I headed back to Pakistan, about two and a half days' walk away. I was stunned by the Keystone Cops nature of these so-called fierce Afghani fighters, who would light up cigarettes in the dark and do all manner of bungling stuff.

'They never really understood why I was there. One day we were under intense mortar and artillery fire and there were guys dropping like flies all over the place. I was behind the wall of a house, there were twenty Afghans lined up against this wall and they were scared to death. I was, too, but I thought to myself "I'm here to work, regardless of how dangerous it is. There is no point being here unless I am working." There was a dead Afghan and they were dragging him up the trail by his legs and to me it just sort of summed up the whole craziness of war, so I jumped over a stream and ran over and started taking pictures. This other Afghan, crazed because

this was probably his friend, picked up a rock and he is standing about three inches from my face, hatred in his eyes and he wants to just bash my head in with it and our eyes connect and I try to explain, with my expression, that I am not here to belittle what you are doing, this isn't a lark, I'm trying to show your struggle, your dedication, your belief in the freedom for your country. The guy didn't bash my brains in, but he came within an inch of it.'

13

On the Road to a Half-Century

STEVE MCCURRY thought he might have been forgiven if the portfolio he presented to the annual meeting in June 1989 to attain full membership was not quite up to scratch. A few weeks earlier he had nearly been killed in an air crash and almost lost his sight because of a detached retina. The time he planned to work on his portfolio he was lying face down on a hospital bed and he was still wearing an eye patch at the time of the meeting. No one was sympathetic. He was told his pictures were not good enough.

'Yeah I was resentful,' he admits. 'I felt I had put my ass on the line. They could have just said "Look, wait another year." Instead there was this big dramatic thing about my portfolio not being strong enough.'

McCurry had been on assignment in Yugoslavia for *National Geographic* and wanted to get some aerial pictures. Unable to get government permission to hire a helicopter, he decided to try a microlight, a little two-seater with an open cockpit. 'I wasn't sure if the vibration would be bearable, or if the wings would get in the way, so the pilot offered to fly me round a lake near Ljubljana to try it out. We had circled an island in the lake, where there were some tourists, and were on our way back to the airport when he decided he wanted to skim the surface, either to impress me or the tourists. I pointed upwards with my finger because I wanted height to take pictures and as I did so the wheels of the ultra-light caught the water. I thought "Oh shit, we're not going to be able to recover, we can't pull out and I don't know how to release these seat belts. This is it, I'm going to die." So the wheels go in deeper and deeper and deeper, then the fuselage hits, all in the space of seconds: the propeller explodes, we flip upside down and I hit the windshield. Suddenly, I'm underwater, I can't see. I had a helmet on, a winter jacket, a seat belt and two shoulder straps. I'm upside down and I am

aware the pilot has got out and swum to the surface. I wanted to breathe, I tried to breathe, but remembered no, you can't breathe because you're in the water, and my body and mind sort of went on automatic pilot. The plane was sinking all the time and there was no air bubble because it was an open cockpit. I somehow slid out from under the seat belts, feet first, but then got caught by my helmet. I ripped it off – when they found it next day, the chin strap was still connected – and started swimming for the surface. I don't know how I knew which way was up since the water was cloudy with sediment and I was weighed down by shoes and this big winter parka. When I got to the surface I saw the pilot was already swimming away, but my only interest was in self-preservation at that point. I started swimming towards the nearest piece of land and after about ten minutes I got picked up by a boat and then taken to hospital. I was all black and blue and had to stay there for four days.

'I had lost a couple of cameras and I had $4,000 in $100 bills and my passport in a fanny pack that I had had to rip off to get out. I didn't bother to tell the salvage people to look for my pack because I figured as soon as I told them there was money in it, they would nick it. It was amazing. When they pulled the microlight out of the lake, my seat belt and shoulder straps were still fastened; no one could figure out how I had got out. It was as if I had dematerialised. And they found my fanny pack behind the seat, still with all the money in it.'

A year later McCurry was back at work for *National Geographic* on a rather different assignment – covering the environmental impact of the Gulf War. He was with a US Army tank regiment in the second wave which crossed the Iraq border. In Kuwait he met up with Bruno Barbey and they shared a room in a hotel full of journalists which had no water, no electricity and, curiously, no doors to any of the rooms. 'We were told the doors had all been stolen by the Iraqi soldiers. It was like living in a little cave in the city. Photographically, it was like being on another planet. There were fires shooting up into the air making a terrific noise like jet engines and the ground was black. Occasionally you would run across an animal like a horse or a camel, but otherwise it was empty of all humanity, like a lost world, a forsaken landscape at the end of the world, with only an odd animal on its last legs, drifting among the empty buildings. Sometimes you would come across dead bodies, preserved in oil, very weird. There was a fine mist of oil everywhere. I had to put plastic bags over my shoes to prevent them becoming caked in oil and wash my car every night with kerosene. At the end of each day I threw all my clothes away. I was appalled by the impact on the

environment and felt it was important to document it. It was a historic time, a perfect combination of history and visual potential coming together.'

After McCurry and Barbey had been in Kuwait for a week, Abbas showed up, followed some time later by Sebastião Salgado. They all tended to work independently during the day; at one point Barbey and McCurry took almost identical pictures of a group of camels foraging for food against a background of burning oil wells, even though they were working quite separately.

Salgado, on assignment for the *New York Times*, concentrated on the burning wells. 'It was probably the most fantastic place I have ever shot a story in my life. You had all these oil wells burning, hundreds of them, and the whole world was covered in black and all this fire going on. I borrowed some protective clothes from Steve McCurry because I got covered in oil every day. I kept a two-litre bottle of petrol with me all the time to clean my cameras and my face and hands. It was very dangerous because there were a lot of weapons and unexploded mines lying around. While I was there two journalists burned to death when their car was crossing a lake of oil and caught fire. Yes, it was very dangerous and at the same time very weird. It was like working in a huge theatre. Some days, when there was no wind, the smoke shut out the light and it was completely dark all day and my light meter would not work.

'I had a car, a four-wheel-drive from Saudi Arabia, and I worked alone and sometimes I thought "My God, if I break down here, I'm dead." One day I came across a large walled garden. The doors were chained, but I broke through them with my car and inside I found a whole collection of animals – horses driven crazy by the fumes and birds covered in oil. It turned out to be a royal garden, but it was the very reverse of paradise. I also found the body of a soldier, burned to death, who had clearly been on guard. I went back next day and buried him.'

While McCurry, Abbas, Barbey and Salgado were toiling in Kuwait in the heroic Magnum tradition, a wonderful row was brewing in New York, also entirely in the Magnum tradition, although considerably less heroic. Gilles Peress had been given an assignment by *National Geographic* to photograph in the footsteps of Simón Bolívar, the soldier-statesman who liberated much of Latin America from Spanish rule. It was unusual for Peress to be given such an assignment and unusual for him to accept. Magnum's New York office clinched a deal for Peress at $400 a day. Many weeks passed, with the editors at *National Geographic* becoming increasingly anxious about the time the assignment was taking and Peress

constantly pleading for more time. When the exasperated editors inquired how much longer they would have to wait, Peress said he needed another six weeks because while he had travelled all over Latin America he had not yet been to Bolivia, the country named after Bolívar!

'*National Geographic* were furious and killed the story,' says Neil Burgess, who would soon be running the New York office. 'Gilles had used 1,600 rolls of film and billed the magazine for $40,000 for film alone. I think they probably could have salvaged the story, but they wanted to make an example of him.'

National Geographic rejected Peress's pictures as 'too complex and disturbing' and although Peress was distraught, the matter would almost certainly have ended there had not the magazine decided to try and resurrect the story with another Magnum photographer, the mild-mannered Stuart Franklin.

At first Franklin resisted the idea because he was aware it would cause trouble within Magnum. Although it was not unusual for one Magnum photographer to re-shoot a story done by a colleague, particularly for a demanding client like *National Geographic,* no one could remember the prickly Peress being involved in such an arrangement. When *National Geographic* asked Franklin to reconsider, he said he would have to talk to Peress first. The magazine said that they would straighten it out with Peress. Next day Franklin got a call from the New York office to say that Peress was unhappy, even though at that stage Franklin still had not agreed to accept the assignment. Franklin telephoned Peress, who was in Caracas, to try and placate him, but he would not be mollified. 'The whole thing was pretty ugly. He waxed on about feeling betrayed by Magnum, suggesting that I had put myself between him and the magazine. He did not take it, in my view, with any degree of maturity and seemed to want to make a martyr out of himself.'

By the time Franklin had put the telephone down he had more or less decided to take the assignment, but first he sought the views of other Magnum colleagues. The majority in the London office thought he should go ahead; Paris was largely opposed and New York was ambivalent.

In September 1991 Patrick Zachmann, Harry Gruyaert and Abbas wrote a joint letter pleading with Franklin to reconsider: 'We are shocked by your decision to reshoot Gilles' story for *National Geographic* but we still hope it is not too late to change your mind and that you will be sensitive to our arguments . . .' It was, they said, a question of 'principle and ethic' and 'unbelievable' that a Magnum photographer would agree to reshoot a story already done by

another Magnum photographer without his agreement. It affected the unity and solidarity of Magnum as a whole. Peress was still prepared to fight to have his pictures used and Franklin's action would weaken his hand. 'Maybe,' the letter concluded, 'you can think it over.'

Actually, Franklin had thought it over, and the more he thought it over the less reasonable it seemed to him that Magnum should refuse an assignment simply to avoid upsetting Peress. He told *National Geographic* he would do the job and carried it out to their entire satisfaction. When the story was published, only Franklin's pictures were used.

Although Peress subsequently claimed that his argument had always been with *National Geographic* rather than with Magnum or Franklin, in an interview in a photographic magazine he said he felt he had been 'betrayed'. 'To be honest, he's been bloody awful about it,' says Franklin. 'It has caused a great deal of tension but I don't have any regrets. I thought what I did was right and I still do. I have tried to effect a rapport through the bureau chiefs but Gilles has not responded. I just have to live with it.'

In June 1992 another bombshell rocked Magnum. Sebastião Salgado, perhaps the agency's most highly regarded photo-journalist of the younger generation and certainly one of its biggest earners, announced, out of the blue, that he was resigning. In a letter to his fellow photographers, he explained he was not in agreement with the way the agency was evolving. 'I am deeply sorry to lose the privileged relationship with you all . . . This break will deeply affect my life and I sincerely hope that our friendship will continue for ever. I am very sorry to leave you in this difficult moment but I cannot deal with this any longer.'

'If I stay,' he added with a touch of high drama, 'I die.'

The cynical view, widely expressed behind his back, was that he had become just too successful and that money was at the heart of his disaffection. He was contributing something like $200,000 to Magnum every year in commission – and for that sum he could easily afford his own, dedicated back-up organisation to service his requirements rather than sharing facilities with a lot of other, far less successful, photographers.

There was something akin to panic at Magnum at the prospect of losing Salgado. 'Magnum divorces,' says Abbas, 'are very, very emotional and painful.' A procession of photographers, including George Rodger and Cartier-Bresson, trooped to Salgado's door to try and persuade him to change his mind. It was agreed that a special emergency meeting would be held in December at which Salgado

would be given the opportunity to air his grievances; in the interim he withdrew his resignation.

Salgado arrived at the emergency meeting with a breathtaking set of proposals. First, he said he could no longer work with François Hebel as the bureau chief and he wanted him either fired or moved to a lesser job; second, he had a number of ideas for re-capitalising the agency, among them a suggestion that members should contribute $15,000 each to modernise the organisation; third, he proposed a radical restructuring of the agency, with groups of photographers getting together and employing their own staff and reducing the existing organisation to nothing more than an archive. The atmosphere of the meeting was already highly charged. Franklin recalls that Peress refused to enter the room because he was present (Peress denies this). Abbas was making dark accusations that Salgado was 'blackmailing' them, but after Salgado had said his piece the debate became extremely heated. At one point Salgado announced that he was walking out, but Cartier-Bresson jumped up, jammed his chair under the handle of the door and said 'Oh no you're not!'

At the end of the meeting Salgado claims he was left with the impression that there was substantial agreement with his ideas and that formal proposals would be ratified at the annual meeting in 1993. He was unable to attend that year, because he was in Brazil, but when he got back to Paris he discovered that most of his proposals had been ignored and his *bête noire*, François Hebel, had not been sacked. Salgado concluded that a *coup d'état* had been mounted, probably led by his great rival, Abbas, and once more resigned. Ian Berry made a final attempt to keep Salgado in the fold, persuading him to attend the annual meeting in London in 1994, but by then the members were beginning to lose patience. Salgado showed up with his wife, spoke with considerable emotion about all the things he thought were wrong with the agency and then sat down, expecting perhaps some response. Instead, Abbas simply said 'OK, that's it, let's get on with the meeting.' Salgado and his wife promptly walked out without another word, closely followed by a furious Ian Berry, who drove them straight to the airport.

Hebel never understood the source of Salgado's antagonism towards him, particularly as the Paris office had sold Salgado's 'work' project very successfully and Hebel personally negotiated unprecedented fees for corporate assignments on the Brazilian's behalf. 'Only Salgado has the answer,' Hebel says. 'He told me himself that a few days before I arrived at Magnum in 1987 he came at night to the office with a Brazilian wizard to remove the spell linked to my arrival.'

Berry, like Salgado, was also concerned about the direction of Magnum, but more by the fact that 'artists' were tending to take over from photo-journalists. 'The point came in Paris where we had more photographers who regarded themselves as artists, than who thought of themselves as photographers. It effected a major change in the style of running the office, away from editorial. It was very divisive, since there were still a lot of photographers who were interested in documentary photography, but the so-called art photographers wanted to try and dictate the way the offices are run, bringing in people who don't even pretend to be photo-journalists and don't really have much to do with us. It has led to a gradual erosion of Magnum's early principles.'

Elliott Erwitt was similarly concerned, partly because he felt his son, Misha, who had been a nominee for a couple of years, had been unceremoniously bounced out of the agency by the 'artists', many of whom he did not think were up to his son's standard as a photographer. 'I felt it was a dumb show of toughness. For me and my son it was a painful and unnecessary hit which still rankles.' Erwitt requested a change of status from member to 'contributor', more of an honorary position, but was persuaded to withdraw his request after a fax from Cartier-Bresson. Nevertheless, he decided to distribute what he described as his *pensée* just the same:

I love and respect many wonderful people in Magnum. Especially our really extraordinary, if weatherbeaten, worldwide staff. I feel a deep fraternity with some, in fact with many of our tenured members and hopeful petitioners, but I find it increasingly difficult and unpleasant to bear the hard-nosed righteousness of our self-anointed 'artists', i.e. the guardians of our flames who permeate the atmosphere and who have changed the character and texture of the 'human' Magnum of old.

This is a new time and so the joint belongs to the newer people . . . and to the majority, for better or worse. That's the way it is. That's the way it should be. If we get lucky, a flash of wisdom will enlighten our 'artists' and the zealots will not run our tattered spirit further into the ground or dissipate the humanity that in my view now lies only dormant within it. Our basic ideals *may* survive the tantrums, jealousies, past mismanagement, the changing marketplace and our current recession because Magnum was fundamentally based on great notions, humanistic scruples that have endured much adversity and tragedy in the past nearly fifty years. I sincerely hope we survive.

Fellow member Thomas Hoepker replied with a plea not to produce yet more splits: 'There still are, Elliott, idealism, "humanistic scruples" and even warmth in this crazy group and that makes me, for one, happy to be part of it – in this otherwise cold-nosed and totally cynical world of our profession . . . I feel there is much too much "us versus them" in our crowd, like us photographers – them staff, us New York – them Paris, us virtuous self-assigned versus them corrupted *National Geographic* slaves. Let's not add a "them artists versus us reporters" to this hate-list. I think all that counts is that we all take good and honest snaps. There are many different ways and many different styles to do that, but certainly not just one correct way where everybody else is a dirty compromiser . . .'

Towards the end of 1992 Tom Keller, the editorial director at Black Star, was approached to take over running the New York office. It was, he recalls, a bizarre experience. As well as being interviewed by the outgoing Neil Burgess several times, he was also interviewed by a number of the photographers. Sometimes he was asked to call them; sometimes they called him. Susan Meiselas wanted him to go down to her loft in the middle of the night. Nick Nichols was supposed to interview Keller with Alex Webb but didn't want Webb to know that he was talking to Keller in private, so arranged to meet Keller on the corner of 68th Street and Lexington. They then took a cab together to the Magnum office but Nichols insisted on getting out before they arrived so that no one would know they had been together. In the office, Gilles Peress walked by the conference room, saw Tom Keller inside, then went out and telephoned from a pay phone in the street to find out what was going on.

There was by no means a consensus that the job should go to Keller; indeed he had the distinct impression that he only got the job because they couldn't find anyone else to take it. He discovered when he arrived that Magnum was split into camps, divided in every imaginable way – by age, background, interests, political commitment and photographic approach. The most glaring division was between those who made money and those who did not, those working in the Capa tradition of photo-journalism and those who considered themselves artists. The only thing they all agreed on, said Keller, was that they were all brilliant, and in a way they were. What united them was a belief that they were better than other photographers and that they cared more about their work than other photographers. The archive was arguably the most interesting set of photographs accumulated anywhere in the world because it

was vetted; photographers only put in the work they thought was worthwhile, which gave the archive extraordinary integrity.

Keller says he found the staff to be extremely demoralised, without proper supervision. Part of the ethos of Magnum was that photographers came in and told staff what they wanted done and how they wanted it done and then another photographer would come in and tell them to do things quite differently. The office on Spring Street was a beautiful space in SoHo, on the twelfth floor, with unobstructed northern views and wonderful light, but it was like a giant fraternity house, with people meandering around and holding slides up to the window. There was no unified marketing effort, no ability or desire to collate material or track finances. No one was held accountable for anything.

Keller's first idea was to try to organise an assignment covering Clinton's first 100 days in office, similar to Cornell Capa's project with Kennedy. He got thirteen photographers on the job, including Chris Steele-Perkins from London and Martine Franck from Paris. 'I tried to organise it as a group of photo-journalists on a major project. That was the first mistake. They defied organisation.' Photographers jockeyed for position and for better assignments, tried to wriggle out of assignments they didn't fancy and complained constantly. Much of the argument was personal and vituperative and put Keller off the idea of ever doing a group project again.

The problem, he concluded, was that Magnum members did not understand the responsibilities of ownership, did not understand that they could not exercise total control. He compared it to shareholders of American Airlines getting on a plane and instructing the pilot where to fly. The problems were exacerbated in New York by the fact that the photographers did not get on well with each other; each one wanted to be at the head of the line for the best services from the office, the best treatment. Keller tried to reason with the photographers, but, he claims, reason did not prevail.

If Keller's job was solely to make photographers happy in order to keep them productive, he says that's what he would have done. But he was told he had to protect the assets, be even-handed and professional, and build up the finances – an impossible task since total control was vested in the photographers, making management untenable. Keller soon realised it was a myth that there was a pool of money to finance any project that took a photographer's fancy, so was reluctant to encourage people to do work that would not produce income. 'There was simply not enough money available for photographers to do their own thing. They could produce interesting pictures, but whether the world wanted those pictures

and how long it would take to repay the costs was really the issue. It was all very well that the photography you practised was of great interest to you personally, but it was still supposed to be a business. What happened was that they were bringing in people who were commercial non-starters and then blaming the staff for not being able to sell their work.'

Not long after being appointed, Keller had a serious falling out with Gilles Peress. It started with a shouting match in front of the staff in the New York office when Keller asked for more participation from Peress in explaining his projects and ended with Keller throwing up his hands and saying he could no longer represent Peress. Peress chose to believe that he had been 'effectively fired' and announced to all and sundry that he was no longer represented by the New York office. Keller quickly realised that he had gone too far, wrote a letter apologising to Peress, telephoned to congratulate him when the *New York Times* published a set of his pictures from Cuba and eventually flew to Paris for a meeting with Peress to try and sort things out. Peress rejected all these olive branches and continued to claim that he had been 'fired'. It was a ridiculous situation: Peress well knew that he could not be fired by Keller, just as Keller knew that he did not have the authority to fire any photographer, no matter how much he would have liked to.

Further letters followed, with Keller insisting he would be 'pleased and proud' to represent Peress and Peress insisting that he had been 'wronged'. Thomas Hoepker, the vice-president in New York, attempted to mediate, sending Peress a fax assuring him that there was no lapse in his representation by the New York office and that no damage had been done to his interests, other than to the atmosphere in the office. Hoepker said he had asked Keller to send Peress another apology, even though he had 'apologised profusely already'.

In the end, Keller circulated copies of the correspondence to members of the board 'in an effort to end this stressful situation' and in the hope that it would 'end this phase of difficulties with Gilles' and Peress made his feelings about the New York office quite clear in an interview with *Die Zeit* magazine in which Magnum was described as a 'passe-partout of faded legends'. He was quoted as saying: 'Magnum used to be a place of intelligence. The Paris office still is, half-way. The New York office is no more.'

Eugene Richards, meanwhile, had had enough of the back-biting in the New York office and decided to leave. His loss was as damaging as that of Salgado in terms of stature. Although he had never even approached Salgado's income – he had rarely earned

more than $20,000 a year – he was recognised as one of the finest documentary photographers working at that time in the United States, a man who epitomised 'the concerned photographer' in the finest traditions of Magnum. His book *Cocaine True, Cocaine Blue* was an extraordinary photographic exposé of hard-core drug addiction in America's inner cities and the result of four years' work in some of the toughest neighbourhoods in New York and Philadelphia.

Richards explained his reasons for resigning in a letter to François Hebel dated 26 November 1993:

Oh, I once had so many hopes for Magnum. While Richard Kalvar recently informed me that, with my personality, I never belonged in Magnum (he also called me self-pitying, cowardly, someone who avoided responsibility by feigning injury and sickness) he was decidedly wrong there. I had planned a life in Magnum. Everyone should know this. And I care now for the place though I am, admittedly, not as involved in its running or politics as maybe I should be, or as others want me to be. I don't want to be part of others' games or power trips. Still, I care for and respect so many of the photographers. You must excuse me for running on here. I am just responding to your news that Salgado has announced leaving and things at Magnum must now surely change. But let's face it – my leaving doesn't mean *shit* to Magnum. Money isn't what I produce. I sure the hell wish it was, then maybe I could hang on with you. But the truth is the market here for my kind of photography has crashed and there's few alternatives in this office for me. I know you've heard the complaint again and again, but in New York you pay your percentage for little or nothing. And I'll soon have nothing to pay and this, Kalvar says, makes me self-pitying. Well, better self-pitying than unable to support one's family. I love Magnum, but need to survive.

Richards had no subsequent regrets. 'When I got out of Magnum I felt profoundly relieved. It was not what I expected and not what I wanted. I left more angry than anything else, but I had never expected to leave. It has been harder since I left Magnum, I have to say. Work fell off to some degree and I am very isolated but there is a great relief to have things straight up front, no illusion, no games, no politics . . .'

In April 1994 Jim Nachtwey made headlines when, a week before

the elections in South Africa which resulted in Nelson Mandela becoming the country's first democratic leader, three photographers were shot during a gun battle between supporters of the ANC and the Inkatha Freedom Party in a township just outside Johannesburg. 'We were taking pictures as a small group advanced close to a workers' hostel where the Inkatha people were holed up and shooting at the ANC. There were six of us working together when there was a volley of machine-gun fire and three of my colleagues went down. Three of us got hit, three didn't. It was pure luck.'

The photographer standing next to Nachtwey, a South African by the name of Greg Marinovich, fell to the ground seriously wounded. Nachtwey began dragging him out of the line of fire, but as he did so he noticed that another colleague, Ken Oosterbroek, had also been hit. Nachtwey laid Marinovich down, told him he would be back and began to crawl towards Oosterbroek with bullets flying all round him. One came so close it actually parted his hair. When he reached Oosterbroek he discovered he was dead, so he scrambled back to Marinovich and pulled him to safety, then called for a police armoured carrier to come and collect the wounded and take them to hospital. A few hours later, Americans at home were able to watch the whole incident on CNN.

Nachtwey says he does not like to waste time thinking about such incidents. His instinct was not to take pictures but to help his wounded colleagues: that was his priority. He had had plenty of close shaves before – he was nicked in the head by a land mine in El Salvador and struck in the face by shrapnel in the Lebanon – and simply accepts that risk is part of the job. For his coverage in South Africa that year, Nachtwey received his fourth Robert Capa Gold Medal. He also received his sixth US Magazine Photographer of the Year award for his work in Rwanda and his second World Press Photo of the Year award for his portrait of a Hutu man mutilated for refusing to take part in a massacre of Tutsis. Nachtwey was the first photographer ever to win all three awards – the most coveted in photo-journalism – in a single year.

Shortly before the annual meeting in June 1994, Philip Jones Griffiths circulated his fellow photographers with an unprecedented plea not to admit an associate to full membership:

I have known Martin Parr for almost 20 years and during that time I have observed his career with interest. He is an unusual photographer in the sense that he has always shunned the values that Magnum was built on. Not for him any of our concerned

'finger on the pulse of society' humanistic photography. He preached against us and was bold enough to deride us in print while his career as an 'art' photographer mushroomed . . . When he applied for associate membership I pointed out that our acceptance of him into Magnum would be more than simply taking on another photographer. It would be the embracing of a sworn enemy whose meteoric rise in Magnum was closely linked with the moral climate of Thatcher's rule. His penchant for kicking the victims of Tory violence caused me to describe his pictures as 'fascistic' . . . Today he wants to be a member. The vote will be a declaration of who we are and a statement of how we see ourselves. His membership would not be a proclamation of diversity but the rejection of those values that have given Magnum the status it has in the world today. Please don't dismiss what I am saying as some kind of personality clash. Let me state that I have great respect for him as the dedicated enemy of everything I believe in and, I trust, what Magnum still believes in.

Martin Parr was unquestionably the most controversial photographer ever admitted into Magnum. Born in Surrey in 1952, he was intent on a career as a photographer from the time he was a teenager and interspersed freelance photography with teaching when he left college. He still has the demeanour of an affable schoolmaster, but he has a cynical, unforgiving and unashamedly voyeuristic eye as a photographer. He leapt to prominence with a savage book, *The Last Resort*, made up of colour plates of ugly families on holiday at a working-class seaside resort on its last legs in the north of England. Parr's vision was widely criticised as grotesque and brutal, while in some quarters he was hailed as a dazzling new talent. Accused of ridiculing mankind in his work, he responds by saying mankind *is* ridiculous.

Parr hesitated before applying to join Magnum because he knew he was far from a typical Magnum photographer, but he needed an agency and did not see any reason why he should not try to join the best. 'I don't think in recent years they have had anyone more controversial attempt to join the organisation. At every single stage, there were huge debates and massive arguments which, of course, I was not party to, but would hear about the day after. I was not particularly surprised. What did surprise me was that I got in at all. I did have some supporters, but there were many people actively attempting to make sure that I did not become a member: you know, sending letters, writing out huge, detailed arguments as to why I should not be accepted. The fundamental essence was that I

did not fit into the humanistic tradition that Magnum still saw itself as pursuing. It was as simple as that.

'I acknowledge that I don't fit into the Magnum tradition in one sense but I believe I do in another, because fundamentally I am interested in going out there and photographing the world as it is and doing very personal pictures. Inevitably, because of the way in which the world is going, there is an element of cynicism creeping into it. I believe it is the photographer's job to be critical of the world, as well as praising it. The tradition of Magnum is that it is fine to go along to wars and say this is a nasty business, but with anything else its role is basically to celebrate the world.'

Although there were rows when Parr was accepted first as a nominee and then as an associate, at his second attempt, they all paled into insignificance when he applied for full membership at the annual meeting in London in 1994. During a heated debate over his portfolio, it became clear the agency was split right down the middle. Philip Jones Griffiths led the opposition on the simple basis that Parr was opposed to everything Magnum stood for. The younger photographers, especially those based in Paris, largely supported Parr with the argument that Magnum should be open to new kinds of photography and different visions. When the first vote was taken, Parr just scraped in with the necessary two-thirds majority, but those opposing him immediately objected that not all members were present and insisted on a second ballot. Emissaries were sent out to scour London to bring in the missing members, and on the second ballot Parr was one vote short of a majority. But all was not lost: there was still one vote to be cast, that of Burt Glinn, who was sick with food poisoning at his hotel. He felt dreadful, but agreed to drag himself into the Magnum office to look at Parr's portfolio. Although he is firmly among Magnum's older generation, Glinn is more open-minded than most about new photography and cast his vote in favour of Parr being admitted.

'I was waiting at home in Bristol while all this was going on,' says Parr. 'First of all Peter Marlow telephoned to say I was in, then he called again and said I had been rejected, then I got a final call to say I had made it by one vote. I went into the London office next day to join the meeting. Normally when someone becomes a member there is universal praise, with clapping and shouting. This certainly wasn't the case with me. Most people came up and shook my hand but it was very subdued.'

'Parr's admission was very unpopular,' said Harry Gruyaert, one of his most fervent supporters. 'Certain people were so angry about him, so aggressive and they couldn't cope with it. I can't understand

it. I think it is very good for people like us to have Martin Parr, who is very different and dealing with things that are very often ugly but which are of modern times.'

The drama of Parr's membership was by no means over. In 1995 an exhibition of his latest pictures – a typically bleak view of world tourism – was held at the Centre National de la Photographie. Among the visitors was Henri Cartier-Bresson, who was appalled that such pictures could be taken by a member of Magnum. He rushed round the exhibition with obvious agitation. When he was finally introduced to Parr he fixed him with a baleful stare for a few moments, then said 'I have only one thing to say to you. You are from a completely different planet to me.' Parr was lost for words. A reporter who was standing nearby and overheard the exchange said to Cartier-Bresson, 'Does this mean you don't like his work?' The Frenchman, by now quivering with anger, shouted 'I never, never repeat myself!' and stormed off.

Next day Cartier-Bresson telephoned his friend René Burri and said 'René, come and explain to me why this chap is in Magnum.' Burri replied: 'Look, why do you want to object? The world is changing. We can't always keep taking the same kind of pictures.' In a more conciliatiory mood, Cartier-Bresson sent a fax to Parr: 'Dear Martin Parr, Being an impulsive photographer I am sorry it was only once in the street I realised how very much I over-reacted to your work, which was practically unknown to me . . . I want to confirm that I still think you are from a different planet. And why not? Yours, HCB.' The Frenchman also wrote to 'other concerned people' with an explanation of the incident: 'I think Parr did not understand that this was absolutely not about photography but about that which it implies, the philosophy of a man taking himself seriously, without humour, where rancour and scorn dominate, a nihilistic attitude symptomatic of society today, from which stemmed my extreme insolence towards him. I personally have nothing against him, aside from a great curiosity about this hiatus which he represents. I do not even sense hatred in him, because hate and love are relations, but only a bitterness of the stomach . . .'

A week later Parr replied: 'Dear Henri, Thanks for your fax . . . I acknowledge there is a large gap between your celebration of life and my implied criticism of it. My intuition tells me these are the issues I must deal with through photography. What I would query with you is "Why shoot the messenger?" Yours sincerely . . .'

Cartier-Bresson sent a copy of Parr's reply to François Hebel with a sour handwritten note: 'It seems to me that he has understood no aspect of my point of view, which does not surprise me at all. If he

had not been elected by Magnum ... I think I would have kept quiet.'

'I think Cartier-Bresson has a strong, idealistic, romantic vision of the world,' Parr said later, 'and is dismayed at the way it is going. My detractors probably think I deliberately set out to portray the brutality of life, the decay, the dissolution. It is not true. I see very clearly in my mind the many things that are going on in the world and I want to take photographs and build them into bodies of work which address these ideas and problems. Of course I am biased, of course I am voyeuristic, of course I exploit, but I believe this applies to all photography and I am only unusual insofar as most photographers always deny these things, whereas I am happy to acknowledge that we are all voyeuristic and exploitative. How can you not be? But built into the psyche of the Magnum photographer is that you should be out there, helping the world to be a better place. I don't believe that is true. I've been at meetings and overheard photographers bemoaning the fact that there wasn't a war on that they could cover.'

The same meeting that reluctantly accepted Parr as a member enthusiastically embraced a young French photographer, Luc Delahaye, as a nominee. Delahaye could not have fitted closer to the Magnum role model. He was thirty-one years old, resourceful and fearless. He had learned his trade at other photo agencies and once sat in a café every day for two weeks to get a picture of a member of the Red Brigade in Italy. The money he made from that assignment earned him enough to buy his first Leica. He covered the fighting in Beirut, was on the last plane into Romania before the overthrow of Ceausescu (he walked into the centre of Bucharest from the airport) and won the Robert Capa Gold Medal and a number of other awards for his coverage of the tortuous break-up of Yugoslavia and the fighting in Rwanda.

He travelled backwards and forwards to Croatia and Bosnia several times, never carrying more than his camera equipment and a spare pair of socks, underpants and shoes: 'You can always find something to eat and somewhere to sleep.' He got into the fighting around Vukovar before any other journalist by faking an entry visa in a hotel room. Using papers from a previous trip, he covered over the details with typewriter correction fluid, typed in new details, then faxed himself a copy: 'Faxed documents always look more authentic.' He was in the war zone while all the other photographers were still waiting in Belgrade for permission to enter the area.

Not long after joining Magnum, Delahaye had a terrifying experience in Bosnia. He had begun to feel there was a kind of

magic about him, protecting him from injury and danger; he was soon to discover it was illusory. 'I was with another photographer [Ron Haviv, of the American agency, Saba] when we were arrested early in the morning in Krajina. They took us to the police station and we spent a lot of time there, waiting. At the end of the day, we understood that they were going to expel us to Croatia. That was OK by me because it was not possible to work with the Serbs in Krajina and I didn't want to waste any more time there. We were taken back to the hotel, where they searched our bags very carefully. We packed them and put them in the car ready to go when they received a counter-order, to take us back to the police station, about twenty kilometres away. There we waited again for the arrival of the commandant of the unit which had arrested us earlier that morning. This guy was smart, well equipped and had a new four-wheel-drive. It made me realise we were talking to someone very serious. They took us to a small farm that was very close to the front line, an hour's drive away, and then it began.

'I don't really think they believed we were spies, they just wanted to play with us. Firstly, they blindfolded us and locked us in a small room outside in the garden. We waited there wondering what was going to happen, then suddenly the door opened and they threw buckets of cold water over us. It was December, very, very cold. It was dark and we were afraid of every step coming towards us. Then they separated us and took me to another room. I wasn't tortured, it was more infernal. This guy told me to lean with my head against the wall, my hands behind my back and my feet spread apart. After only five minutes, it hurt a lot and I fell. Every time I fell he would kick me with his boots. Then I was taken into another room; I couldn't see anything because I was still blindfolded but I could sense the presence of other people, ten maybe. It was a small room, hot and very silent. They kept the silence for ten minutes to prepare me psychologically, to pressure me. I could barely hear the breathing of the people, sometimes just a movement, and then the guy, speaking in French, started the interrogation. He has nothing to ask and I have nothing to say. 'What are you doing here?' 'I am a photographer.' Each time I gave an answer that was not convenient for him, I received a blow on the head with one or two fists. Then I realised why they had put the scarf on my head and I knew they were not going to kill me, because they wanted to protect my face in order to liberate me in good condition.

'I learned a lot about the psychology of torture. The victim is responsible, by his answers or his silence, for unleashing the blow. For example, the torturer asked who I worked for and I answered

'Magnum'. The torturer would have preferred me to answer that I was working for French Intelligence, and by not giving him the answer that he wanted, I was smashed with a fist. After twenty minutes, I fainted and they stopped the interrogation. When I came round they told me that they had killed my friend already and that I was going to be killed in one hour. I was thrown back into the room in the garden and they came back one hour later. All the time I was blindfolded and had my hands tied behind my back. They took me outside and I began to have serious feelings that they might kill me after all. They took a big tank of water and threw it over me and I just screamed because it was so cold, but rather this than be killed. All this lasted for three days, although they didn't beat us again. We thought nobody knew where we were, but in fact something was going on with the embassies and agencies, and so after three days, they had to release us because it was going to make too much trouble for them.

'There is a lot of violence in this job: you can be shot at sometimes, because from a distance you are like everybody else. But when you are targeted specifically it is much more disturbing. I was not happy to undergo such an experience because you lose your lightness and your naivety and both are useful for taking pictures.'

The Magnum office in Paris was in fact instrumental in getting Delahaye released. Other journalists in Bosnia had heard that he and Haviv had been arrested and had passed the word on. Magnum immediately contacted the French Foreign Office, which instructed the French ambassador in Bosnia to expedite their release. Delahaye lost all his equipment during the incident and when he arrived back in Paris Cartier-Bresson invited him to dinner and gave him one of of his own Leicas.

In London Delahaye had worthy competition from another young photographer determined to follow in the footsteps of Robert Capa. Paul Lowe pinned one of Jim Nachtwey's pictures from El Salvador on the wall of his room while he was reading modern history and politics at Cambridge and was determined to be a photographer as soon as he graduated. He cut his teeth in Belfast, where he met both Nachtwey and Peress, went on to cover the fall of the Berlin Wall and the famine in Somalia, where he came across Chris Steele-Perkins, and first went to Sarajevo in 1992, where he fell in love. Towards the end of 1994 his girlfriend came to visit him in London for Christmas and she had barely arrived before Lowe was on his way to Chechnya on assignment for *Stern*.

'I remember the morning I set off there was a report that the Russian and Chechen leaders had met and there was going to be no

war. I got on the plane feeling incredibly despondent. I had just left behind my girlfriend, who had travelled over specially to see me, and I was faced with the prospect of a week in a nasty, dirty, unpleasant cold part of the world with no story. A classic nightmare. I had backed the wrong horse but I still had to go because I had a guarantee from *Stern*. I got to Moscow that night and met quite a few other journalists there, most of whom thought nothing would happen, that it would fizzle out. So, again, rather despondently, I set off for Chechnya. I was the only Westerner on the plane to Dagestan, on the border, and when I arrived I just walked to the taxi rank outside the airport and and said "How much to Grozny?"

'I found a cab driver who said he would take me all the way but then got cold feet and dropped me halfway. I got on to a bus full of women and chickens as it was starting to get dark. I only had a tourist visa and I was nervous that I would get turned back, but we went through all the checkpoints without being stopped. I got off the bus in the middle of Grozny and was immediately grabbed by a couple of soldiers shouting *korrespondenti* and was taken to the press centre where I began to get a feel for what was going on. I borrowed a sleeping bag and found some space on the floor of a nearby *pension*.

'Next day things started to get really hot. The Russians started flying jets over and there was great tension so I decided to get to work on a story on the Chechens, because nobody really knew who they were, or what they were about. In doing so, I discovered that they were not the gangsters and Mafia types we had been led to believe; sure, they were tough, hardened fighters, but they were also some of the most hospitable, warm and generous people I have ever met. I started doing portraits of their life, the morale of little people caught up in a fight against a mighty military machine, and all the time the action was building up. I covered the first Russians crossing the border into Chechnya and flew back to Moscow to ship my film out. It was a risk, but I was able to get back in with a Swedish television crew.

'I became very committed to the struggle of the Chechens and got to know many of the fighters around the presidential palace. Each day I would go up, shake their hands and ask how the fight was going. One of my happiest moments was when we got into the main square on the 2nd of January, after the Russians had claimed to have taken the palace, and found the Chechens still very much in control. It was an incredible scene, with the square littered with the wrecks of Russian tanks and the charred bodies of Russian soldiers and the victorious Chechens waving flags and dancing in the streets. Most of my friends among the fighters were still alive and I remember

hugging them and cheering. I was so proud of them I kept telling my journalist friends 'My boys have done it! They've kicked Russian ass!"

'But at a particular point, it no longer became a story for me; it became personal. Steve Lehman, a photographer from *Newsweek*, and Cynthia Elbaum, a young American photographer on her first big story, and myself had been working together for several days covering the aftermath of the Russian bombing and we had all become close friends. We had gone to the scene of the previous night's bombing in an area north-east of the city called Micro Rayun. At least six bombs had been dropped on to a housing estate, devastating several houses. Steve and I were inside the wreckage of one of the houses photographing men trying to dig out a body from the debris, while Cynthia was outside, talking to a group of about thirty women and children, who had gathered to see what was going on.

'We were just about to leave when we heard the scream of jets overhead, very low, very fast and very close. We crouched down in the wreckage, burying our heads in our hands. There was a huge bang and the world went orange from the brick dust. I couldn't even see my hands in front of my face. I staggered out of the building, stepping over dead bodies in the entrance, into a scene of utter carnage, like something out of Dante's *Inferno*. There were at least eighteen dead bodies, torn apart from the force of the blast, a child was crying out for its father, cars were blazing and ammunition was exploding in the wreckage, sending bullets off in all directions.

'I was torn by three conflicting emotions. Firstly I knew these were important pictures to make, that these images gave the lie to Yeltsin's claim that his planes were only bombing strategic and military targets. Secondly, I was scared that the planes would return for another attack. But more importantly than either, I knew that Cynthia had been standing right where the bomb had fallen. We were screaming out her name, desperately searching for her. People would come up and drag us to a body, cruelly disfigured, asking if this was our friend. Eventually, Macksharip, our interpreter and friend, shouted to us. Cynthia had been thrown against the wall of a café. Her body lay crumpled, covered in debris. She had been killed instantly.'

Lowe had an even worse experience not long afterwards in Rwanda, when hundreds of Hutu refugees were massacred by government troops at the Kibeho camp. 'It was very chaotic, there were a lot of injured and wounded and many more people had been killed by the stampede that followed when the soldiers started

shooting. I felt I ought to help but I was the only journalist and I knew it was my duty to make pictures that would record the event. And anyway, what can one person do? At the end of the day, by the late afternoon, all the action was over and there was just this terrible scene of a whole field strewn with corpses. A lot of little babies had been on their mothers' backs, and the mothers had died, but the babies were still alive. I went out with one of the aid workers to collect these little children, to carry them back to the compound. It was a terrible experience. One of the doctors at the camp said "Look, you must stop bringing these people in because we've got nowhere to put them, you'll just have to leave them. If we take any more, they're going to get dysentery and they're going to die. We can just about look after the ones we've got and maybe we can save their lives. If you bring in any more, we may lose everybody." I literally had two babies in my arms at this point. I had to put them down by the entrance to the camp. There was nothing I could do, I couldn't take them with me. At the end of the day, you are only there because you are a journalist. It was very, very harrowing. I was in quite a state when I got back home.'

In 1995 Chris Steele-Perkins was elected president of Magnum. Almost his first sad duty was to inform members that George Rodger had died at his home in Smarden, Kent, on the evening of 24 July. Only a few months earlier, Peter Marlow had organised an enormously successful retrospective exhibition of his work at the Barbican in London.

Steele-Perkins took the opportunity of expressing the hope that Rodger's death would help them recapture something of Magnum's old spirit:

Every one of us who works in Magnum, as a photographer or on the staff, owes him a profound debt of gratitude . . . the qualities of his personality have gone into the early clay of this organisation to give it shape, direction and purpose as a collective enterprise for the mutual benefit and support of all of us – photographers and staff alike. As photographers we sometimes seem to have lost our direction, our reason for being part of Magnum itself. Self interest, a lack of caring, an unwillingness to make that extra effort for everyone's benefit sometimes clouds and poisons the atmosphere between us. And yet we all know that there is a collective heart in Magnum whose beat we all wish to be firm, strong and healthy. A heart that pumps something intangible into our lives which we treasure. Something that continues to make Magnum worthwhile.

I hope that George's death will focus our minds on what we should be doing in Magnum: working together to produce the finest work we can, which, through its quality, integrity and commitment, stands as a testament to our time in all its glory and misery . . .

A few months later, Steele-Perkins was in Afghanistan wondering about the wisdom of being a family man with children and risking his life for his work. 'There were four of us, Jim Nachtwey, myself, a French photographer and a Reuters cameraman with the government forces outside Kabul, which had been taken by the Taliban. The advance was moving quite smoothly, so Nachtwey and I went to the top of the hill to check things out, to take some pictures of the activity. Suddenly, there was a huge volley of fire from the Taliban. Our group started running around like headless chickens, making no attempt to hold their position or anything. We could hear small arms fire, so it was clear that the Taliban were not far away. Jim and I had started trotting back to the village when we heard the whistle of an incoming missile, dropped to the ground and covered our ears. An RPG [rocket-propelled grenade] landed a few feet away. I saw it bounce in front of us. We looked at it for another second or so and as it obviously wasn't going to go off, we legged it.

'I must say, I was thinking from the time the grenade landed to the time we were trying to get away up this exposed hill and being shot at: this isn't really what I want to be doing any more. I've got two kids. Apart from my own health – and that is an issue of major significance – even if I am not killed maybe I will be walking around with only one leg so won't be able to play football with them. It doesn't make a lot of sense to me now. When similar things happened before, I was single and I was seeing whether I could take it or not. Then you just think you got lucky and you put it away. But these things build up and you start to think there are other things you want to be doing. I've been shot at before, I've been bombed before, I've been mortared before, but you never get good pictures out of it. I've yet to see a decent front-line war picture. All the strong stuff is a bit further back, where the emotions are.'

Only a matter of weeks after returning from Afghanistan, Steele-Perkins was in New York to preside over a Magnum board meeting, this time dodging brickbats rather than bullets. There was, of course, a row. In fact there were several rows. First, the much-vaunted plan to rescue the agency from its financial difficulties by selling pictures

out of a catalogue ran into immediate and predictable problems when the Tokyo office rushed through the printing of its first catalogue. The trouble was that it was produced with a view to selling the maximum number of pictures in the Japanese market, rather than accommodating the sensibilities of the photographers. So, naturally, none of them liked it and none of them thought the right pictures had been chosen for inclusion. It did not bode well for the smooth production of further catalogues. 'The photographers.' said Steele-Perkins firmly, 'will have to be persuaded to respond sensibly to the selection.'

Then the thorny question of the use of Magnum photographs in advertising was raised once again. A few months earlier, Colin Jacobson, a respected picture editor in Britain, had written an article for the *Art Review* arguing that the agency was setting a dangerous precedent by allowing editorial pictures to be used out of context in advertising. He quoted as examples two photographs taken by Martin Parr as part of extended documentary essays appearing in advertisements to sell jeans and cars. A picture of a Conservative Party summer fête in Bath was used in a Pepé jeans ad with the line 'The world is full of people you hope you'll never meet', and a picture taken years earlier of a bored couple at a seaside resort featured in an advertisement for Fiat finance under the caption 'No interest for two years'.

Jacobson accused Parr of 'uncaring arrogance' and questioned Magnum's ethical position (in fact, the subjects have all given their permission for the photographs to be used). David Hurn made no secret of his concern: 'I squirm for the memory of George Rodger. Martin represents the genre of anarchic irreverence for everything and he is perfectly in tune with his times. [But] is this the way Magnum wants to go?'[1]

The article struck a raw nerve at Magnum and prompted Abbas to circulate an open letter to all members: 'If portraying people in a public place for what they appear to be is arrogant, then most of my photographs are arrogant too. When I photograph a wounded child in Sarajevo, is it merely the child I am portraying, or am I showing, through this child, the horrors of war brought home to thousands of children? What do I know of the life of the millions of people I have photographed so far?'

Another issue that sent blood pressures soaring at the board meeting was inter-office friction over computerisation. The Paris office had insisted on going ahead with a system designed specifically to meet its needs, but it had been hugely expensive and plagued with headaches, not least the disinclination of its designer to make himself

available to sort out all the teething troubles. Members based in London and New York gleefully accused their French colleagues of a botch-up and the Paris office was finally forced to concede it had made a mistake and accept that a new system was needed which would be compatible throughout the agency.

Magnum now has to respond to the challenge presented by digital image databases, which are capable of swallowing photographers' archives and collections wholesale and threaten to corner the market. In common with nearly all other photo agencies, Magnum has seen its income shift from new assignments and photo-journalism to the point where 60 per cent of its turnover comes from archive sales. The Magnum archive, one of the finest in the world, covers the entire spectrum of photography, from art to journalism, from landscape to portraiture, from crisis to culture. Many of the existing members – Martine Franck, Ferdinando Scianna, Inge Morath and Eve Arnold – continue the tradition of portraiture established by the agency's founders and an extraordinary numbers of artists and intellectuals, many of them personal friends of the photographers, have been photographed by Magnum over the years. The long personal projects undertaken by members also provide invaluable material to feed the archive.

But in order to compete with giant digital predators like Bill Gates's creation, Corbis, Magnum must invest in digitalisation. 'If we are to continue working as a collective, continue to take pictures we believe in, we must make greater use of the fantastic resource that is our archive,' says Chris Steele-Perkins. 'In order to market the archive globally we need to invest in it and as we don't have the money we must borrow it, or sell shares, or futures, or bonds, whatever. This is an alien concept to Magnum. We have never done it before, but unless we seize the initiative we are not going to survive.'

In some ways, as Magnum enters its fiftieth year, members can perhaps reflect that while everything is different everything is the same. As Howard Squadron says: 'All the issues that have plagued Magnum over the years, and still plague Magnum, were in existence when I first became their counsel – the issue of photographer control, the relationship between the photographers and staff, how the agency should market its pictures, battles between an artistic and commercial view of the world, personal battles, people resigning.'

So it is that the photographers still behave badly to each other and to the staff. So it is that Magnum's projected fiftieth anniversary book

is mired in precisely the same problems that delayed the fortieth anniversary book and is likely to be just as late on the bookstalls. So it is that computerisation of the archive is not just causing the inevitable technical difficulties but bitter disagreements between the offices, with accusations of favouritism – since the system was developed in the Paris office, the French photographers are said to be getting priority. So it is that the great plan to rescue Magnum from its financial difficulties with a catalogue is already the cause of dissension.

Yet despite it all, Magnum is still unchallenged as the finest photo agency in the world, its members still stretch the photographic canon and its integrity is still miraculously intact. When the photographers felt that insufficient world attention was being directed at Bosnia, the Paris office persuaded a billboard company to plaster the city with huge pictures of Bosnia taken by Gilles Peress. Despite everything that has happened in the world in the last half-century, Magnum today clings to the basic principles that were laid down by its founders, still functions as a co-operative.

As president in Magnum's fiftieth year, Steele-Perkins's ambitious objective is to get the agency working at its optimum level and to equip it for the next century. Two or three years ago he seriously considered resigning because of all the back-biting and 'stupid, time-wasting stuff', but now he is much more optimistic. 'I want to be part of Magnum, I want Magnum to succeed and I'll do my best to make it happen. I don't want to be part of an organisation destined to fail despite its illustrious past. I don't think that now. I feel we have got a future.'

What he can count on is the extraordinary loyalty and affection that Magnum generates in its members, despite the fact, paradoxically, that they are constantly at each other's throats. Even those members who have decided to resign, almost invariably leave with some smatterings of regret.

Burt Glinn, a member since 1951: 'I worry about whether Magnum will survive, but I wouldn't think of leaving. A lot of my career has been formed in Magnum and I know what I got out of it. I feel an obligation to the traditions, of what it is and what it stood for. I don't think there is anything else in photography like it. If I can help it in some way, then I will, if it doesn't kill me in the meantime.'

Abbas, member since 1981: 'Once you are a Magnum member, it is for life. Whatever you do, even if you don't take one single picture again, you are in for life. This creates a financial imbalance because we have some members who do not contribute financially,

but they bring in something else – they are very productive, we see their photographs, we see their energy, we see their view of the world: that is very important for the group.'

Erich Hartmann, member since 1951: 'The greatest frustration of belonging to Magnum is when a photographer's individuality asserts itself with not enough sense of self-discipline of belonging to a group. There is a sense that many photographers feel that what is good for them is also good for Magnum. I believe in exactly the opposite. When one reaches the moment of realisation that what is good for Magnum is no longer good for the individual, the individual has to leave. There has to be a kind of self-effacement along with the assertion of one's personality. I think that is the price of admission to this kind of organisation. Other than that, you are just a very high-priced agency of individual photographers who fight with each other all the time. By definition it takes egomaniacs not just to do this work but to prevail in it. You are asking this conglomeration of egomaniacs to submerge their ego-mania and think for each other. It is very difficult.'

Eve Arnold, member since 1951: 'We exist in a world where most marriages don't last fifty years. Here we are with this bunch of nutcases still alive and breathing. It has survived and endured. It's not been easy and very often I didn't think it was possible, but it has done some very good things. I never had any regrets. All the years I have been with Magnum it never occurred to me that I didn't want to be with Magnum, never occurred to me to want to get out. I find it is like being part of a family. You love all of them, but you don't like all of them. It is an organic thing. Sometimes it is perfect, sometimes much less than perfect, but it is an ongoing and living thing and I think for that reason it is very important; certainly it is very important to me. It has given me a lot more than I have given it.'

Carl De Keyzer, member since 1991: 'A Magnum photographer, in my view, is not a hero. What I admire in most Magnum photographers, young and old, is their ability to come back with something different, their ability to put their personality and views into their photography through technical and personal experience. I don't admire Henri Cartier-Bresson or Josef Koudelka because they found great subjects, but because they developed a very personal style and view. They knew, and know, how to frame reality in a way no other photographer could, or can. I think this is the only thing that distinguishes us from other photographers with the same kind of bravery and the same amount of heroic stories, but without the ability to grasp the world in their frame. During the six years I have

been in the agency I have never seen a photographer accepted because he dared risk his life for a photograph, but because he was able to combine different elements like ideas, concepts, light, movement, etcetera, not just into one frame but into a consistent series of frames. Sometimes too much attention is given to heroic adventures in faraway destinations and to backstabbing and jealousy and not enough to what each individual photographer has to say with his or her photography and what it means to a co-operative group like Magnum.'

Cornell Capa, member since 1954: 'Do you think I am crazy enough to tell you what I think about the future of Magnum? They have fumbled along for fifty years, they'll probably continue fumbling for another fifty.'

The author is grateful for permission to quote from the following works:

George Rodger: Humanity and Inhumanity, intro. by Bruce Bernard, copyright © Phaidon Press 1994; *Magnum Cinema,* intro. Alain Bergala, copyright © text Alain Bergala, English translation copyright © Phaidon Press Ltd. 1995; *Robert Capa,* Richard Whelan, Faber & Faber, copyright © Richard Whelan 1985; *A Love Affair with Life and Smithsonian,* Edward K. Thompson University of Missouri Press copyright © Edward K. Thompson 1995, reproduced by permission of the author; *The Concerned Photographer* and *The Concerned Photographer 2,* ed. Cornell Capa, International Center of Photography / Grossman Publishers; *The Making of the Misfits,* James Goode, Limelight Editions, copyright © James Goode 1986; *Flashback! The 50s,* Eve Arnold, Alfred A Knopf Inc., copyright © Eve Arnold 1978, reproduced by permission of the author; *Great Photographers of World War II,* Chris Boot, Magna Books, copyright © Chris Boot 1993, reproduced by permission of the author; *Werner Bischof 1916–1954 His Life and Work,* René Burri and Marco Bischof, Thames and Hudson, copyright © René Burri and Marco Bischof 1990; *After the War was Over,* intro. Mary Blume Thames and Hudson, copyright © Mary Blume 1985; *The Decisive Moment,* Henri Cartier-Bresson, Simon & Schuster / Editions Verve, copyright © Henri Cartier-Bresson 1952, reproduced by permission of the author; *Gordon Fraser Photographic Monograph #4,* intro. Inge Bondi copyright © Inge Bondi 1975, reproduced by permission of the author; *Chim: The Photographs of David Seymour,* Inge Bondi, André Deutsch, essay copyright © Inge Bondi 1996, foreword copyright © Cornell Capa 1996, introduction copyright © Henri Cartier-Bresson 1995, reproduced by permission of the author; *A Two Quart Bottle of Spirits,* John Morris, ICP / Grossman Publishers, reproduced by permission of the author; *W. Eugene Smith,* Jim Hughes, McGraw-Hill, copyright © Jim Hughes 1989, reprinted by permission of the author and his agents, Scott Meredith Literary Agency, L.P.

Every effort has been made to obtain necessary permissions with reference to copyright material. The publishers apologise if inadvertently any scources remain acknowledged.

Notes

Introduction

1 Review of *Magnum Cinema* by Anthony Haden-Guest, Phaidon, London, in *Sunday Times Magazine*, 23 March 1995.

1 The Meeting

1 Interview, *The Magnum Story*, BBC2, October 1989.

2 The Founders

1 Tribute to George Rodger, *Photo*, September 1995.
2 *Capa and Capa*: catalogue for exhibition of pictures at International Centre of Photography, 1990.
3 Inge Bondi, *Chim: The Photographs of David Seymour*, André Deutsch, London, 1996.
4 Henri Cartier-Bresson, *The Decisive Moment*, Simon & Schuster, New York, with Éditions Verve de Paris, 1952.
5 *Capa and Capa*.
6 René Burri and Marco Bischof, *Werner Bischof 1916–1954: His Life and Work*, Thames & Hudson, London, 1990.
7 Bondi, *Chim*.
8 Cornell Capa (ed.), *The Concerned Photographer*, Grossman, New York, 1972.
9 Irwin Shaw, *Views of Paris: Notes on a Parisian*, Aperture Books, New York, 1981.
10 Richard Whelan, *Robert Capa*, Alfred A. Knopf, New York, 1985.
11 Capa, *Concerned Photographer*.
12 Bruce Bernard, *George Rodger: Humanity and Inhumanity*, Phaidon, London, 1994.

13 Inge Bondi, *George Rodger*, Gordon Fraser, London, 1975.
14 Bernard, *George Rodger*.
15 Ibid.
16 *The Magnum Story*, BBC2.
17 Ibid.
18 Shaw, *Views of Paris*.
19 Capa, *Concerned Photographer*.
20 Inge Bondi, *David Seymour: Chim*, Studio Vista, London, 1974.
21 Capa, *Concerned Photographer*.
22 *New Yorker*, October 1989.
23 *The Magnum Story*.
24 *Time*, 30 April 1945.
25 Alain Bergala, *Magnum Cinema*, Phaidon, London, 1995.

3 The Founding

1 René Burri and Marco Bischof, *Werner Bischof 1916–1954: His Life and Work*, Thames & Hudson, London, 1990.
2 John Morris, 'A Two Quart Bottle of Spirits', in *Robert Capa*, Grossman, New York,
3 Irwin Shaw, *Views of Paris: Notes on a Parisian*, Aperture Books, New York, 1981.
4 George Rodger, 'Random Thoughts of a Founder Member', *Photo Technique*, November 1977.
5 Richard Whelan, *Robert Capa*, Alfred A. Knopf, New York, 1985.
6 Ibid.
7 Ibid.
8 Bruce Bernard, *George Rodger: Humanity and Inhumanity*, Phaidon, London, 1994.
9 *Photo Technique*, November 1977.
10 Bernard, *George Rodger*.
11 Ibid.
12 *New Yorker*, October 1989.
13 Ibid.
14 Ibid.
15 Ibid.

4 The Recruits

1 René Burri and Marco Bischof, *Werner Bischof 1916–1954: His Life and Work*, Thames & Hudson, London, 1990.
2 Ibid.
3 Jim Hughes and Alexander Haas, *Ernst Haas in Black and White*, Little Brown, Boston, 1992.
4 *Modern Photography*, July 1969.

5 Inge Morath, 'Meeting Magnum', in *Magnum Paris – Photographs 1935–1981*, Aperture Books, New York, 1981.
6 Inge Bondi, *Ernst Haas: Colour Photography*, Harry N. Abrams, New York, 1989.
7 *Independent*, 13 March 1991.
8 John Morris, 'A Two Quart Bottle of Spirits', in *Robert Capa*, Grossman, New York,
9 *The Magnum Story*, BBC2
10 *Erich Lessing: Fifty Years of Photography*, exhibition catalogue, 1955.
11 George Rodger, 'Random Thoughts of a Founder Member', *Photo Technique*, November 1977.
12 *35mm Photography*, Winter 1976.
13 Mary Blume, *After the War Was Over*, Thames & Hudson, London, 1985.
14 Burri and Bischof, *Werner Bischof*.
15 *Independent on Sunday*, 13 October 1996.
16 Morath, 'Meeting Magnum'.
17 Burri and Bischof, *Werner Bischof*.
18 Ibid.
19 *Reportage*, Spring 1995.
20 Burri and Bischof, *Werner Bischof*.
21 Ibid.
22 Ibid.
23 *Modern Photography*, July 1969.

5 The Decisive Moment

1 René Burri and Marco Bischof, *Werner Bischof* 1916–1954: *His Life and Work*, Thames & Hudson, London, 1990.
2 Henri Cartier-Bresson, *The Decisive Moment*, Simon & Schuster, London, with Editions Verve de Paris, 1952.
3 *Esquire*, April 1974.
4 Burri and Bischof, *Werner Bischof*.
5 Ibid.

6 Deaths in the Family

1 Irwin Shaw, *Views of Paris: Notes on a Parisian*, Aperture Books, New York, 1981.
2 Inge Morath, Meeting Magnum, in *Magnum – Photographs 1935–1981*, Aperture Books, New York, 1981.
3 *The Magnum Story*, BBC2.
4 Edward K. Thompson, *A Love Affair with Life and the Smithsonian*, University of Missouri Press, Columbia, 1995.
5 Richard Whelan, *Robert Capa*, Alfred A. Knopf, New York, 1985.

6 Ibid.
7 Ibid.
8 *35mm Photography*, Winter 1976.
9 Mary Blume *After the War Was Over*, Thames & Hudson, London, 1985.
10 *Popular Photography*, September 1957.
11 *Independent on Sunday*, 13 October 1996.
12 John Morris, 'A Two Quart Bottle of Spirits', in *Robert Capa*, Grossman, New York,
13 George Rodger, 'Random Thoughts of a Founder Member', *Photo Technique*, November 1977.
14 Mary Blume *After the War Was Over*.
15 Ibid.
16 Inge Bondi, *David Seymour: Chim*, Studio Vista, London, 1974.

7 *The Saga of Eugene Smith*

1 Jim Hughes, *W. Eugene Smith – Shadow & Substance*, McGraw-Hill, New York, 1989.
2 *The Magnum Story*, BBC2,
3 Eugene Smith Archive, Center for Creative Photography, Tucson, Arizona.
4 Chris Boot, *Great Photographers of World War Two*, Magna Books, London, 1993.
5 Hughes, *W. Eugene Smith*.
6 Cornell Capa (ed.), *The Concerned Photographer*, Grossman, New York, 1972.
7 Edward K. Thompson, *A Love Affair with Life and the Smithsonian*, University of Missouri Press, Columbia, 1995.
8 Ibid.
9 Eugene Smith Archive, Center for Creative Photography.
10 Ibid.
11 Hughes, *W. Eugene Smith*.
12 Eugene Smith Archive, Center for Creative Photography.
13 Ibid.
14 Ibid.
15 Ibid.
16 Ibid.
17 Ibid.
18 Ibid.
19 Eugene Smith Archive, Center for Creative Photography.
20 Ibid.
21 Ibid.
22 *Sunday Times Magazine*, 6 August 1995.

23 *American Photographer*, December 1985.

8 Censors and Self-Censors

1 *The Magnum Story*, BBC2.
2 'Kryn Taconis, Photo-Journalist'. Introduction by George Rodger for National Archives of Canada, 1989.
3 *Photo*, 1995.
4 *Bruce Davidson Photographs*, Agrinde/Summit Books, New York, 1978.
5 *The Magnum Story*.
6 James Goode, *The Making of the Misfits*, Limelight Editions, 1963.
7 Ibid.
8 Alain Bergala, *Magnum Cinema*, Phaidon, London, 1995.
9 Introduction to Edward Steicher, *The World as Seen by Magnum Photographers*, exhibition catalogue, May 1962.

9 The Che Diaries Affair

1 Eve Arnold *Flashback! The 50s*, Alfred A. Knopf, New York, 1978.
2 *Bruce Davidson Photographs*, Agrinde/Summit Books, New York, 1978.
3 *The Magnum Story*, BBC2.
4 *Bruce Davidson Photographs*.

10 Vietnam

1 *Independent on Sunday*, 1 December 1996.
2 Philip Jones Griffiths, *Vietnam Inc.*, Collier-Macmillan, London, 1972.
3 Ibid.
4 *The Magnum Story*, BBC2.

11 End of the Glory Days

1 *The Magnum Story*, BBC2.
2 *Sunday Times Magazine*, 13 August 1989.
3 Ibid.
4 *The Independent*, 21 January 1992.
5 Cornell Capa (ed.), *The Concerned Photographer*, Grossman, New York, 1972.
6 *The Magnum Story*, BBC2.

7 Ibid.

12 *A Crisis and a Shooting*

1 Press release from Castelli Photographs, May 1981.
2 *Photo-Metro*, November/December 1989.
3 *The Magnum Story*, BBC2.
4 Ibid.
5 Ibid.
6 *Sunday Times*, 11 March 1990.

13 *On the Road to a Half-Century*

1 *Art Review*, July/August 1996.

Index